This book is to be returned on or
the last date stamped belo

1

CHINESE DESIGN

daab

Introduction 4

A JOURNEY THROUGH CHINA,
A COUNTRY BUILDING ITS FUTURE

China, a country of immense landmass and more than five-thousand years of history, is currently undergoing a tremendous transformation, boosted by its rapid and constant economic growth. A consequence of this lies in the country's flourishing new architecture, itself a reflection of China's growing self-confidence. However amid this building frenzy, some contradictory results have begun to emerge. Although the government has been trying to preserve the architectural, cultural and historical heritage that managed to survive the ideological fever that swept through during the Sixties and Seventies, preference given to the rapid development of infrastructures has led to fairly disastrous results. For example, the disappearance of the majority of the extraordinary *hutongs* (old alleyways) that have given Beijing so much of its traditional character; or more general speaking, how many Chinese cities have become enormous and poorly planned urban sprawls. Still, as China is basking in continuous self-reliance, the negative aspects of its urban cityscape, represented by an excessive rapid development and environmental pollution, are already being re-addressed thanks to a progressive awareness amongst China's architectural ateliers and design institutes, wich have become significantly more cultured and refined in the past decade. The Chinese government has also, in turn, been fairly rational when commissioning large and complicated projects to foreign firms, encouraging, or even requiring those to team up with local partners, thus bringing about a considerable amount of technological transfer, indirect know-how, and, ultimately, improving the capabilities of local Chinese professionals. Another important factor that has contributed to this trend of conciousness-raising has been the return to the mainland of a large number of talented Chinese architects and designers, who, having worked or studied abroad, have brought new expertise and a very positive influence into the current Chinese architectural scene.

In this book *Chinese Design*, we are pleased to introduce a wide array of different architectural projects, and the various designers, architectural ateliers and developers that have made these works come to light. While in China on a research visit for this book, we had the opportunity and pleasure to meet most of them. The distribution of the book has been done in three chapters according to the three main geographical areas—Beijing, Shanghai, and Hong Kong—where most of these projects are located. A forth chapter covers the architectural projects located in other parts of the Chinese mainland.

Beijing, the capital of the country, is also its political and intellectual hub. The city, previously known for its grey austerity, is currently experiencing a profound change of its public face, with some of the world's most acclaimed architects and designers competing with dazzling, innovative projects that are literally clearing away large sections of the old city. During the Eighties, a good number of large post-modern buildings were erected that were meant to substitute the traditional Chinese architecture. They were eclectic and reminiscent of western modern edifices, but topped with massive Chinese-style roofs, wich added a certain kitsch and a bizarre spirit to the city's skyline. Lately, this architectural trend seems to be coming to an end. Nowadays, in the period leading up to the 2008 Olympics, a number of boastful, flamboyant new projects are in the process of stamping a new character, a totally futuristic new-look to the Chinese capital. Such are projects like the new Olympic Stadium designed by the Swiss architects Herzog & De Meuron, the National Grand Theatre by French architect Paul Andreu, or the impressive CCTV building housing the headquarters for China's Central Television, with its Z-shaped towers enclosing a gigantic empty hole, designed by the Dutch architect Rem Koolhaas. The Chinese have thus chosen modernity, not only through their own traditional style, but also opting for innovative western design. Not only has the latter been accomplished through these renowned foreign architects, but also thanks to a new breed of Chinese star designers and architects, such as Ai Weiwei and Chang Yung Ho, local, totally independent people, who after long-held careers overseas, have returned home. They belong to a new elite of emergent *amphibious* professionals, fully bilingual, who can operate and play a very active role in both Chinese and Western design scenarios. Just as in ancient China, Confucius (551-479 bc) preached that supreme wisdom is for humans to live in harmony with nature, so too can these two artists skillfully translate thousand-year-old Chinese traditions into their modern day designs, ranging out from small interiors to huge landscape projects. Ai Weiwei and Chang Yung Ho also project a very active and

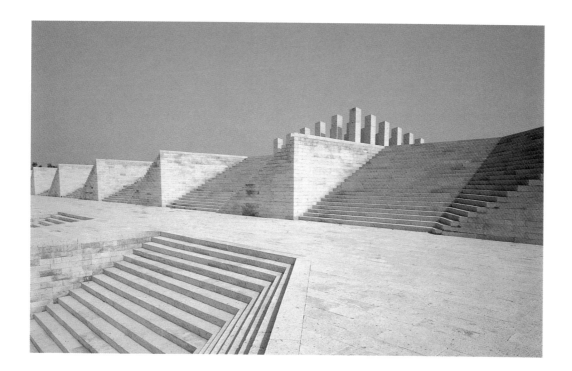

key role in the thriving, contemporary, avant-garde and experimental art and design scene of China's capital, Beijing. Together with many other artists and creators from the city's design scene, they set-up the famous 798 Space, a decayed East-German designed military factory from the Fiftees, formerly known as joint Factory 718, turned into a contemporary art and culture community space, with art galleries, artists residences and workshops, cafés, restaurants, etc. Chang Yung Ho did all the master renovation work to convert this old factory known as Join Factory 718 into the 798 Space.

The Chinese Museum of Film and the Beijing Planetarium designed by RTKL Associates and Amphibious Arc, respectively, will also certainly become an epoque-making project of Beijing's cultural scene.

Despite the tense political relations that still continue to linger between the governments of China and Japan, one can detect a real interest and a growing interaction between their peoples. Hence the increasing collaboration between young Chinese and Japanese architects. Beijing-based architects Keiichiro Sako of SKSK Architects and Hironori Matsubara are a prime example of this trend.

Beijing cuisine has traditionally not been highly regarded in comparison to the styles of cooking offered in other parts of China. This doesn't seem to be the case any more. Modern-designed restaurants, published in this book, like the Huang Ting in the Peninsula Palace Hotel in Beijing, Made in China in the Grand Hyatt Hotel, or Il Milione & Q's Café situated inside a modern residential complex are proof of the high-quality standard that both Chinese and Western cooking have been acquiring in the capital.

Soho China, the local private developer, famous for its Great Wall Project, an upscale gated community composed of 12 residential houses, each designed by a different Asian architect, is also present in this book with massive projects like Soho New Town and Jianwai Soho, two huge large-scale development complexes, composed of commercial spaces, restaurants, offices, and residential flats, situated right in the heart of the capital. Within the movement to preserve the landscape of Beijing's ancient remaining *hutong* areas, traditional

spaces and old courtyard houses have been converted, combining old and new architecture, as it is shown in works featured in this book like the Bamboo Garden Hotel, Café Sambal, MIMA Café or the Red Capital establishments.

Shanghai, which evolved between 1843 and 1943 from a small port on the entrance of the Yangtze river into a major city in East Asia, is now an incredible bustling metropolis of more than 13 million people. Indeed, as one of the world's more sensational booming areas, the city has often been described as the site of the wildest and most ambitious construction boom of the past decade. Amid its profusion of skyscrapers, high-rise residential flats and the omnipresent bright neon-lights, this book presents some of the colossal projects that are under way in the city, such as the Japanese landscape architect Mitsuru Senda's project, the Qi Zhong Forest Sports City Tennis Center. On the other hand, it is imperative to mention the work of two local architects that belong to a new generation of professionals who have also been educated abroad. Both Ma Weidong of the CA Group and Chen Xudong of Datrans, bring a new enlightment into the Shanghai design scene with fresh, knowledgeable information on new architectural tendencies, as well as with a promising and proven ability to convert old buildings. Two hours by car south of Shanghai, lies the city of Hangzhou, specially known for its famous West Lake (Xihu). Located in this beautiful spot, which Marco Polo already described centuries ago as heaven on earth, the Fuchun Resort complex is another of the projects presented in the book.

Hong Kong is known for being one of the most densely populated cities in the world. With a scale totally different from Beijing or Shanghai, the city's landscape seems to be constantly changing, as perfectly sound buildings are replaced by taller and more modern structures, almost on a monthly basis. From the city, we present the work of Alan Chan, one of its most successful graphic and interior designers, as well as other well-known architectural worshops like Edge Design Institute, AB Concept, etc. As in the films of the celebrated cinema director Wong Kar Wai, icon of Hong Kong's modern culture, the shops of Chen Mi Ji and Maymayking, also featured in the book, breath also an undisputed Hong Kong ambiance. History and tradition at its best are to be found at the Peninsula Palace Hotel, one of the great symbols in town.

About Chinese Design

Like the Great Wall, which with its 2,400 km is the only built structure on earth visible from outer space, China is so huge and profound, that to make an attempt to analyse its design is practically as impossible as trying to interpret its ethnic and racial mix-up; in Beijing alone there are about 23 different ethnic groups. The basic principle, however, that seemed to influence space design in China was related to a number of different philosophies like Confucionism, Taoism or Fengshui. Ancient values, different beliefs and philosophies have gradually settled in a pile of different layers that still are very much alive in today's China. Although nowadays, in general, people do not really like being bound by ancient tradition, still most of them follow, or at least cannot ignore, the Fengshui laws of space direction or some other philosophies. China's complex, harsh and hazardous history partly explains one of the reasons why many residential houses and buildings look often like solid fortresses, with its inner space clearly separated and differentiated from the outer part of the house. Inside the house compound, the patio serves not only as a source of visual delight, but it is used also for outdoor inner living throughout the various seasons of the year. If we looked for an opposite example, we would come across the Japanese style house, made out of wood and paper, looking rather more simple, modest, and fragile, with its inner space connected directly to the outer space, to the exterior of the house.

Finally, we would like to introduce a few distinctive examples of iconography in China, a symbology that plays a very important role within Chinese design. It is said that the famous Dutch architect Rem Koolhaas did a lot of research so as to acquire the necessary knowledge about Chinese iconography in order to be able to successfully enter the important project contests his architectural office was involved in in China. Colours like red, aside from being the colour of the Chinese national flag, have signified fortune and luck since ancient times. Gold means Yang. Silver means Yin. Both are also symbols for luck. Happy animals like the Dragon, the Peacock and the Goldfish embody the concept of protection, intelligence, happiness and wealth. Slogans splashed on red textile banners, painted on the walls or on signboards are another unique feature of this con-

spicuous symbology present all over China's urban landscape. Visually, sometimes it seems as if every single city of the country lies under the overriding spell of the Chinese character script.

China, with an extraordinary appetite for the new, certainly a powerful driving force for its rapid change, seems to have borrowed from the urban models of the 60's or 70's of Hong Kong or the United States in order to design, thirty years on, its own model. As a consequence of this, the end product is a somewhat general retro-futuristic urban landscape spreading all over its cities. It would now be ideal for the country to learn to pause a little, while on its way to modernity, in order to draw much needed inspiration from its impressive historical heritage and tradition. At the same time, take heed of some of the failed urban landscapes that its neighbour, Japan, has created in similar past circumstances. Examples like the amount of unnecessary pedestrian bridges as well as the steady progression of elevated highways running through the heart of its cities, would seem to suggest that China is following quite closely in the footsteps of Japan's past lack of foresight in urban planning.

Still, as mentioned earlier, we are most grateful and comforted by the fact of having had the opportunity to meet and get to know quite a number of really talented Chinese architects, designers, and promoters whose vision and expertise will certainly be exerting a very positive impact, gradually influencing tomorrow's architectural scene in China.

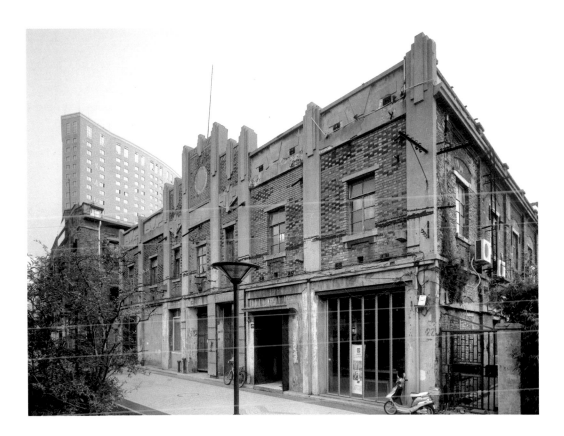

EINE REISE DURCH CHINA,
EIN LAND BAUT AN SEINER ZUKUNFT

In China, das über eine riesige Landmasse verfügt und auf mehr als 5000 Jahre Geschichte zurückblickt, finden zur Zeit gewaltige Veränderungen statt, die durch das schnelle und anhaltende Wirtschaftswachstum verursacht werden. Eine Folge dieser Veränderungen und auch eine Widerspiegelung des wachsenden Selbstvertrauens ist das neue und florierende architektonische Panorama des Landes. Inmitten dieser fieberhaften Bautätigkeit beginnt man aber auch einige sehr widersprüchliche Ergebnisse wahrzunehmen. Obwohl die Regierung seit Jahren versucht, das architektonische, kulturelle und historische Erbe zu bewahren, das das ideologische Fieber der Sechziger- und Siebzigerjahre des vergangenen Jahrhunderts überlebt hat, hat man doch der schnellen Schaffung von Infrastruktur den Vorrang gegeben, was zu sehr extremen Ergebnissen geführt hat, wie zum Beispiel dem Verschwinden der meisten der einzigartigen *Hutongs* (Viertel voller enger Gassen), die den besonderen Charakter der Stadt Peking ausmachten, und zur Transformation großer Teile der chinesischen Städte in unkontrollierte und schlecht geplante bebaute Flächen. Insgesamt ist China in den letzten Jahren ein sehr selbstbewusstes Land geworden, wobei sich jedoch die viel zu schnelle Entwicklung und die damit zusammenhängende Umweltverschmutzung sehr negativ auf die Stadtlandschaften ausgewirkt hat. Glücklicherweise werden sich die Architektur- und Innenarchitekturstudios des Landes dieser Situation immer mehr bewusst und sie verfügen über eine wachsende Kapazität, diese negativen Aspekte einzuschätzen, vor allem, wenn man einen Vergleich mit dem vorhergehenden Jahrzehnt zieht. Die Regierung Chinas hat ihrerseits relativ viel Einfühlungsvermögen gezeigt und die großen ausländischen Unternehmen, die große Infrastrukturplanungen durchführen, dazu ermutigt oder sogar aufgefordert, sich mit lokalen Unternehmen zu verbinden, um so Technologie, Kenntnisse und Erfahrung weiterzugeben und auch das Personal vor Ort weiterzubilden. Ein anderer, wichtiger Faktor, der zu der vorher erwähnten Bewusstseinsbildung beigetragen hat, ist die Tatsache, dass eine beträchtliche Zahl an talentierten Architekten und Innenarchitekten in ihr Heimatland zurückgekehrt sind, nachdem sie jahrelang ihren Beruf im Ausland ausgeübt oder dort studiert haben. Diese Rückkehr wirkt sich sehr positiv auf den Sektor aus, da diese Menschen Erfahrung und Kompetenz mitbringen.

In dem Buch *Chinese Design* zeigen wir Ihnen eine Vielzahl architektonischer Projekte und stellen Ihnen verschiedene Architekten, Innenarchitekten und Bauherren vor, die hinter diesen Werken stehen. Während unseres letzten Besuchs in Chinas, bei dem wir weitere Dokumentation für dieses Buch suchten, hatten wir die Gelegenheit und Freude, die meisten dieser Menschen persönlich kennen zu lernen. Das Buch gliedert sich in drei Kapitel, die mit den drei großen geographischen Gebieten Peking, Shanghai und Hong Kong übereinstimmen, wo sich die meisten dieser Bauwerke befinden. In einem vierten Kapitel werden Bauprojekte in anderen Gebieten des kontinentalen Chinas vorgestellt.

Peking, die Hauptstadt des Landes, ist auch das politische und intellektuelle Zentrum Chinas. Das Erscheinungsbild der Stadt, die einst für ihre Schlichtheit bekannt war, hat sich sehr stark verändert. Einige weltbekannte Architekten und Innenarchitekten stehen hier mit beeindruckenden und innovativen Bauprojekten im Wettstreit, mit denen sie im wahrsten Sinne des Wortes riesige Teile der alten Stadt hinwegfegen. Während der Achtzigerjahre wurde eine große Zahl postmoderner, eklektischer Gebäude errichtet, die deutlich westlichen Bauten gleichen, aber von riesigen Dächern im chinesischen Stil gekrönt werden. So wurde dem städtischen Horizont eine irgendwie skurrile und kitschige Note hinzugefügt. In letzter Zeit scheint dieses architektonische Muster allmählich zu verschwinden. In der Gegenwart prägen eine große Zahl extravaganter und luxuriöser Bauprojekte den neuen futuristischen Charakter der Hauptstadt, die sich auf die Olympischen Spiele 2008 vorbereitet. Es handelt sich um Projekte wie das Olympiastudium, das von dem Schweizer Architekturstudio Herzog & De Meuron geplant wird, das Große Nationaltheater von dem französischen Architekten Paul Andreu oder das beeindruckende Gebäude der CCTV mit seinen Türmen, die ein Z bilden, von dem holländischen Architekten Rem Koolhaas für die zentralen Studios des öffentlichen Fernsehens Chinas entworfen. Auch die Chinesen haben auf Modernität gesetzt, wobei sie nicht nur ihren eigenen traditionellen Stil wahren, sondern auch ein innovativeres westliches Design übernehmen. Das wurde sowohl durch die Beteiligung berühmter internatio-

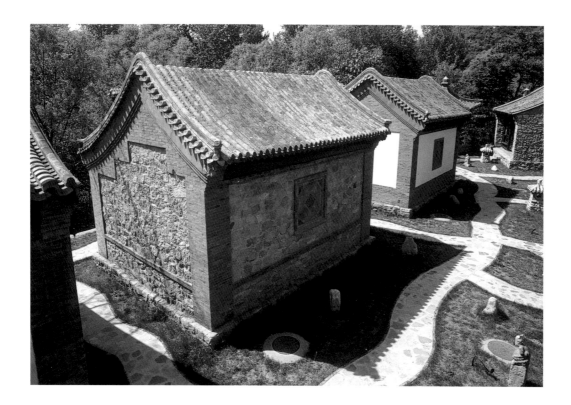

naler Architekten als auch durch eine neue Generation großer chinesischer Architekten und Innenarchitekten wie Ai Weiwei und Chang Yung Ho erreicht, die im Land geboren und völlig unabhängig sind, und die nach einer langen beruflichen Tätigkeit im Ausland mit all den gesammelten Erfahrungen in ihre Heimat zurückkehrten. Sie gehören zur neuen beruflichen Elite, die absolut zweisprachig und dazu in der Lage ist, eine aktive Rolle in China und auch in der westlichen Welt zu spielen. Ebenso wie im alten China, in dem Konfuzius (551 – 479 v. Chr.) verkündete, dass die höchste Weisheit des menschlichen Wesens darauf beruht, der Natur nahe zu sein, können diese beiden Künstler erschaffen, indem sie mit großer Geschicklichkeit die tausendjährige chinesische Tradition in das avantgardistische Design der heutigen Zeit übersetzen. So entstehen außerordentliche und sehr einfache Räume, angefangen bei kleineren Räumen bis hin zu sehr großen Landschaftsplanungsprojekten. Ai Weiwei und Chang Yung Ho spielen auch eine sehr aktive Schlüsselrolle innerhalb der zeitgenössischen, experimentellen und avantgardistischen Kunst und Design in der Hauptstadt Chinas. Zusammen mit anderen Künstlern gründeten sie den bekannten 798 Space in einer verfallenen alten Militärfabrik, die in den Fünfzigerjahren von der ehemaligen DDR errichtet wurde. Sie machten aus der Fabrik einen städtischen Raum für zeitgenössische Kunst und Kultur, voller Galerien, Ateliers und Künstlerwohnungen, Cafés, Restaurants usw.. Chang Yung Ho führte die Umbauarbeiten zur Umgestaltung dieser alten Fabrik in den 798 Space durch, vorher unter dem Namen Joint Factory 718 bekannt.

Das Chinesische Kinomuseum und das Peking Planetarium, die von den Architekturstudios RTKL Associates und Amphibious Arc geplant wurden, sind zwei weitere Projekte, die eine wichtige Rolle im architektonischen Panorama und in der Innenarchitektur der Stadt spielen. Trotz der gespannten diplomatischen Beziehungen zwischen China und Japan kann man eine fortschreitende Interaktion und gegenseitiges Interesse der Menschen beider Länder beobachten. Davon zeugt die wachsende Zusammenarbeit zwischen jungen chinesischen und japanischen Architekten. Japanische Architekten mit Sitz in Peking wie Keiichiro Sako von SKSK Architects und Hironori Matsubara sind ein überzeugender Beweis für diesen neuen Trend.

Die Gastronomie Pekings war traditionell nicht so gut angesehen wie die anderer Landstriche Chinas. Das scheint heute jedoch nicht mehr der Fall zu sein. In diesem Buch werden sehr modern gestaltete Restaurants wie das Made in China im Grand Hyatt Hotel, das Huang Ting im Peninsula Palace Hotel und das Il Milione & Q's Café in einem modernen Wohnhauskomplex vorgestellt. Sie zeugen von dem neuen gastronomischen Niveau, das die Hauptstadt heute zu bieten hat.

Soho China, eine unabhängige Bauherrin mit Sitz in der Hauptstadt, bekannt aufgrund des berühmten Great Wall Project, einer Gruppe aus zwölf luxuriösen Wohnhäusern, von denen jedes von anderen Architekten aus verschiedenen asiatischen Ländern entworfen wurde, wird ebenfalls mit bedeutenden Bauprojekten wie Soho New Town und Jianwai Soho vorgestellt. Es handelt sich um zwei riesige Wohnkomplexe im Herzen der Stadt, in denen viele kleine Läden und Einkaufszentren, Restaurants, Büros, Wohnungen usw. zu finden sind.

Aufgrund einer Initiative zur Erhaltung der wenigen *Hutongs*, die es noch in der Stadt gibt, wurden traditionelle alte Häuser mit Innenhöfen umgestaltet und saniert, wobei moderne Architektur mit der traditionellen kombiniert wurde. Einige dieser Projekte werden in diesem Buch vorgestellt, so z. B. das Bamboo Garden Hotel, das Café Sambal, das MIMA Café un die Anlagen Red Capital usw..

Shanghai entwickelte sich zwischen 1843 und 1943 von einem kleinen Hafen an der Mündung des Flusses Yangtze zu einer großen Stadt im östlichen Asien, heute eine hektische und prachtvolle Metropolis mit über 13 Millionen Einwohnern. In der Stadt ist nicht nur ein starker Wirtschaftsaufschwung zu verzeichnen, wie er kaum sonstwo auf der Welt finden ist, sondern man sagt ihr auch nach, der Ort zu sein, wo einer der größten, ehrgeizigsten und heftigsten Baubooms des letzten Jahrzehnts stattgefunden hätte. Inmitten einer solchen Fülle an Wolkenkratzern, extrem hohen Wohngebäuden und der allgegenwärtigen, starken Neonbeleuchtung zeigt Ihnen dieses Buch einige der überwältigenden Bauprojekte, die zur Zeit in der Stadt durchgeführt werden, wie z. B. der Tennisclub Qi Zhong Forest, entworfen von dem japanischen Architekten Mitsuru Senda. Ebenso muss unbedingt die Arbeit von zwei anderen, ortsansässigen Architekten genannt werden, die zur neuen Generation von Architekten gehören, die im Ausland studiert haben. Ma Weidong von CA Group und Chen Xudong von Datrans bringen neue Kenntnisse in das architektonische Panorama von Shanghai ein. Sie sind gut über neue Trends in der Architektur und Innenarchitektur informiert, und verfügen über ausgezeichnete Kenntnisse und viel Erfahrung bei der Umgestaltung alter Gebäude. Zwei Autostunden im Süden Shanghais liegt die Stadt Hangzhou, die vor allem aufgrund des berühmten Westsees (Xihu) bekannt ist. Sie ist von einer wundervollen Landschaft umgeben, von der Marco Polo bereits vor Jahrhunderten geschwärmt hatte. Er beschrieb sie als ein Paradies auf Erden. Dort befindet sich eines der Bauprojekte, das in diesem Buch vorgestellt wird, das Fuchun Resort.

Hong Kong ist dafür bekannt, eine der am dichtesten bevölkerten Städte auf diesem Planeten zu sein. Die Stadt unterscheidet sich völlig von Peking und Shanghai und die Stadtlandschaft scheint sich ständig zu verändern, da praktisch jeden Monat völlig gut gebaute und stabile Gebäude durch höhere und modernere ersetzt werden. In diesem Buch stellen wir die Arbeit von Alan Chan vor, ein bekannter Grafikdesigner und Innenarchitekt, und auch Arbeiten anderer bekannter Architekturstudios wie Edge Design Institute, AB Concept usw.. Ebenso wie die Filme des berühmten Regisseurs der Stadt, Wong Kar Wai, Ikon der kulturellen Avantgarde von Hong Kong, haben auch die Arbeiten von Chen Mi Ji und Maymayking die gleiche unvergleichliche Aura, die Hong Kong prägt. Das gleiche gilt für das Peninsula Palace Hotel, ein Gebäude, das prägender Bestandteil des Stadtbildes und das prachtvolle Ergebnis der Vermischung der interessantesten historischen und traditionellen Aspekte ist.

Über das chinesische Design

Wenn man die 2.400 km lange Chinesische Mauer, das einzige große Bauwerk auf diesem Planeten, das man vom All aus sehen kann, als Beispiel für die chinesische Baukunst nimmt und bedenkt, wie riesig und tiefgründig das Land China ist, wird deutlich, dass es schwer ist, Architektur, Design und Gestaltung in China in allgemeiner Weise zu analysieren. Das ist genauso unmöglich wie die Diversität der Ethnien und Rassen des Lan-

des zu definieren, allein in Peking leben ungefähr 23 verschiedene ethnische Gruppen zusammen. Was jedoch grundlegend die Architektur und Innenarchitektur des Landes zu beeinflussen scheint, ist das Zusammenfließen verschiedener Philosophien wie der Konfuzianismus, der Taoismus, Feng Shui usw.. Alte Werte, verschiedene Glaubensrichtungen und Philosophien haben sich langsam gesetzt, abgelagert, so dass allmählich eine Berg aus mehreren Schichten entstanden ist. Diese Werte sind im heutigen China weiterhin lebendig und gültig. Obwohl gegenwärtig ein großer Teil der Bevölkerung sich nicht allzusehr mit der Tradition zu identifizieren scheint, ignoriert doch die Mehrheit die Gesetze der Feng Shui-Philosophie zur Gestaltung des Raumes und die anderen Philosophien nicht, und viele befolgen sie auch weiterhin. Die komplexe, raue und gewalttätige Geschichte Chinas erklärt teilweise die Gründe, warum die Häuser und Gebäude Chinas wie eine Festung wirken, fest und solide, mit einem inneren Teil, der deutlich von außen abgetrennt ist. Im Inneren jedes dieser Wohnkomplexe dient der Innenhof dazu, den Bewohnern einen schönen Ausblick zu gewähren und bietet ihnen die Möglichkeit, sich während der verschiedenen Jahreszeiten im Freien aufzuhalten. Einen Gegensatz dazu bildet das Haus im japanischen Stil, das traditionell aus Holz und Papier gefertigt ist und viel zerbrechlicher, einfacher und bescheidener wirkt. Seine Innenräume sind direkt mit der äußeren Umgebung verbunden.

Schließlich stellen wir noch kurz einige Beispiele aus der Ikonographie Chinas vor, eine Symbologie, die eine wichtige Rolle innerhalb des Designs in diesem Land spielt. Man sagt, dass sogar der berühmte holländische Architekt Rem Koolhaas dieses Thema gründlich studierte, um die notwendigen Kenntnisse der Ikonographie zu erwerben, und sich so mit Aussicht auf Erfolg um Ausschreibungen zu bemühen, bei denen sich sein Architekturstudio um wichtige Bauprojekte bewarb. Farben wie Rot, das auch die Farbe der chinesischen Flagge ist, stehen für Glück und Reichtum. Die Farbe Gold symbolisiert Yang, die Farbe Silber Yin. Beide zusammen bilden das Symbol für Glück und Reichtum. Happy Animals (glückliche Tiere), die vom Drachen, dem Pfau und dem Goldfisch repräsentiert werden, symbolisieren Konzepte wie Schutz, Intelligenz, Glück und Reichtum. Viele Slogans und Losungen, die überall auf Spruchbändern, auf den Wänden, auf Plakaten und Schildern zu finden sind, sind ein anderer typischer Zug dieser Symbologie, die in der Stadtlandschaft Chinas so sichtbar ist. Visuell hat man manchmal den Eindruck, dass die chinesischen Städte völlig dem kraftvollen Zauber ihrer Schriftzeichen unterliegen.

China hat voller Gier alles, was neu ist, in sich aufgenommen, so dass eine bahnbrechende Kraft für Veränderungen entstand. Es scheint, als habe man sich das Stadtmodell der Sechziger- und Siebzigerjahre, das Hong Kong und die Vereinigten Staaten geprägt hat, zum Beispiel genommen, um dreißig Jahre später die eigenen Städte neu zu gestalten. Daraus ergibt sich, dass sich in allen Städten des Landes ein Charakter herausgebildet hat, den man vielleicht als „retrofuturistisch" bezeichnen könnte. Vielleicht wäre nun der Moment gekommen, in dem das Land eine kleine Pause auf seinem Weg zur Modernität einlegen und sich auf sein beeindruckendes kulturelles und traditionelles Erbe besinnen sollte, um so gleichzeitig Rückschlüsse über die verunstalteten Stadtbilder im Nachbarland Japan zu ziehen, die ein Ergebnis ähnlicher Umstände sind, wie sie im heutigen China zu finden sind. Beispiele wie unnötig viele Fußgängerbrücken über Verkehrswege und die ständige Konstruktion von erhöhten Autobahnen, die das Herz der Innenstädte durchschneiden, sollten China zu erkennen geben, dass es sehr nahe daran ist, den gleichen Kurs wie Japan einzuschlagen, wo man von einem völligen Fehlen der Planung im Städtebau sprechen kann.

Auf alle Fälle haben wir uns, wie bereits gesagt wurde, sehr darüber gefreut, die Gelegenheit zu haben, persönlich so viele fähige und begabte Architekten, Innenarchitekten und Bauherren lokaler Bauprojekte kennen zu lernen, deren Weltanschauung, Erfahrung und Kompetenz ganz ohne Zweifel einen sehr positiven Einfluss ausüben werden, der allmählich das architektonische Panorama des zukünftigen Chinas beeinflussen wird.

VIAJANDO POR CHINA,
UN PAÍS QUE CONSTRUYE SU FUTURO

China, con su inmensa masa continental y con sus más de cinco mil años de historia, está experimentando una enorme transformación, estimulada por su rápido y constante crecimiento económico. Consecuencia de ello, y reflejo también de una creciente confianza en sí mismo, es el nuevo y próspero panorama arquitectónico del país. En medio de una febril actividad constructora empiezan, no obstante, a aflorar algunos resultados contradictorios. Aunque el gobierno lleve años intentando conservar el patrimonio arquitectónico, cultural e histórico que sobrevivió a la fiebre ideológica de los años sesenta y setenta del pasado siglo, la prioridad dada al acelerado impulso en la creación de infraestructuras trajo consigo consecuencias bastante graves, como, por ejemplo, la desaparición de la mayoría de los singulares *hutongs* (entramado de callejuelas que daban a Pekín gran parte de su peculiar carácter) o la transformación de muchas ciudades chinas en vastos ensanches de dudosa planificación que se expanden de manera descontrolada. Con todo, mientras China disfruta de una plena seguridad en sí misma, los aspectos negativos de su paisajismo urbano, representados por un desarrollo excesivamente apresurado y por el consecuente impacto medioambiental, se están afrontando gracias a una progresiva concienciación de los estudios de arquitectura y de los institutos de diseño del país, más preparados que hace una década para evaluar adecuadamente el problema. El gobierno chino ha mostrado, por su parte, suficiente sensibilidad al exigir a las grandes empresas foráneas —que se encargan de llevar a cabo grandes proyectos de infraestructuras— que se asocien con compañías locales para propiciar el intercambio de conocimientos tecnológicos y de experiencia y, en último término, para perfeccionar las aptitudes profesionales del personal local. Otro factor de importancia que ha contribuido a esta progresiva concienciación ha sido el regreso de un significativo número de arquitectos y diseñadores chinos de talento que, tras pasar años estudiando o ejerciendo profesionalmente en el extranjero, han vuelto al país para aportar a su sector profesional pericia y competencia renovadas.

Con el libro *Chinese Design* nos complacemos en presentar un amplio abanico de proyectos arquitectónicos y en dar a conocer a los arquitectos, diseñadores y promotores que están detrás de estas obras. Durante nuestra última visita a China para recopilar información para el libro, tuvimos la oportunidad y el placer de conocer a la mayoría de ellos. El contenido se distribuye en tres capítulos, que coinciden con las tres grandes áreas geográficas donde se ubica la mayor parte de los proyectos: Pekín, Shanghái y Hong Kong. Un cuarto capítulo recoge el resto de los proyectos, situados en otras zonas de la China continental.

Pekín, la capital, es el centro político e intelectual del país; antes famosa por su austeridad, actualmente está experimentando profundos cambios en su imagen. De hecho, algunos de los arquitectos y de los diseñadores mundialmente más famosos compiten entre sí con deslumbrantes e innovadores proyectos que están literalmente barriendo enormes zonas de la antigua ciudad. Durante la década de los ochenta se levantó un gran número de enormes edificios posmodernos —eclécticos, similares a construcciones occidentales, aunque coronadas con gigantescas cubiertas al estilo chino— y un cierto aire estrambótico y kitsch irrumpió en el horizonte urbano. Últimamente esta pauta arquitectónica muestra una clara tendencia a la baja. En la actualidad, mientras la ciudad se prepara para acoger los Juegos Olímpicos del 2008, un buen número de extravagantes y suntuosos proyectos están imprimiendo una fisonomía futurista a la capital, proyectos como el estadio olímpico, diseñado por el estudio suizo de arquitectura Herzog & De Meuron, el Gran Teatro Nacional, del arquitecto francés Paul Andreu, o el impresionante edificio de la CCTV, con sus torres en forma de Z, diseñado por el arquitecto holandés Rem Koolhaas para albergar los estudios centrales de la televisión pública china. Así, también China ha apostado por la modernidad, uniendo el propio estilo tradicional al diseño occidental más innovador. Esto se ha logrado con la colaboración de famosos arquitectos de la escena internacional y con una nueva generación de grandes arquitectos y diseñadores chinos como Ai Weiwei y Chang Yung Ho, nacidos en el país, independientes, que han vuelto tras haber desarrollado una larga trayectoria profesional en el extranjero; forman una nueva elite de profesionales *anfibios*, bilingües, que pueden desempeñar un papel muy activo tanto en la escena china como en la occidental. Siguiendo las huellas de Confucio, que proclamaba que la suprema sabiduría del ser humano radica en saber vivir cerca de la naturaleza, estos dos artistas pueden crear —traduciendo con suma habilidad la milenaria tradición china al diseño vanguardista de hoy en día—

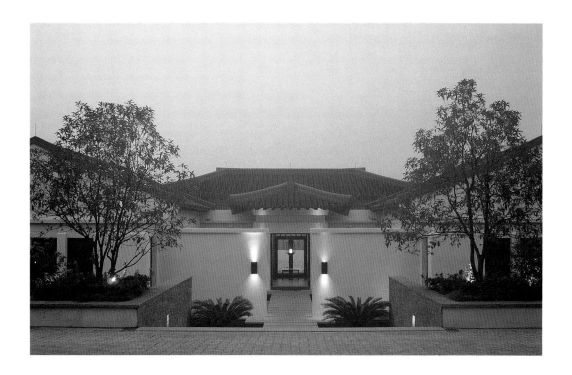

espacios excepcionales, de una gran simplicidad, que van desde pequeños interiores hasta enormes proyectos paisajísticos. Ai Weiwei y Chang Yung Ho ejercen también un papel clave y muy activo dentro del floreciente campo del arte y del diseño contemporáneo, experimental y vanguardista de la capital; junto a otros artistas, crearon el conocido 798 Space, una antigua fábrica de los años cincuenta, diseñada por arquitectos de la entonces Alemania Oriental, que fue reconvertida en un espacio de arte y cultura contemporáneos, repletas de galerías, talleres, residencias para artistas, cafés y restaurantes. Chang Yung Ho realizó los trabajos de remodelación general que transformaron la antigua fábrica Joint Factory 718 en el 798 Space.

El Museo Chino del Cine y el planetario de Pekín, diseñados respectivamente por los talleres de arquitectura RTKL Associates y Amphibious Arc, son asimismo dos proyectos que harán época en el panorama arquitectónico de la capital.

A pesar de las tensas relaciones diplomáticas que aún persisten entre China y Japón, entre los ciudadanos de a pie de ambos países se observa una creciente interrelación y un interés mutuo. De ello da fe la creciente colaboración entre sus jóvenes arquitectos; profesionales como los japoneses Keiichiro Sako –de SKSK Architects– e Hironori Matsubara, ambos establecidos en Pekín, son la prueba evidente de esta tendencia.

Las artes culinarias pekinesas no habían recibido el reconocimiento que se había tributado tradicionalmente a las de otras partes del país. Sin embargo, esta afirmación parece haber pasado a mejor vida. Restaurantes de actualizado diseño que se presentan en este libro, como el Made in China del Grand Hyatt Hotel, el Huang Ting del Peninsula Palace Hotel o Il Milione & Q's Café, situado dentro de un moderno complejo residencial, son una muestra del alto nivel gastronómico que actualmente ofrece la capital.

De Soho China, promotora inmobiliaria independiente afincada en la capital, ampliamente conocida por su famoso Great Wall Project, un conjunto de 12 casas residenciales de alto nivel, cada una de las cuales fue diseñada por un arquitecto procedente de un país asiático, se presentan en este libro proyectos como el Soho

New Town y el Jianwai Soho, dos inmensos complejos residenciales situados en el corazón de la capital, que dan cabida a un amplio abanico de tiendas y espacios comerciales, restaurantes, apartamentos y oficinas.

Para intentar conservar las pocas áreas de *hutongs* que aún quedan en la capital, se han remodelado y transformado viejos espacios tradicionales y antiguas casas con patios interiores y se ha mezclado la arquitectura moderna con la tradicional; así lo testimonian varios de los proyectos presentados en este libro, como el Bamboo Garden Hotel, el Café Sambal, el MIMA Café o los establecimientos Red Capital.

Shanghái, que entre 1843 y 1943 pasó de ser un pequeño puerto situado en la desembocadura del río Yangtse a convertirse en una gran ciudad de Asia oriental, es, en la actualidad, una deslumbrante y bulliciosa metrópoli de más de trece millones de habitantes. En efecto, además de constituir una de las zonas de mayor actividad económica del mundo, la ciudad se describe también a menudo como el enclave donde se está produciendo uno de los *boom* de la construcción más ambiciosos y desenfrenados de la última década. Entre la profusión de rascacielos, de altísimos edificios de apartamentos residenciales y de la omnipresente iluminación de neón, el libro presenta algunos de los majestuosos proyectos que están ahora en marcha en la ciudad, como el centro tenístico Qi Zhong Forest, diseñado por el arquitecto japonés Mitsuru Senda. Asimismo, es de rigor mencionar el trabajo de otros dos arquitectos locales, pertenecientes a una nueva generación de profesionales también educados, como otros mencionados anteriormente, en el extranjero: Ma Weidong, de CA Group, y Chen Xudong, de Datrans, aportan ideas nuevas al panorama arquitectónico de Shanghái, nuevos conocimientos e información sobre las últimas tendencias del sector, y su probada y prometedora experiencia en la reconversión de viejos edificios. A dos horas de coche al sur de Shanghái surge la ciudad de Hangzhou, conocida sobre todo por su famosísimo lago del Oeste (Xihu); ubicado en este maravilloso paraje, del cual ya Marco Polo cantó las excelencias siglos atrás al describirlo como un paraíso terrenal, se halla otro de los proyectos presentados en este libro, el Fuchun Resort.

Hong Kong es famosa por ser una de las urbes más densamente pobladas del planeta. De escala totalmente diferente a Pekín y a Shanghái, su paisaje urbano experimenta constantes cambios, ya que se reemplazan con frecuencia casi mensual edificios sólidos y firmes por otras edificaciones más altas y modernas. De esta ciudad presentamos en este libro los trabajos de Alan Chan −reconocido diseñador gráfico e interiorista− y de otros conocidos talleres de arquitectura como el Edge Design Institute o el AB Concept; igual que en las películas del famoso director de cine local Wong Kar Wai −ídolo del vanguardismo cultural de esta región− los espacios de Chen Mi Ji y de Maymayking, aquí recogidos, evocan la peculiar atmósfera de Hong Kong. Lo mismo ocurre con el Peninsula Palace Hotel, uno de los grandes símbolos de la ciudad, donde se funden lo mejor de la historia y de la tradición en el máximo esplendor.

Sobre el diseño chino

Igual que la Gran Muralla, que con sus 2.400 km de longitud es la única construcción humana visible desde el espacio, la inmensidad de China es tal que es difícil aventurar un análisis general de las características de su diseño e imposible intentar una interpretación de su diversidad étnica y racial. Solo en Pekín conviven cerca de 23 grupos étnicos diferentes. No obstante, el principio básico que influye en el diseño de los espacios tiene que ver con diferentes filosofías como el confucionismo, el taoísmo o el fengshui. Antiguos valores y diferentes creencias se han ido sedimentando gradualmente hasta crear un cúmulo formado por distintos estratos que se mantienen aún muy vivos y vigentes en la China de hoy en día. Aunque en la actualidad gran parte de la población no sienta ya un particular apego a la tradición, la mayoría no se permite, sin embargo, ignorar las leyes del espacio direccional de la filosofía fengshui o de otras filosofías. La compleja y violenta historia de China explica, en parte, la razón por la cual sus casas y sus edificios residenciales tienen un marcado carácter de fortaleza, un aspecto sólido y firme, con el interior claramente separado del exterior. El patio interior de los complejos residenciales deleita la vista de los moradores y sirve, al mismo tiempo, como espacio donde disfrutar del aire libre. El ejemplo opuesto es la casa de estilo japonés, tradicionalmente fabricada en madera y papel, de aspecto frágil, modesto y simple, con espacios interiores que conectan directamente con el exterior.

Para terminar, quisiéramos presentar brevemente unos ejemplos de inconografía china, cuya simbología desempeña un importante papel dentro del panorama del diseño de este país; se dice que incluso el famoso arquitecto holandés Rem Koolhaas estudió a fondo el tema para poder adquirir los conocimientos necesarios que le permitieran optar con garantías a los concursos en los que su taller de arquitectura se presentaba con importantes proyectos. El rojo, por ejemplo, aparte de ser el color dominante en la bandera china, trae buena suerte. El color oro simboliza el yang, el color plata el yin; ambos son símbolos también de buena suerte. El dragón, el pavo real y los pececillos de colores simbolizan conceptos como la protección, la inteligencia, la felicidad y la riqueza. Muchos eslóganes y consignas –omnipresentes en pancartas, pintadas y carteles– son también un rasgo característico de esta simbología tan presente en el paisaje urbano de este país; a veces, parece como si todas las ciudades de China se hallaran sometidas al potente hechizo de los caracteres de su escritura.

Con una voracidad por todo lo novedoso que anuncia rápidos cambios, China ha seguido el mismo modelo que marcó el desarrollo urbanístico de Hong Kong y de muchas ciudades de Estados Unidos durante los años sesenta y setenta, y lo aplica, treinta años después, para rediseñar su entramado urbano. Consecuencia de ello ha sido un paisaje urbano marcado por cierto carácter retrofuturista, característico de la mayoría de las ciudades chinas. Este sería, quizás, el momento adecuado para que el país hiciera una pequeña pausa en su camino hacia la modernidad y buscara la necesaria inspiración en su impresionante legado de tradición y cultura, intentando aprender, al mismo tiempo, del ejemplo negativo del vecino Japón, cuyo paisaje urbano es fruto de un desarrollo que se produjo en circunstancias similares. La excesiva cantidad de puentes peatonales que cruzan las vías públicas y el constante aumento de autopistas elevadas que atraviesan el corazón de las ciudades parece sugerir que China ha iniciado el mismo camino que en su día llevó a Japón a una planificación urbana completamente falta de previsión.

Sea como fuere, nos alegramos de haber tenido la oportunidad de conocer en persona a muchos arquitectos, diseñadores y promotores inmobiliarios de gran talento, cuyos pericia y competencia influenciarán, sin duda positivamente, el panorama arquitectónico de la China de mañana.

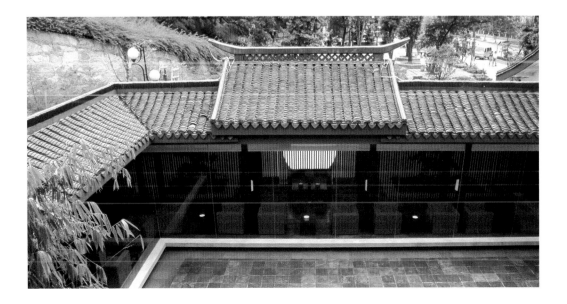

La Chine, son immense masse continentale et son histoire de plus de cinq mille ans sont soumises à une transformation colossale, stimulée par une croissance économique rapide et constante. Le nouveau et prospère panorama architectural du pays en est une conséquence mais aussi un reflet de sa confiance renouvelée en elle-même. Au cœur de cette activité constructive fébrile, des résultats contradictoires commencent, cependant, à devenir patents. Bien que le gouvernement tente depuis des années de préserver le patrimoine architectural, culturel et historique ayant survécu à la fièvre idéologique qui se propagea au cours des années soixante et soixante-dix du siècle passé, la priorité donnée à l'impulsion accélérée pour la création d'infrastructures a entraîné des résultats plutôt extrêmes : ainsi la disparition de la plupart des *hutongs* (réseaux de ruelles typiques) singuliers qui conféraient à Pékin une large part de sa personnalité si particulière ; ainsi, de manière plus générale, la transformation de pans entiers des villes chinoises en de vastes extensions urbaines sans contrôle et à la planification douteuse. Ceci étant, la Chine bénéficie également d'une assurance sans faille en elle-même, les aspects négatifs de son paysagisme urbain – ainsi une pression excessive du développement et la pollution qu'il entraîne pour l'environnement naturel – étant déjà en cours de traitement grâce à une prise de conscience progressive de la part des ateliers d'architecture et de design du pays, bien mieux formés pour apprécier correctement ces effets que lors de la précédente décennie. Le gouvernement chinois a montré, pour sa part, une sensibilité suffisante en promouvant, voire en exigeant aux grandes entreprises étrangères chargées de mener à bien de grands projets d'infrastructure une association avec des entreprises locales, afin de faciliter ainsi les transferts de technologie, de savoir et d'expérience et, enfin, afin de perfectionner les aptitudes professionnelles du personnel local. Autre facteur ayant contribué à cette prise de conscience : le retour au pays d'un nombre significatif d'architectes et créateurs chinois de talent qui, après plusieurs années d'activité professionnelle ou d'études à l'étranger, ont rapporté à leur secteur professionnel une expertise et des compétences renouvelées ainsi qu'une influence très positive.

L'ouvrage *Chinese Design* nous offre l'occasion de présenter un large éventail de projets architecturaux tout en faisant connaître les divers architectes, créateurs et promoteurs qui se cachent derrière chaque œuvre. Au cours de notre dernière visite en Chine, afin de collecter la documentation pour ce livre, nous avons eu la chance et la satisfaction d'en rencontrer la plupart. La composition du livre s'est distribuée selon trois chapitres qui coïncident avec les trois grandes régions géographiques de Pékin, Shanghai et Hong Kong, accueillant la majeure partie des projets présentés. Un quatrième chapitre incorpore le reste des travaux, situés dans d'autres zones de la Chine continentale.

Pékin, la capital du pays, est également son centre politique et intellectuel. La ville, auparavant célèbre pour son austérité, expérimente aujourd'hui de profonds changements de son image externe. Certains des architectes et créateurs, bénéficiant de la plus grande renommée internationale, rivalisent entre eux au travers de projets éblouissants et novateurs qui balaient littéralement des sections entières de l'antique cité. Durant la décennie des années quatre-vingt, un grand nombre d'immeubles post-modernes et éclectiques ont vu le jour, similaires à des constructions très clairement occidentales bien que couronnés de gigantesques toitures de style chinois. L'horizon urbain a été envahi d'un certain air excentrique et kitsch. Finalement, cette influence architecturale semble afficher une nette tendance à la baisse. Actuellement, alors que la ville se prépare à accueillir les Jeux Olympiques de 2008, une foule de projets aussi extravagants que somptueux impriment un futurisme nouveau et renouvelé à la capitale. Des œuvres comme le stade olympique, conçu par le cabinet d'architecte suisse Herzog & De Meuron, le Grand Théâtre National, de l'architecte français Paul Andreu, ou l'impressionnant immeuble de la CCTV, avec ses tours en forme de Z, réalisé par l'architecte hollandais Rem Koolhaas et accueillant les studios centraux de la télévision publique chinoise. Les Chinois ont fait ainsi également le pari de la modernité, en adoptant non seulement leur propre style traditionnel mais aussi le design occidental, plus innovant. Ce mouvement est devenu possible grâce à la participation de célèbres architectes de la scène internationale mais aussi en s'appuyant sur une nouvelle génération de grands architectes et créateurs chinois comme Ai Weiwei et Chang Yung Ho, tous deux nés en Chine et complètement indépendants,

qui, après une longue trajectoire et une expérience professionnelle accumulée à l'étranger, ont rejoint leur patrie. Ils appartiennent à une nouvelle élite émergente de professionnels *amphibies* bilingues, à même de travailler et d'endosser un rôle très actif sur la scène chinoise comme en Occident. À l'instar du Confucius (551-479 av. J.C.) de l'antique Chine, proclamant que la sagesse suprême de l'être humain naissait de son savoir-vivre proche de la nature, ces deux artistes peuvent créer – en traduisant avec habileté de la tradition chinoise millénaire en un design avant-gardiste contemporain – des espaces exceptionnels, d'une grande simplicité et allant d'intérieurs réduits à de vastes projets urbanistiques. Ai Weiwei et Chang Yung Ho revêtent également un rôle clé et très actif dans le champ florissant de l'art et du design contemporains, expérimentaux et avant-gardistes de la capitale chinoise. Avec d'autres artistes, ils ont créé le célèbre 798 Space à partir d'une ancienne usine d'armement délabrée – produit de l'Allemagne de l'Est des années cinquante – reconvertie en espace communal d'art et de culture contemporains, fourmillant de galeries, ateliers et résidences pour artistes, cafés, restaurants, etc. Chang Yung Ho a réalisé les travaux de rénovation générale pour transformer cette ancienne usine auparavant connue comme Joint Factory 718 et la transformer en le 798 Space.

Le Musée Chinois du Cinéma et le planétarium de Pékin, respectivement conçus par les ateliers d'architecture RTKL Associates et Amphibious Arc, sont ainsi deux projets qui feront date dans le programme architectural et de design de la capitale. En dépit des tensions persistantes dans les relations diplomatiques entre la Chine et le Japon, l'on peut observer dans la rue une interrelation et un intérêt mutuels progressifs entre les citoyens des deux pays. Cette évolution est corroborée par la coopération croissante entre les jeunes architectes chinois et japonais. Des architectes nippons mais vivant à Pékin, comme Keiichiro Sako de SKSK Architects et Hironori Matsubara, sont les exemples vivants de cette tendance.

Les arts culinaires de la cuisine pékinoise n'ont pas bénéficié de la même reconnaissance que ceux originaires d'autres parties du pays. Cette affirmation peut sembler aujourd'hui anti-datée. Les restaurants au design

moderne présentés dans cet ouvrage, ainsi le Made in China du Grand Hyatt Hotel, le Huang Ting du Peninsula Palace Hotel voire Il Milione & Q's Café, situé au cœur d'un complexe résidentiel moderne, sont les symboles du haut niveau gastronomique actuellement offert par la capitale.

Soho China, promoteur immobilier indépendant installé dans la capitale, surtout connu pour son célèbre Great Wall Project, un ensemble de 12 demeures résidentielles de haut niveau chacune pensée par un architecte différent et procédant de divers pays asiatiques, est également présent dans ce livre avec de grands projets comme le Soho New Town et le Jianwai Soho, deux immenses complexes de résidences, situés au cœur de la ville, qui accueillent tout un éventail de boutiques et espaces commerciaux, restaurants, bureaux, appartements résidentiels, etc.

Répondant à une action de conservation des rares quartiers anciens de *hutongs* qui ont résisté dans la capitale, de vieux espaces traditionnels et d'anciennes maisons aux patios intérieurs ont été rénovés et transformés, avec un métissage d'architectures moderne et traditionnelle, ainsi que le reflètent des projets représentés dans le livre comme le Bamboo Garden Hotel, le Café Sambal, le MIMA Café ou les établissements Red Capital. Shanghai, qui entre 1843 et 1943 se convertit d'un petit port de pêche à l'embouchure du Yang-Tsé en une grande cité de l'Asie orientale, est aujourd'hui une métropole éblouissante et effervescente de plus de 13 millions d'habitants. En effet, outre le fait d'être l'une des zones de plus forte croissance au monde, la cité est souvent décrite comme l'enclave où se déroule l'un des booms de la constructions les plus effrénés et ambitieux de la dernière décennie. Au cœur d'une telle profusion de gratte-ciel, d'immenses édifices d'appartements résidentiels, du fort éclairage au néon qui se fait omniprésent, le livre introduit quelques-uns des majestueux projets qui sont aujourd'hui en développement dans la ville comme le club de tennis Qi Zhong Forest, conçu par l'architecte japonais Mitsuru Senda. D'autre part, il est également de rigueur de mentionner les travaux de deux autres architectes locaux, appartenant à une nouvelle génération de professionnels formés, comme ceux antérieurement cités, à l'étranger. Ma Weidong de CA Group et Chen Xudong de Datrans apportent une doctrine rafraîchissante au panorama architectural et créatif de Shanghai avec une information renouvelée et des connaissances sur les nouvelles tendances du secteur, ainsi qu'une capacité prometteuse – qui a déjà passé l'épreuve du feu – à reconvertir d'anciens édifices. À deux heures de route au sud de Shanghai, se trouve la ville de Hangzhou, connue essentiellement pour son célébrissime lac de l'Ouest (Xihu). Le Fuchun Resort, un autre des projets présentés dans ce livre, s'invite dans ce site merveilleux dont Marco Polo chanta les louanges des siècles auparavant, le décrivant comme un paradis terrestre.

Hong Kong est célèbre pour être l'une des villes les plus densément peuplées du monde. Sur une échelle totalement différente de celle de Pékin ou Shanghai, son paysage urbain semble sujet à des évolutions constantes, des immeubles parfaitement solides et stables étant remplacés, presque chaque mois, par d'autres édifications plus hautes et modernes. De cette cité, cet ouvrage souhaite présenter le travail de Alan Chan, créateur graphique et d'intérieur reconnu, ainsi que les œuvres d'autres cabinets d'architecture réputés, ainsi le Edge Design Institute, AB Concept, etc. Comme dans les films du célèbre réalisateur local, Wong Kar Wai, icône de l'avant-gardisme culturel de l'enclave, les espaces présentés de Chen Mi Ji et de Maymayking respirent également une sorte d'atmosphère incontestablement propre à Hong Kong. Comme pour le Peninsula Palace Hotel, un des grands symboles de la ville, où fusionnent le meilleur de son histoire et de sa tradition, à l'apogée de leur splendeur.

Sur le design chinois

Comme la Grande muraille avec ses 2.400 km de long – la seule grande construction de la planète visible depuis l'espace – l'immensité et la profondeur de la Chine sont telles qu'il peut être difficile d'essayer d'analyser sa créativité au travers de généralisations tout comme il est pratiquement impossible d'interpréter sa diversité ethnique et raciale : dans la seule Pékin pourraient coexister près de 23 groupes ethniques différents. Toutefois, le principe fondamental qui semble influencer le design des espaces dans le pays est lié à un certain nombre de philosophies différentes comme le Confucianisme, le Taoïsme, le Feng Shui, etc. Anciennes valeurs, croyances et philosophies différentes se sont sédimentées graduellement en un ensemble conformé

par diverses strates, restant encore très vivantes et en vigueur dans la Chine de tous les jours. Bien que, présentement, une grande partie de la population ne semble pas ressentir un attrait particulier pour la tradition, la majorité suit ou ne se permet pas d'ignorer, toutefois, les lois de l'espace directionnel de la philosophie feng shui ou d'autres philosophies. L'histoire de la Chine – complexe, crue et violente – explique en partie quelques une des raisons pour lesquelles ses demeures et immeubles résidentiels revêtent un aspect de forteresse très prononcé, une apparence solide et ferme, avec une partie intérieure séparée de l'extérieur de la maison. À l'intérieur de chaque complexe résidentiel, le patio sert à la fois au ravissement visuel de ses habitants tout en permettant de vivre à l'air libre tout au long des saisons de l'année. En contrepoint, nous rencontrons la maison au style japonais, traditionnellement construite en bois et en papier, d'aspect bien plus fragile, modeste et simple et dont les espaces intérieurs se connectent directement avec les parties extérieures.

Finalement, nous souhaiterions vous présenter quelques exemples de l'iconographie chinoise, un symbolisme qui revêt un rôle important dans le panorama du design de ce pays. Il est dit que le célèbre architecte hollandais Rem Koolhaas a étudié lui-même à fond le thème, afin de pouvoir acquérir les connaissances nécessaires pour se présenter avec assurance aux concours pour lesquels son cabinet d'architecture postulait pour d'importants projets. Une couleur comme le rouge, outre le fait d'être celle du drapeau chinois, recèle des connotations de chance et de bonne fortune. L'or est associé au yang, et l'argent au yin. Tous deux projettent le symbole de bonne fortune et de chance. Happy Animals (les animaux heureux), représentés par le dragon, le paon royal et le poisson rouge symbolisent des concepts comme la protection, l'intelligence, le bonheur et la richesse. De nombreux slogans et consignes omniprésents sur des pancartes, peints sur les murs, les affiches et autres affichages sont aussi des traits caractéristiques de ce symbolisme si visible du paysage urbain de ce pays. Visuellement, il semble parfois que les villes chinoises sont toutes soumises à un sortilège très puissant des caractères de son écriture.

La Chine, avec une voracité difficilement crédible pour chaque nouveauté et donc une force certainement puissante annonçant des changements rapides, semble avoir pris le chemin du modèle urbain des années soixante et soixante-dix de Hong Kong et des États-Unis pour mener à bien, trente ans plus tard, la conception de son propre modèle. En conséquence, le produit final s'est révélé être la propagation dans tous le pays d'un paysagisme urbain marqué par un certain caractère rétro-futuriste. Le moment est peut être venu pour le pays d'effectuer une légère pause dans son cheminement vers la modernité, pour reprendre une inspiration nécessaire de son héritage impressionnant de tradition et de culture et d'essayer de tirer – parallèlement – des conclusions de l'échec de l'urbanisme de son voisin, le Japon, soumis auparavant à des circonstances similaires à celles rencontrées par la Chine aujourd'hui. Des exemples comme le foisonnement inutile de ponts piétonniers sur la voie publique ainsi que la progression constante des autoroutes aériennes parcourant le cœur des villes suggèrent que la Chine suit de très près le même sillon que le Japon autrefois, avec une déficience totale de prévision en termes de planification urbaine.

Quoi qu'il en soit, et comme nous l'indiquions déjà, nous apprécions au plus haut point le fait d'avoir saisi la chance de connaître directement un nombre notable d'architectes, de créateurs et de promoteurs immobiliers locaux de talent dont la vision, l'expertise et les compétences exerceront sans aucun doute un impact très positif, influençant progressivement le panorama architectural de la Chine de demain.

VIAGGIO IN CINA,
UN PAESE CHE COSTRUISCE IL SUO FUTURO

La Cina, terzo paese al mondo per estensione e con oltre cinquecento anni di storia alle spalle, è oggetto attualmente di un'enorme trasformazione, stimolata dalla rapida e costante crescita economica. Una tra le principali conseguenze, riflesso anche della ritrovata e crescente fiducia in se stessa, è il nuovo e prospero panorama architettonico del paese. Ciò nonostante, in mezzo a questa febbrile attività costruttiva si comin- ciano ad evidenziare alcuni risultati contraddittori. Sebbene il governo cerchi da tanti anni di conservare il patrimonio storico-culturale e architettonico sopravvissuto alla febbre ideologica propagatasi nel periodo degli anni sessanta e settanta dello scorso secolo, la priorità concessa alla promozione e realizzazione, alquanto affrettata, di nuove infrastrutture ha comportato risultati a dir poco estremi. Tra questi, per esempio, la par- ziale scomparsa dei singolari *hutongs* (griglia di vicoli tipici) a cui Pechino deve gran parte del suo carattere, così come, in generale, la trasformazione di numerose città cinesi in vaste espansioni urbane sregolate e di controversa pianificazione. Lo sviluppo economico e la ristrutturazione urbanistica della Cina sembrano non fermarsi, e il paesaggio urbano è in costante trasformazione. Non mancano però gli aspetti negativi di questa frenetica espansione, come l'inquinamento e il conseguente impatto ambientale. Va notato, comunque, l'au- mento della sensibilità a questi problemi, soprattutto da parte degli studi di architettura e istituti di design del paese, molto più preparati per una loro corretta valutazione rispetto ai decenni anteriori. Da parte sua, anche il governo cinese ha dimostrato una certa sensibilità, incoraggiando o persino esigendo alle grandi imprese straniere, incaricate di realizzare grandi progetti architettonici, di collaborare con le compagnie del posto. Il tutto al fine di favorire uno scambio di esperienze, abilità, know-how, e in ultima istanza, di perfezionare le capacità professionali del personale locale. Un altro fattore decisamente importante che ha contribuito alla progressiva sensibilizzazione, citata sopra, è stato il rientro in patria di un notevole numero di architetti e pro- gettisti cinesi di talento. Questi, dopo aver esercitato la loro professione o studiato per vari anni all'estero, con il loro ritorno hanno apportato al loro settore professionale una rinnovata perizia, competenza nonché un'in- fluenza molto positiva.

Il presente volume *Chinese Design* ci dà l'opportunità di presentare un vasto ventaglio di progetti architettoni- ci, e far conoscere così i diversi architetti, progettisti e promotori che stanno dietro le opere in questione. Nel corso della nostra ultima visita in Cina, realizzata per raccogliere informazioni per questo libro, abbiamo avuto l'occasione e l'onore di conoscere la maggior parte di loro. Il volume è suddiviso in tre capitoli che corrispon- dono alle tre grandi aree geografiche di Pechino, Shanghai e Hong Kong, dove sono situati la maggior parte dei progetti. Un quarto capitolo raccoglie il resto dei progetti realizzati in altre zone della Cina continentale.

Pechino, la capitale, è anche il centro politico e intellettuale del paese. Oggi giorno, l'immagine della città, rinomata anticamente per la sua austerità, è oggetto di profondi cambiamenti. Alcuni dei più prestigiosi archi- tetti e progettisti di fama mondiale gareggiano tra di loro con progetti sbalorditivi e innovativi che stanno let- teralmente spazzando via enormi superfici della vecchia città. Durante gli anni ottanta sono stati fabbricati numerosi edifici postmoderni, eclettici, simili a costruzioni dalla marcata impronta occidentale, sebbene sor- montati da gigantesche coperture in stile cinese. Di conseguenza, la skyline urbana ha assunto dei connotati alquanto kitsch e stravaganti, anche se negli ultimi anni questo modello architettonico sembra essere sempre più in declino. Attualmente, mentre la città si prepara ad ospitare i Giochi Olimpici del 2008, un nutrito grup- po di singolari e sontuosi progetti stanno imprimendo un nuovo e rinnovato carattere futurista alla capitale. Progetti quali lo stadio olimpico, disegnato dallo studio di architettura svizzero Herzog & De Meuron, il Gran Teatro Nazionale, opera dell'architetto francese Paul Andreu, o l'impressionante edificio della CCTV, con le sue torri a forma di Z, disegnato dall'architetto olandese Rem Koolhaas per accogliere gli studi centrali della tele- visione pubblica cinese. Da ciò si evince una chiara scommessa dei cinesi sulla modernità e sulle linee del design occidentale più all'avanguardia. Tutto ciò è stato possibile sia grazie all'intervento di famosi architetti del panorama internazionale che di una nuova generazione di grandi architetti e progettisti cinesi quali Ai Weiwei e Chang Yung Ho, nati in Cina, del tutto indipendenti e che dopo una lunga esperienza maturata all'e- stero, hanno deciso di rientrare in patria. Questi fanno parte di una nuova e versatile élite di professionisti

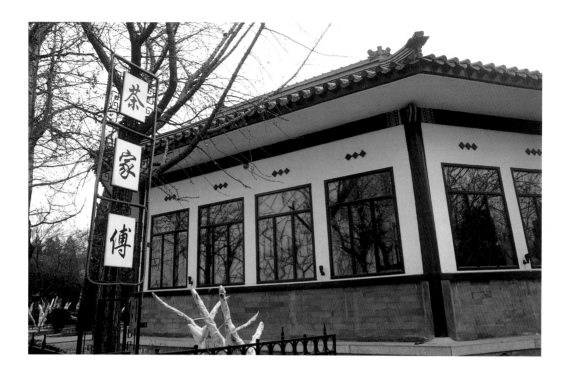

emergenti, totalmente bilingue, in grado di operare e svolgere un ruolo decisamente attivo sia nel panorama architettonico cinese che occidentale. Così come accadeva nell'antica Cina, in cui Confucio (551-479 aC) proclamava che la suprema saggezza dell'essere umano consisteva nel saper vivere vicino alla natura, questi due artisti sono in grado di creare, trasponendo abilmente la millenaria tradizione cinese al design avanzato di oggi giorno, spazi eccezionali, di grande semplicità, che vanno da piccoli interni fino a grandi progetti paesaggistici. Ai Weiwei e Chang Yung Ho svolgono anche un ruolo chiave e molto attivo nel sempre più fiorente campo dell'arte e del design –contemporaneo, sperimentale e all'avanguardia– della capitale cinese. Assieme ad altri artisti hanno realizzato il famoso 798 Space, uno spazio ricavato da una ex fabbrica militare ormai in disuso disegnata negli anni 50' da ingegneri della Germania dell'Est e riconvertita in un laboratorio comune di arte e cultura contemporanea pieno di gallerie, atelier, caffè, ristoranti e residenze per artisti. Chang Yung Ho si è occupato dei lavori di ristrutturazione generale per trasformare questa antica fabbrica anteriormente conosciuta col nome di Joint Factory 718 nell'odierno 798 Space.

Il Museo Cinese del Cinema e il planetario di Pechino, progettati rispettivamente dagli studi di architettura RTKL Associates e Amphibious Arc sono anch'essi due progetti che passeranno alla storia nel panorama architettonico e del design della capitale. Nonostante i tesi rapporti diplomatici che tuttora persistono tra la Cina e il Giappone, sullo sfondo si osserva una progressiva interrelazione e interesse reciproco tra i cittadini di entrambi i paesi. Ne è la prova la crescente collaborazione tra giovani architetti cinesi e giapponesi. Tra quest'ultimi, figurano architetti come Keiichiro Sako, di SKSK Architects, e Hironori Matsubara, da anni stabilitisi e operanti a Pechino.

Tradizionalmente, le specialità culinarie della cucina pechinese non sono state riconosciute quanto quelle di altre parti del paese. Questa tendenza sembra comunque ormai del tutto superata. E lo dimostrano infatti alcuni ristoranti dal design moderno presentati in questo libro quali il Made in China del Grand Hyatt Hotel, lo Huang Ting del Peninsula Palace Hotel, o Il Milione & Q's Café, situato dentro un moderno complesso residenziale. Tre esempi dell'alto livello dell'offerta gastronomica che vanta attualmente la capitale.

Questo volume illustra anche alcuni progetti della Soho China, una società edilizia indipendente, con sede nella capitale, e internazionalmente rinomata per il suo Great Wall Project, un complesso di 12 abitazioni residenziali di qualità progettate da architetti diversi provenienti da vari paesi asiatici. Soho New Town e Jianwai Soho sono due immensi complessi residenziali, situati nel cuore di Pechino, che ospitano tra l'altro vari negozi, superfici commerciali, uffici, ristoranti e appartamenti.

In risposta all'intervento di tutela delle poche aree di *hutongs* rimaste nella città, si sono gradualmente ristrutturati e ammodernati anche vecchi spazi tradizionali e antiche case con il giardino interno, mescolando architettura moderna e tradizionale, come dimostrano vari progetti presenti nel libro quali: il Bamboo Garden Hotel, il Café Sambal, il MIMA Café o gli stabilimenti Red Capital.

Da piccolo porto situato alla foce del fiume Yangtze, Shanghai divenne, tra il 1843 e 1943 una delle maggiori città dell'Asia Orientale. Attualmente è una sfavillante e cosmopolita metropoli sempre in pieno fermento dove vivono più di 13 milioni di abitanti. In effetti, oltre ad essere una delle zone con la maggior crescita economica di tutto il mondo, spesso si parla di Shanghai per via del recente e sfrenato boom urbanistico che nell'ultimo decennio ha modificato radicalmente l'aspetto della città. Tra innumerevoli grattacieli e altissimi edifici residenziali resi ancora più visibili dall'onnipresente illuminazione al neon, il presente volume illustra, tra l'altro, alcuni dei maestosi progetti in corso nella città, quali lo centro tennistico Qi Zhong Forest di Shanghai disegnato dall'architetto giapponese Mitsuru Senda. Degne di nota sono anche le opere di due architetti locali, che come altri loro colleghi, si sono formati all'estero e da poco sono rientrati in Cina. Si tratta di Ma Weidong, di CA Group, e di Chen Xudong, di Datrans, due artisti che apportano nozioni fresche al panorama architettonico e al design, nonché un vasto know-how sulle ultime tendenze del settore già comprovato nella riconversione di alcuni vecchi edifici. A due ore di strada a sud di Shanghai si trova la città di Hangzhou, la cui attrattiva principale risiede nella sua posizione ai bordi del lago dell'Ovest (Xihu). Sempre nei pressi di questo posto meraviglioso, già descritto da Marco Polo secoli fa come un paradiso terrestre, si trova un altro singolare progetto, un albergo, noto col nome di Funchun Resort.

Hong Kong è una delle aree al mondo più densamente popolate. La città presenta una scala completamente diversa da quella di Pechino o Shanghai e il suo panorama urbano è costantemente soggetto a cambiamenti; quasi mensilmente edifici totalmente solidi vengono sostituiti da altre costruzioni più alte e moderne. Il volume presenta i lavori di Alan Chan, riconosciuto disegnatore grafico e per interni, e di altri noti studi di architettura quali Edge Design Institute, AB Concept, ecc. I progetti di Chen Mi Ji e di Maymayking selezionati per questo libro, traspirano l'inconfondibile atmosfera malinconica e lussureggiante di Hong Kong, così come accade per i film del famoso e contemporaneo regista locale Wong Kar Wai, vera e propria icona dell'avanguardismo culturale di questa città. La stessa cosa si può affermare per il Peninsula Palace Hotel, uno dei grandi simboli della città, nonché uno dei più lussuosi alberghi al mondo, autentico connubio di tradizioni e modernità.

Cenni sul design cinese

Al pari della Grande Muraglia, che con i suoi 2.400 km di lunghezza, è l'unica grande costruzione umana visibile dallo spazio, l'immensità della Cina è tale che è difficile cercare di eseguire un'analisi generica del suo design così come un'interpretazione della sua vasta diversità etnica e razziale. Nella sola Pechino potrebbero convivere circa 23 gruppi etnici diversi. Ciò nonostante, sembra che le principali influenze esercitate sul disegno di spazi e luoghi nel paese siano strettamente legate a varie dottrine filosofiche quali il Confusionismo, il Taoismo, il Fengshui, ecc. Diversi, infatti, sono i valori e i principi di queste dottrine che sono stati tramandati fino ai giorni nostri e sono ancora molto sentiti nella Cina attuale. Sebbene attualmente la popolazione non sembri essere particolarmente attaccata alla tradizione, gran parte di essa, segue o comunque, non ignora affatto le leggi dello spazio direzionale della filosofia Fengshui, o di altre filosofie. La complessa, cruenta e violenta storia della Cina spiega in parte alcune delle ragioni per cui le sue case ed edifici residenziali hanno un marcato carattere di fortezza, un aspetto solido e stabile, con la parte interna separata dall'esterno. All'interno di ogni complesso residenziale, il cortile serve per dilettare la vista dei condomini, e al contempo, fornire

loro uno spazio dove trascorrere del tempo all'aria aperta nel corso delle varie stagioni. In contrapposizione a questo modello, troviamo la casa di stile giapponese, tradizionalmente fabbricata in legno e carta, dall'aspetto molto più fragile, modesto e semplice, e dove i suoi spazi interni sono direttamente collegati all'esterno.

In ultimo, presentiamo brevemente alcuni esempi di iconografia cinese, la cui simbologia svolge un ruolo fondamentale all'interno del panorama artistico di questo paese. Si dice che persino il famoso architetto olandese Rem Koolhaas studiò a fondo l'argomento in modo tale che le sue conoscenze di iconografia gli dessero maggiori garanzie di successo nei concorsi a cui il suo studio si presentava per l'appalto di grandi progetti. I colori hanno una forte simbologia: il rosso, per esempio, oltre ad essere il colore della bandiera cinese, è associato alla fortuna e alla sorte. Il color oro e l'argento richiamano due elementi molto ben radicati nella cultura cinese, Yin e Yang, che esprimono la dualità dei fenomeni, la loro opposizione e complementarietà. Per quanto riguarda gli animali, i cosiddetti happy animals (animali felici) includono il drago, il pavone e il pesce rosso e simboleggiano concetti quali protezione, intelligenza, felicità e ricchezza. Molti slogan e motti presenti costantemente su cartelloni, dipinti sui muri e tabelloni sono un altro dei tratti caratteristici di questa simbologia così visibile del paesaggio urbano di questo paese. Sul piano visivo, a volte sembra che le città cinesi siano tutte sottoposte al potente fascino magico dei caratteri della loro lingua.

La Cina, paese precursore di rapidi cambiamenti, con una inverosimile voracità per tutto ciò che è nuovo, sembra aver imboccato il percorso del modello urbano degli anni 60 e 70, applicato a Hong Kong e gli Stati Uniti, per riprogettare, trenta anni dopo, il proprio. Di conseguenza, il prodotto finale ottenuto è stata la propagazione in tutto il paese di un panorama urbano marcato da un certo carattere retro-futurista. Sarebbe forse opportuno che il paese arrestasse momentaneamente questa sua frenetica corsa verso la modernità e cercasse, al tempo stesso, di trarre le dovute conclusioni dal poco riuscito progetto di paesaggio urbano del suo vicino, il Giappone, avvenuto all'epoca in circostanze simili a quelle attuali della Cina. Esempi come l'eccessivo numero di ponti pedonali sulla via pubblica così come il costante aumento di autostrade sopraelevate che si insinuano nel cuore delle città lasciano capire che la Cina sta percorrendo una strada molto simile a quella del Giappone, con poca o inadeguata previsione in termini di pianificazione urbana.

Ad ogni modo, così come abbiamo detto in precedenza, apprezziamo enormemente il fatto di aver potuto conoscere da vicino un notevole numero di abili architetti, progettisti e promotori immobiliari locali. Siamo certi che la loro perizia e competenza, nonché il loro indiscusso talento artistico eserciteranno un'influenza molto positiva che inciderà progressivamente sul panorama architettonico della Cina.

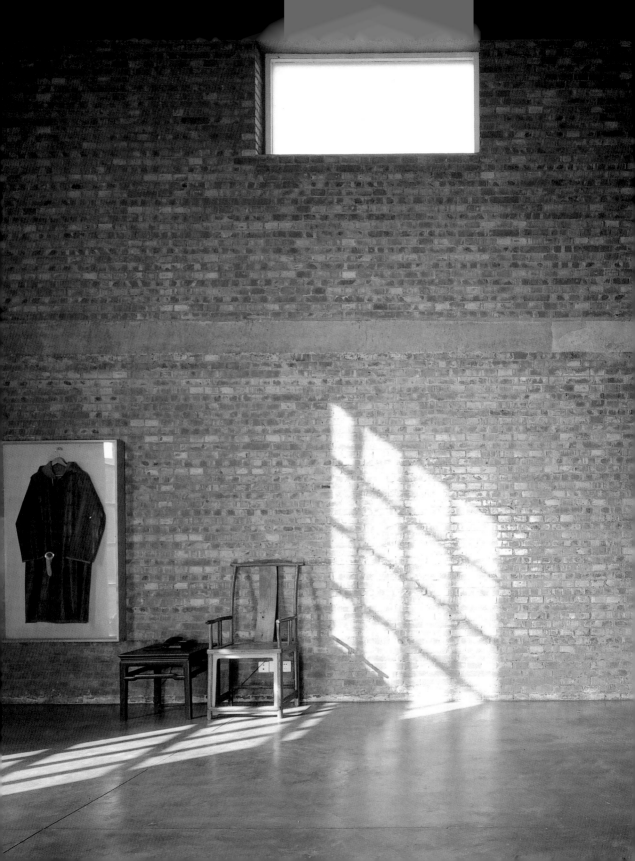

AI WEIWEI/FAKE DESIGN | **BEIJING**
AI WEIWEI'S HOUSE
Beijing | 1999

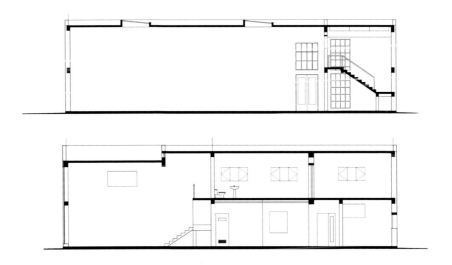

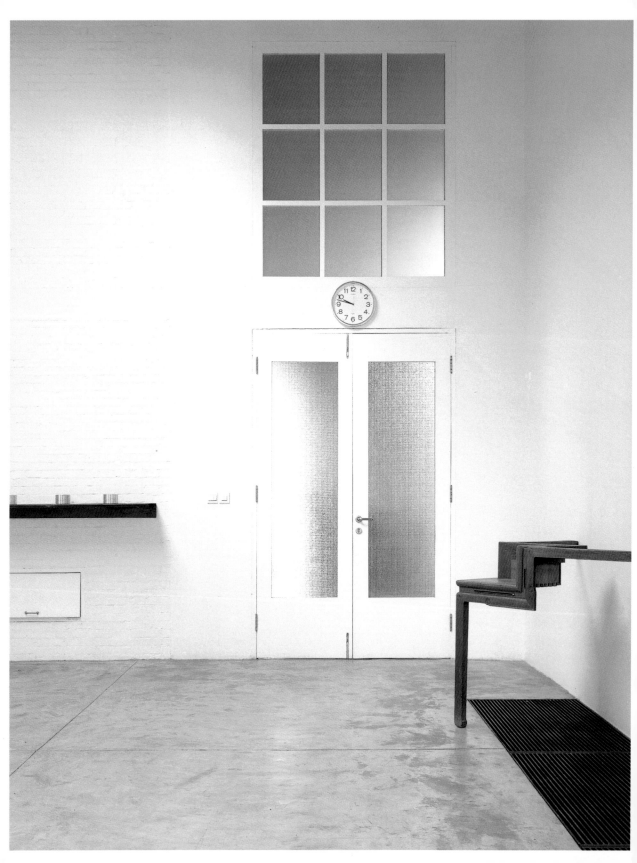

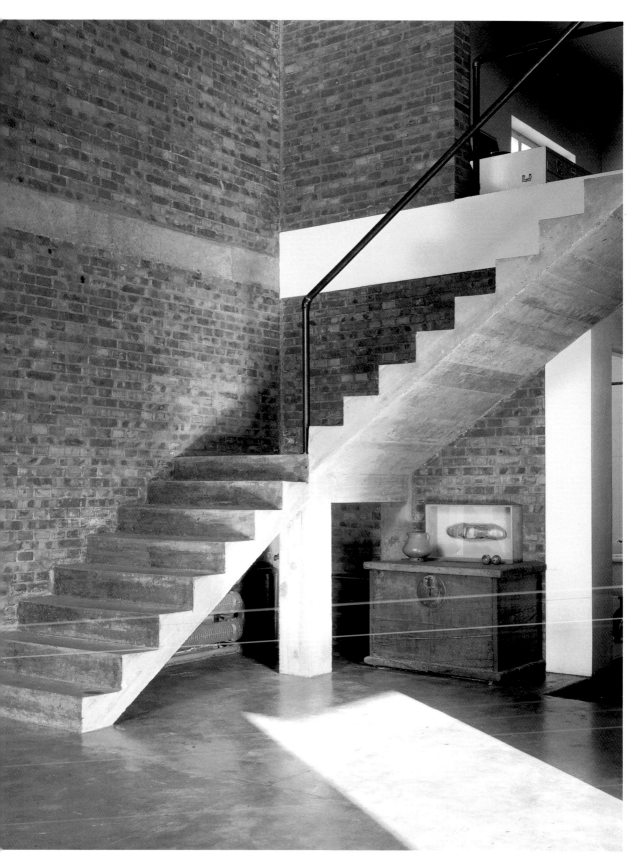

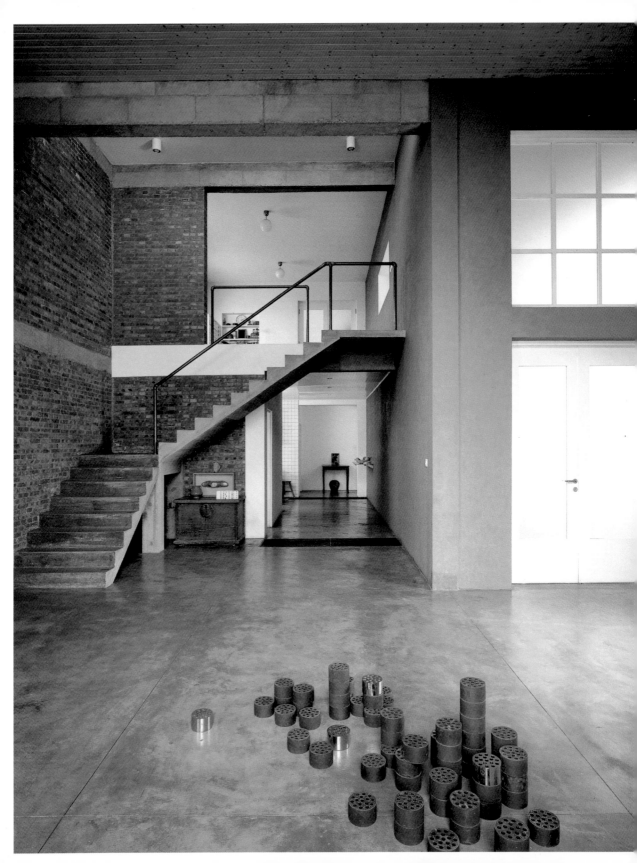

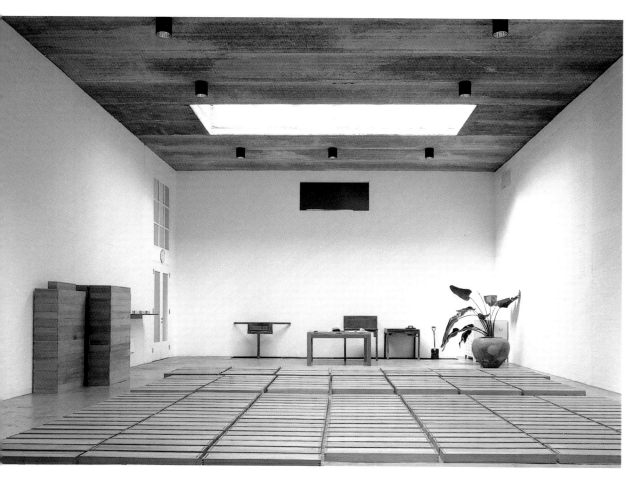

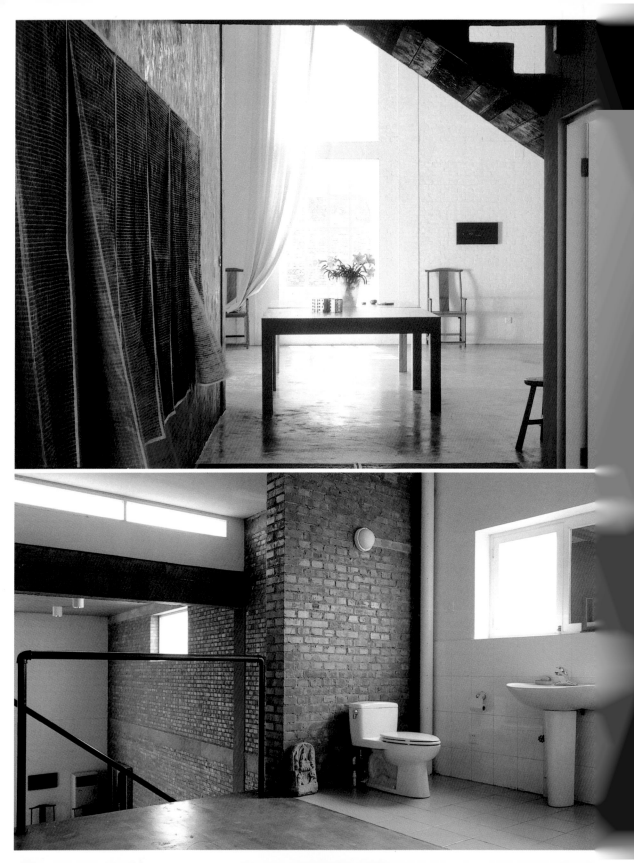

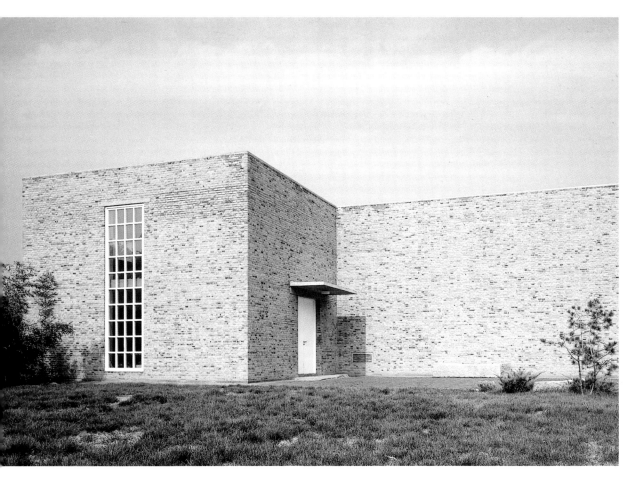

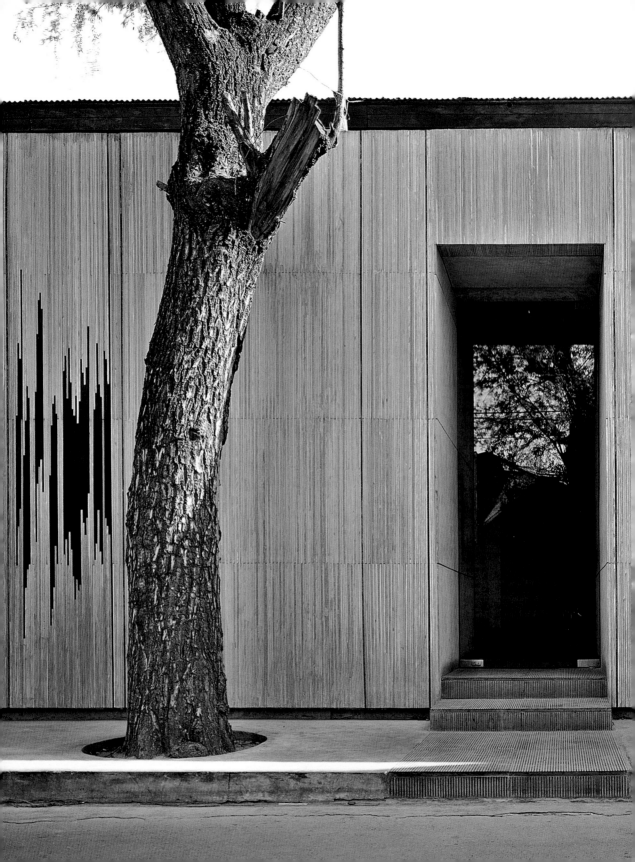

AI WEIWEI/FAKE DESIGN | BEIJING
WHERE TO GO RESTAURANT
Beijing | 2004

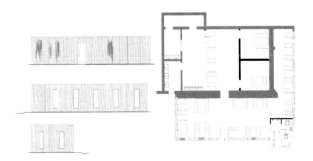

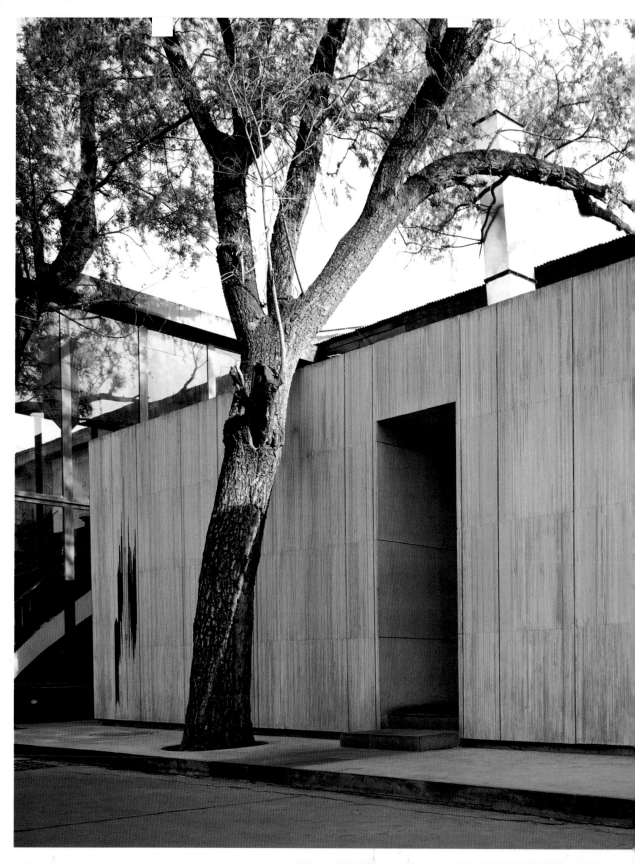

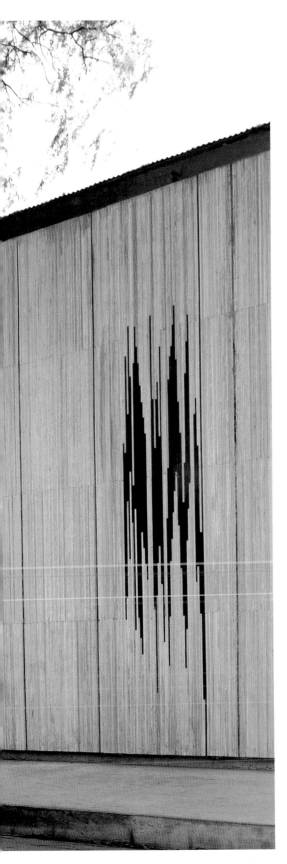

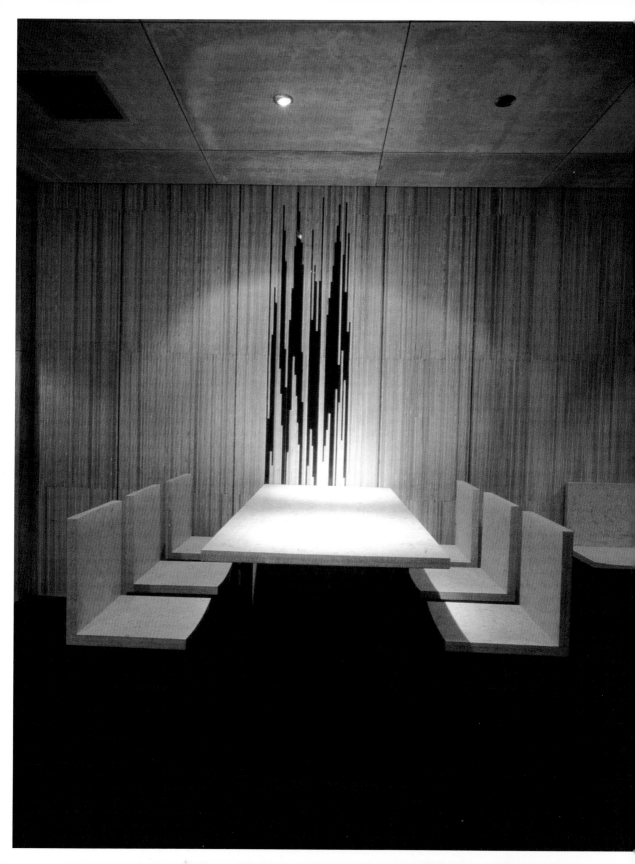

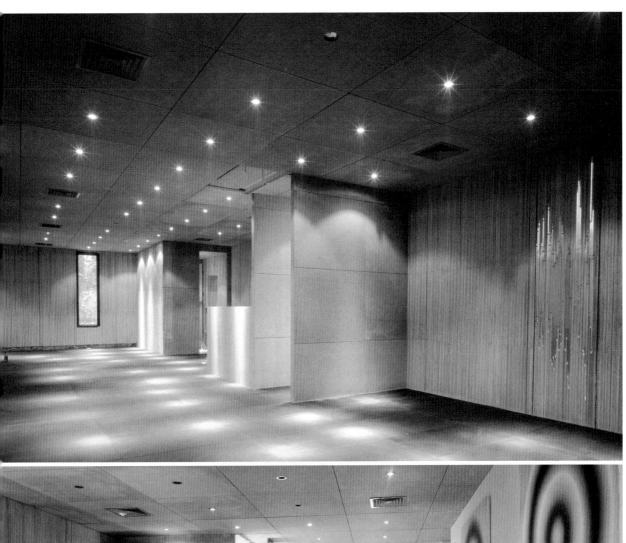
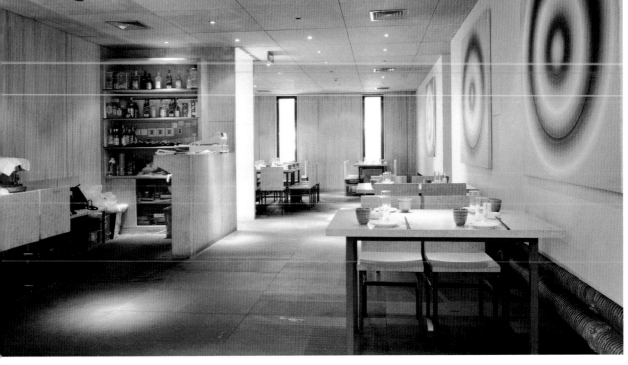

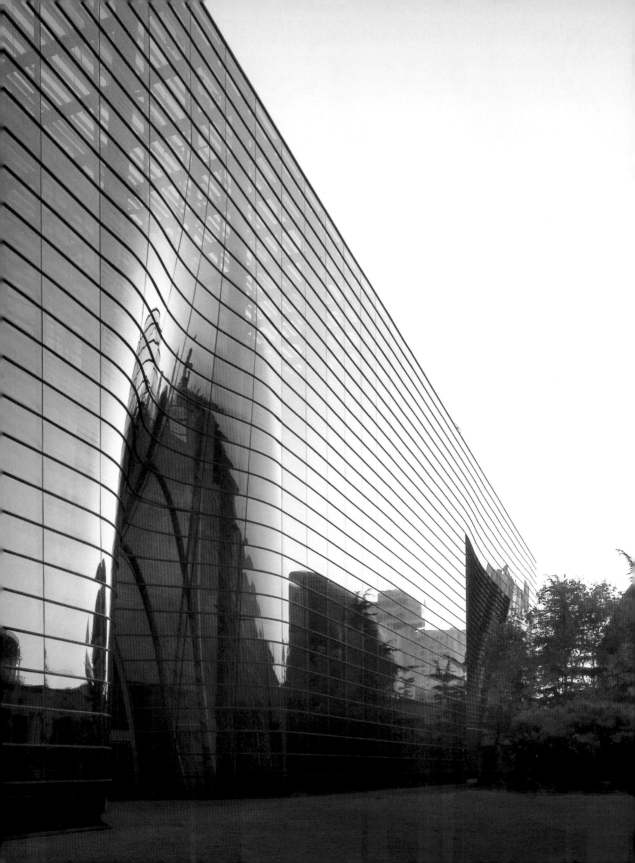

AMPHIBIAN ARC | USA
BEIJING PLANETARIUM
Beijing | 2004

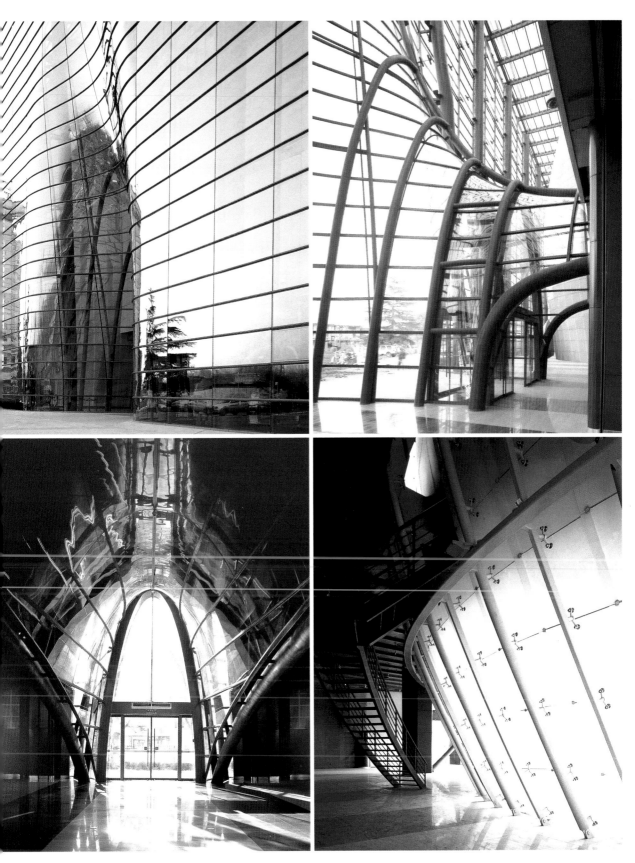

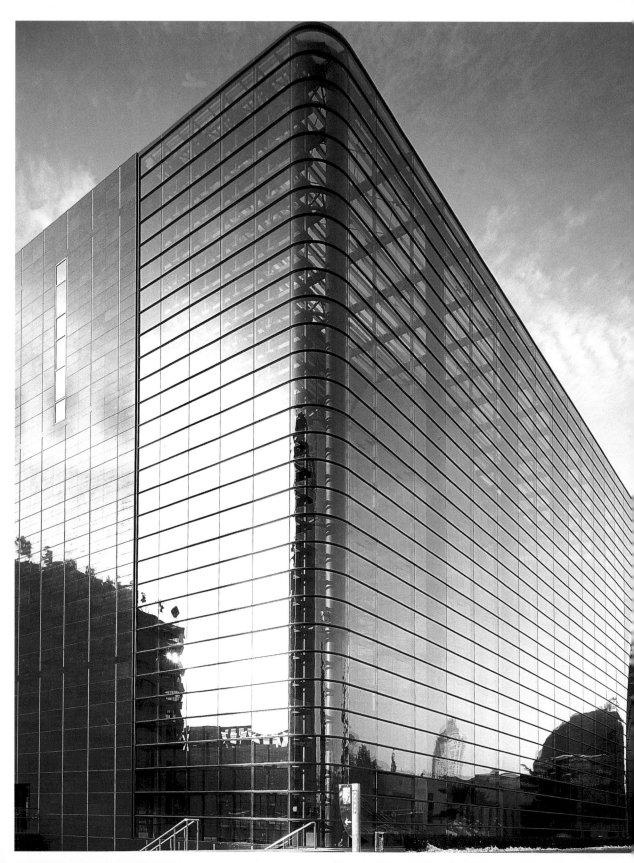

actual position

apparent position

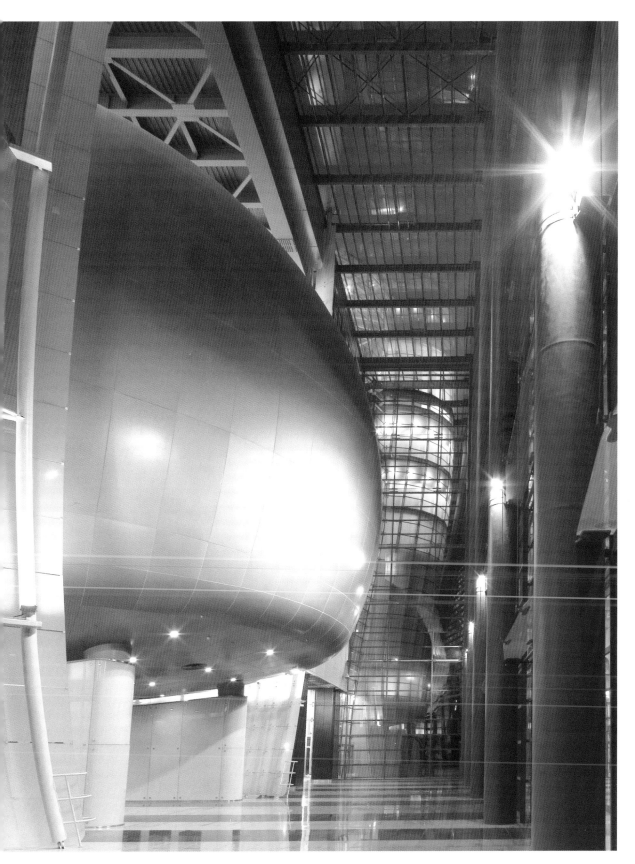

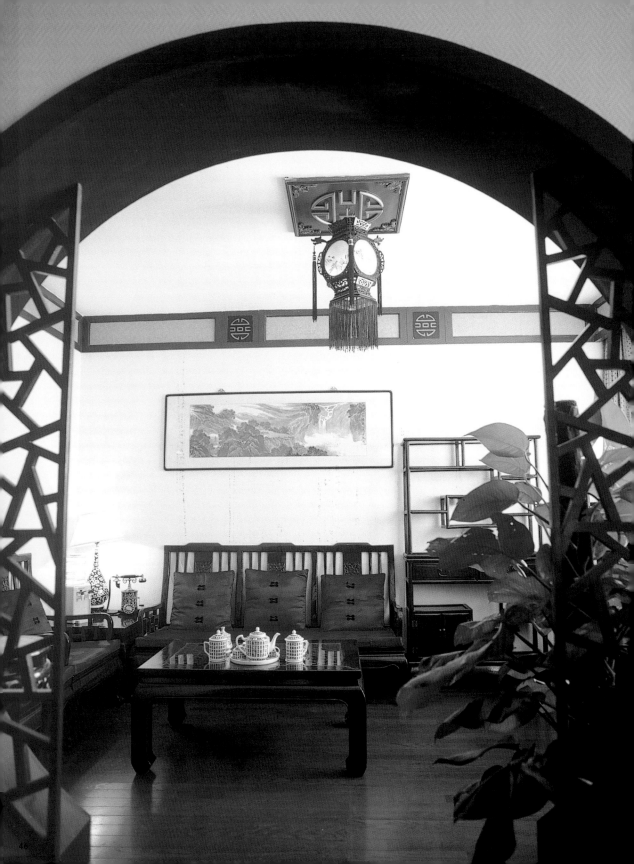

BAMBOO GARDEN HOTEL | BEIJING
BAMBOO GARDEN HOTEL
Beijing | 1981

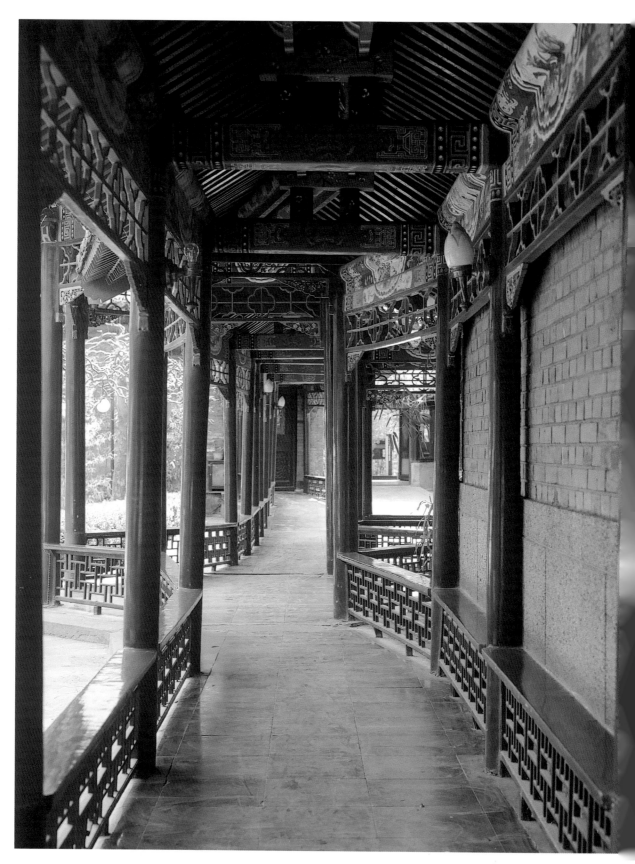

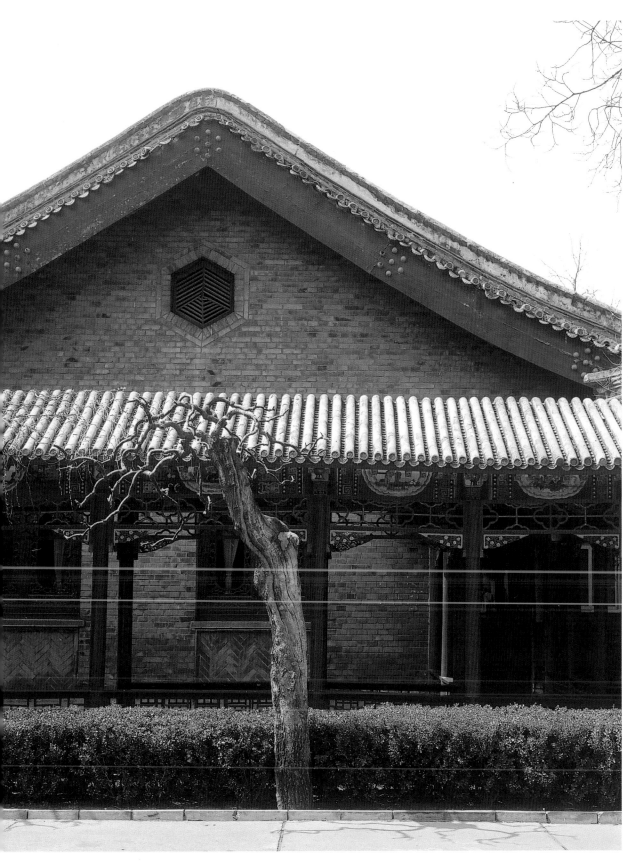

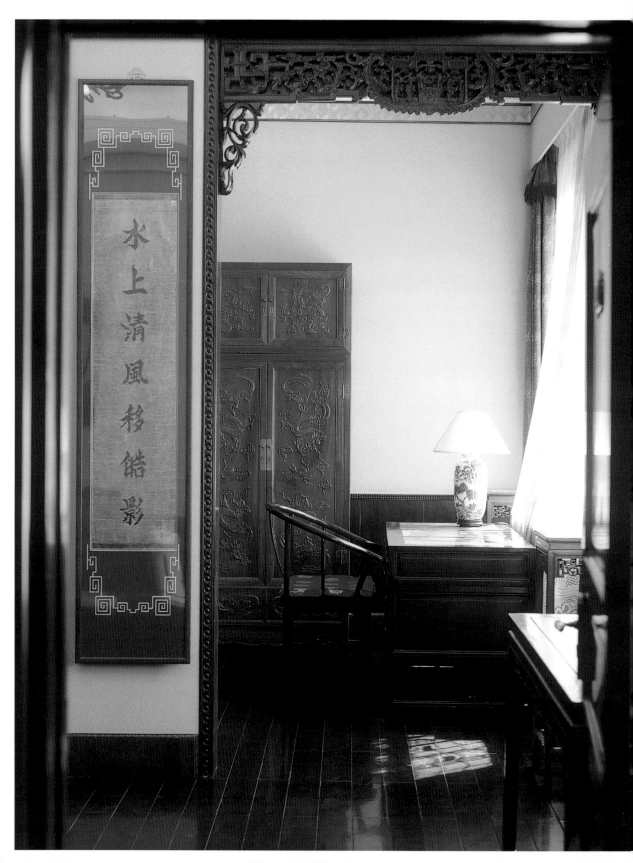

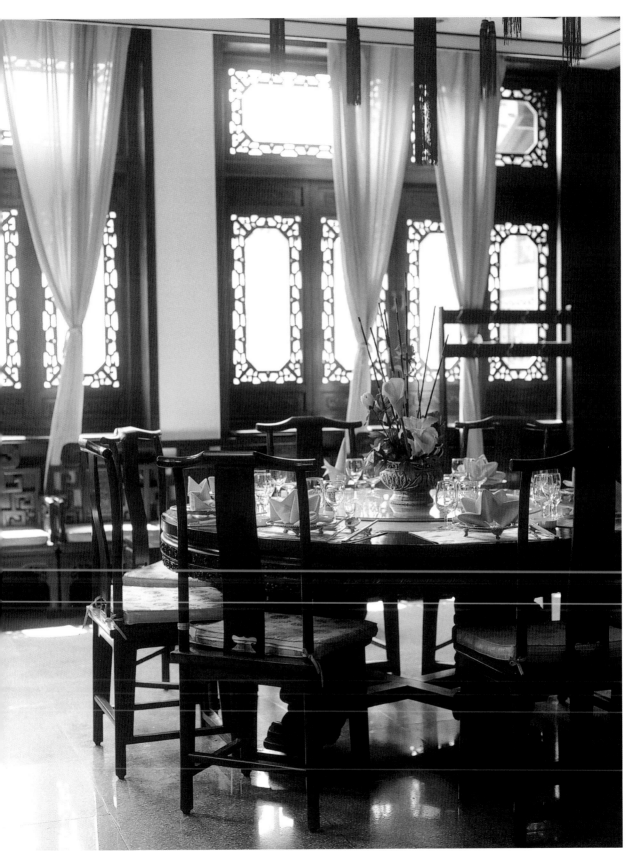

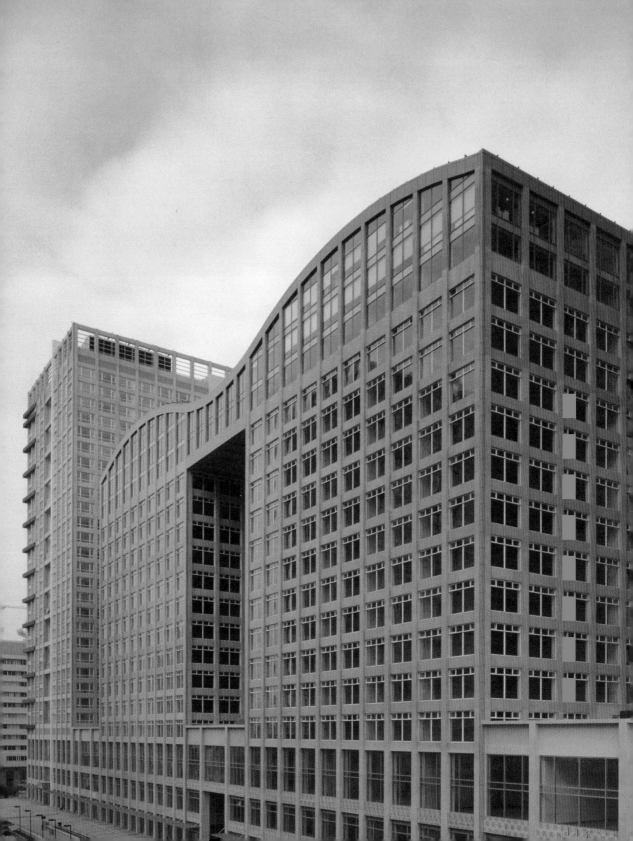

CUI KAI AND ZHU XIAODI FOR SOHO CHINA | BEIJING
SOHO NEW TOWN
Beijing | 2001

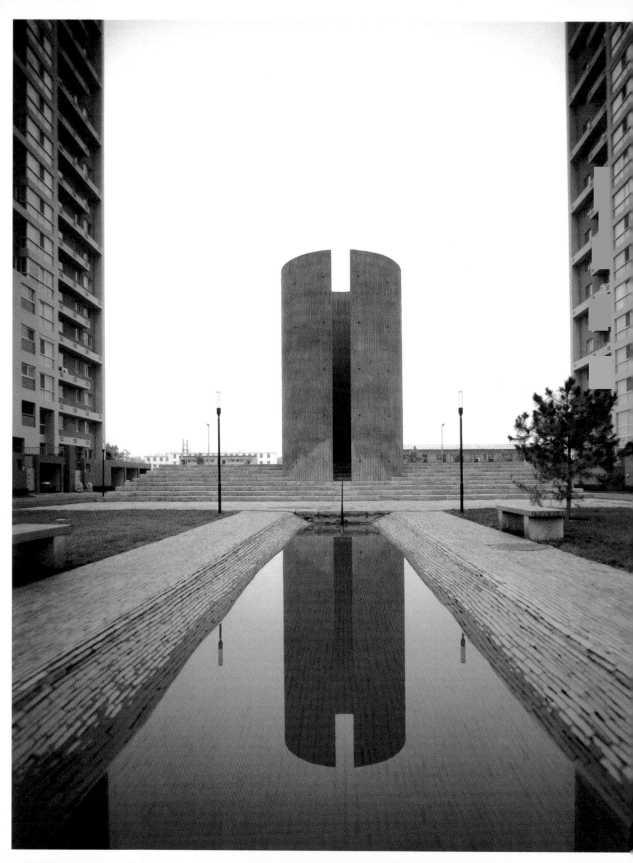

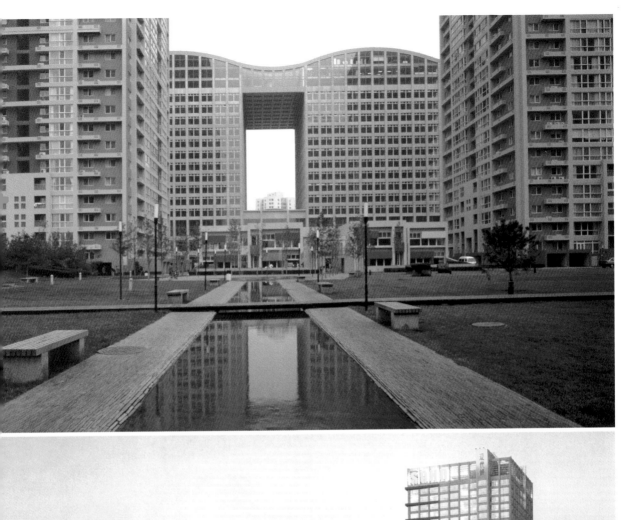

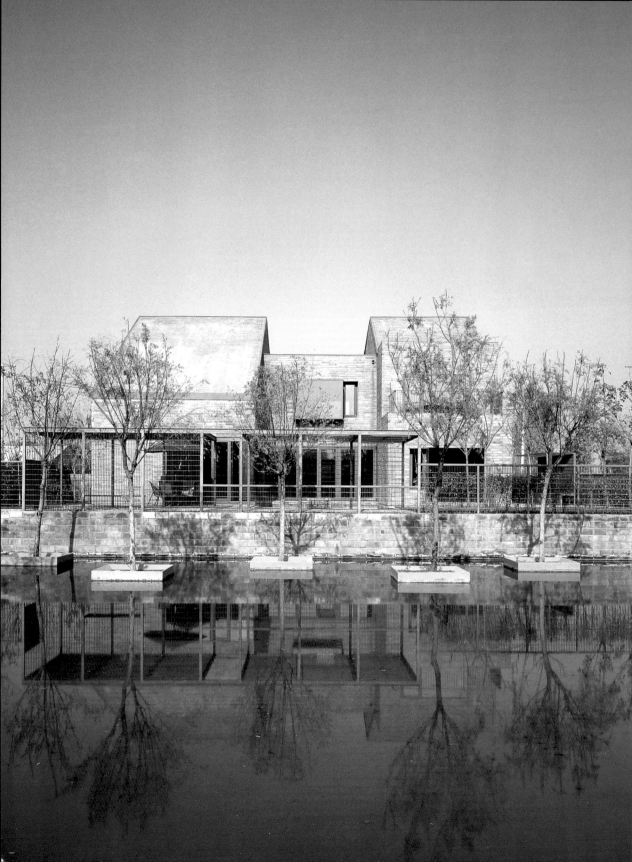

CHANG YUNG HO / FCJZ – ATELIER FEICHANG JIANZHU | BEIJING
CANAL RESIDENTIAL PROJECT
Beijing | 2004

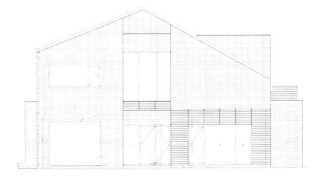

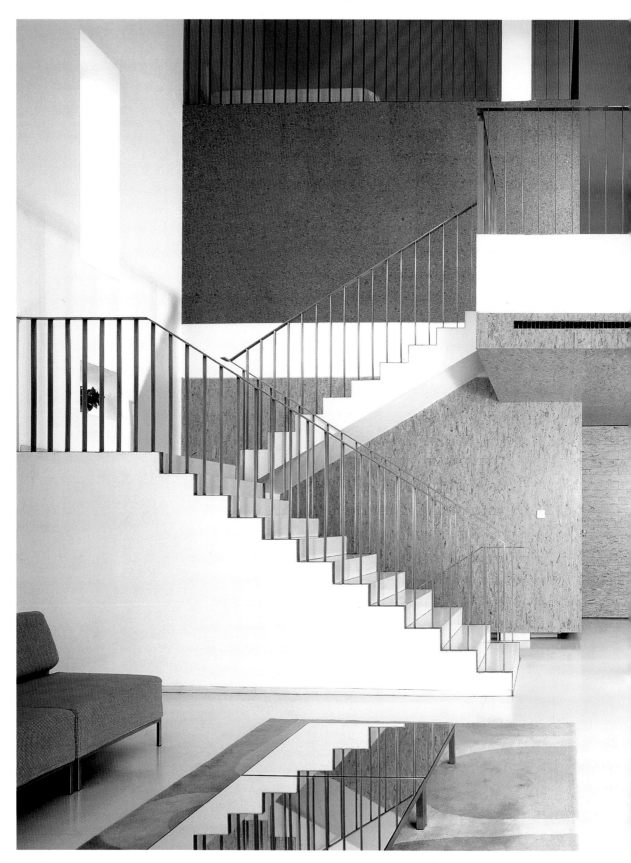

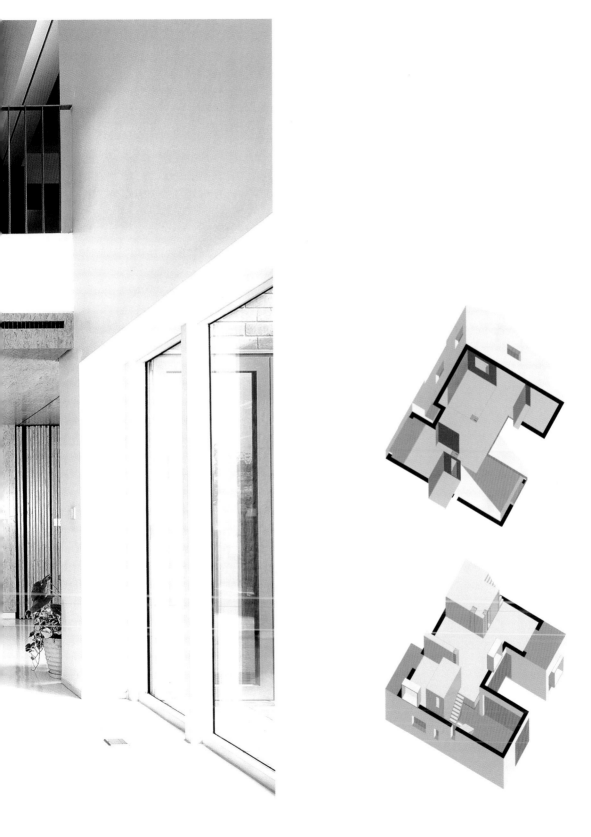

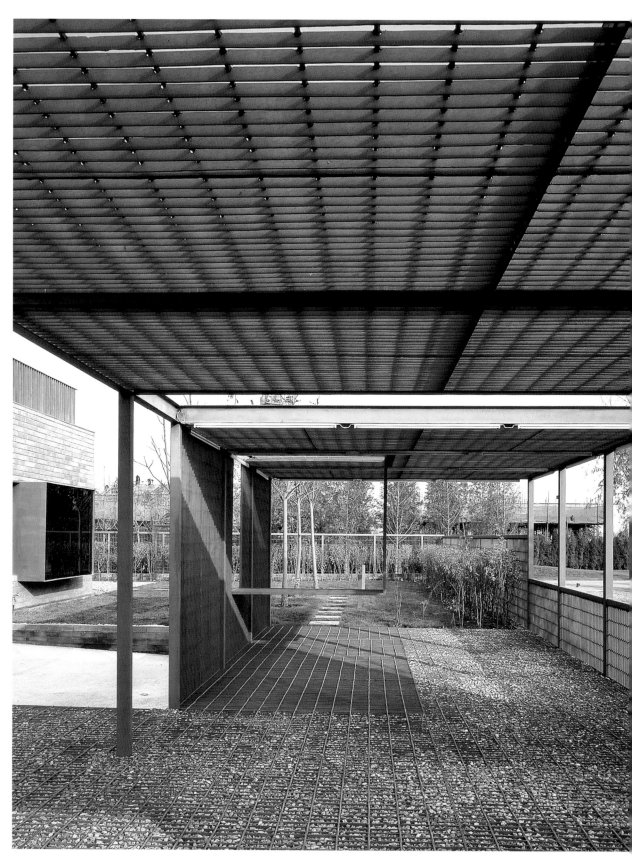

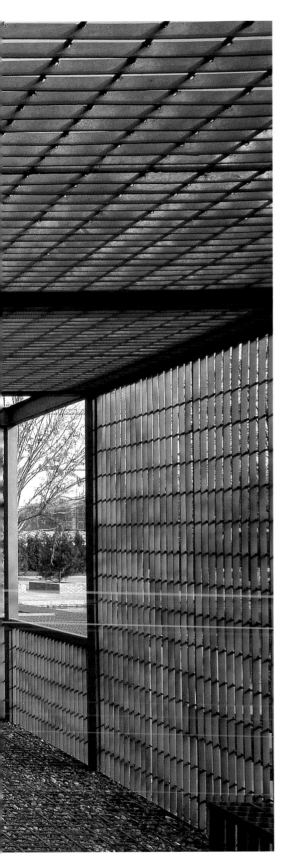

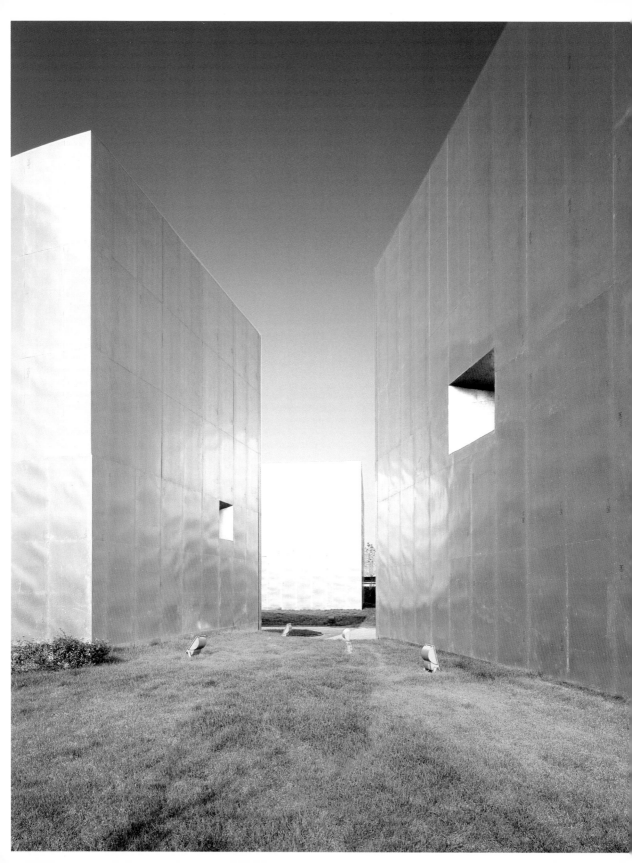

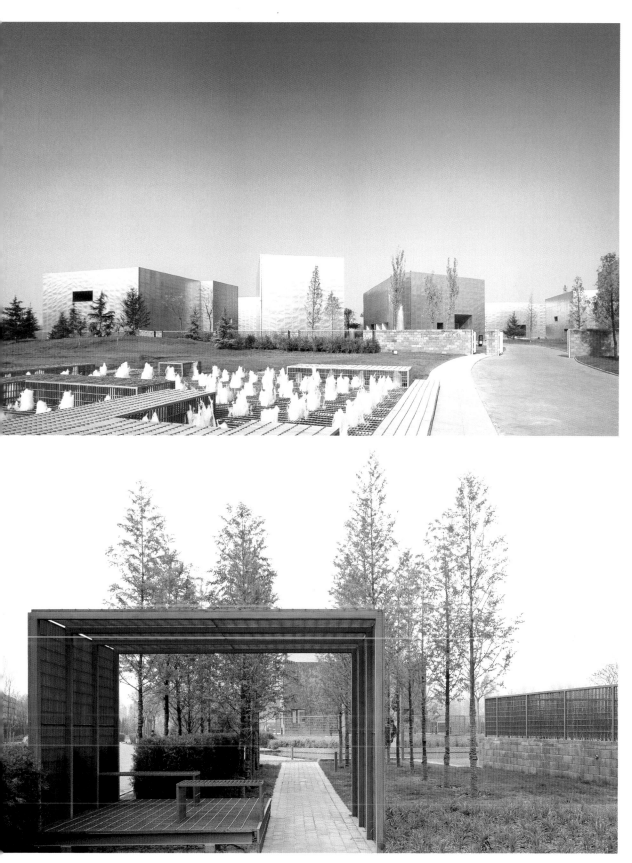

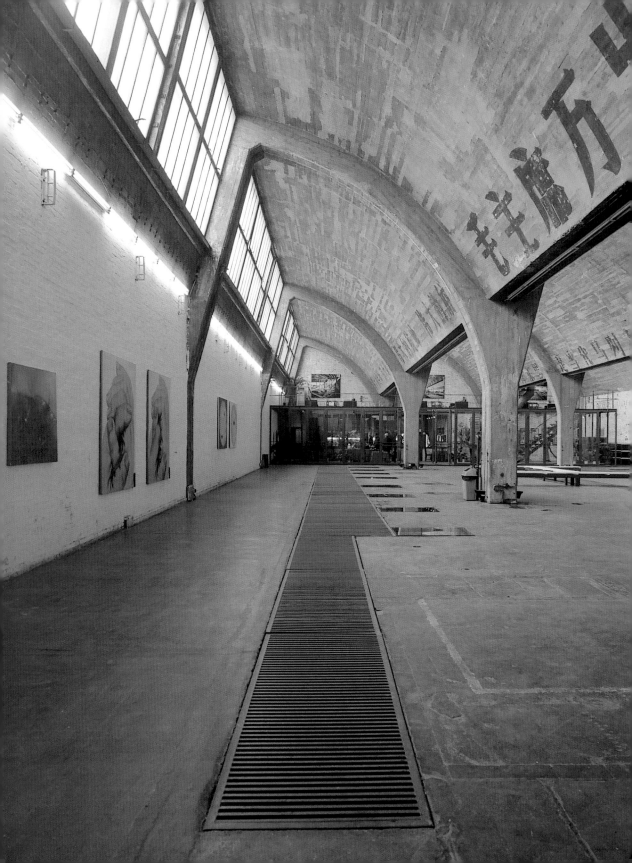

CHANG YUNG HO / FCJZ – ATELIER FEICHANG JIANZHU | BEIJING
798 SPACE
Beijing | 2002

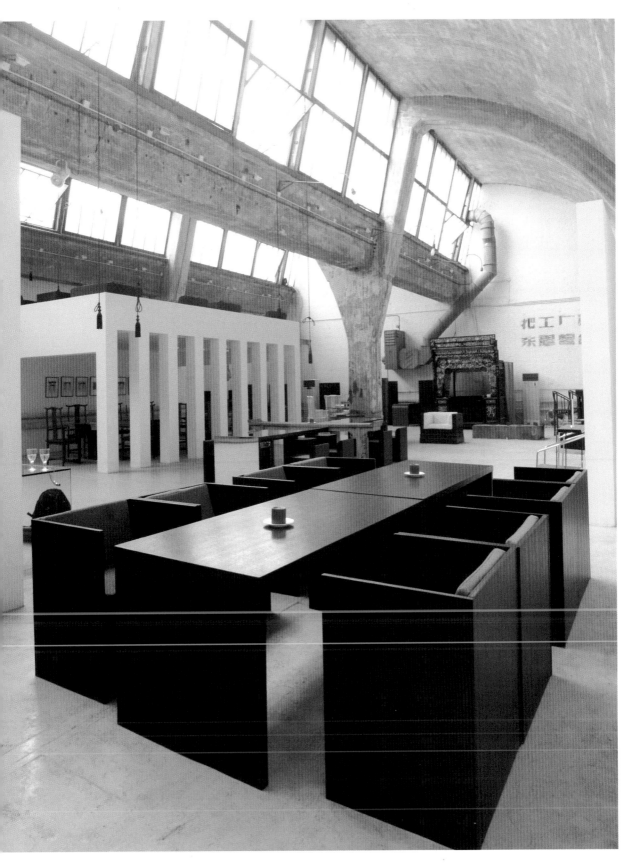

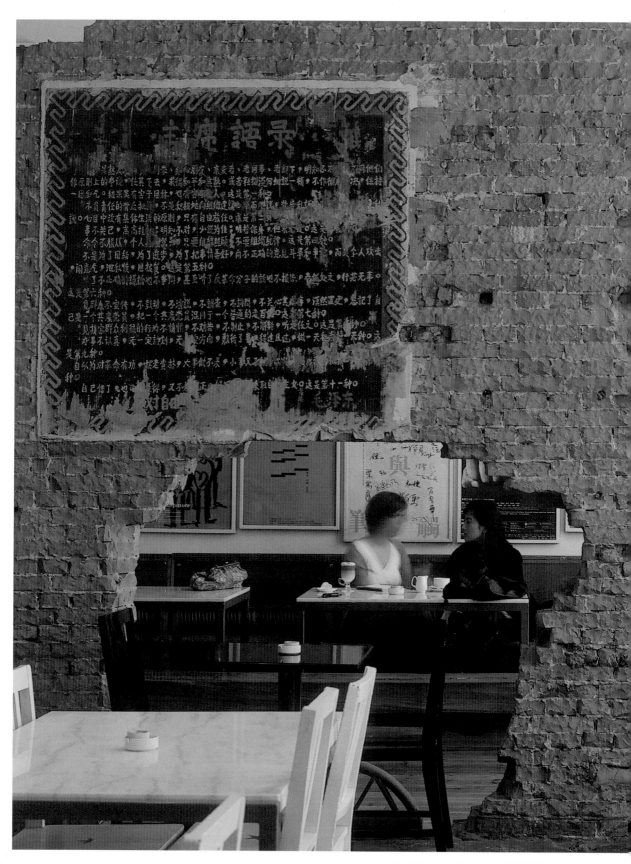

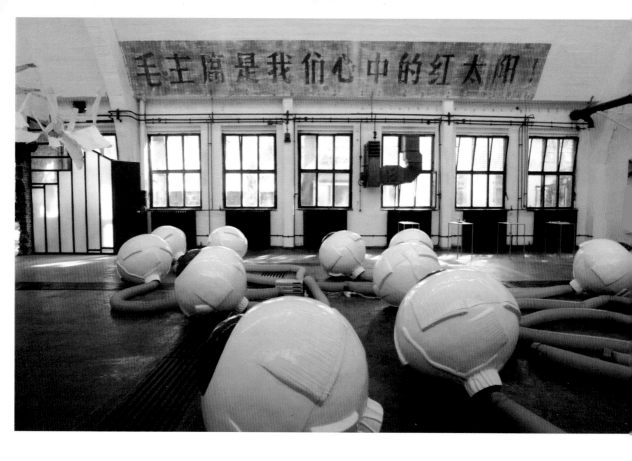

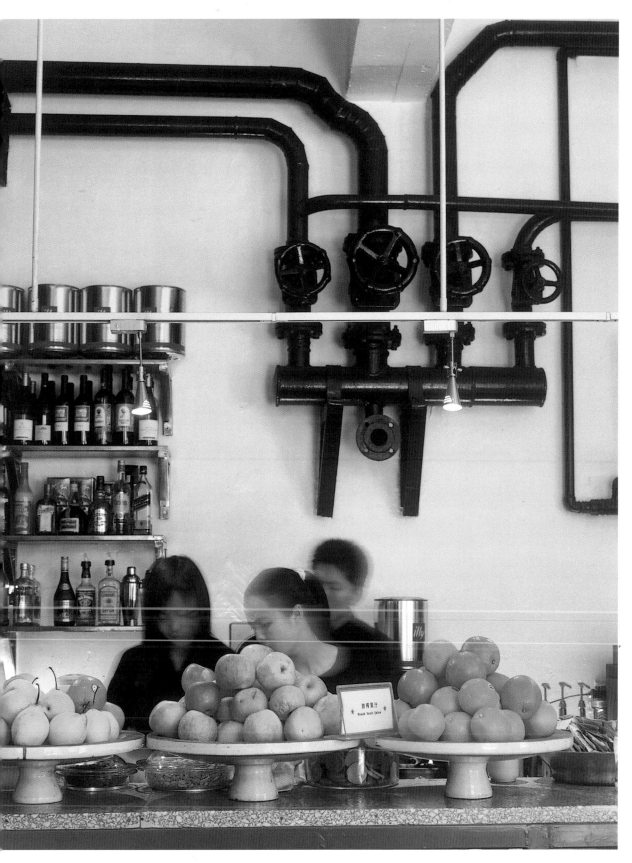

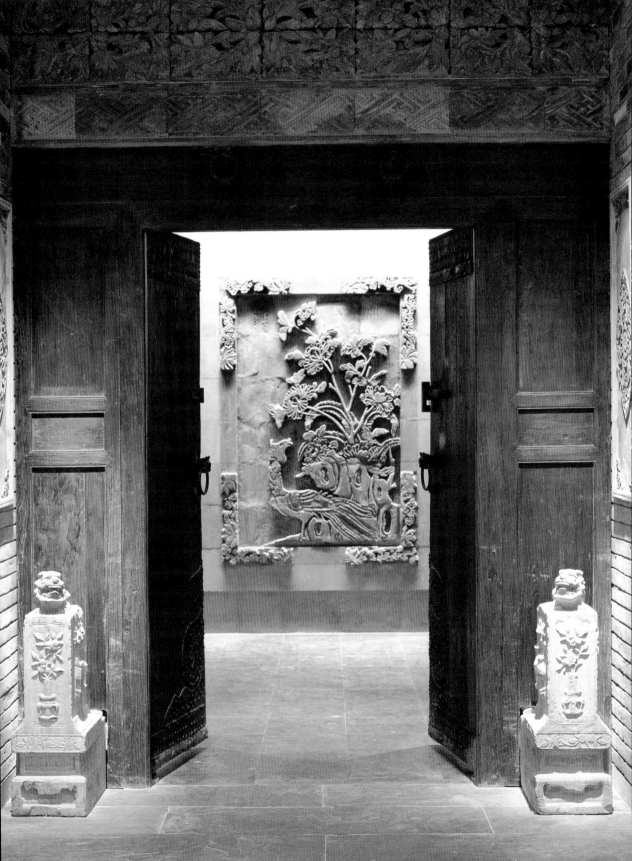

CHHADA SIEMBIEDA AND ASSOCIATES | HONG KONG
HUANG TING RESTAURANT IN THE PENINSULA PALACE HOTEL
Beijing | 2003

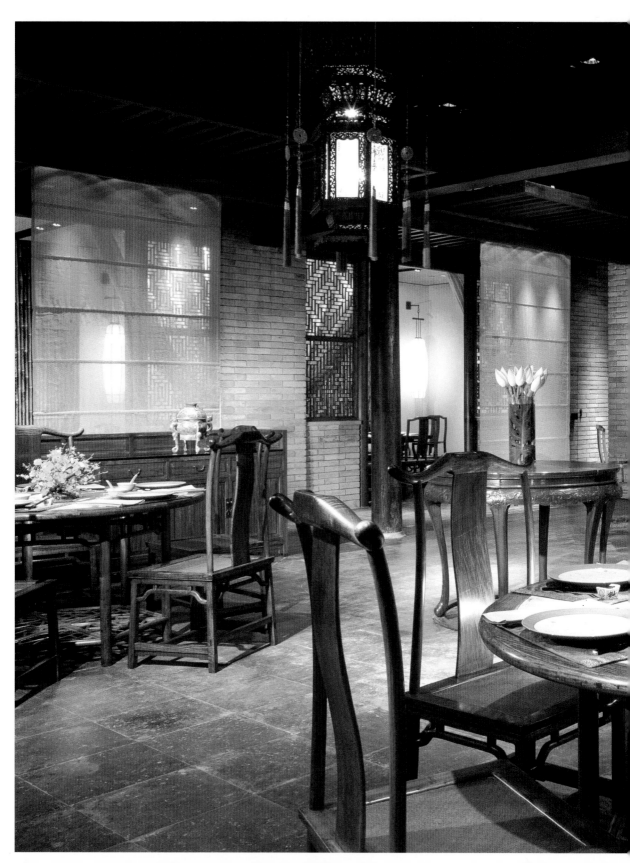

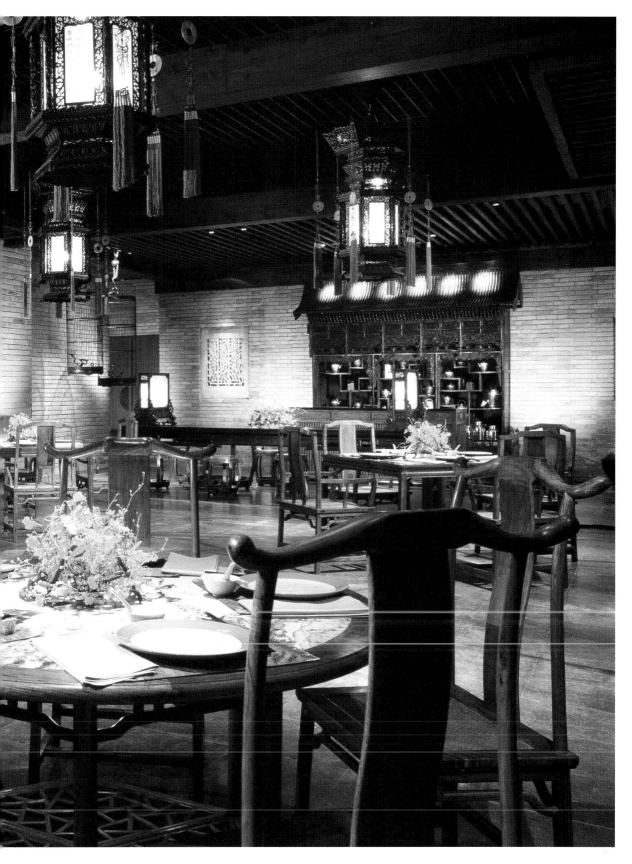

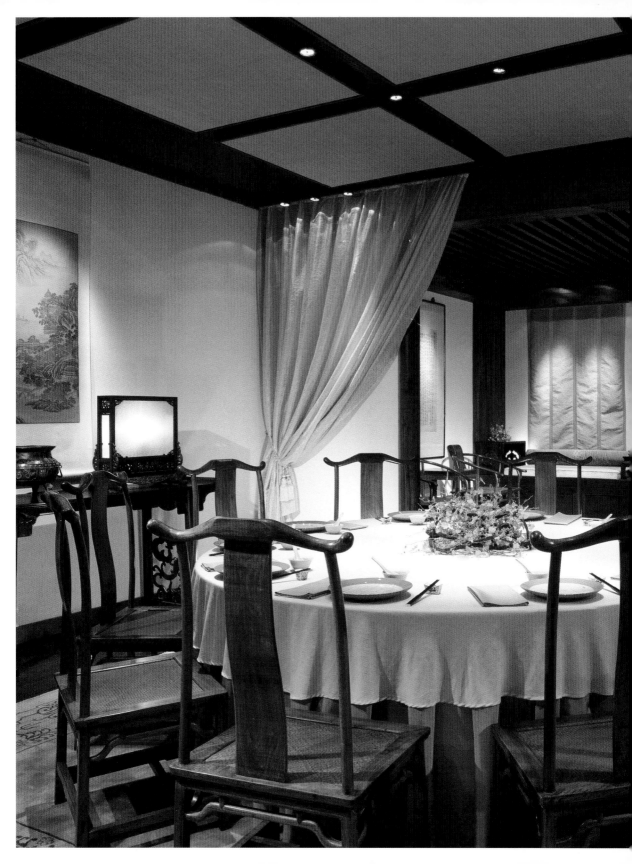

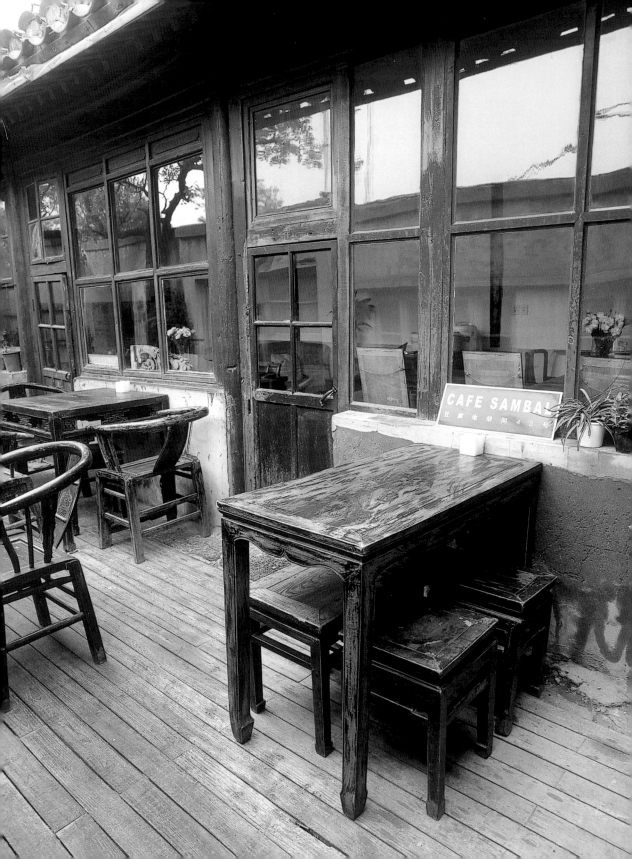

CHO CHONG GEE / CAFÉ SAMBAL | BEIJING
CAFÉ SAMBAL
Beijing | 2002

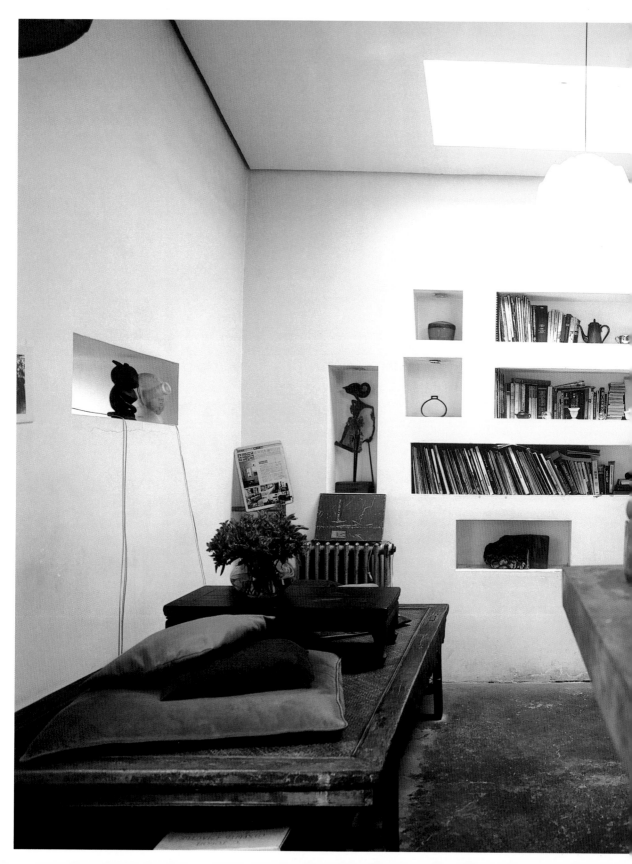

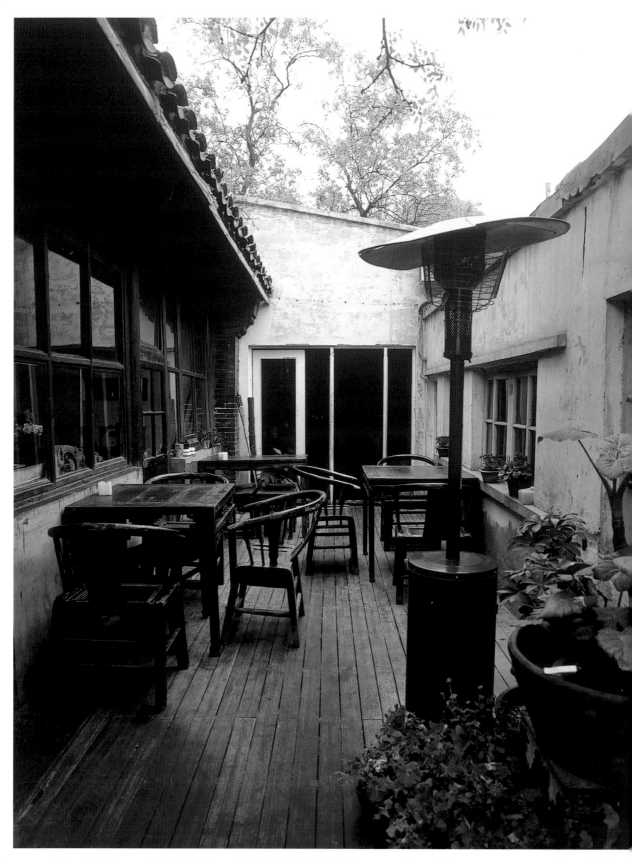

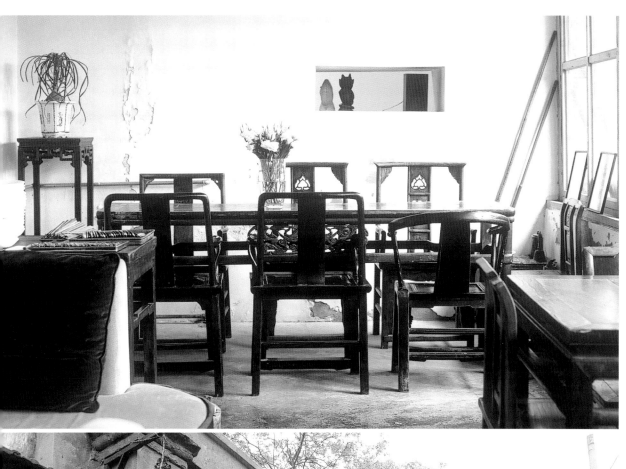
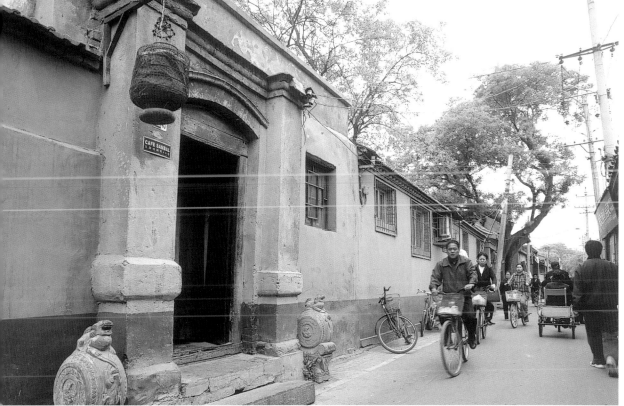

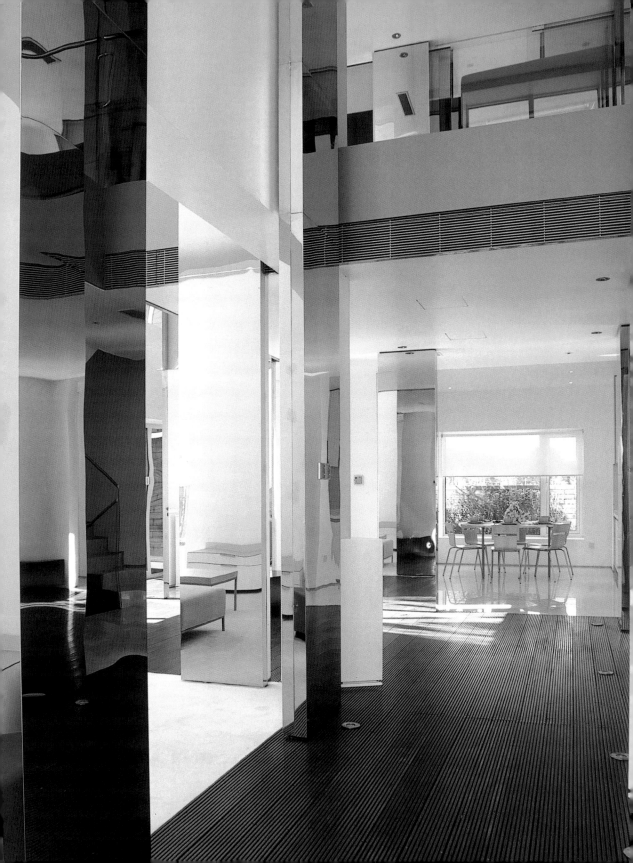

HIRONORI MATSUBARA / BMA – BEIJING MATSUBARA AND ARCHITECTS | BEIJING
COURTYARDS BY THE CANAL
Beijing | 2004

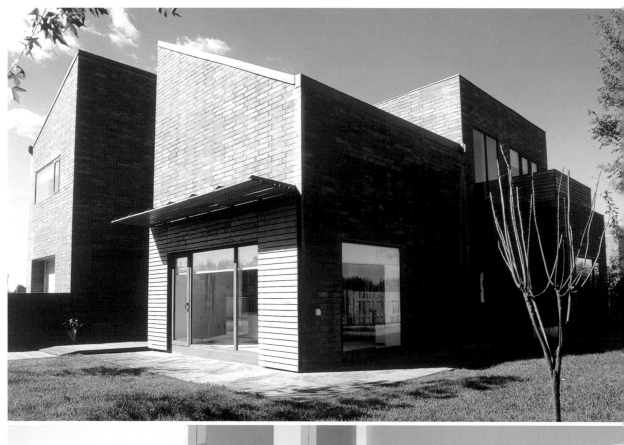

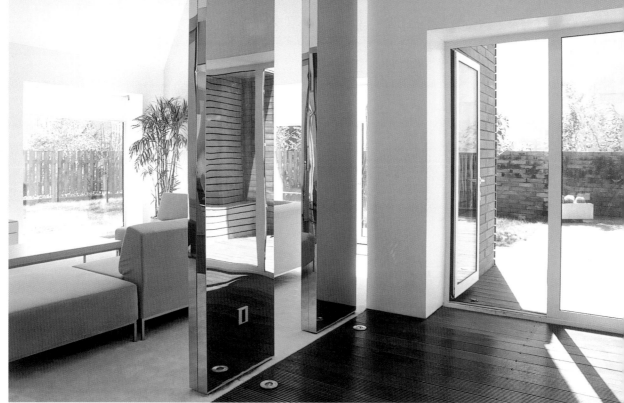

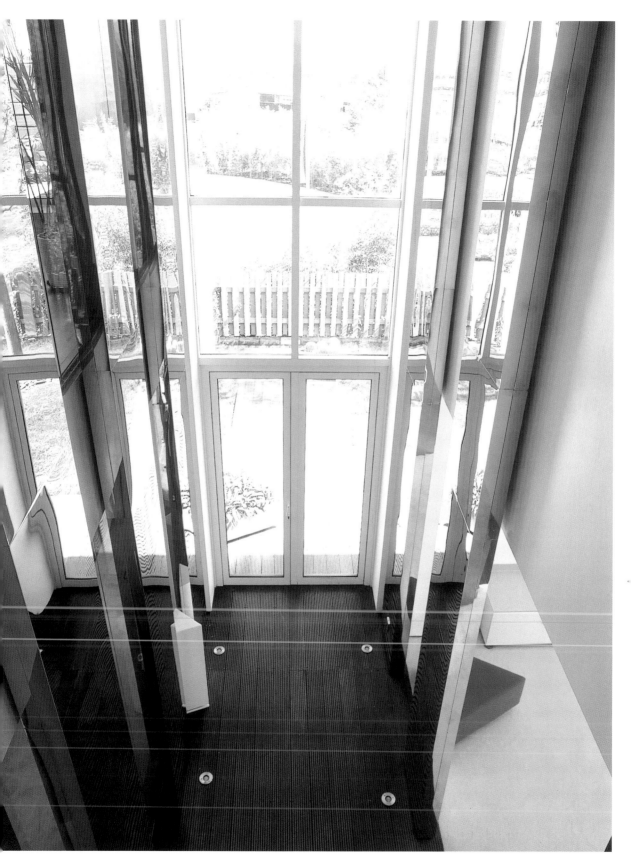

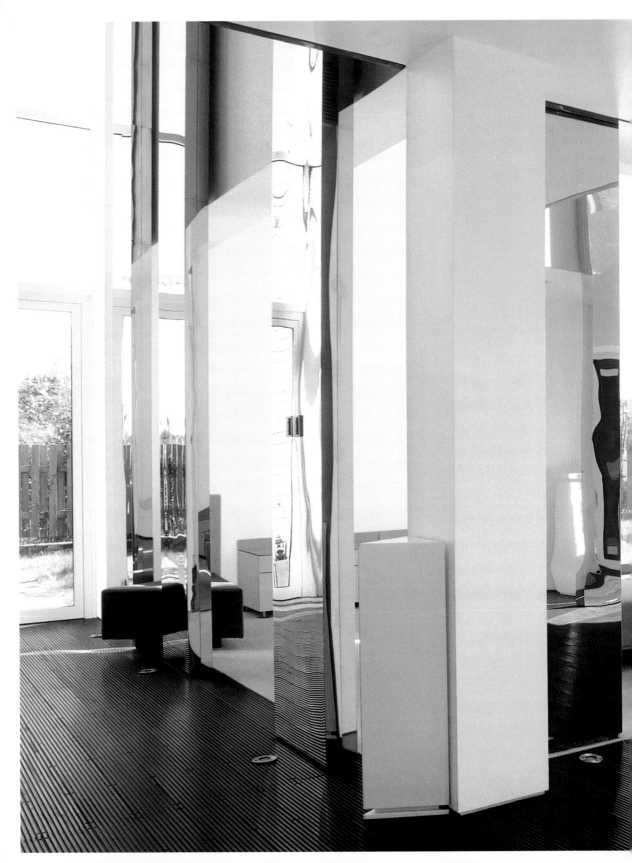

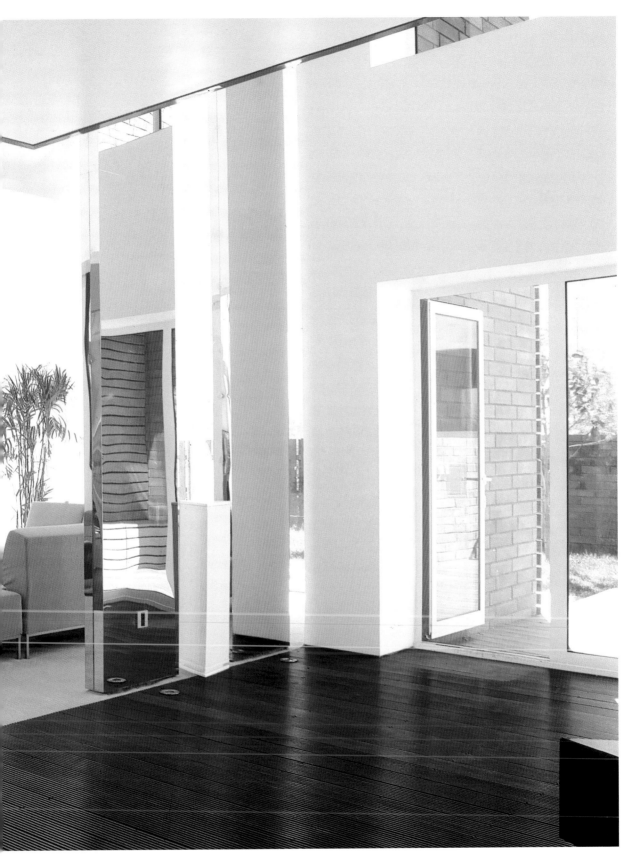

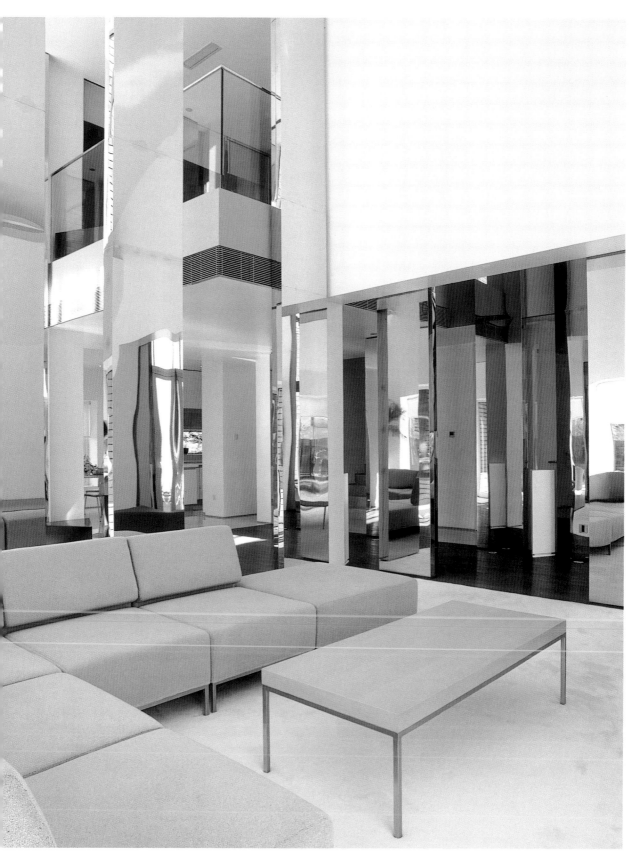

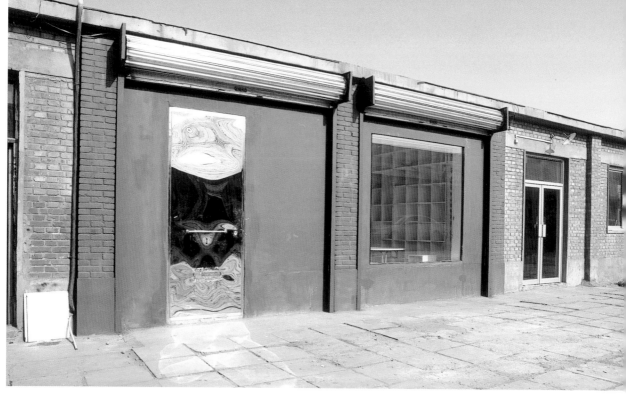

HIRONORI MATSUBARA/BMA – BEIJING MATSUBARA AND ARCHITECTS | BEIJING
LIULIQUIAO OFFICE RENOVATION
Beijing | 2003

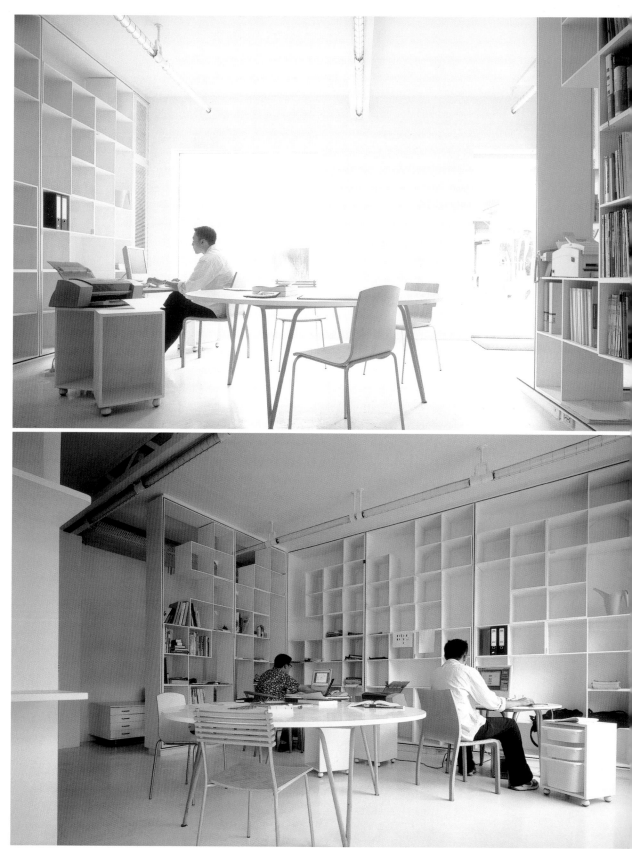

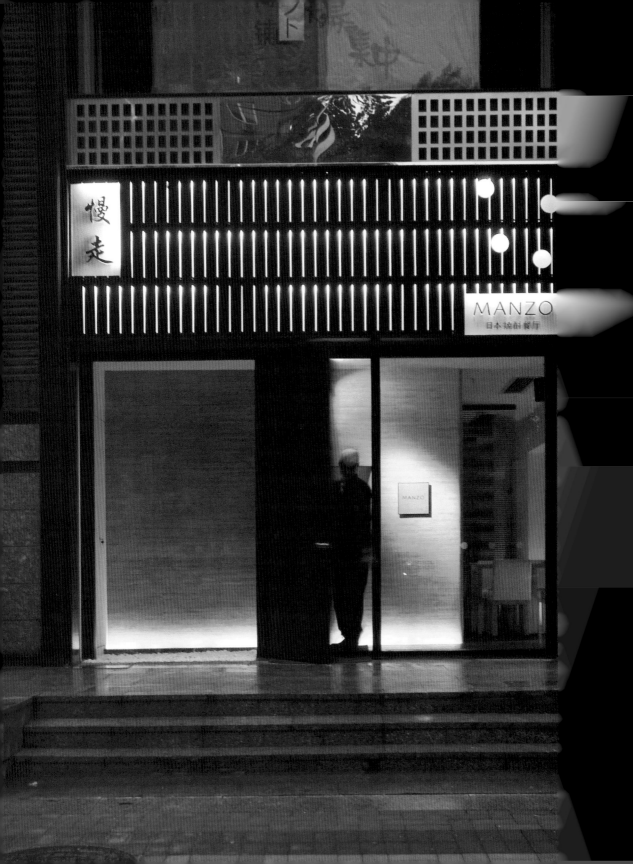

HIRONORI MATSUBARA/BMA – BEIJING MATSUBARA AND ARCHITECTS | BEIJING
MANZO BAR & JAPANESE RESTAURANT
Beijing | 2005

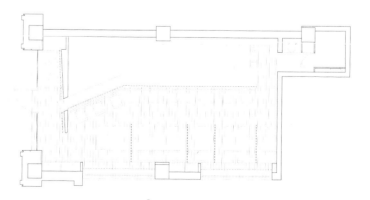

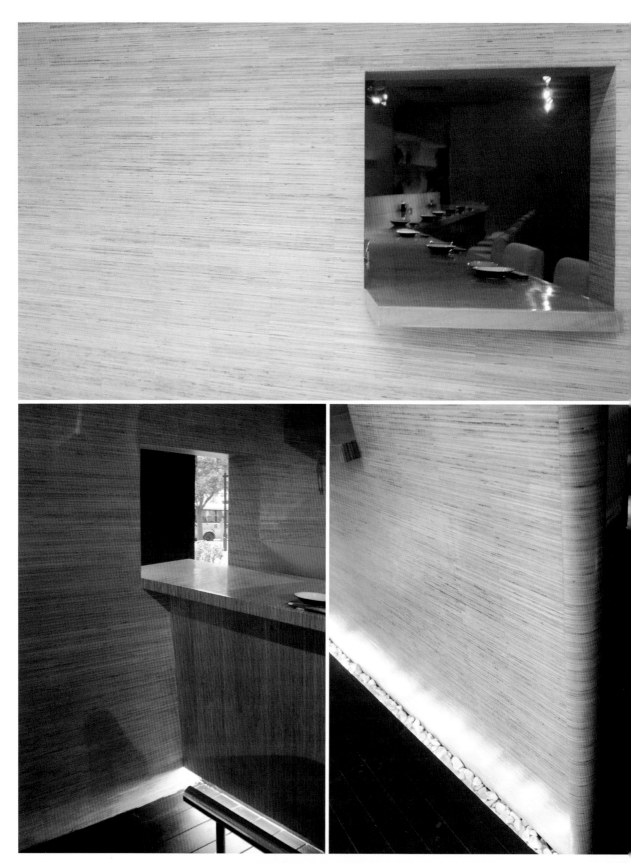

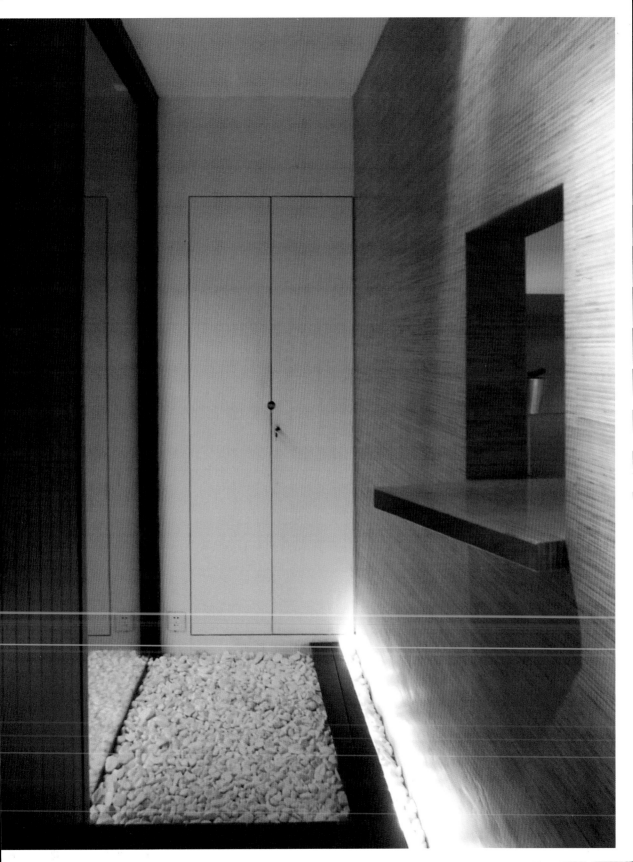

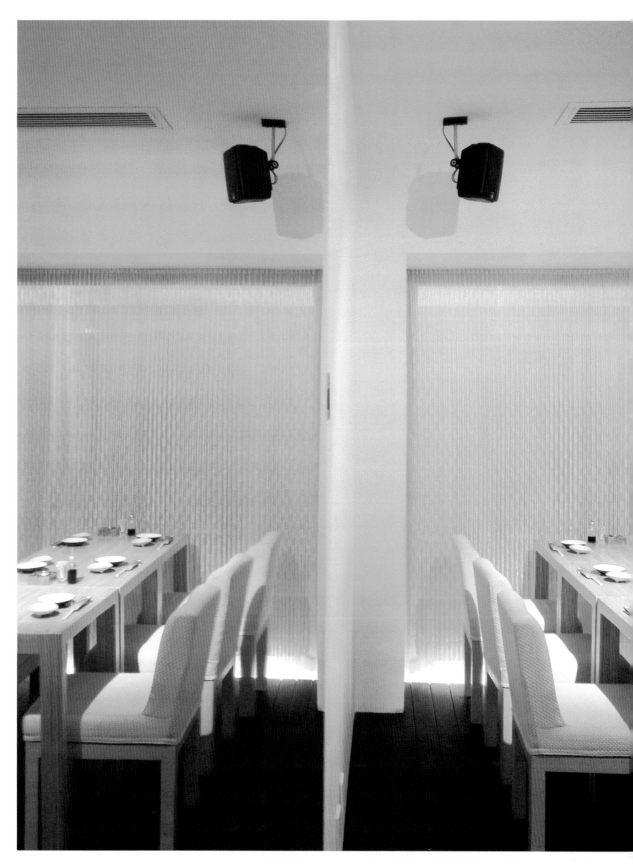

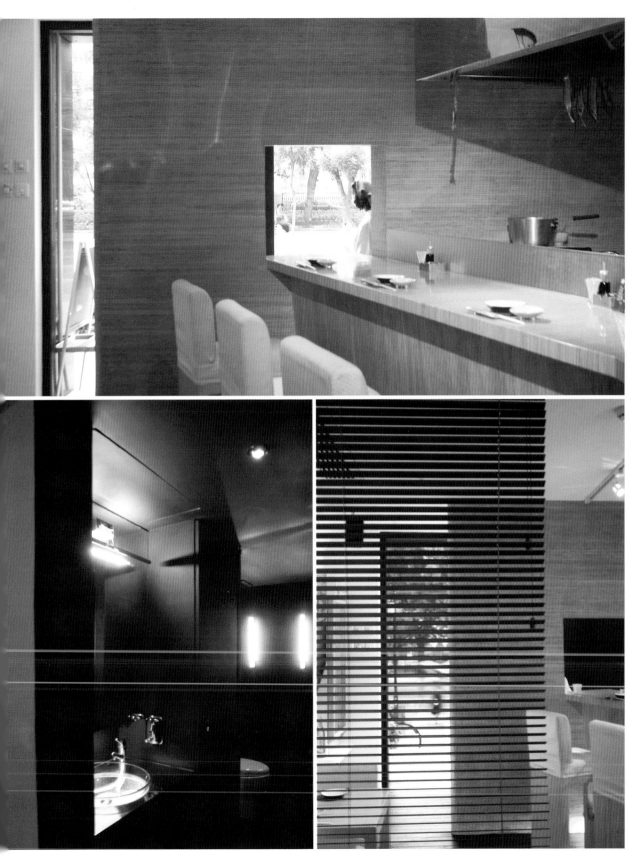

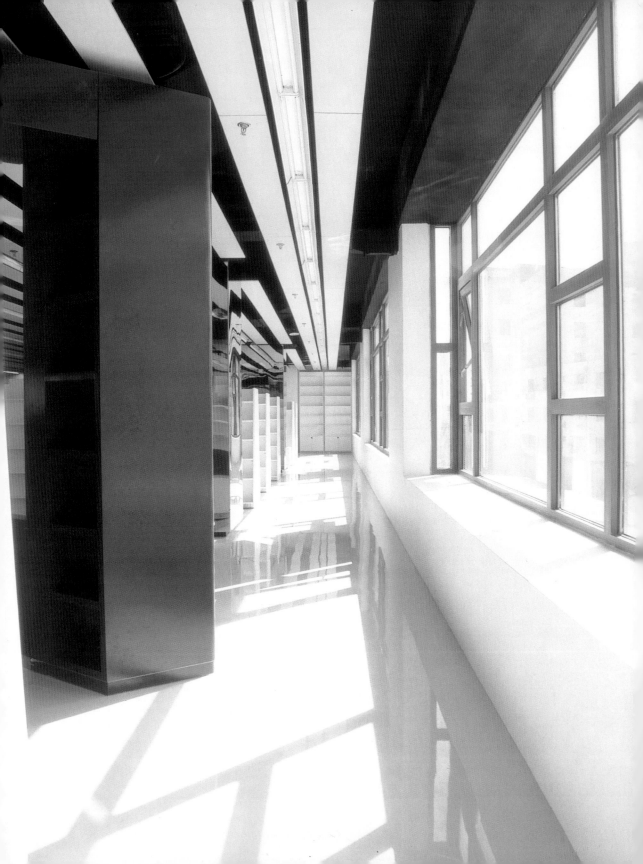

HIRONORI MATSUBARA / BMA – BEIJING MATSUBARA AND ARCHITECTS | BEIJING
ZHONGGUANCUN MULTI-STOREY BOOKSHOP INTERIOR RENOVATION
Beijing | 2003

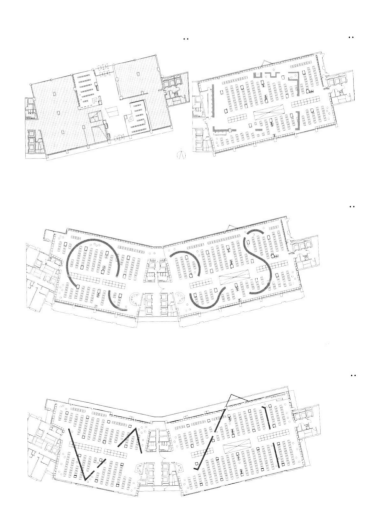

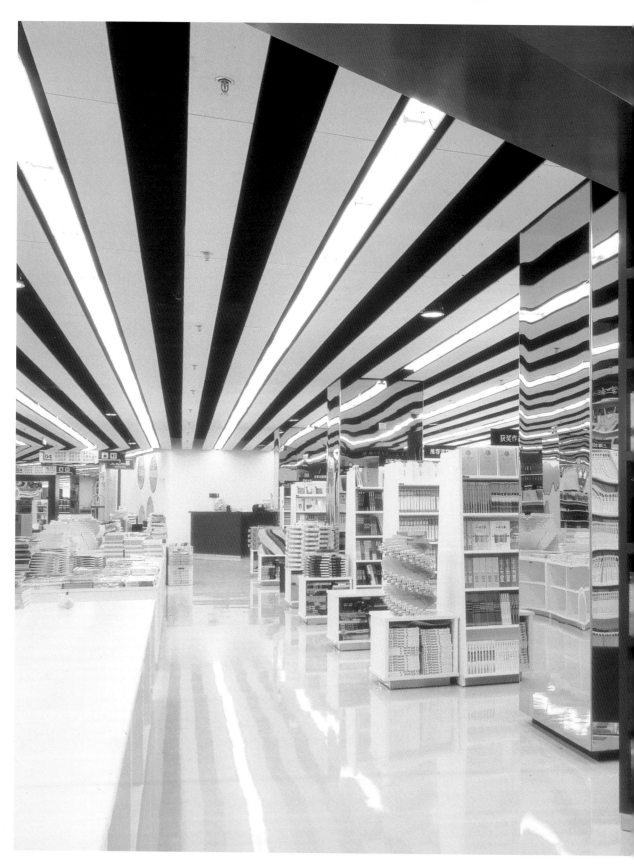

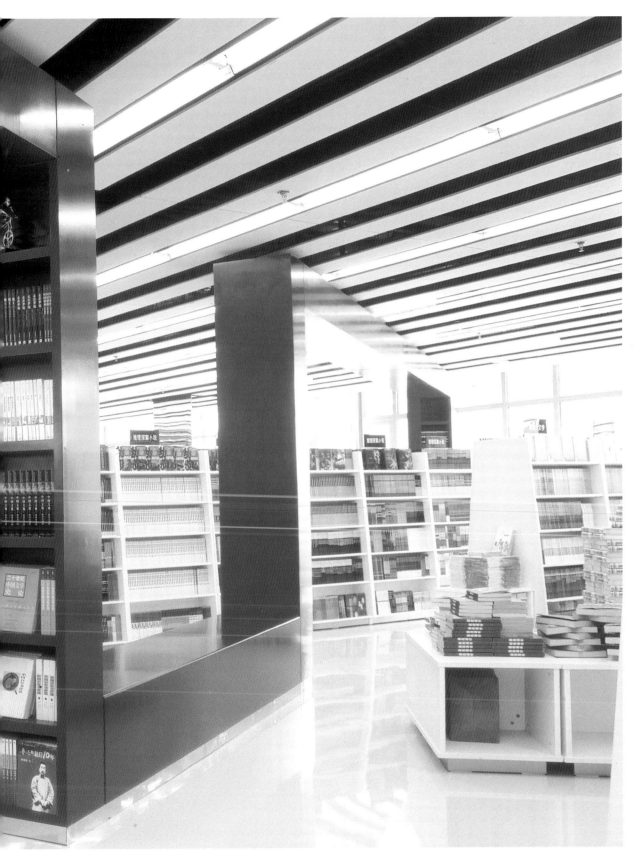

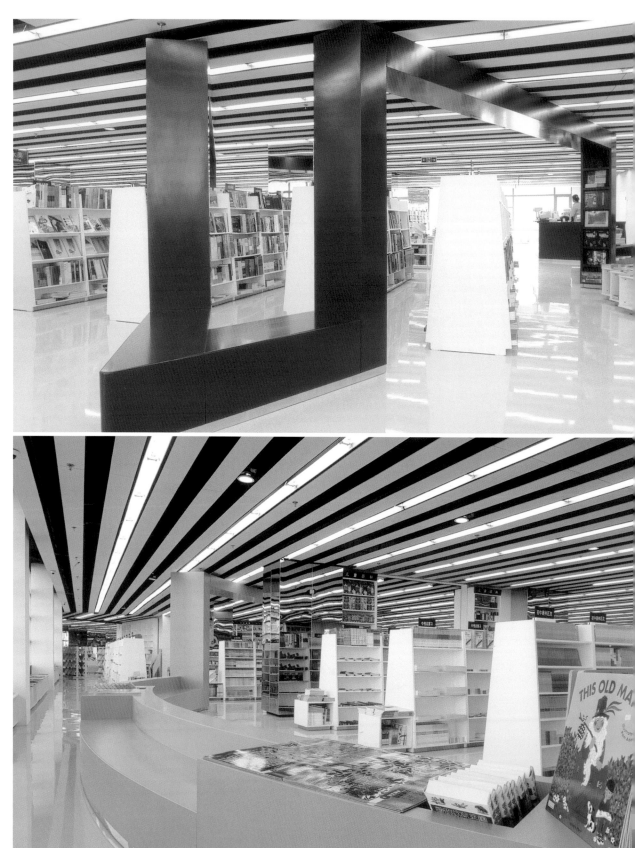

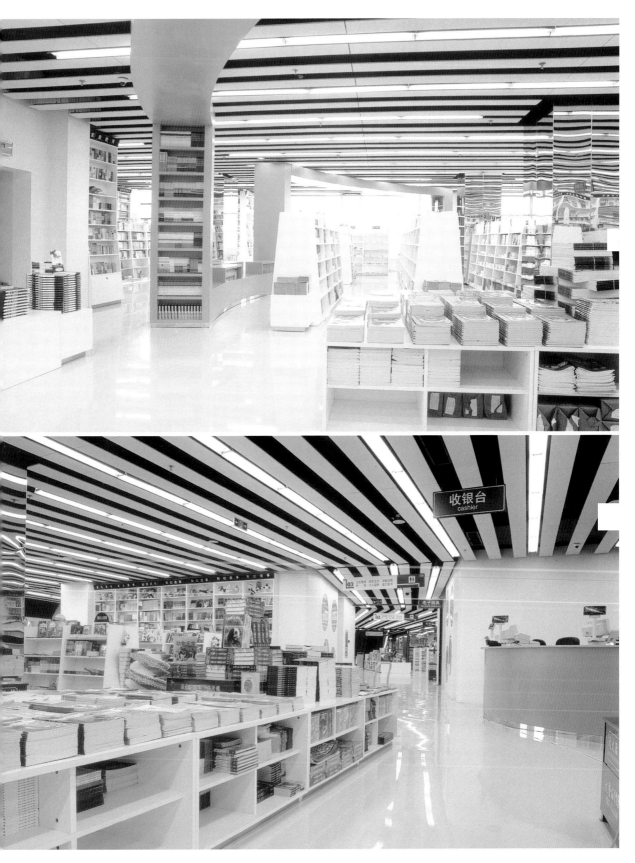

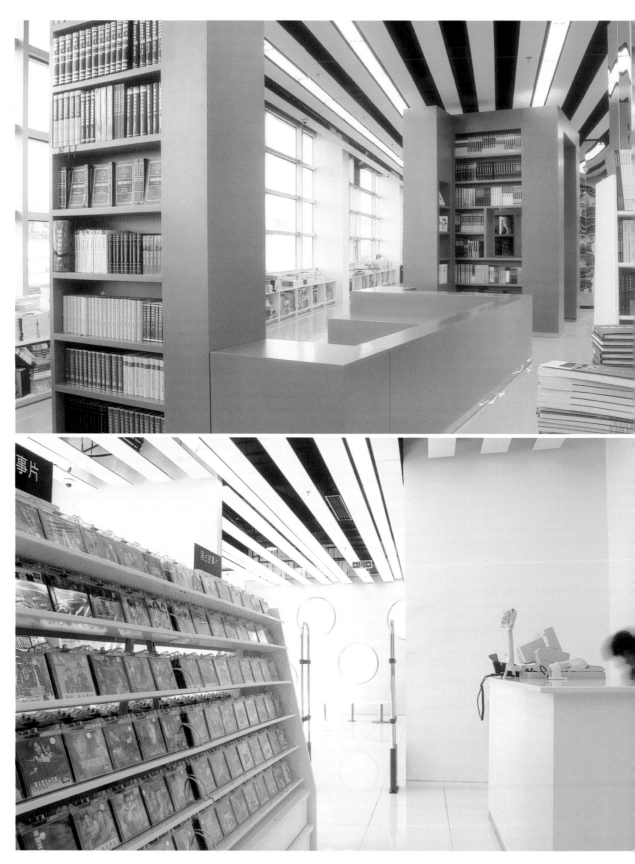

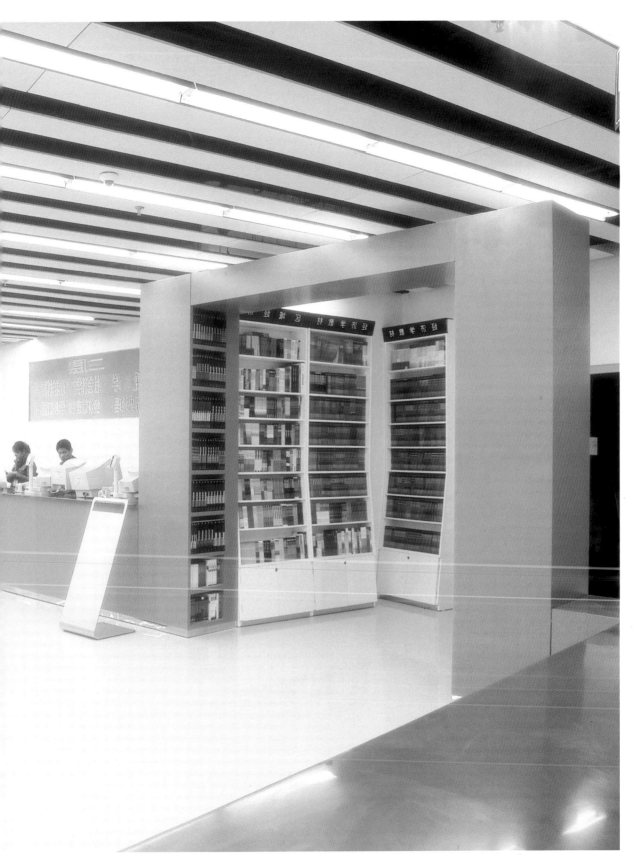

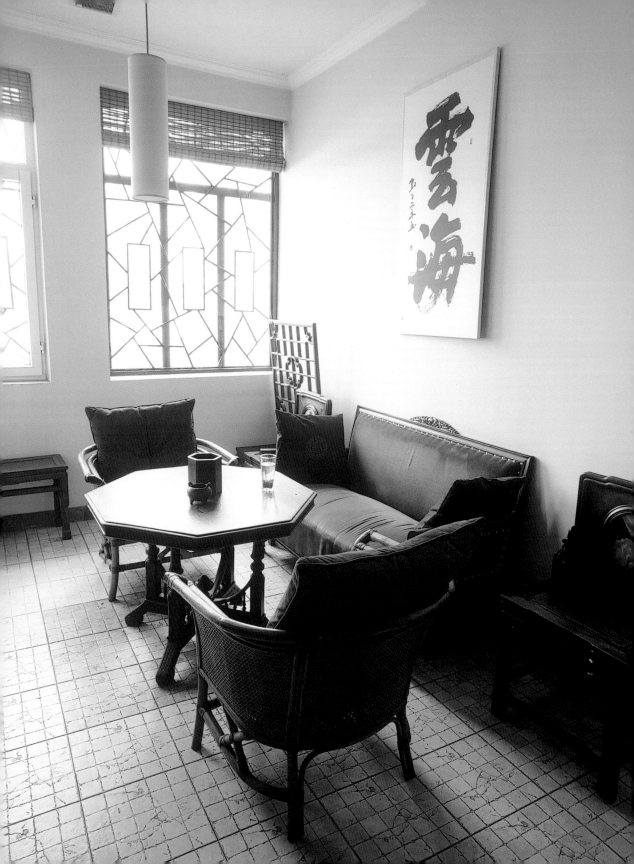

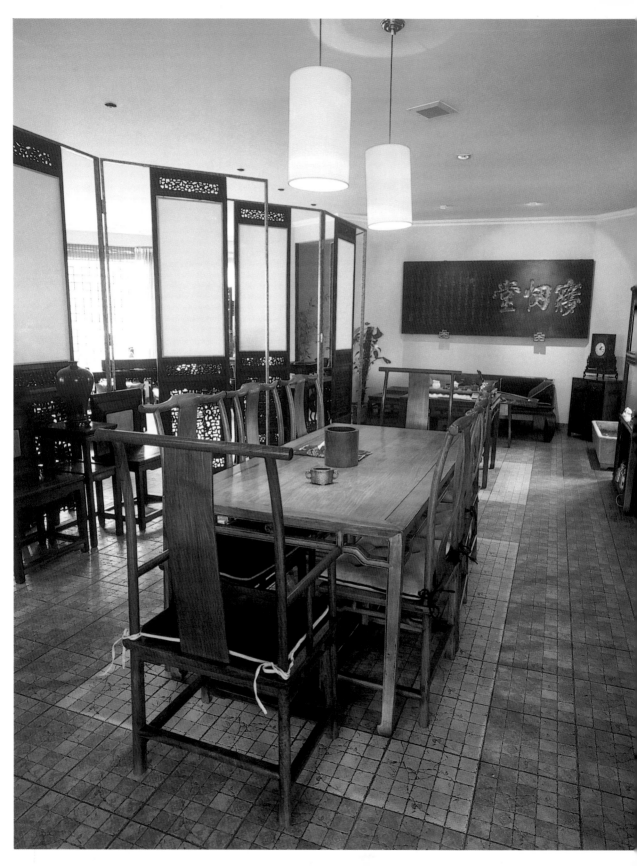

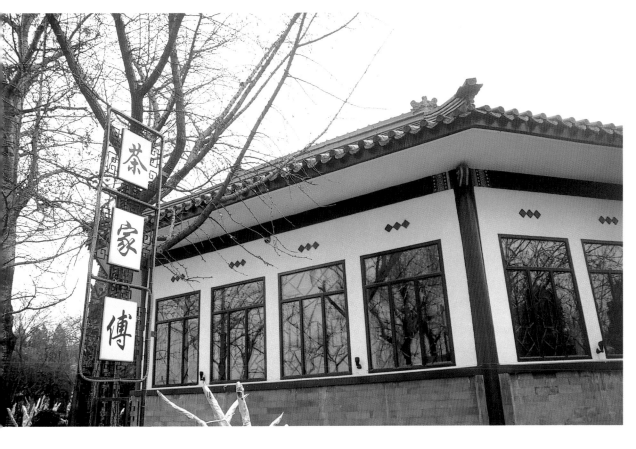

JIN R. + JIANG TAO / JIA XIN YI HE | BEIJING
GREEN T. HOUSE
Beijing | 2002

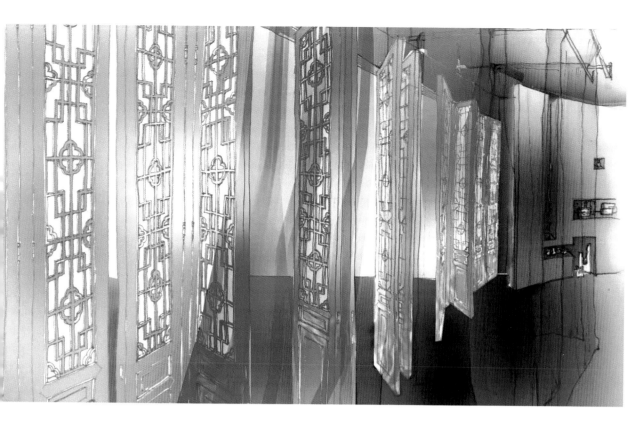

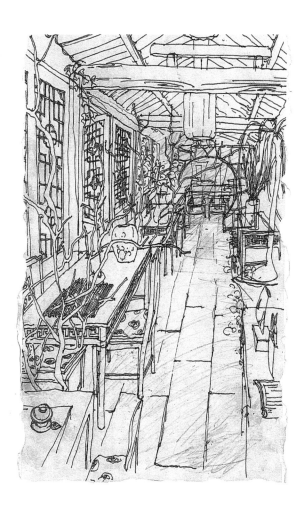

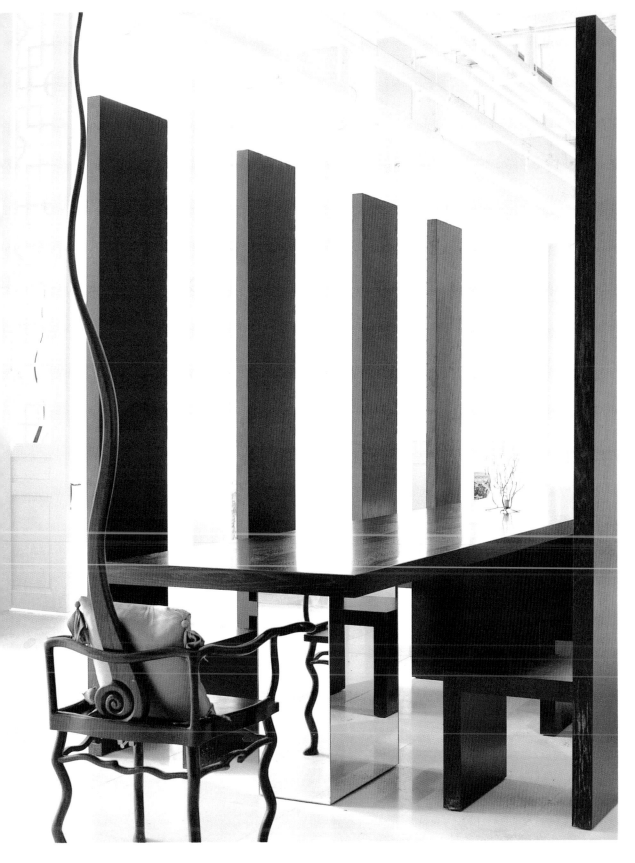

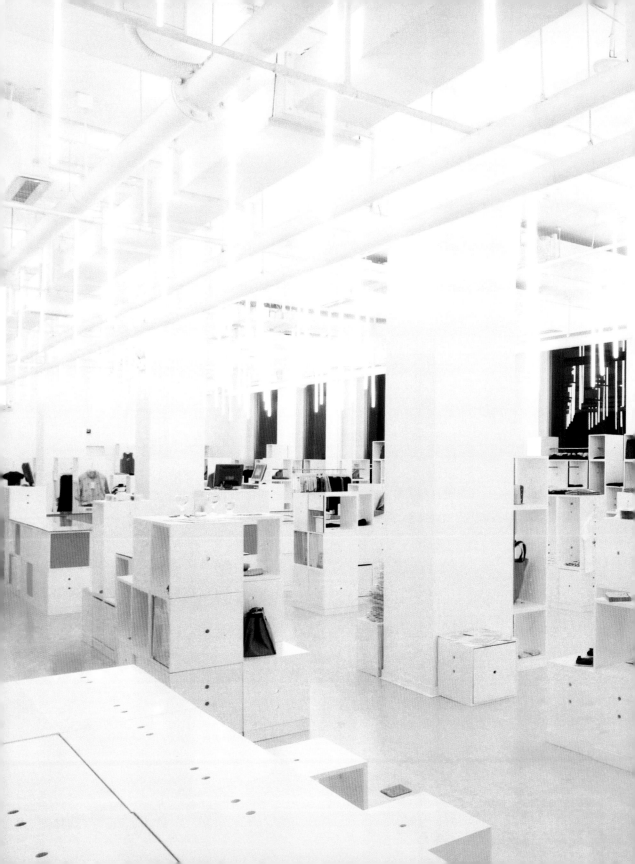

KEIICHIRO SAKO / SKSK ARCHITECTS | BEIJING
FELISSIMO
Beijing | 2004

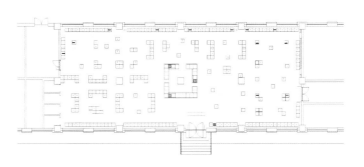

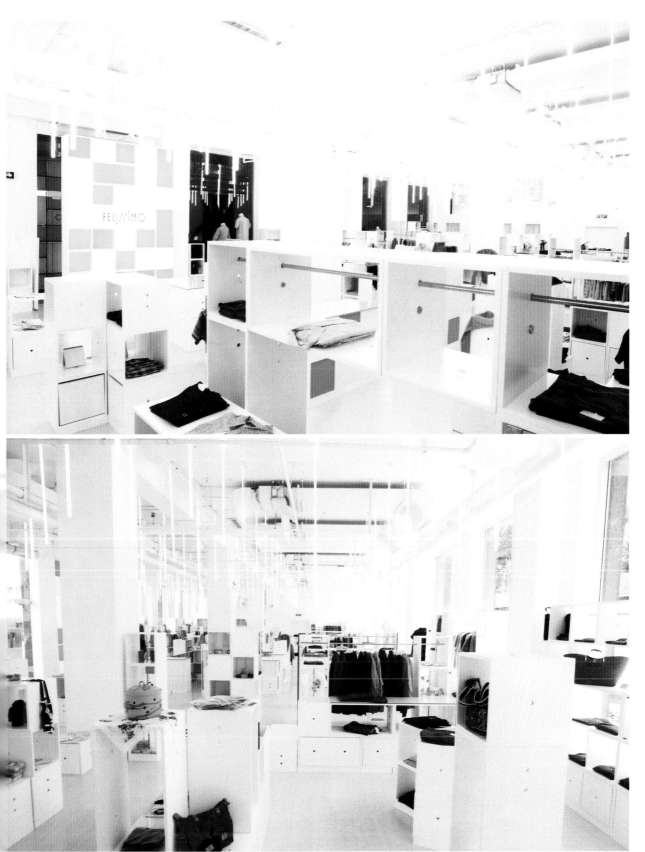

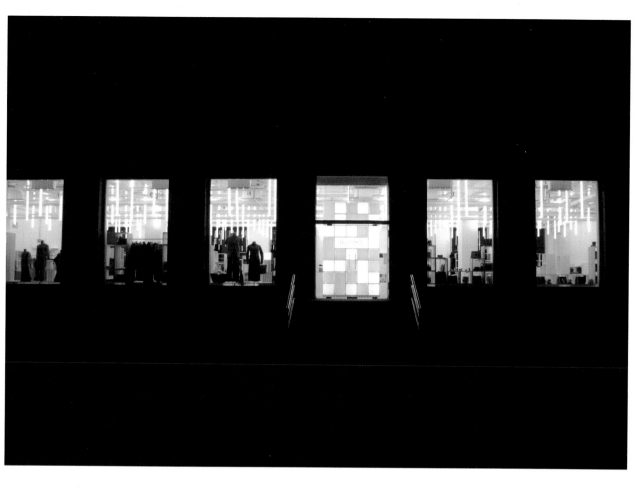

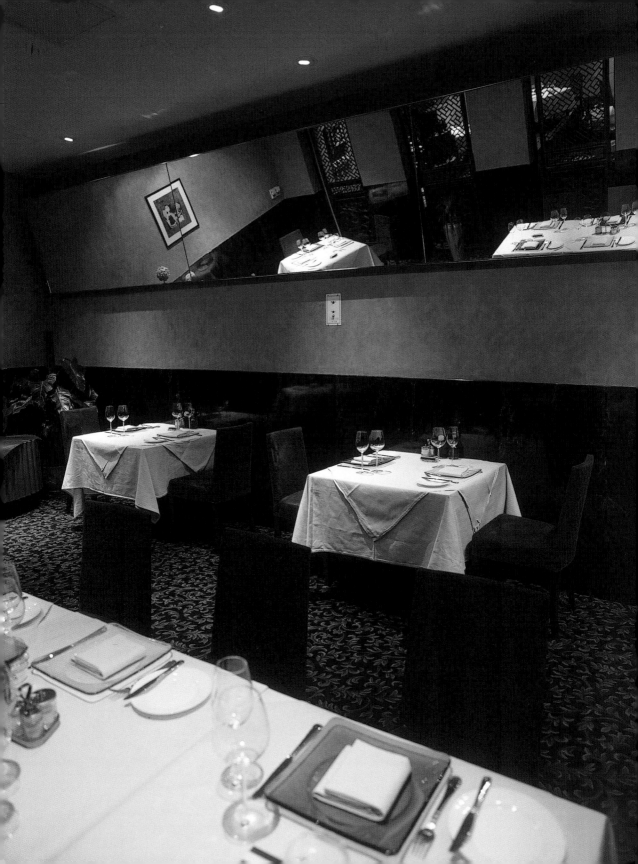

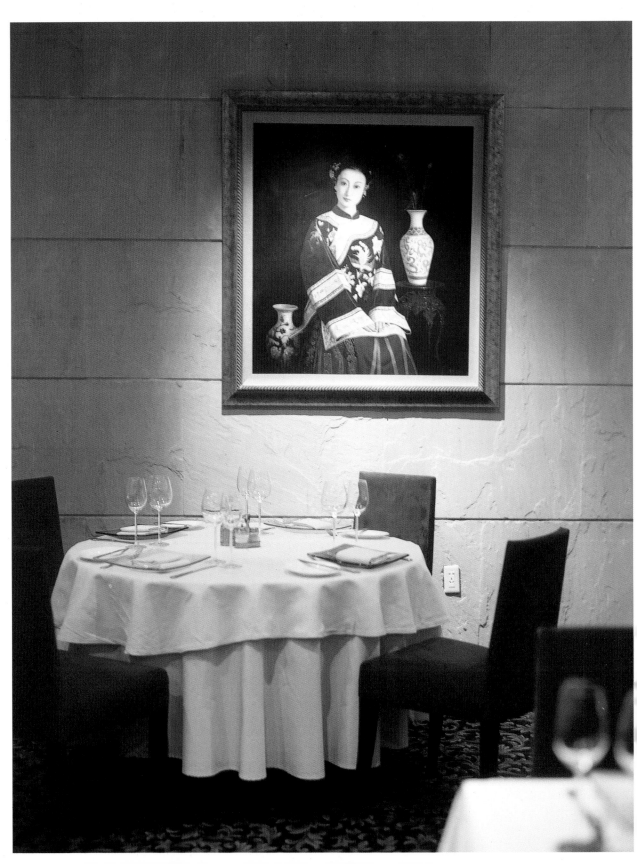

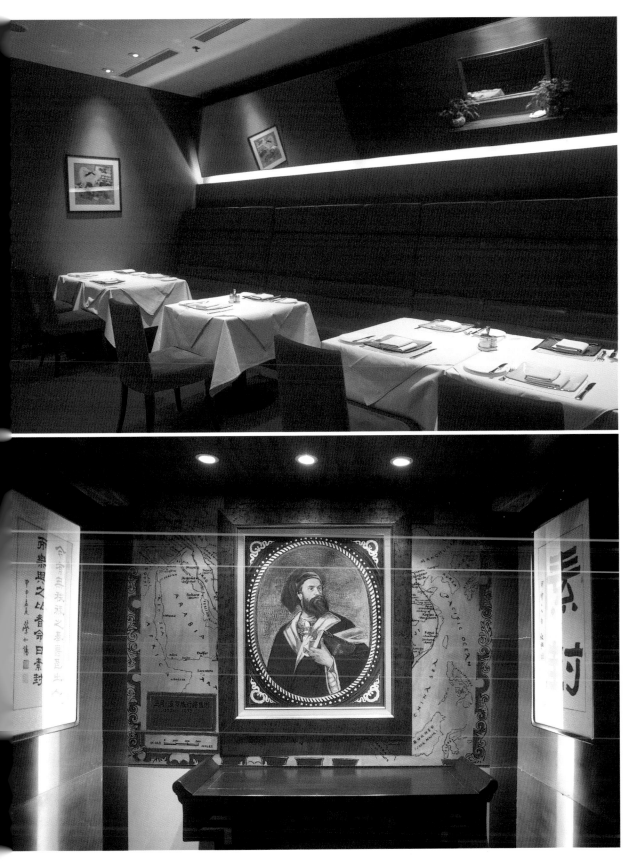

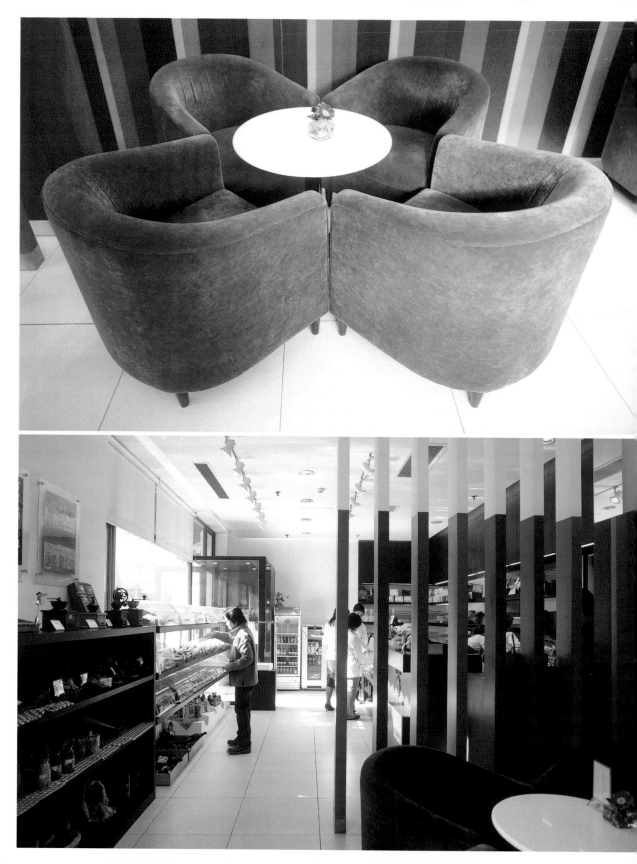

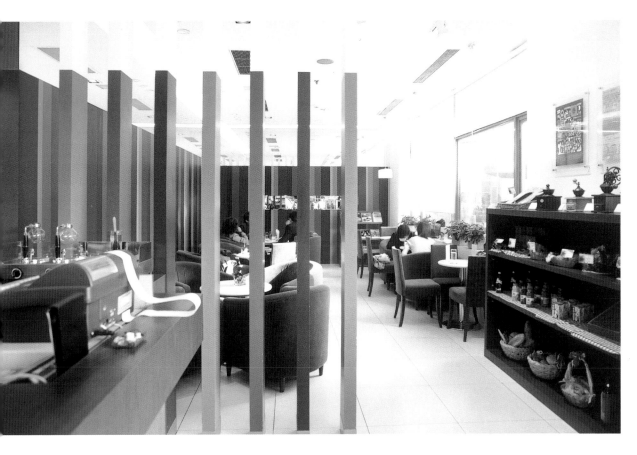

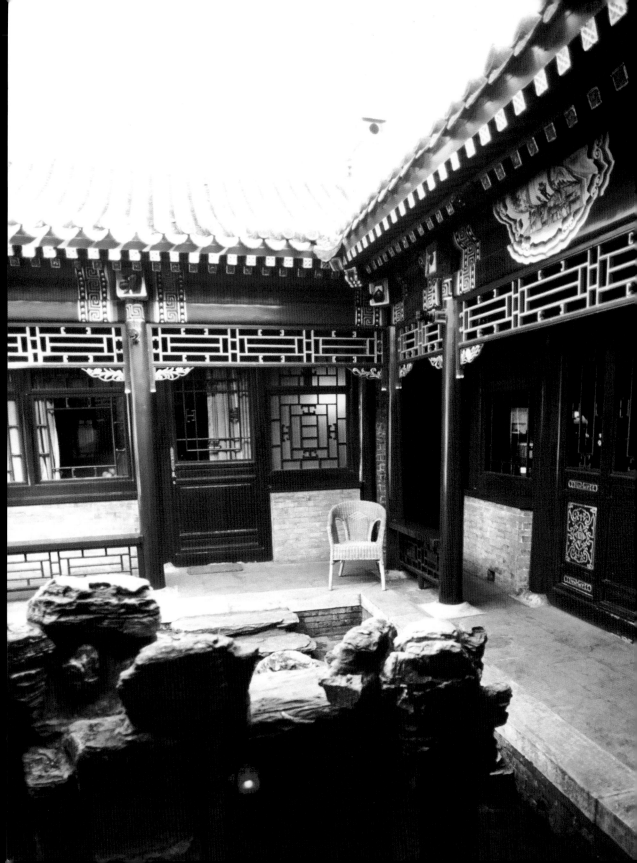

LAURENCE J. BRAHM / RED CAPITAL CLUB | BEIJING
RED CAPITAL CLUB, RED CAPITAL RESIDENCE
Beijing | 2001

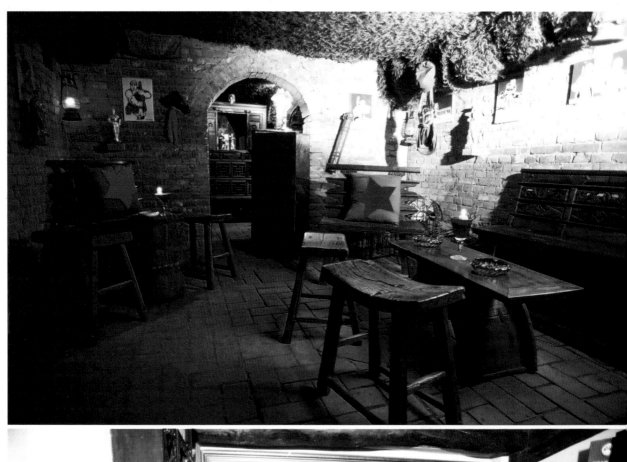
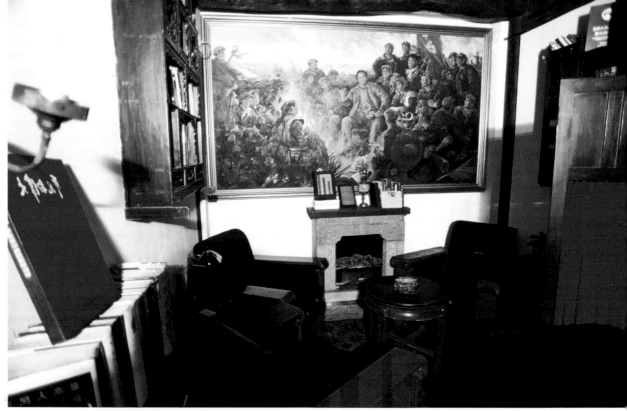

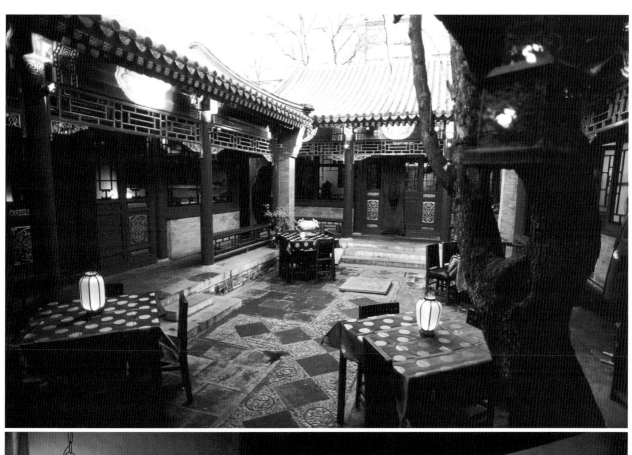
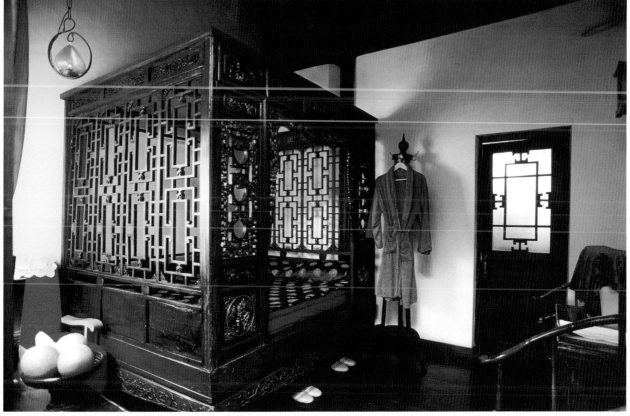

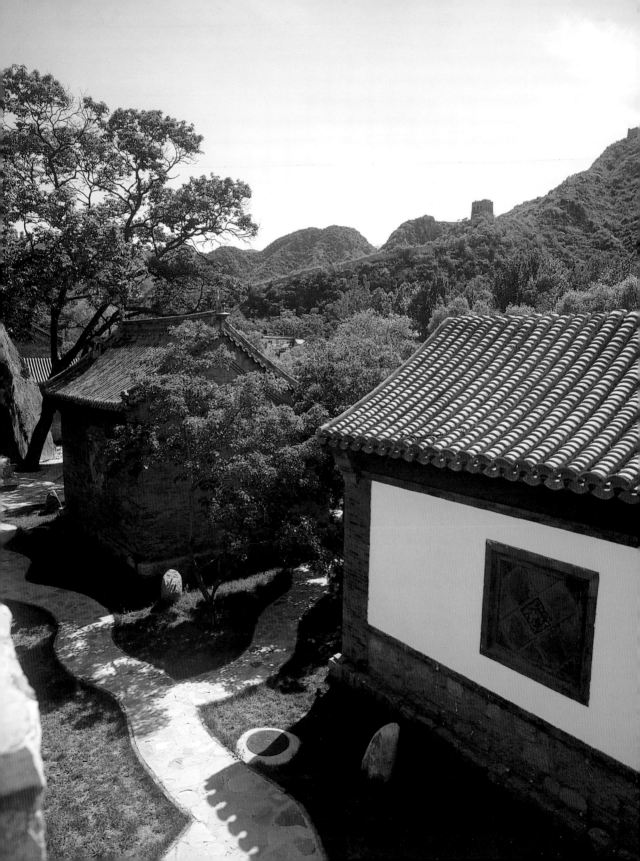

LAURENCE J. BRAHM / RED CAPITAL CLUB | BEIJING
RED CAPITAL RANCH
Beijing | 2003

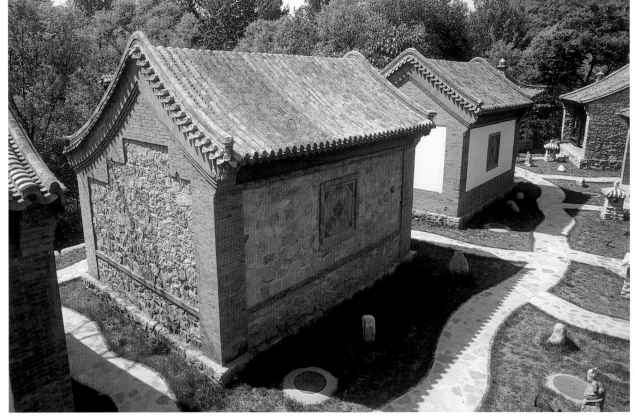

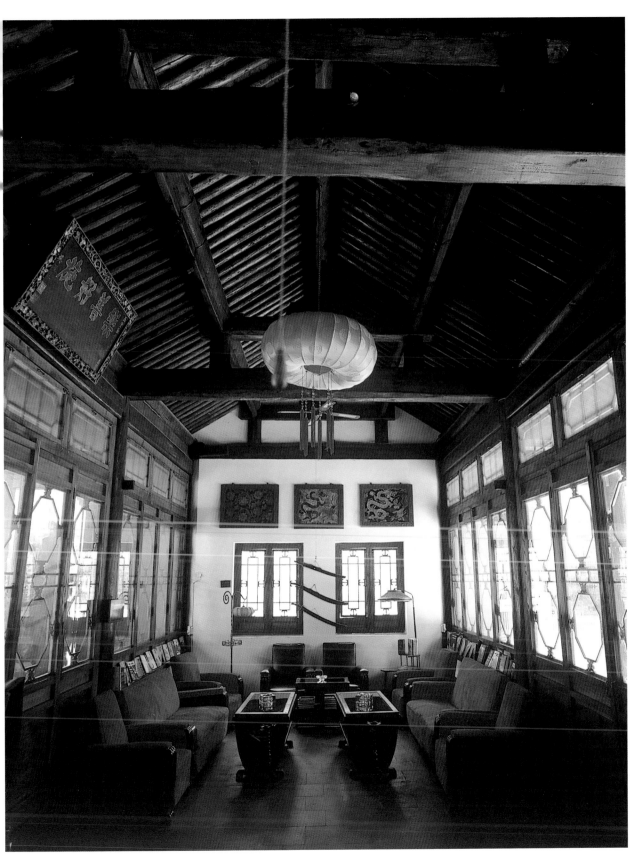

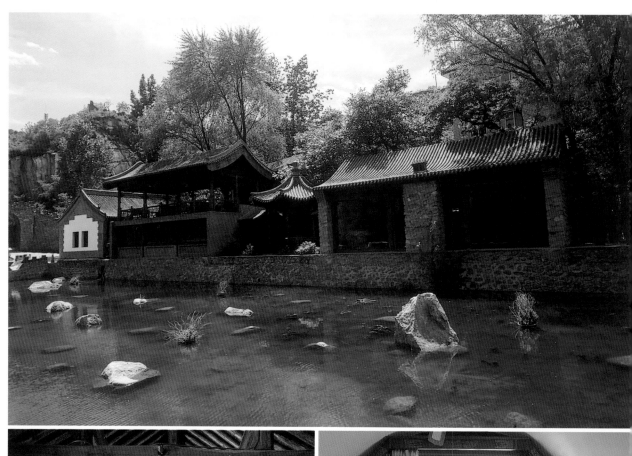

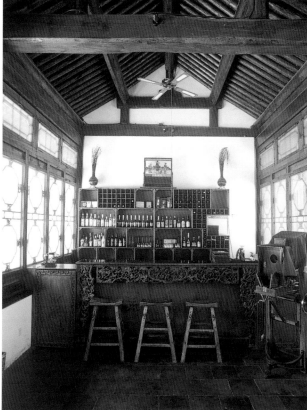

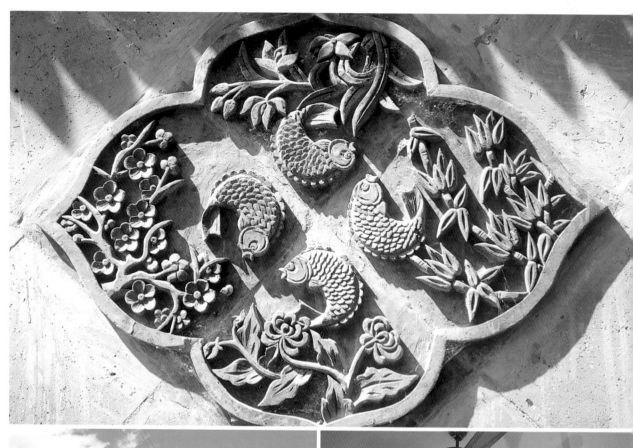

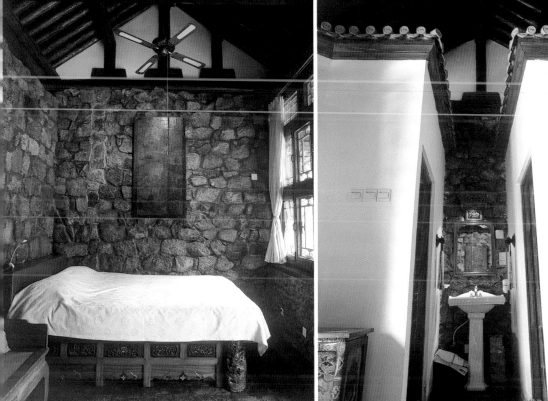

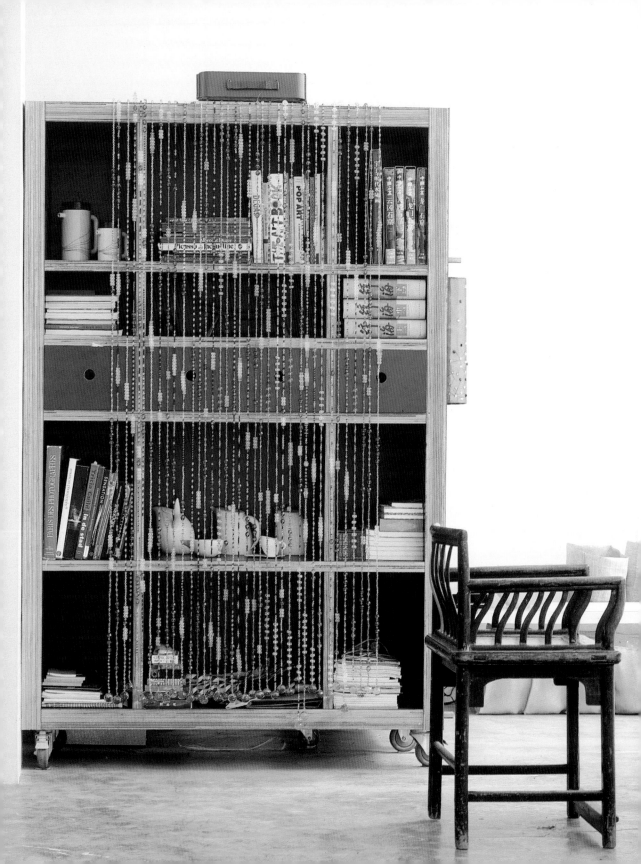

LIN JING / LINSTALLATION WORSHOP | BEIJING
LIN JING'S LOFT
Beijing | 2000

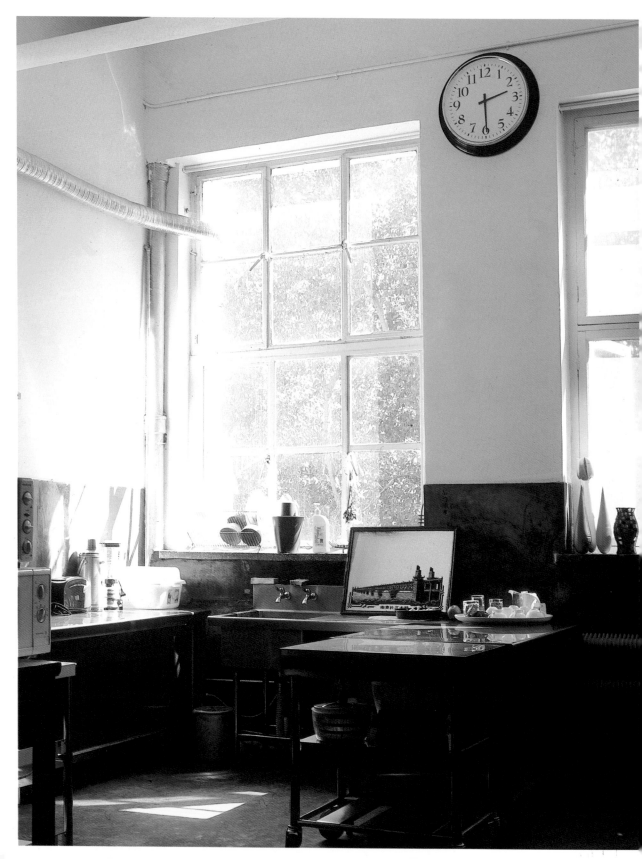

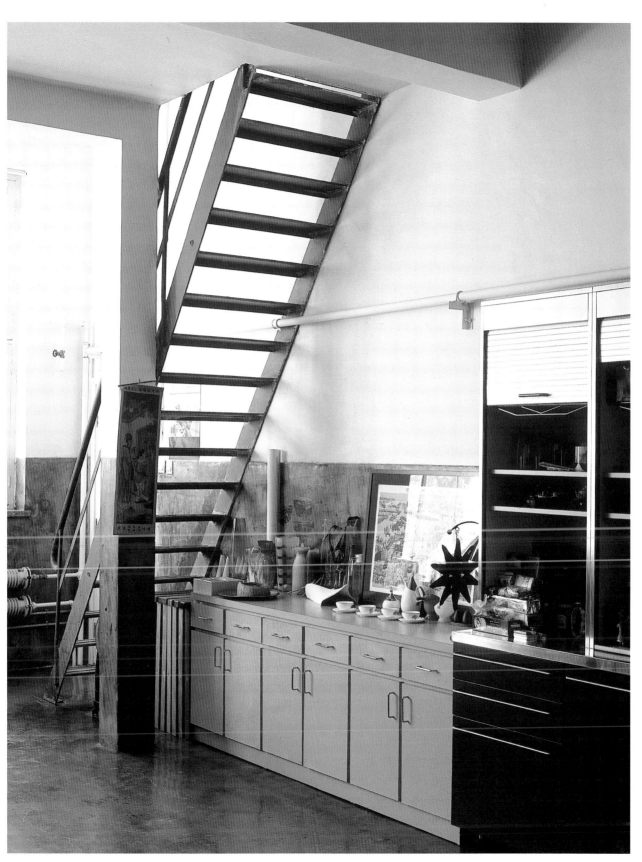

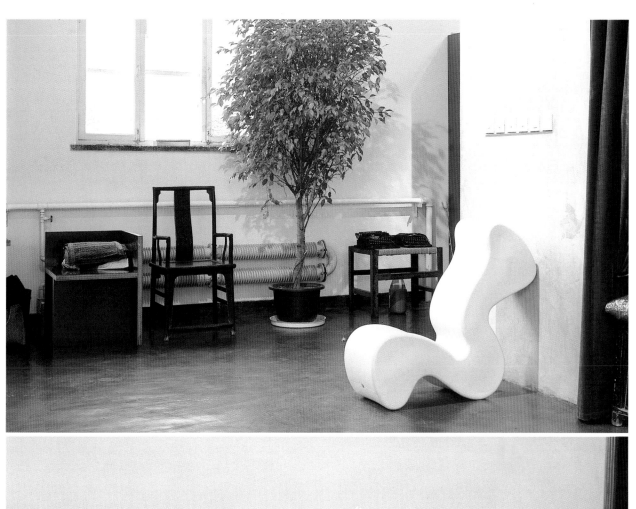
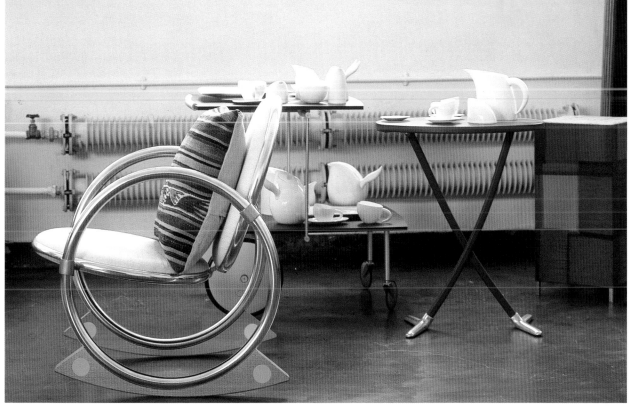

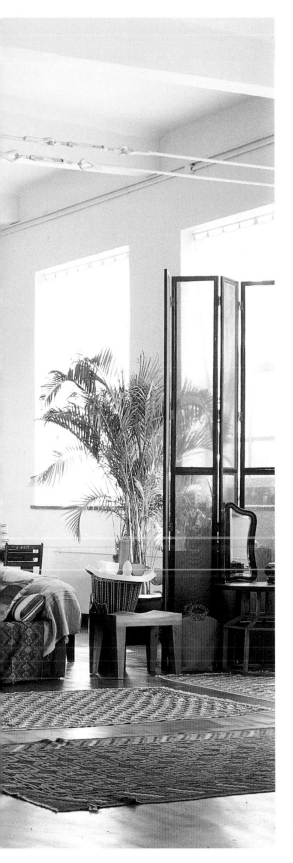

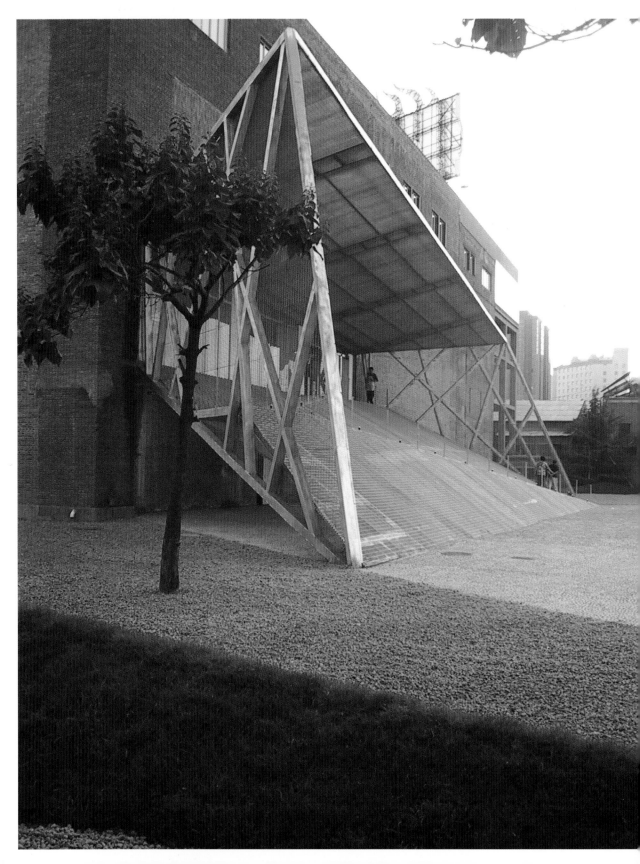

MIMA DESIGN WORKSHOP | **BEIJING**
APPLE SALE CENTER
Beijing | 2003

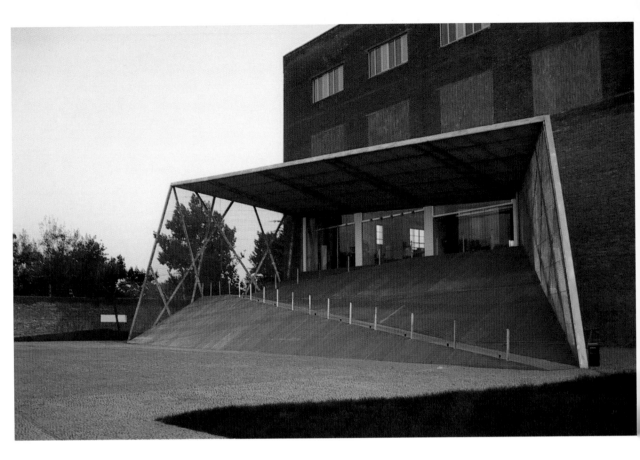

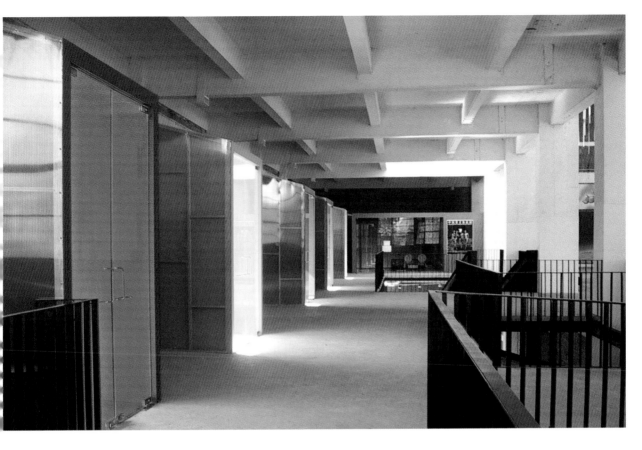

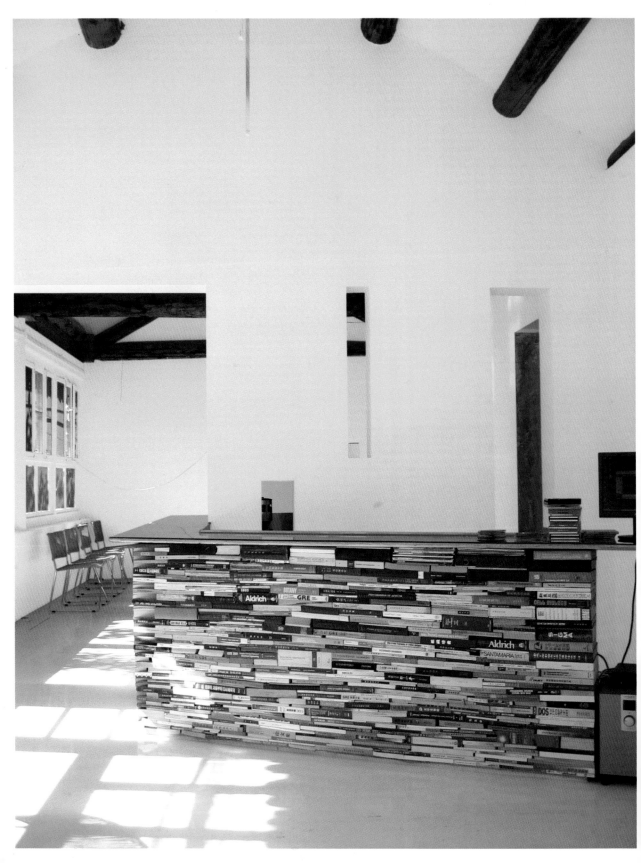

MIMA DESIGN WORKSHOP | BEIJING
MIMA CAFÉ
Beijing | 2003

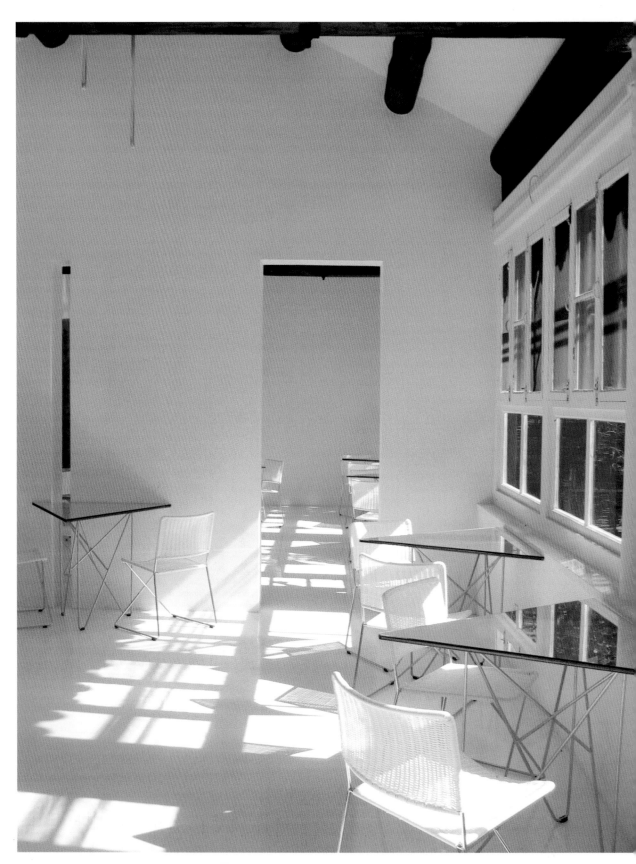

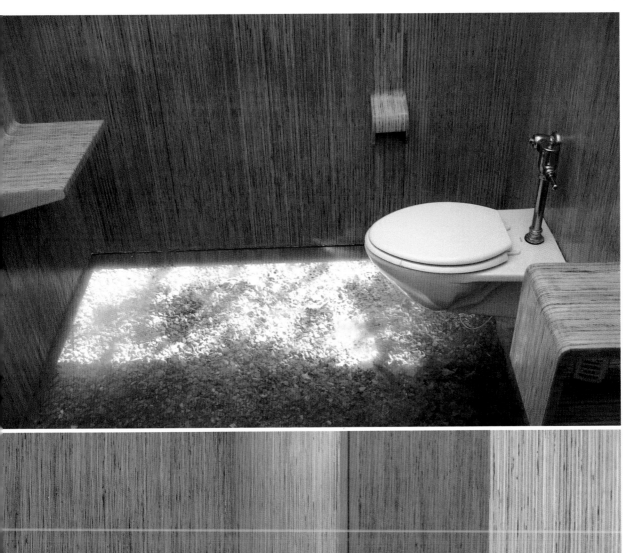

PETER DAVIDSON AND LAB ARCHITECTURE STUDIO FOR SOHO CHINA | BEIJING
SOHO SHANG DU
Beijing | 2007

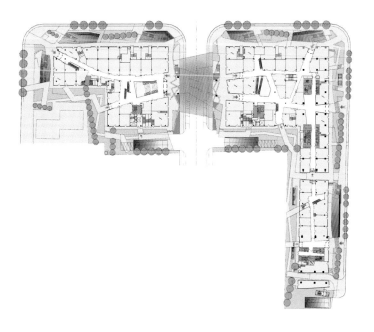

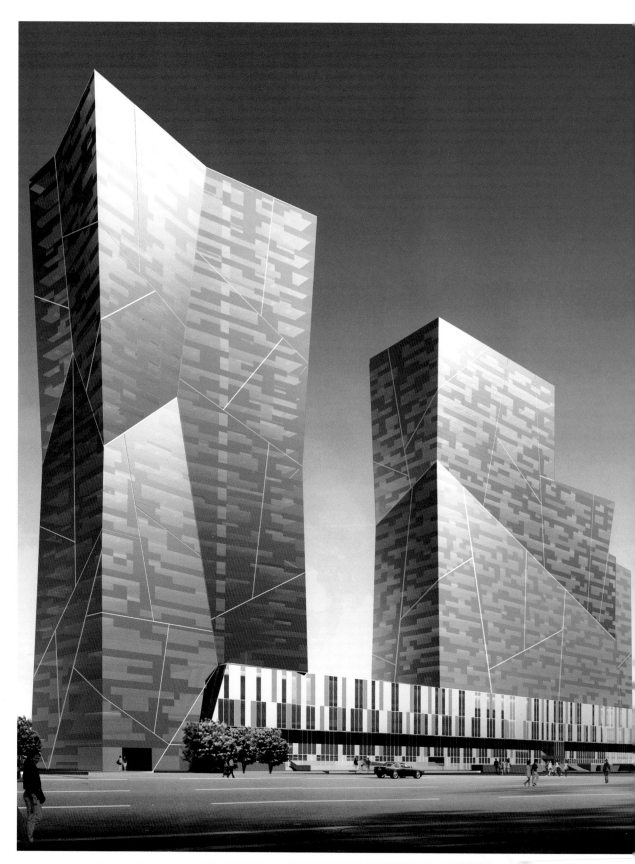

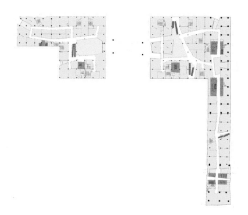

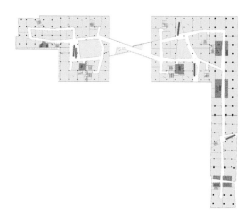

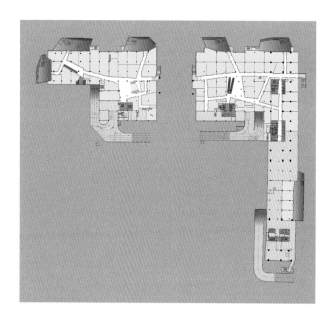

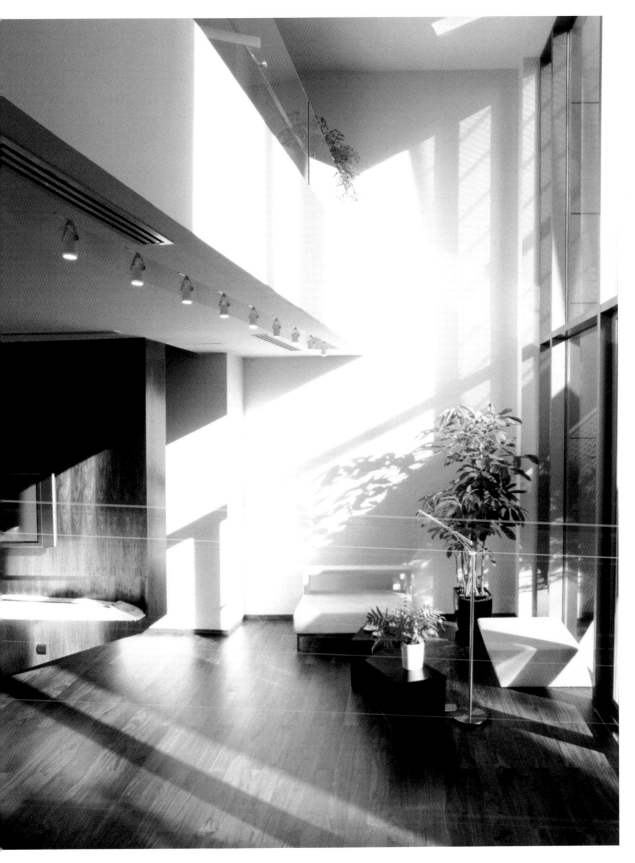

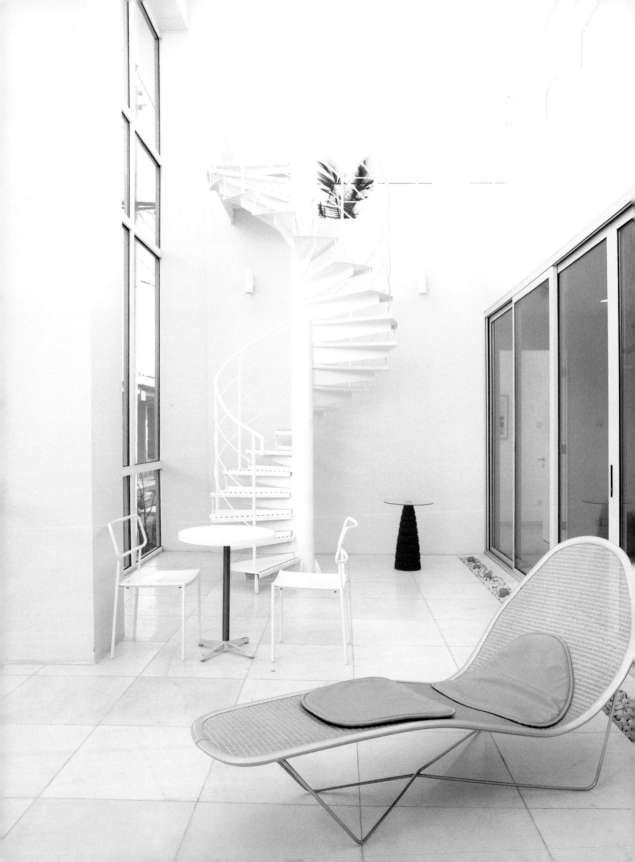

RIKEN YAMAMOTO, FIELD SHOP AND MIKAN FOR SOHO CHINA | BEIJING
JIANWAI SOHO
Beijing | 2006

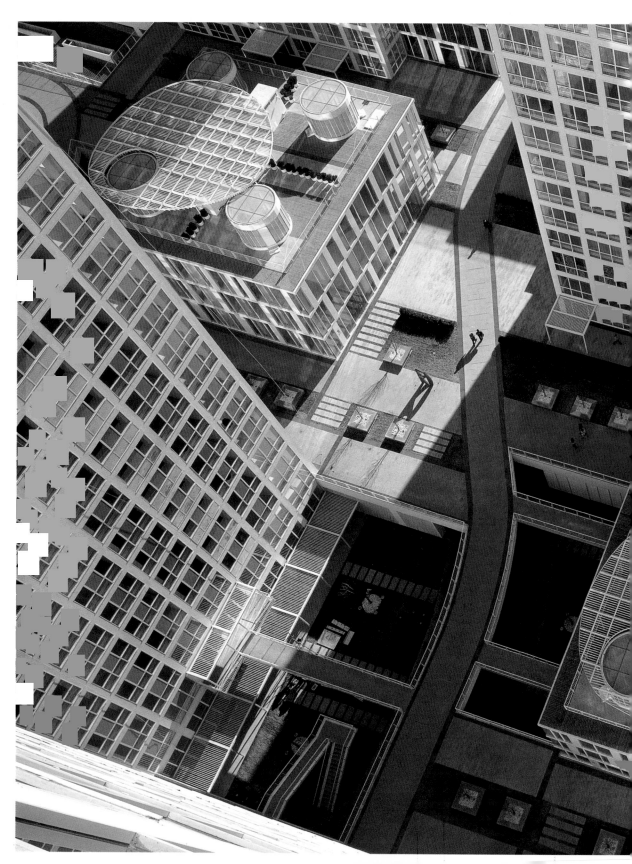

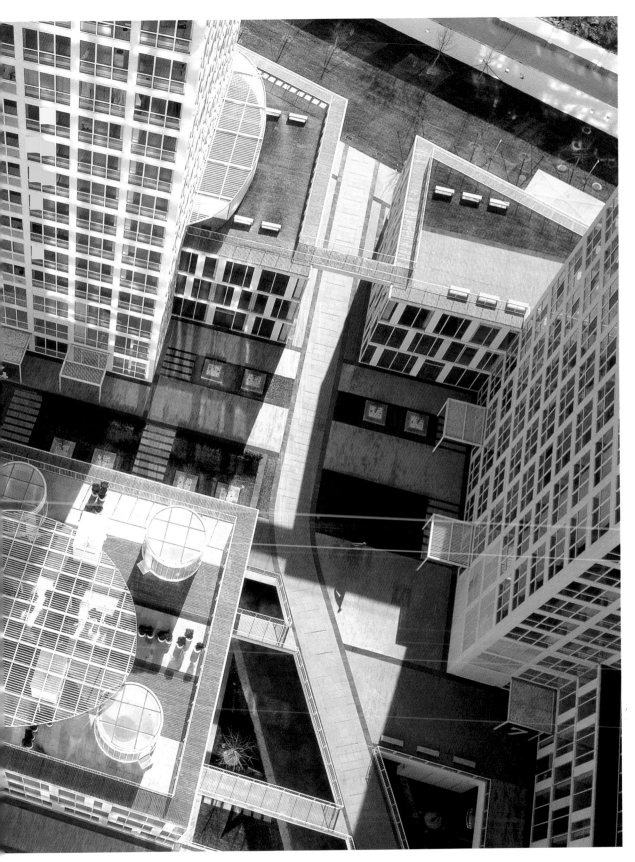

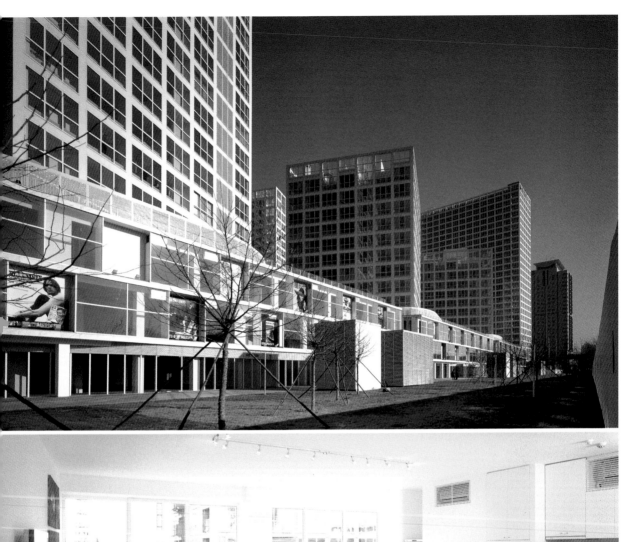

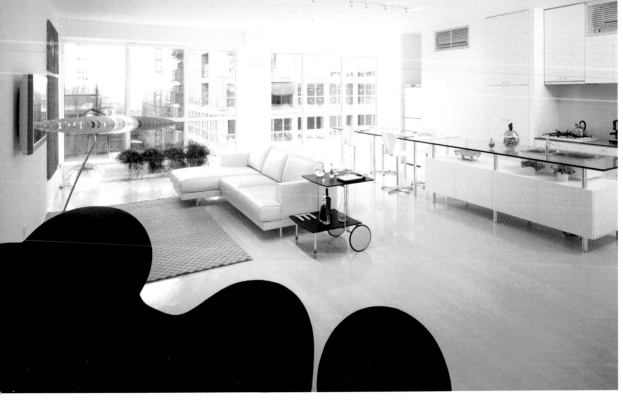

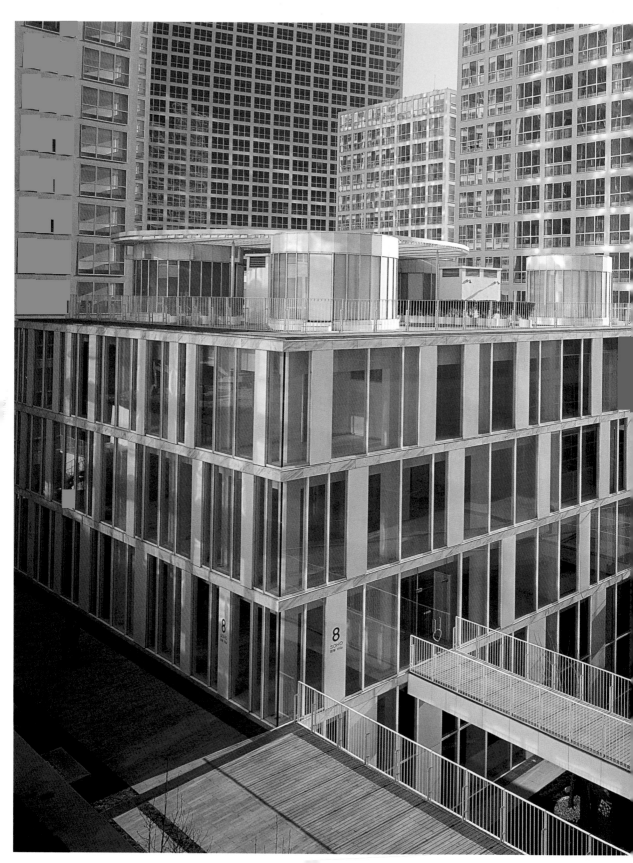

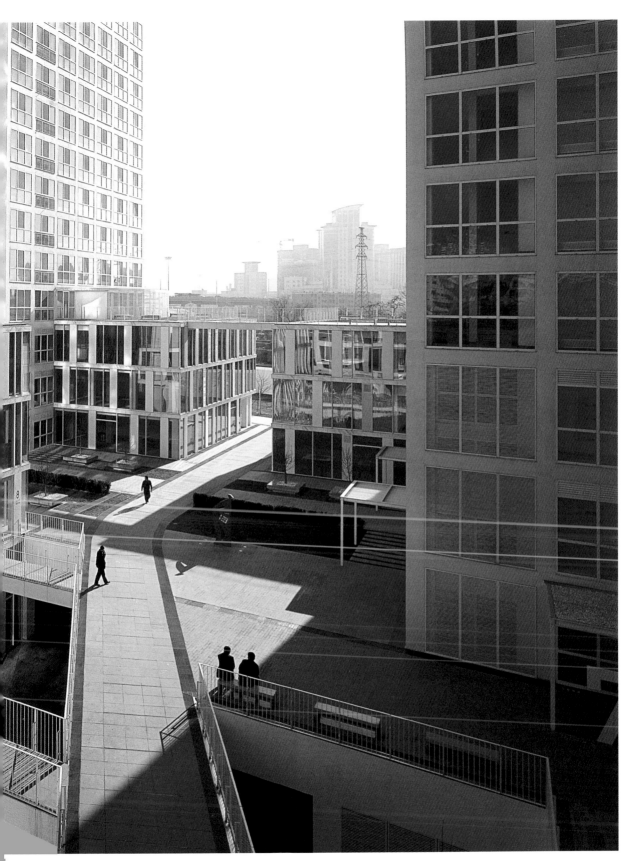

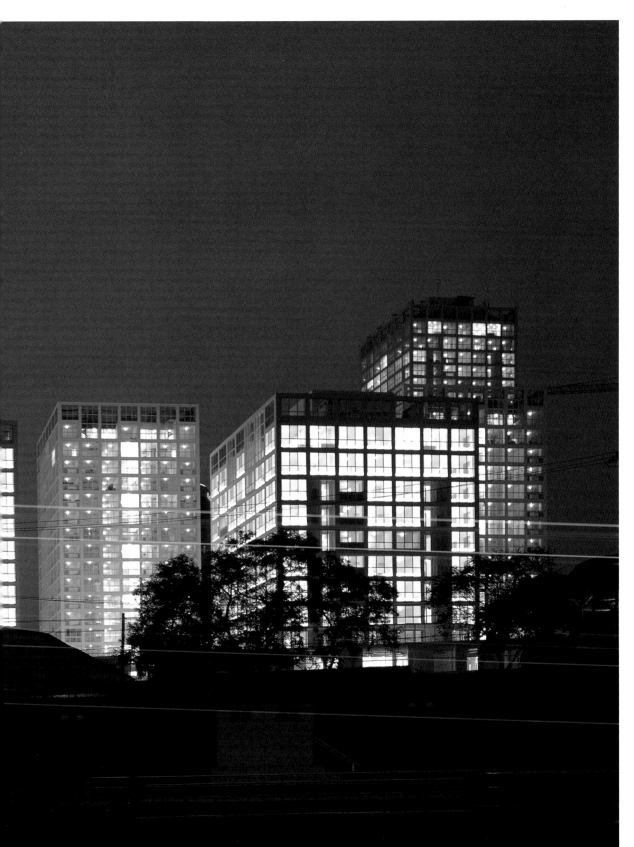

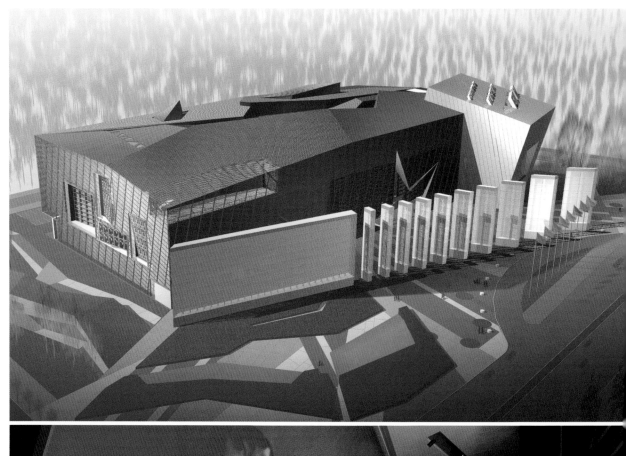

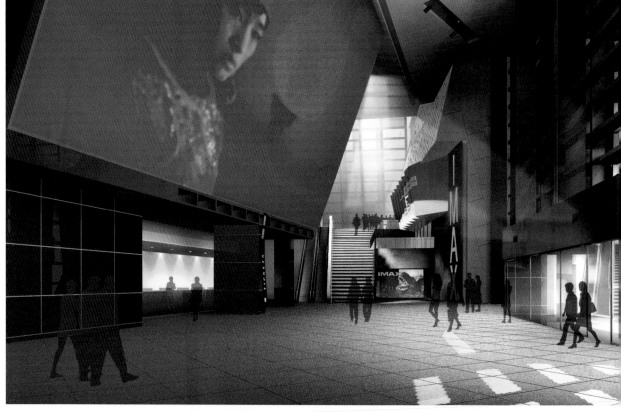

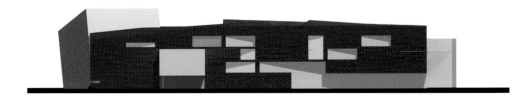

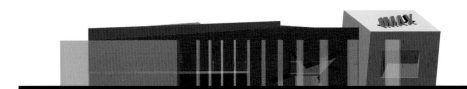

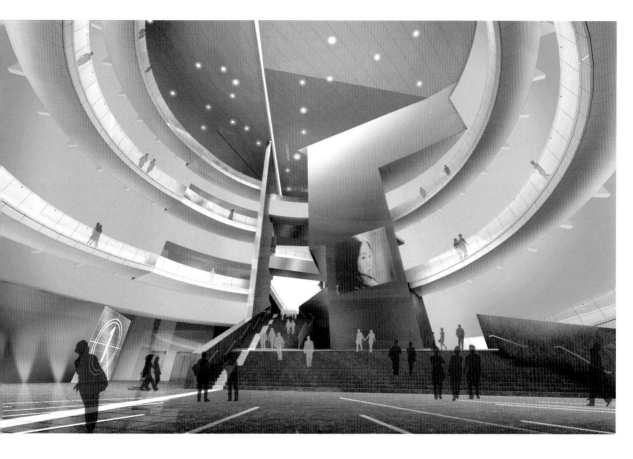

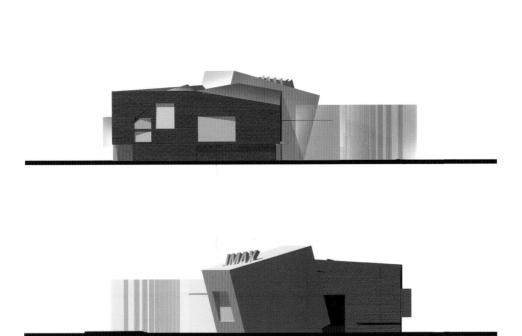

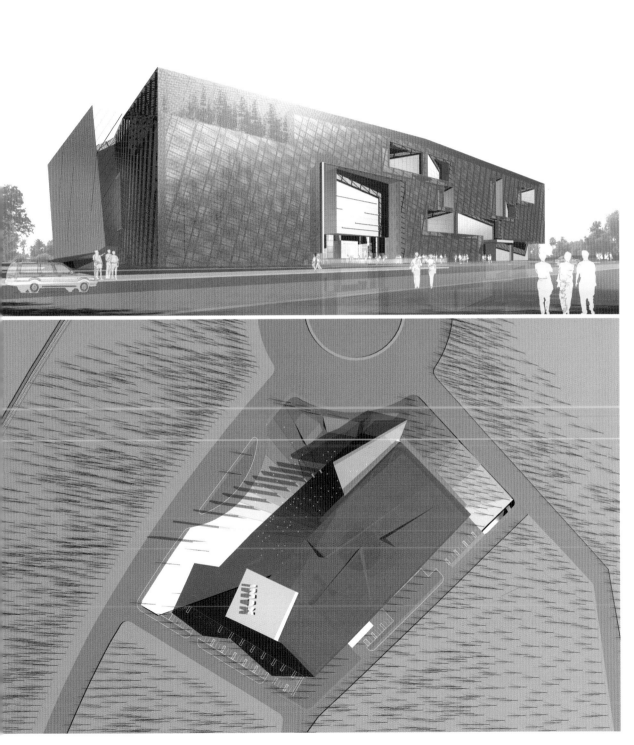

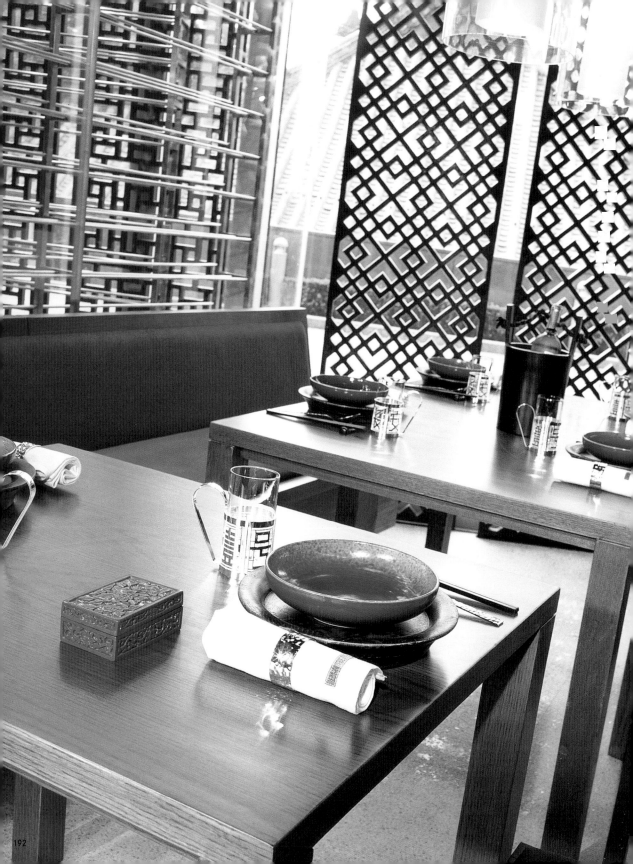

TAKASHI SUGIMOTO / SUPER POTATO | TOKYO
MADE IN CHINA RESTAURANT IN THE GRAND HYATT BEIJING
Beijing | 2003

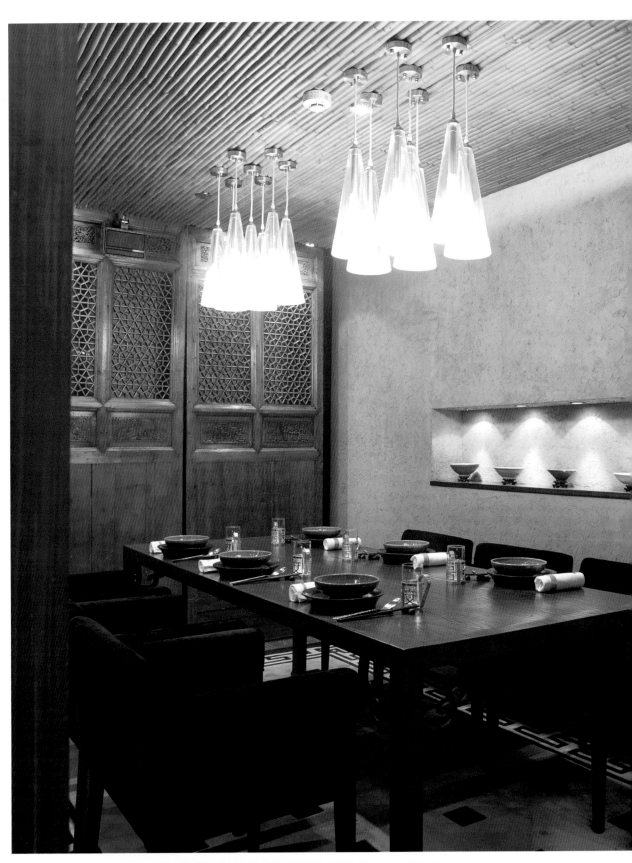

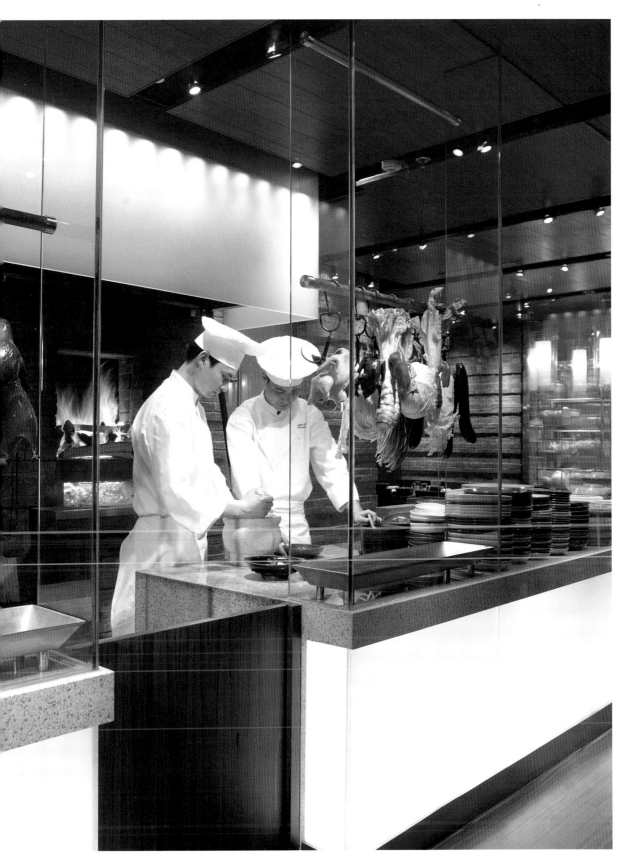

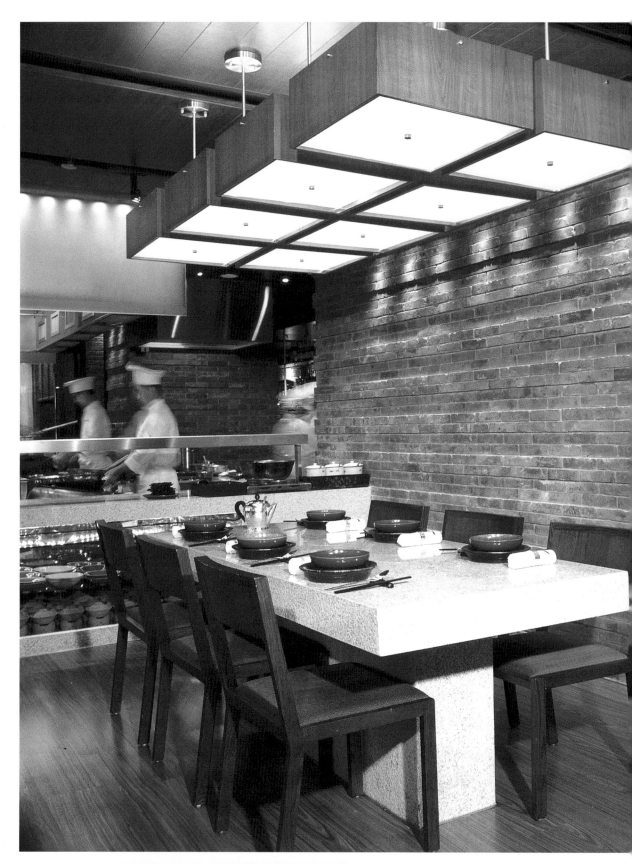

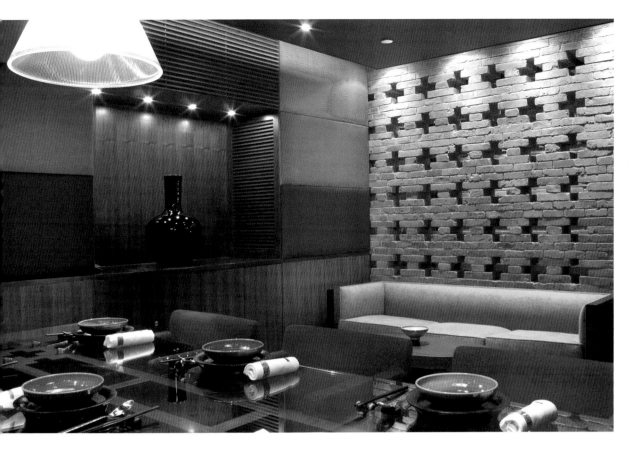

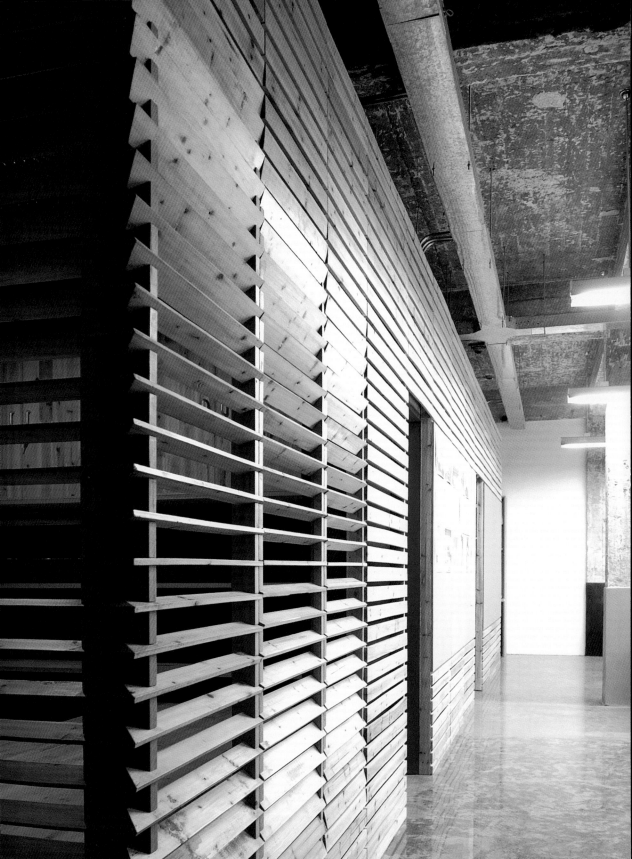

DATRANS | SHANGHAI
DATRANS STUDIO
Shanghai | 2004

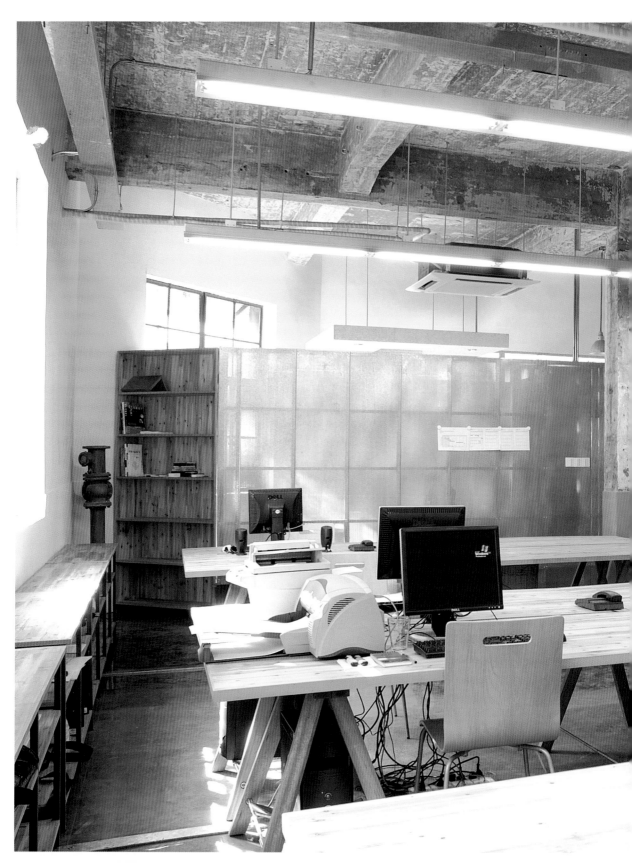

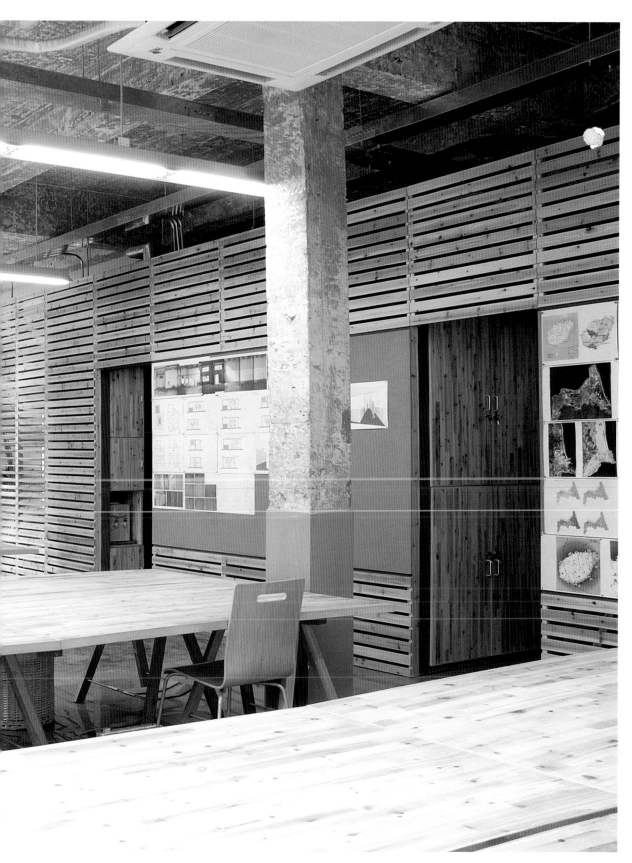

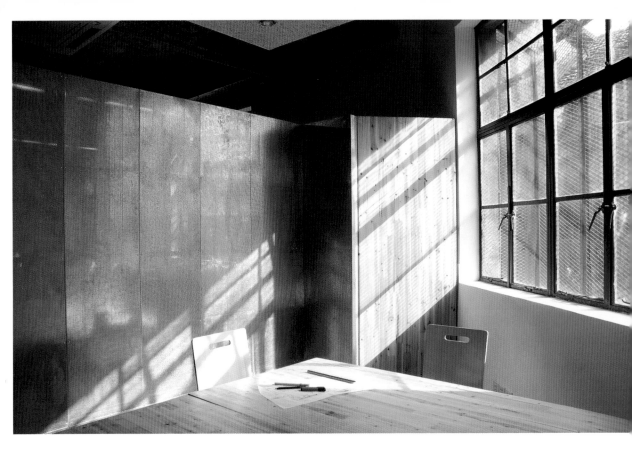

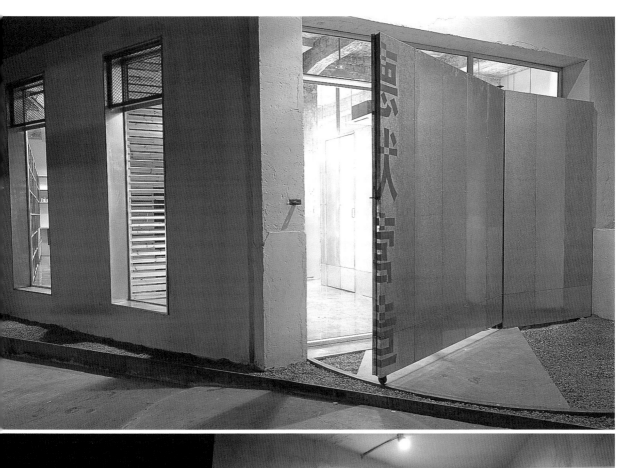
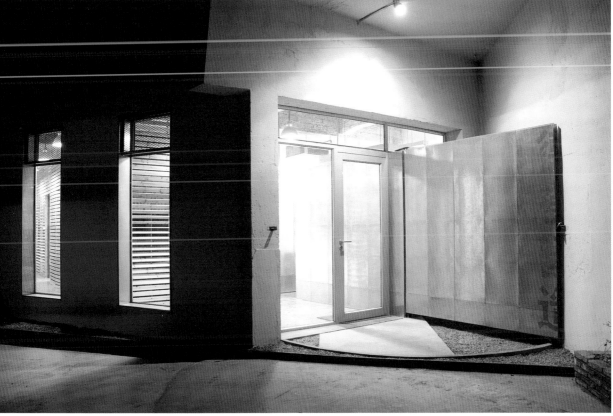

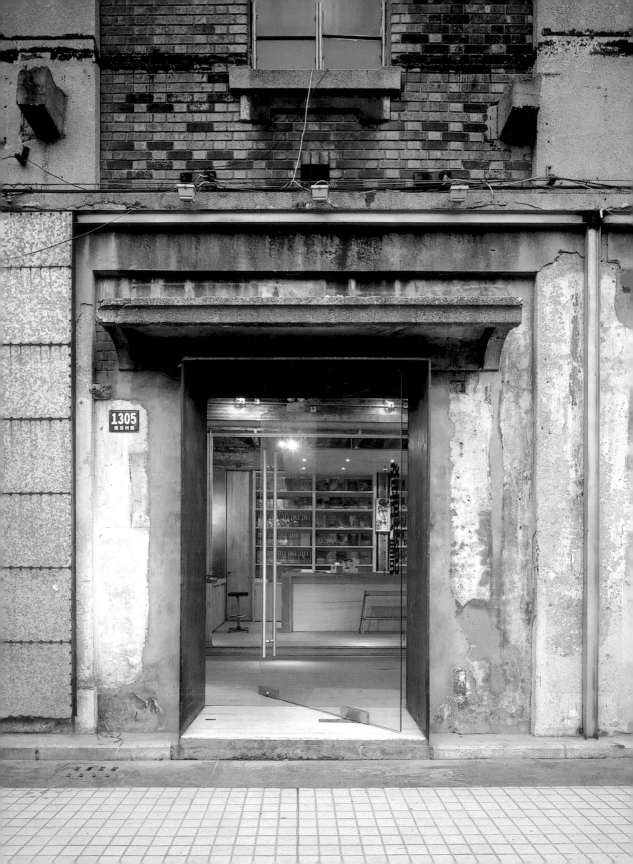

MA WEIDONG AND TENG KUNYEN FOR CA GROUP | SHANGHAI
CA GROUP WAREHOUSE ON SUZHOU RIVERBANK
Shanghai | 2003

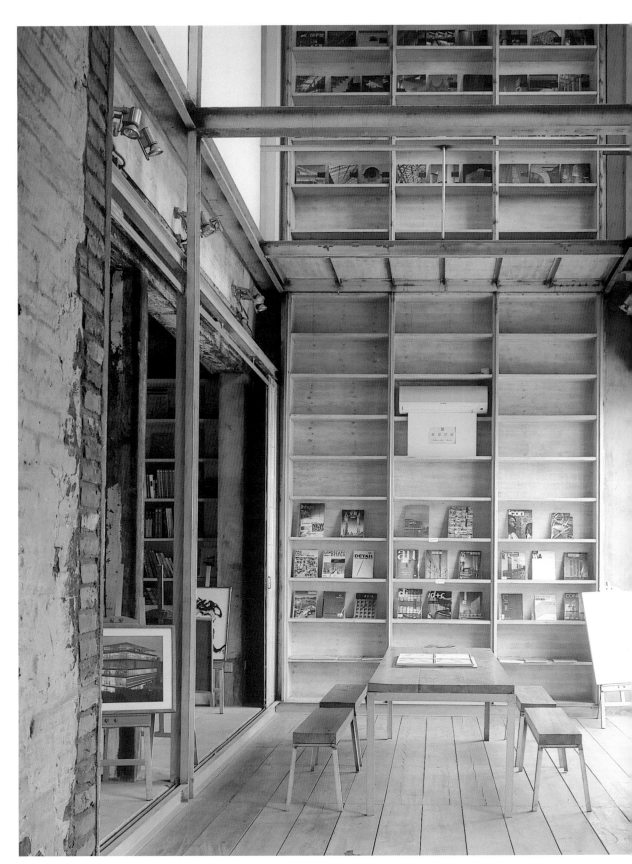

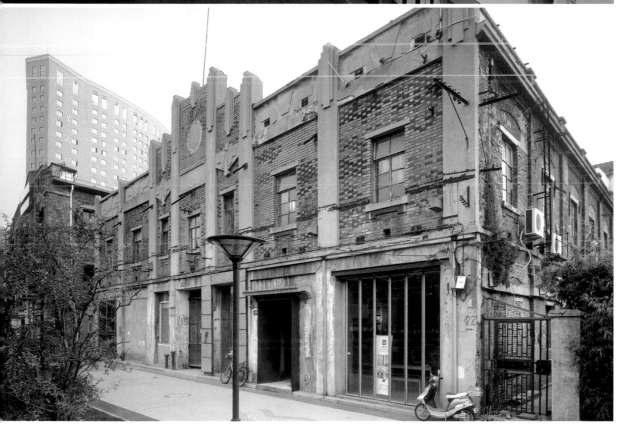

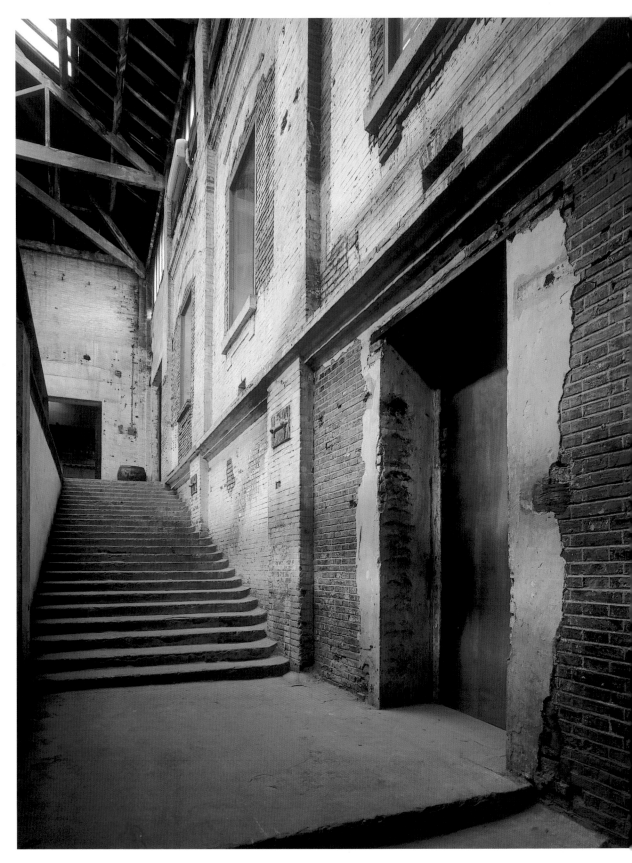

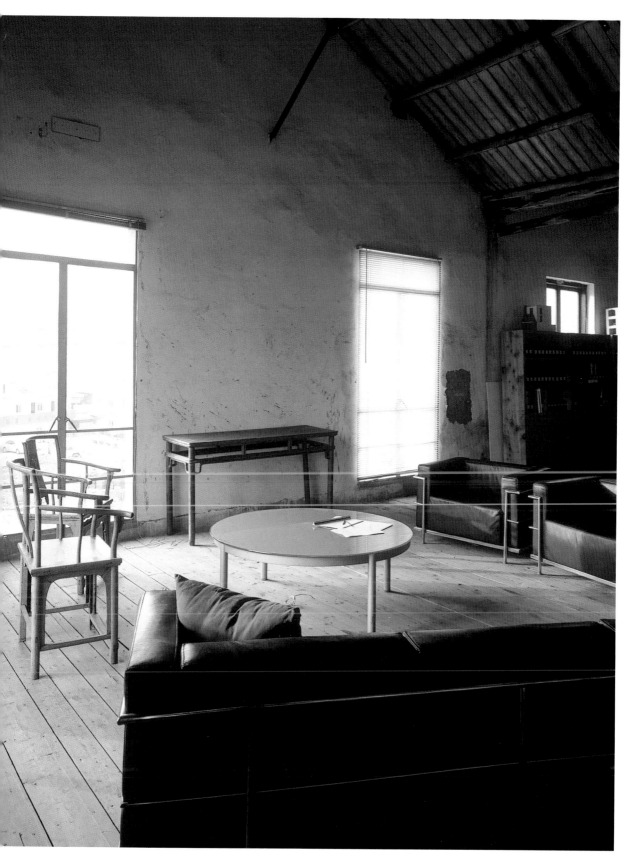

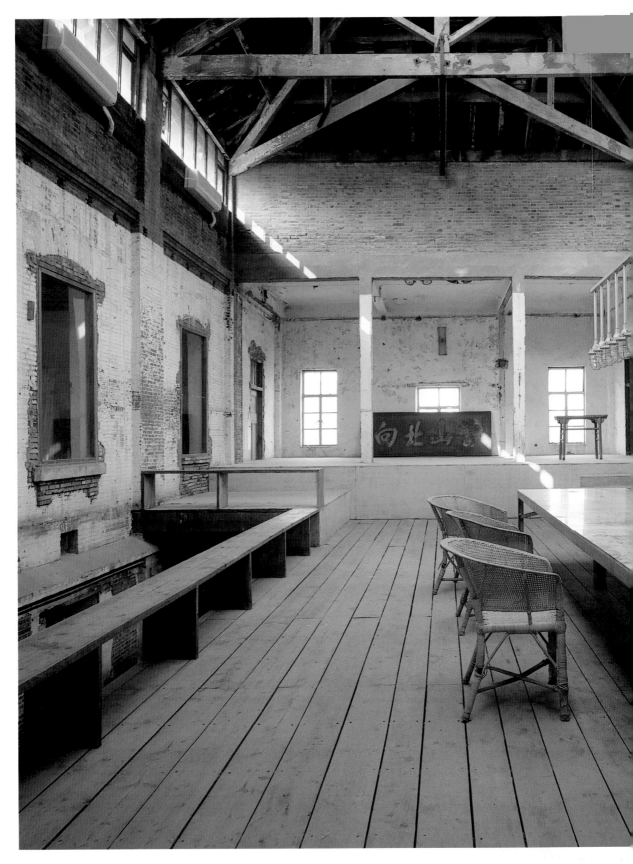

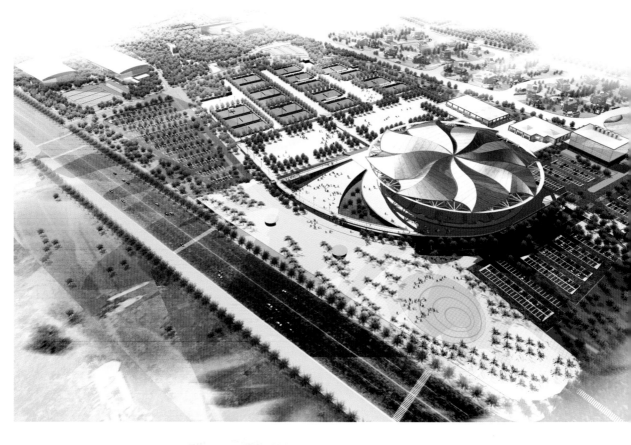

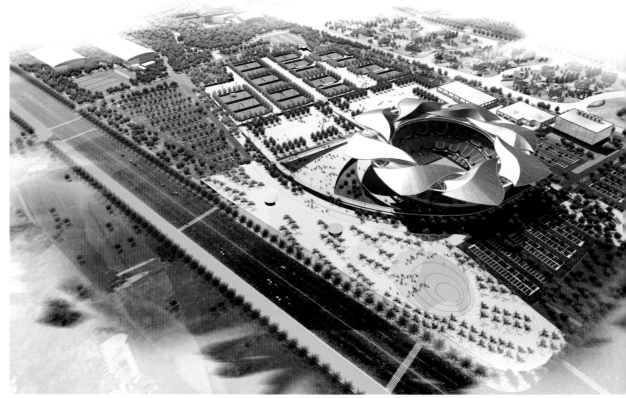

MITSURU SENDA∕ENVIRONMENT DESIGN INSTITUTE | JAPAN
SHANGHAI QI ZHONG FOREST SPORTS CITY TENNIS CENTER
Shanghai | 2005

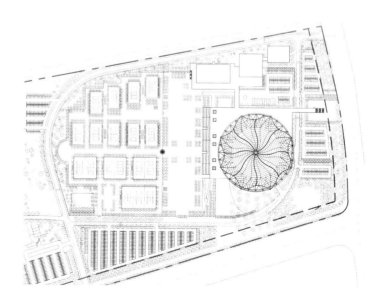

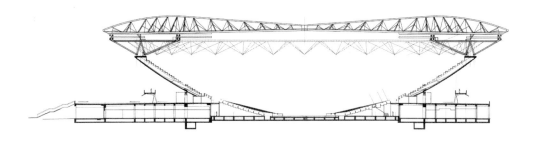

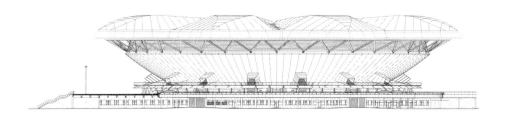

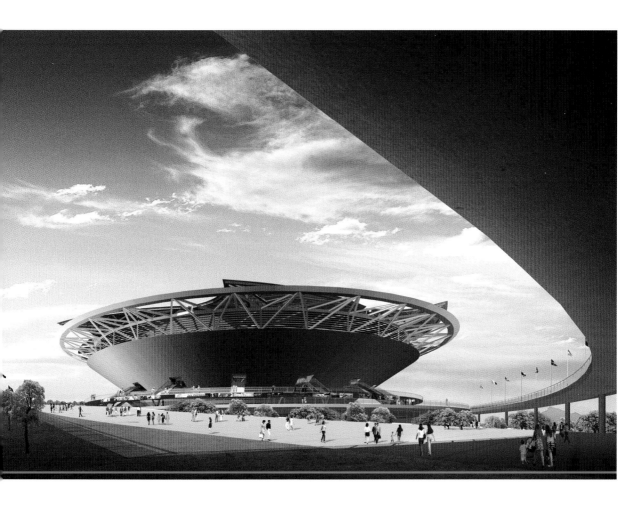

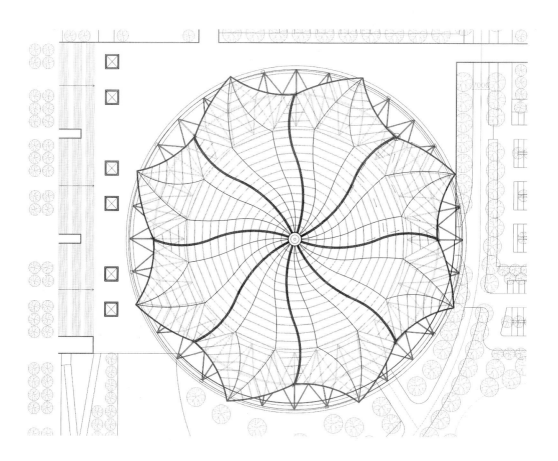

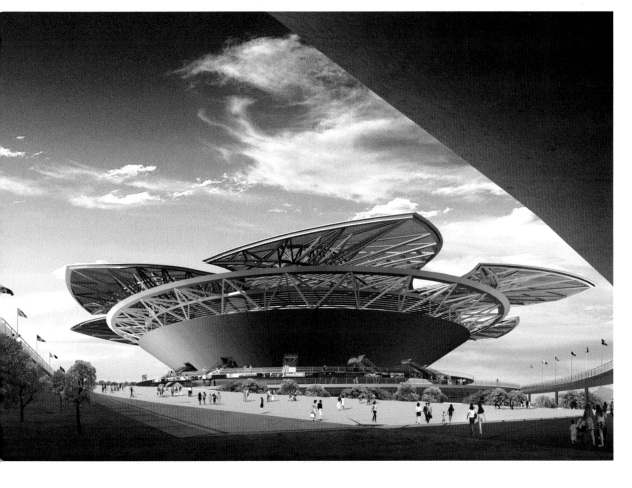

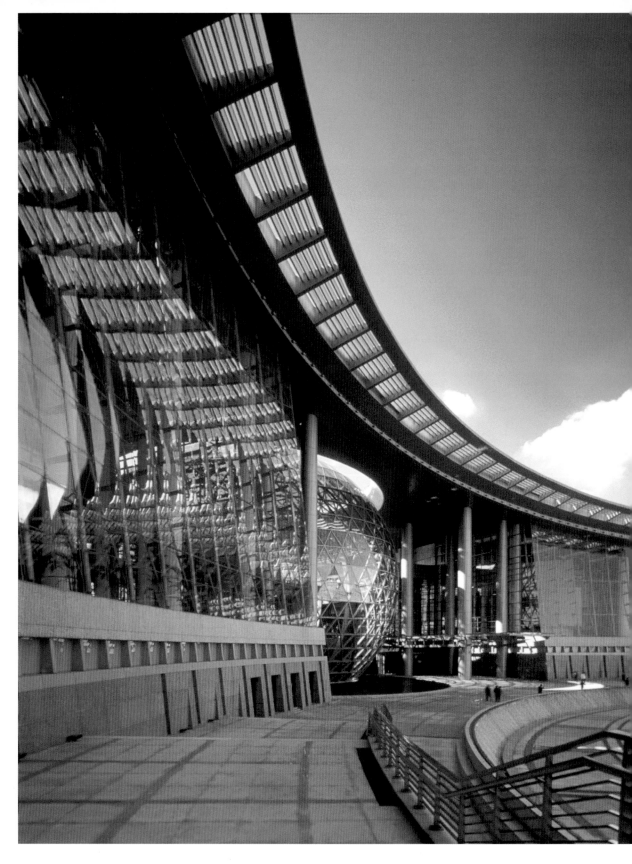

RTKL ASSOCIATES | USA
SHANGHAI SCIENCE AND TECHNOLOGY MUSEUM
Shanghai | 2001

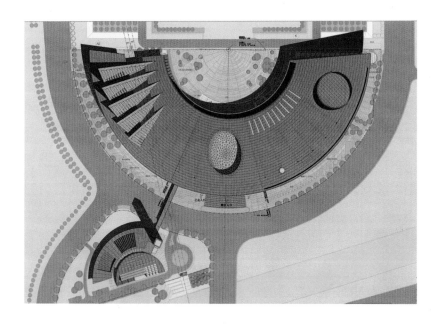

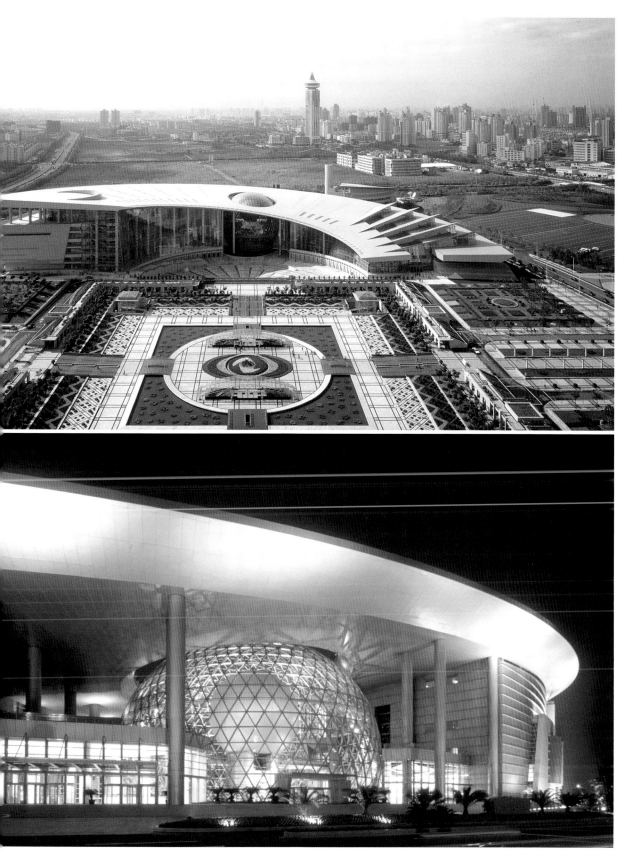

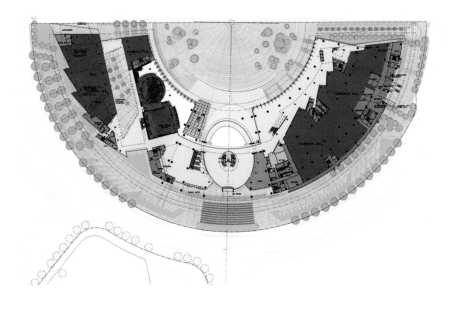

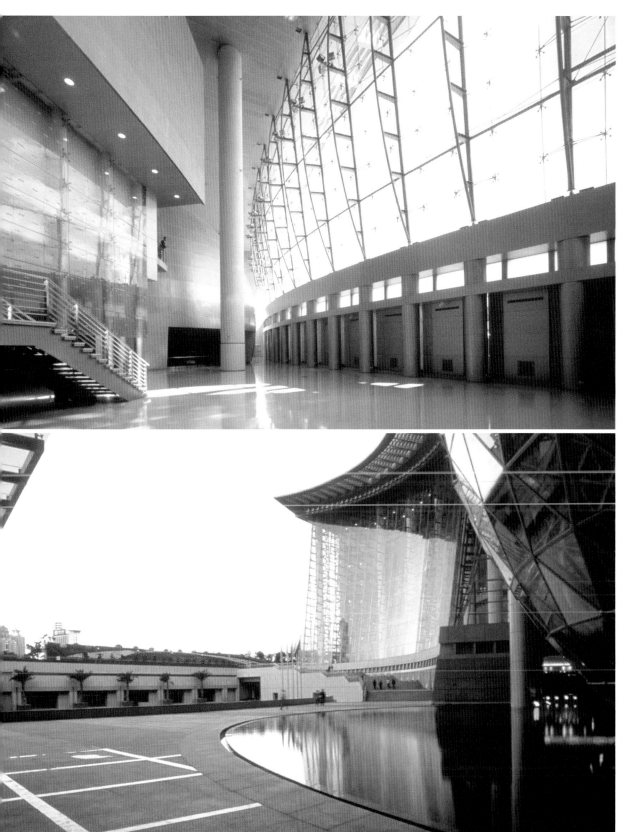

AB CONCEPT | HONG KONG
APARTMENT IN CHUNG HOM KOK
Hong Kong | 2002

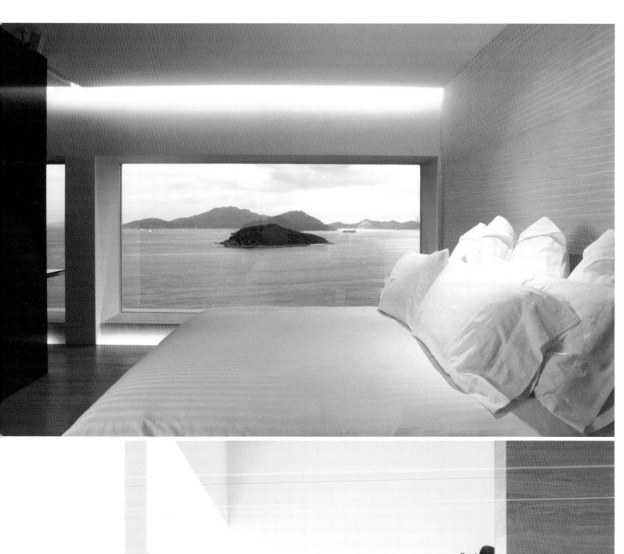

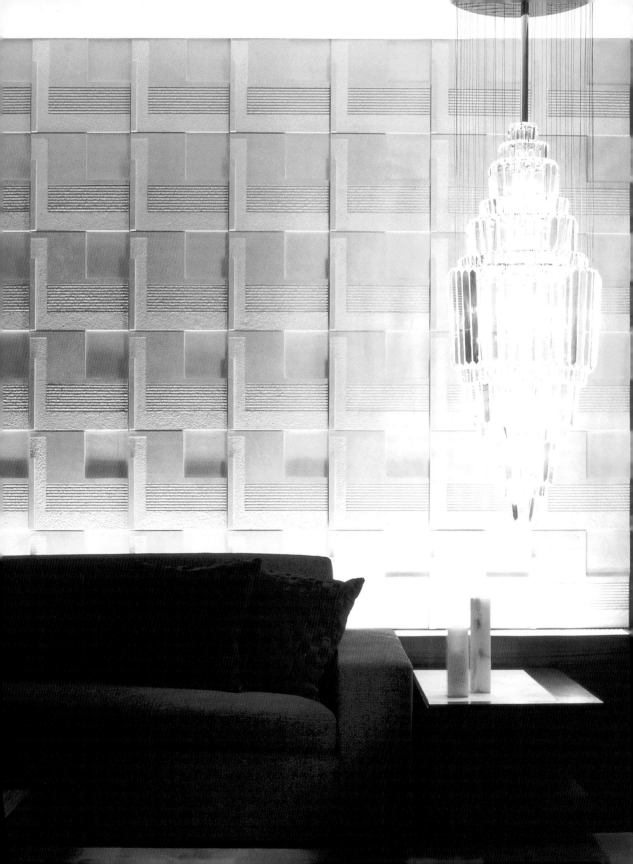

AB CONCEPT | HONG KONG
APARTMENT IN OLD PEAK ROAD
Hong Kong | 2004

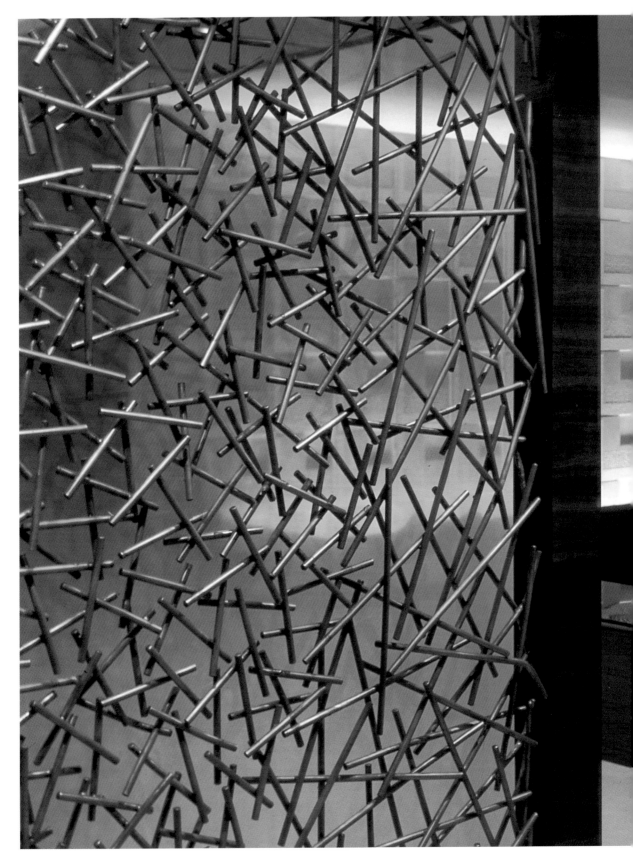

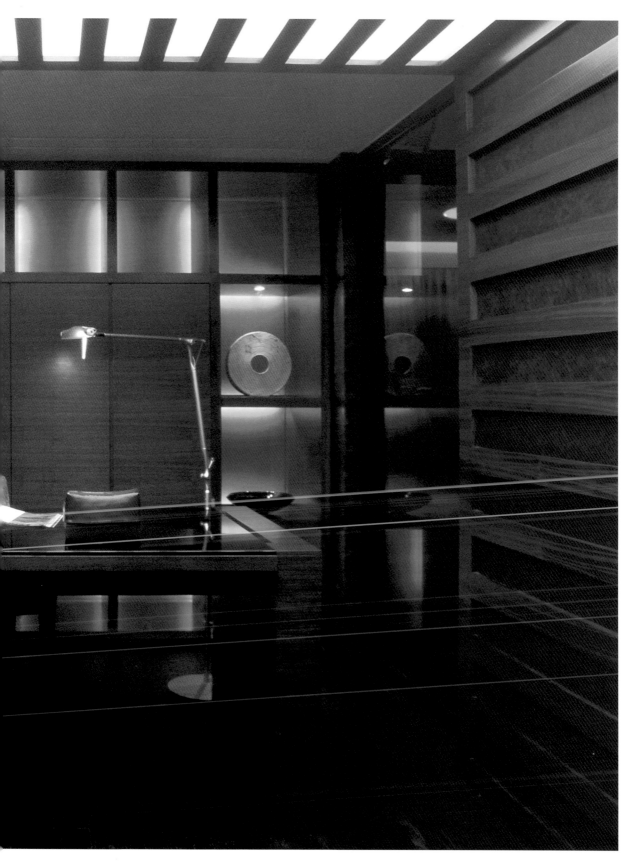

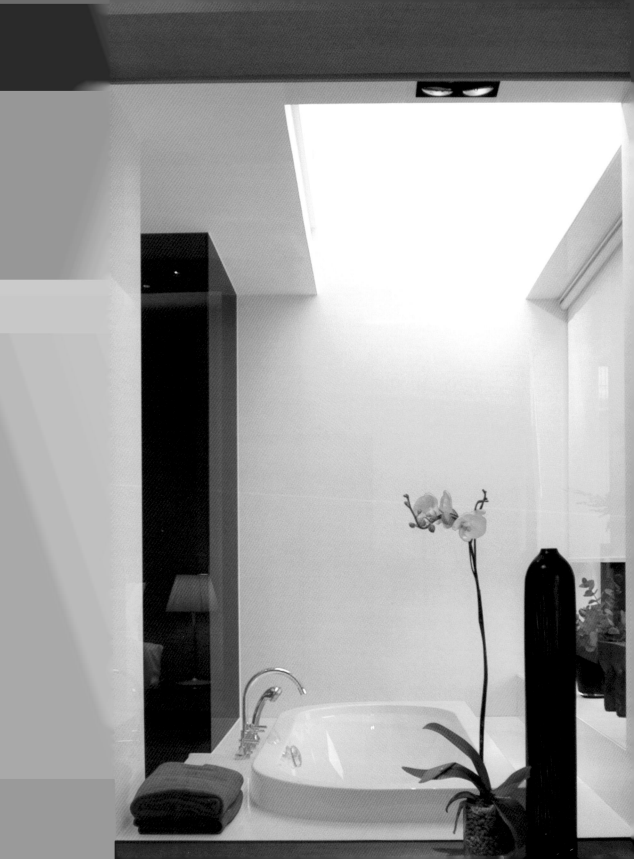

AB CONCEPT | HONG KONG
HOUSE IN KING'S PARK HILL
Hong Kong | 2003

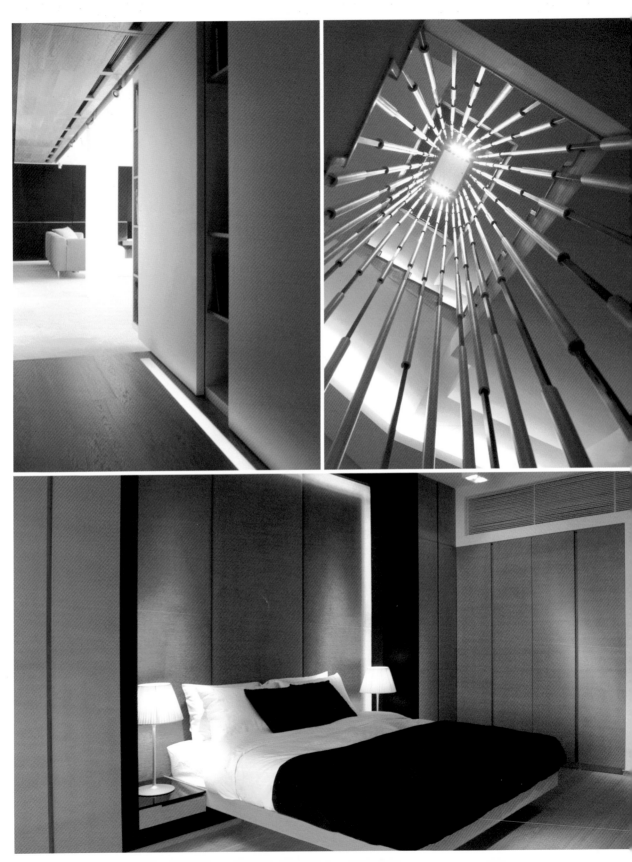

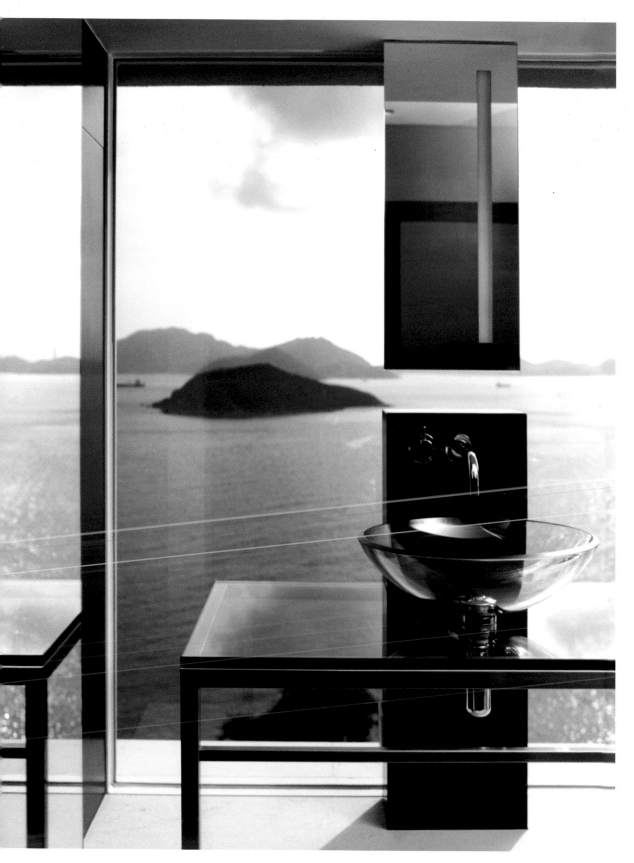

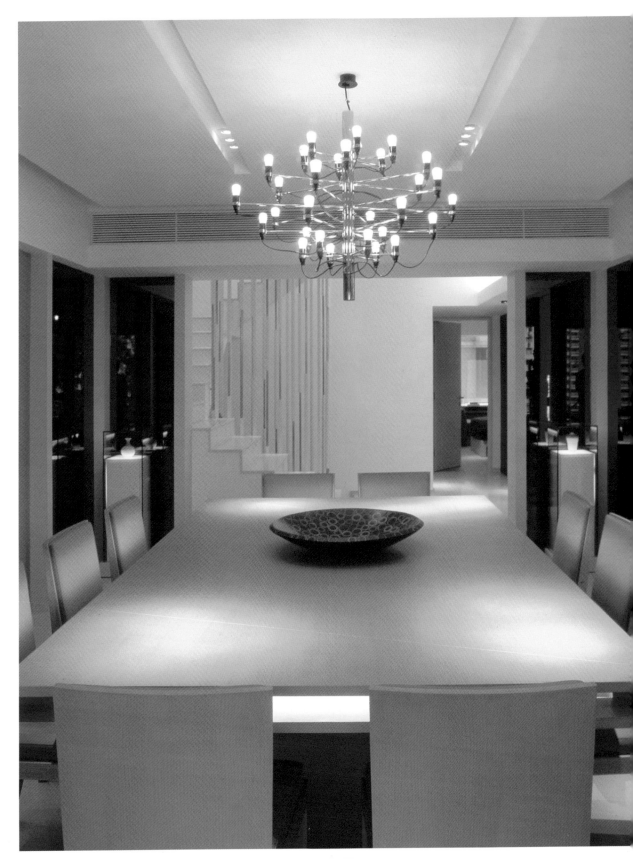

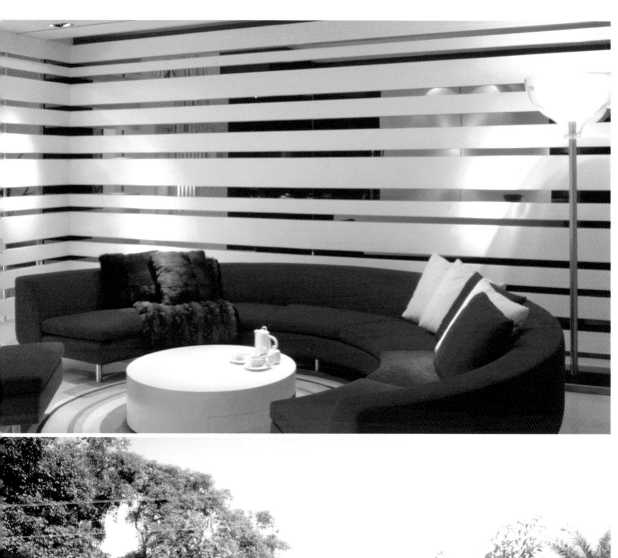
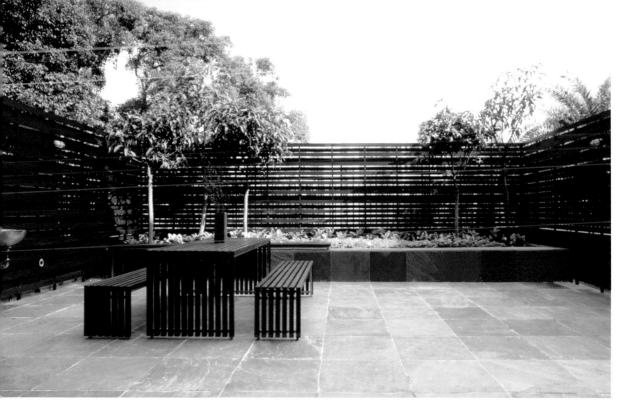

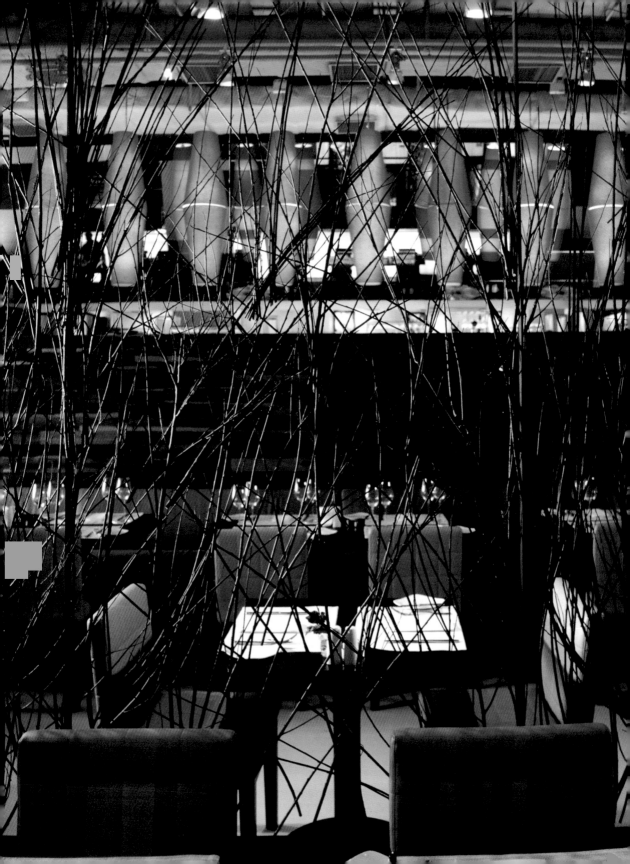

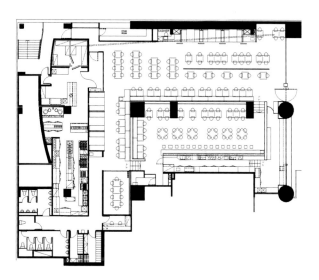

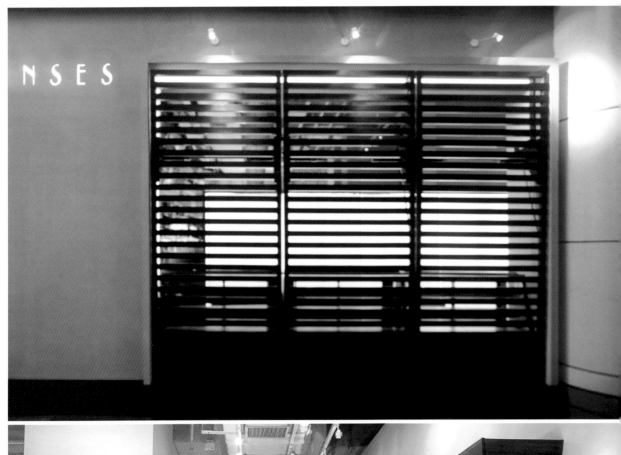

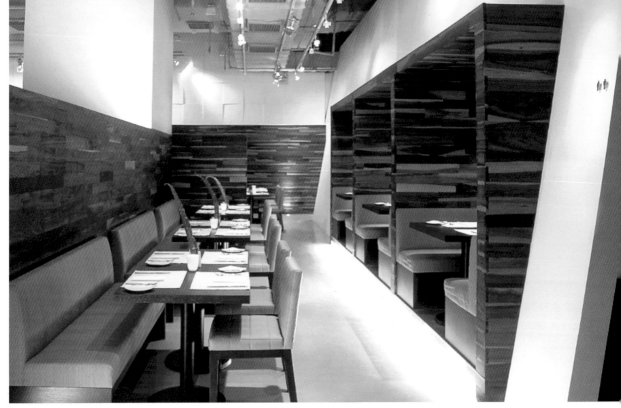

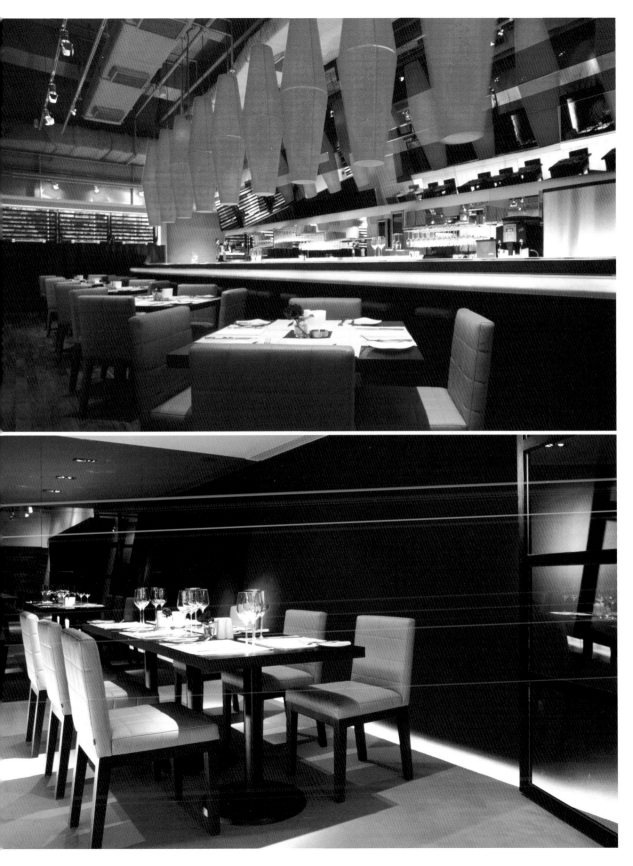

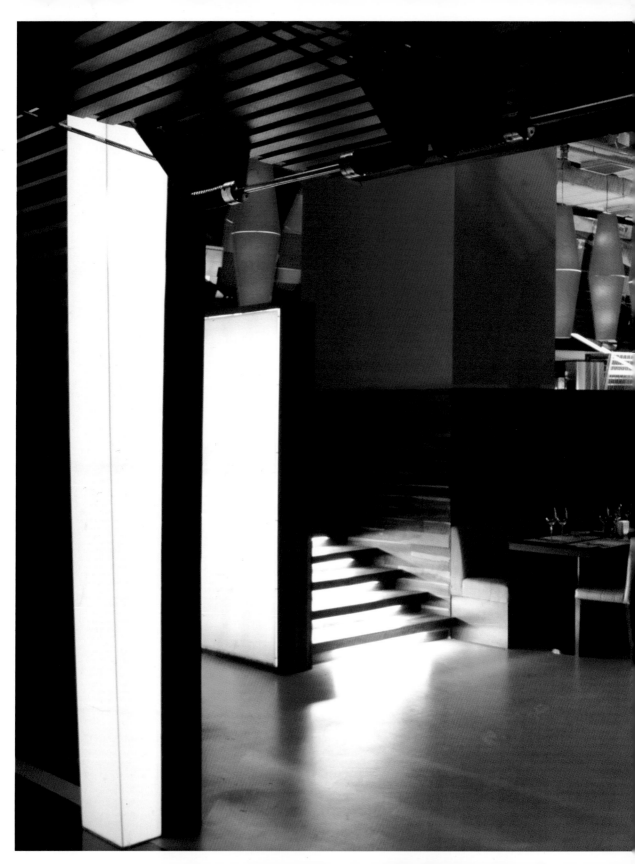

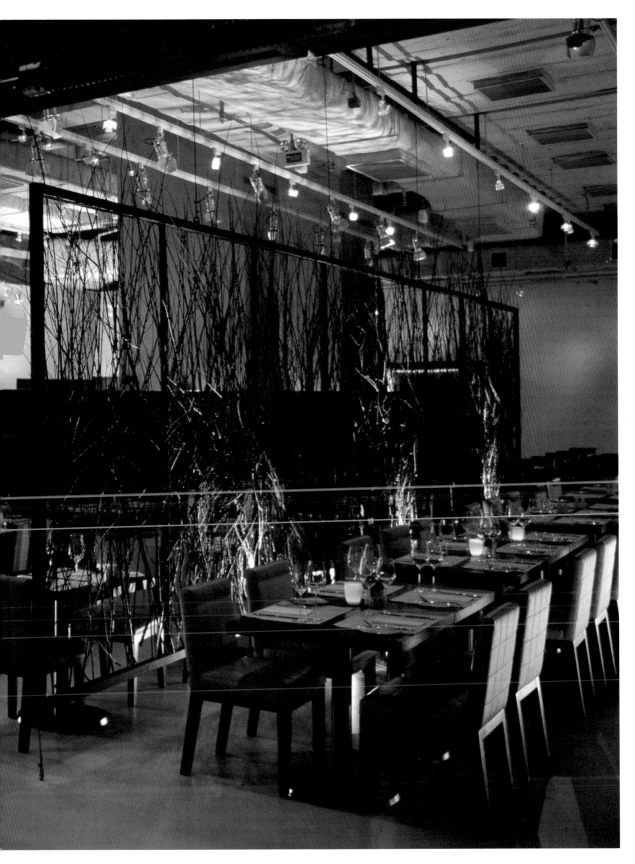

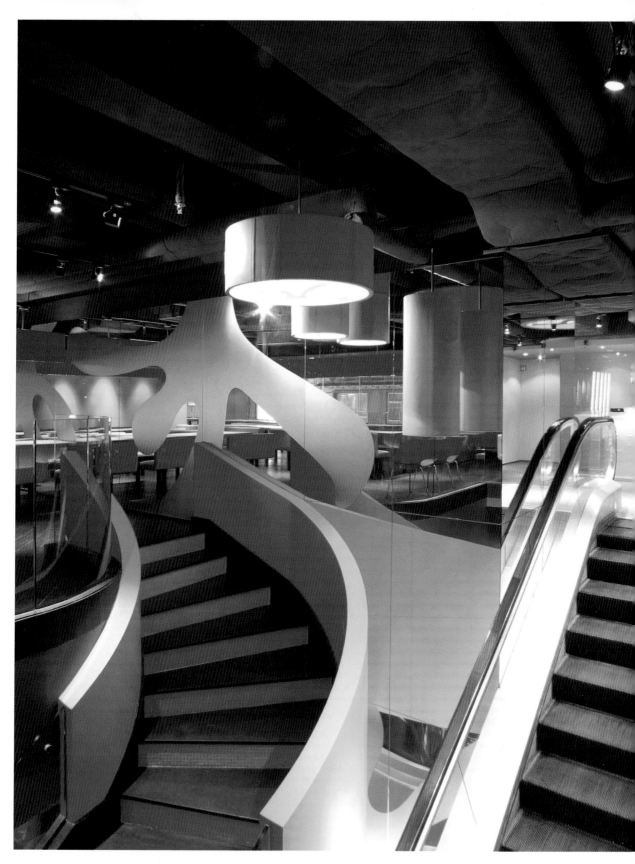

ALAN CHAN DESIGN COMPANY | HONG KONG
FAIRWOOD FAST FOOD RESTAURANT
Hong Kong | 2003

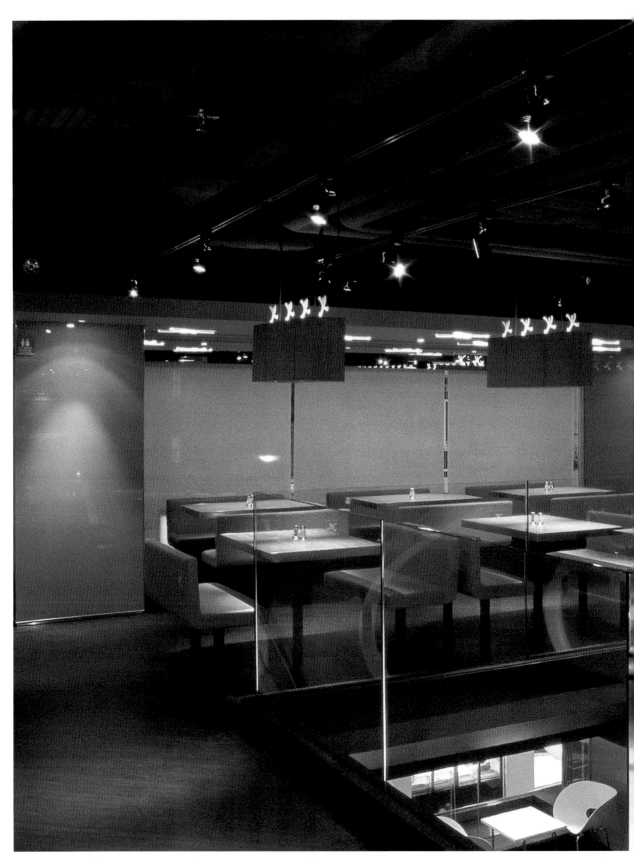

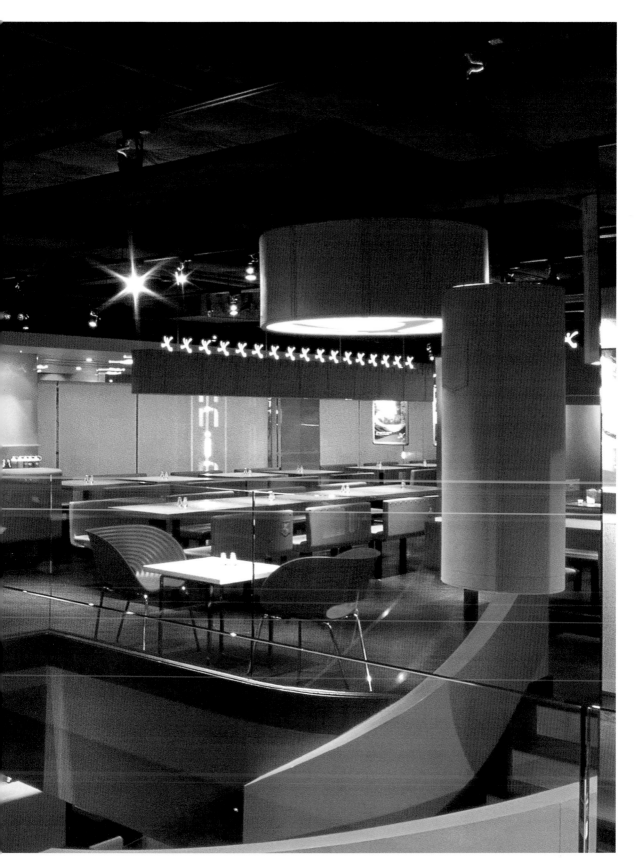

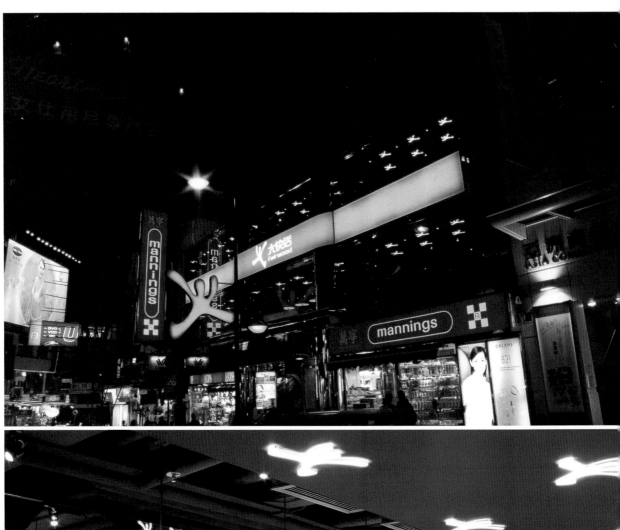
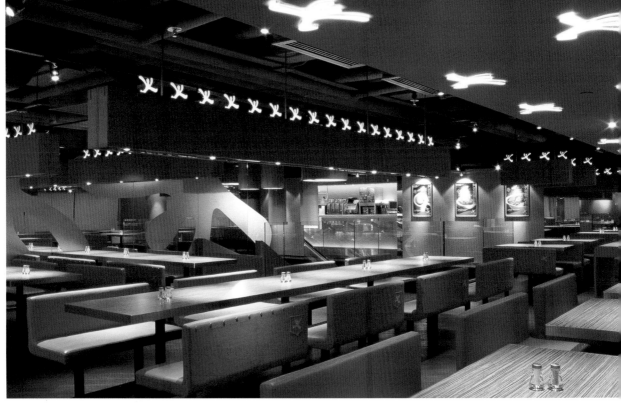

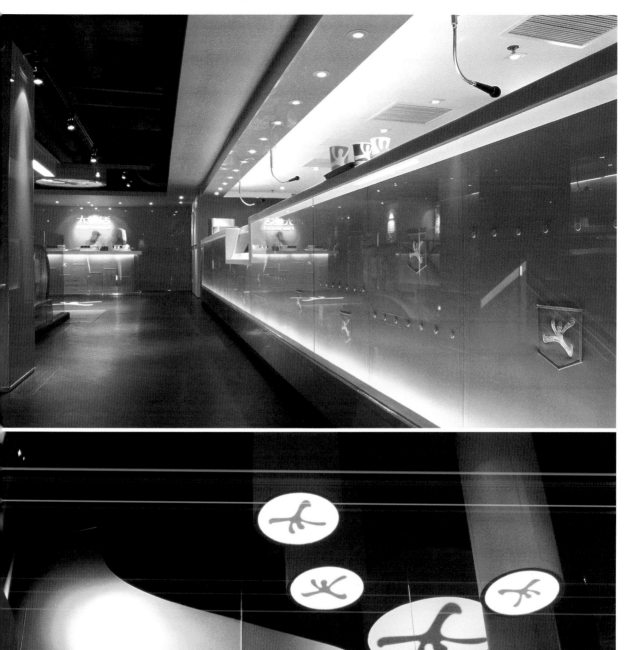

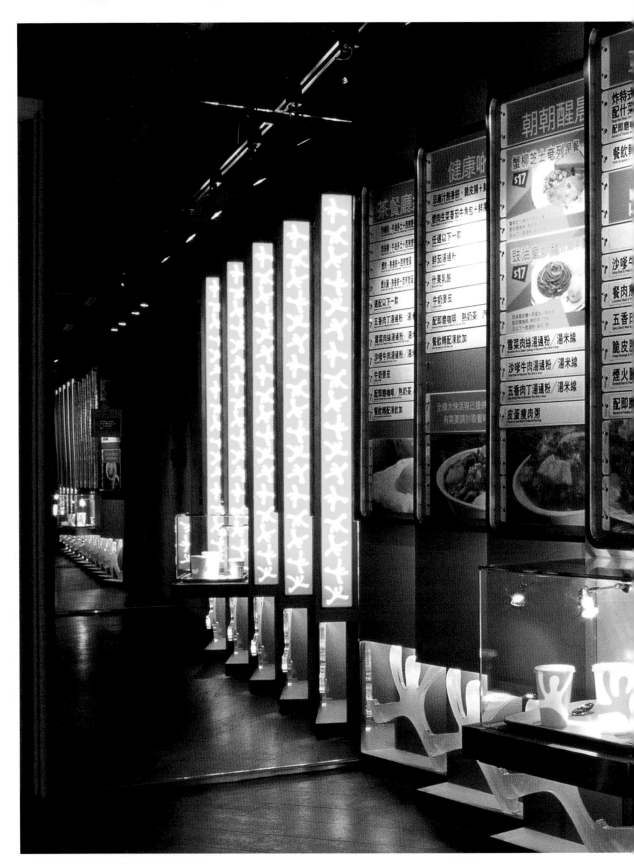

星晨	
椒醬炒腸粉 Fried Spicy Rice Rolls	9.00
豉油皇炒麵 Fried Noodle in Soy Sauce	9.00
煎蘿蔔糕 Pan-fried Turnip Cake	4.00
配皮蛋瘦肉粥加 Served w/ Congee w/ Lean Meat & Preserved Duck Egg	4.00
配即磨咖啡／熱奶茶 汽水加 Served w/ Freshly Brewed Coffee/ Hot Tea/ Soft Drink Add	4.00
皮蛋瘦肉粥 Congee w/ Lean Meat & Preserved Duck Egg	10.00

茄汁豆 18.

一丁 麵 18

丁麵 18

麵 18

麵 18

麵 18

／汽水

全線大快活現已提供「代糖」
有需要請於取餐時索取

	8.00
熱奶茶 Hot Tea	12.00
香濃凍咖啡 Iced Coffee	

全線大快活現已提供「代糖」
有需要請於取餐時索取

TWENTY SEVEN

ALAN CHAN DESIGN COMPANY | HONG KONG
ALAN CHAN DESIGN COMPANY OFFICE
Hong Kong | 2002

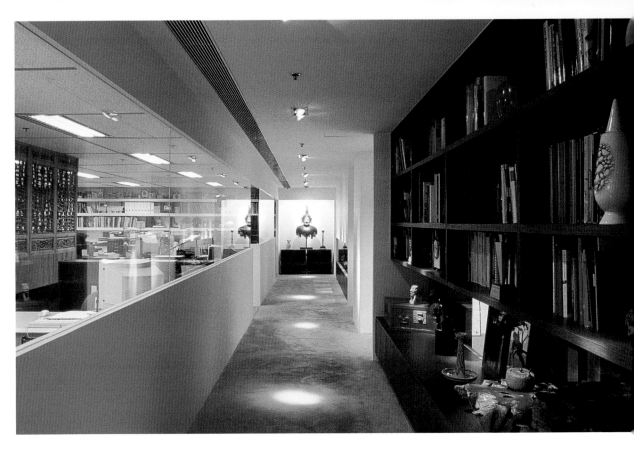

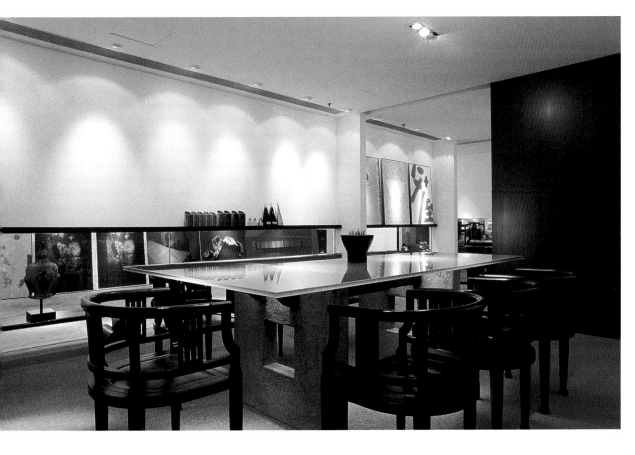

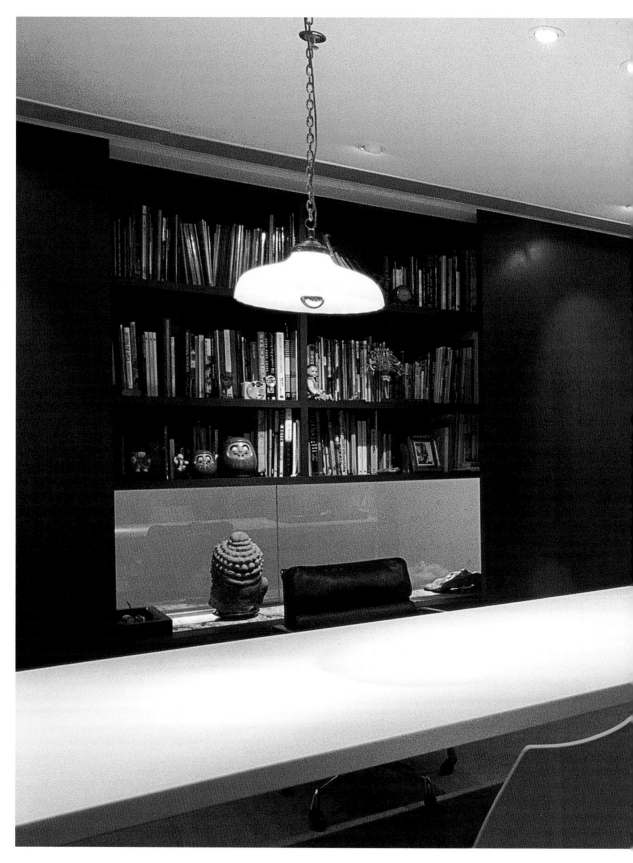

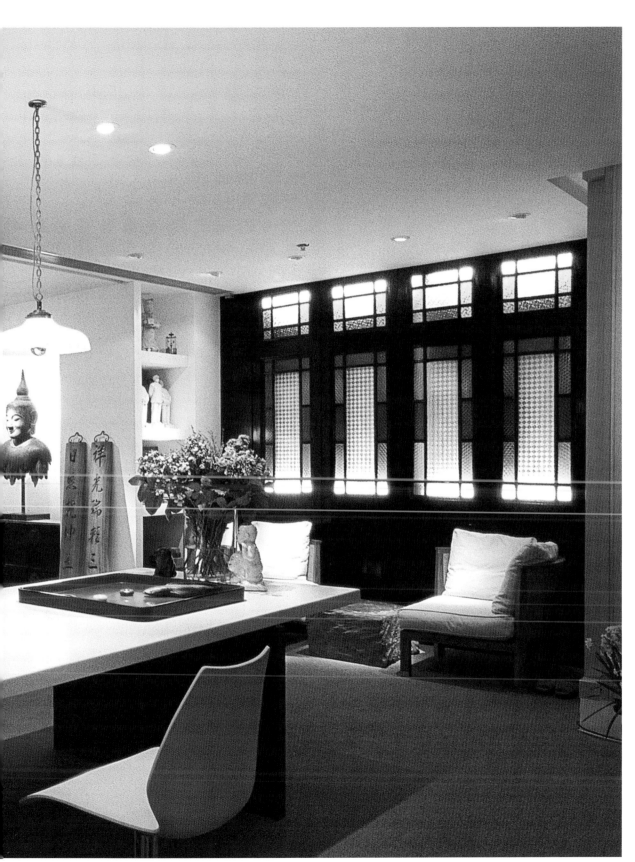

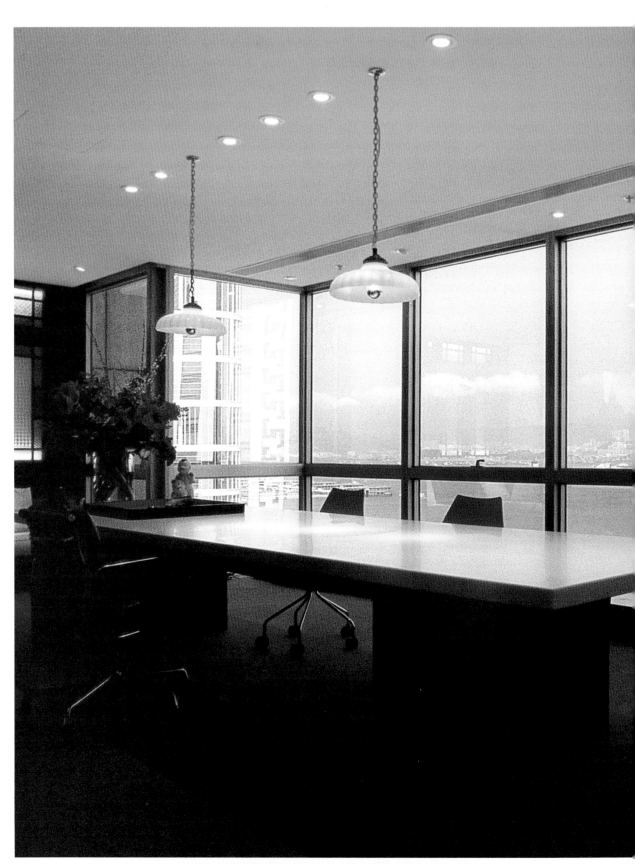

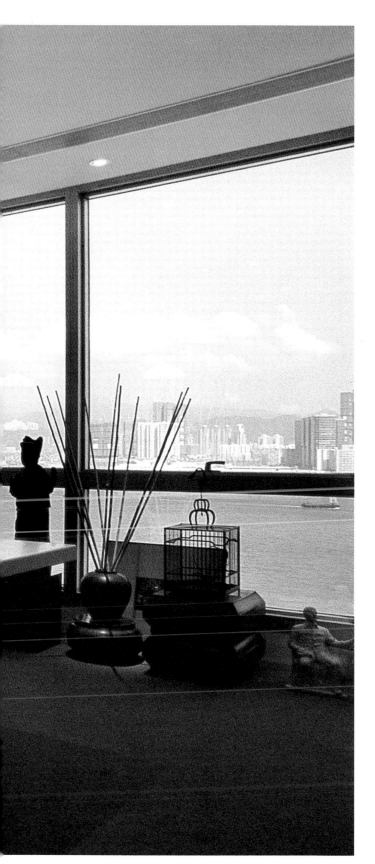

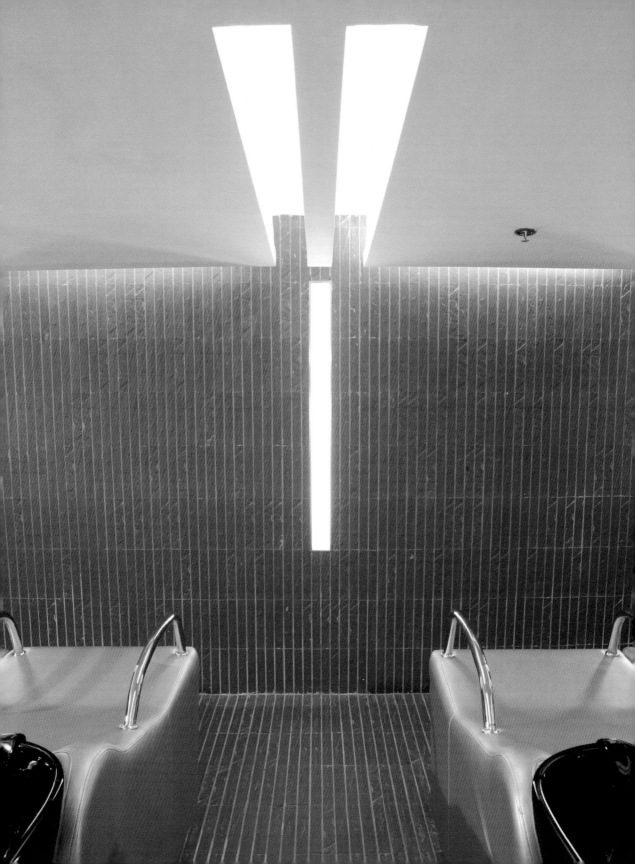

BARRIE HO ARCHITECTURE INTERIORS | HONG KONG
IMAGE CENTRE
Hong Kong | 2004

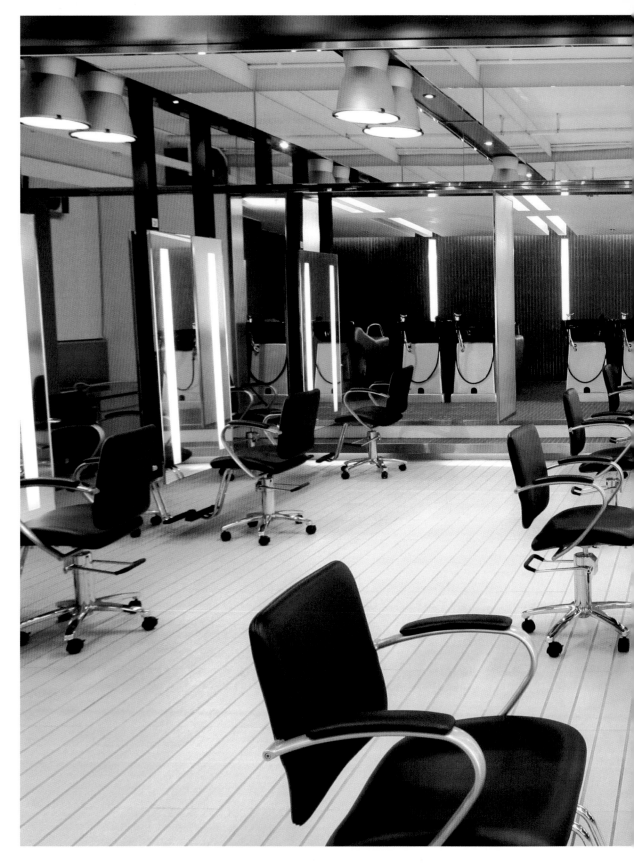

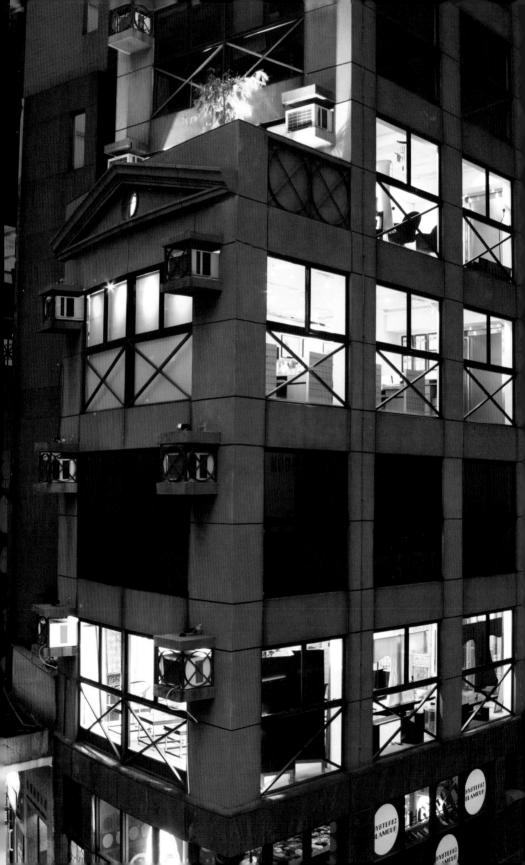

BARRIE HO ARCHITECTURE INTERIORS | HONG KONG
LAN KWAI FONG
Hong Kong | 2004

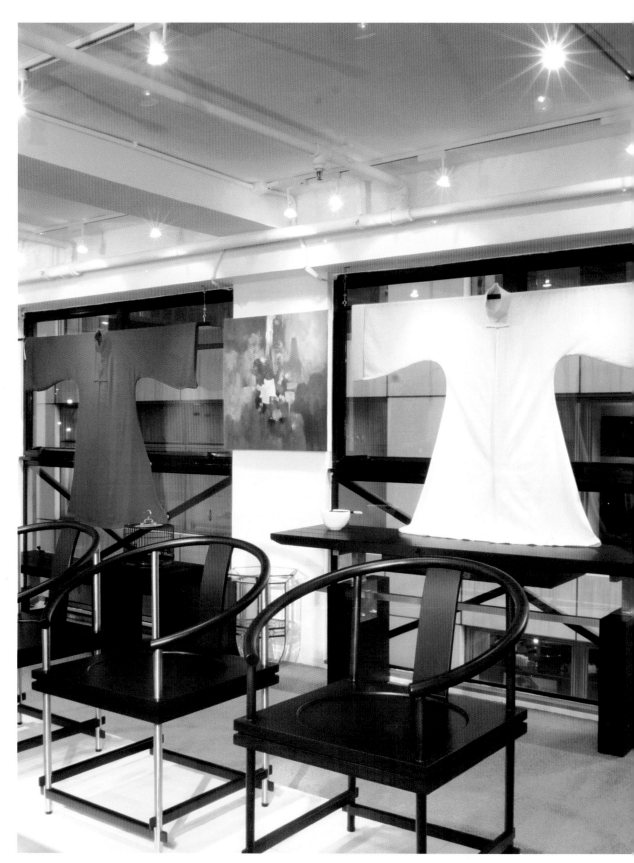

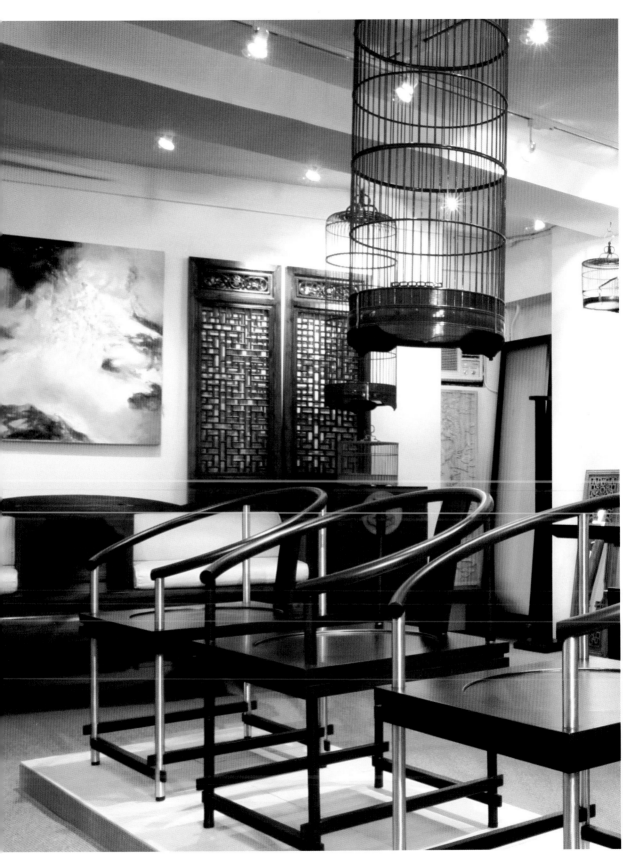

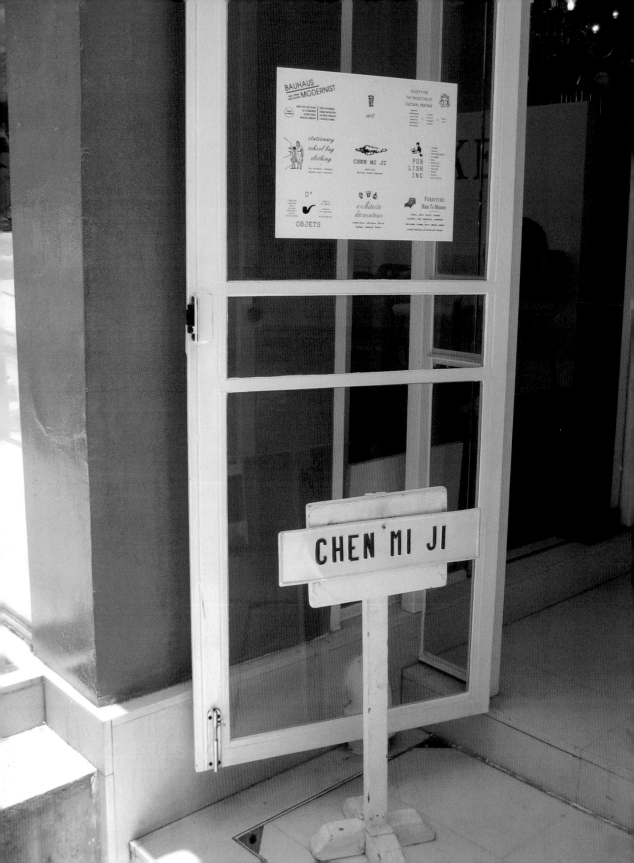

CHEN MI JI | HONG KONG
CHEN MI JI FURNITURE SHOP
Hong Kong | 1995

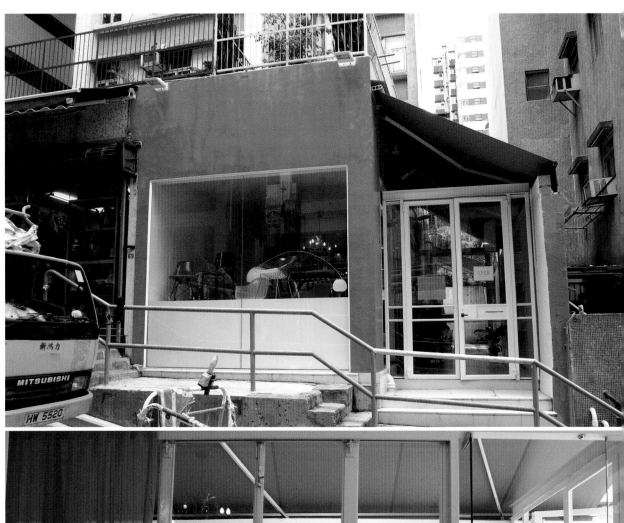

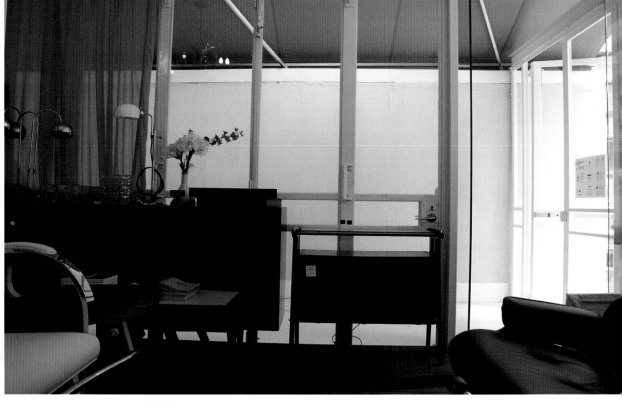

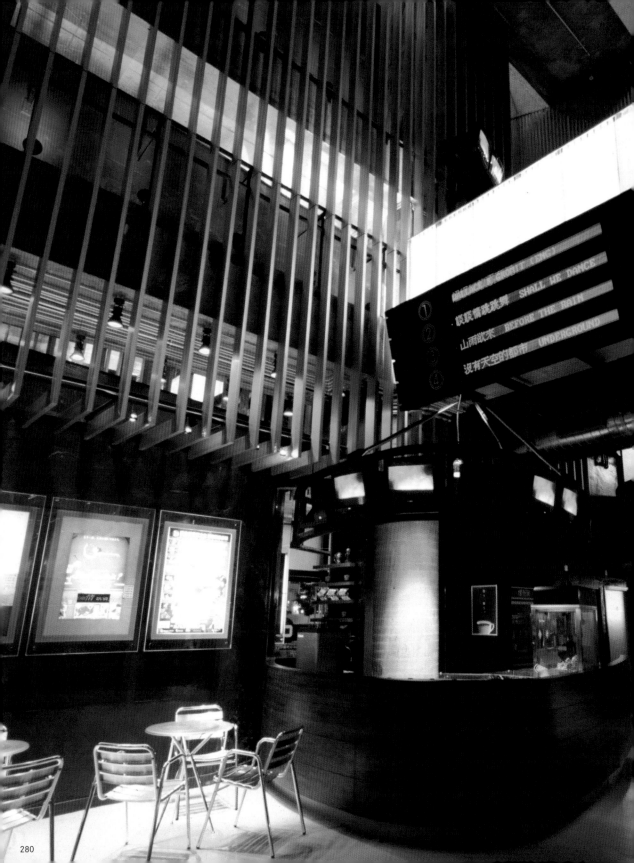

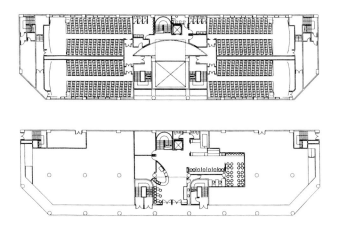

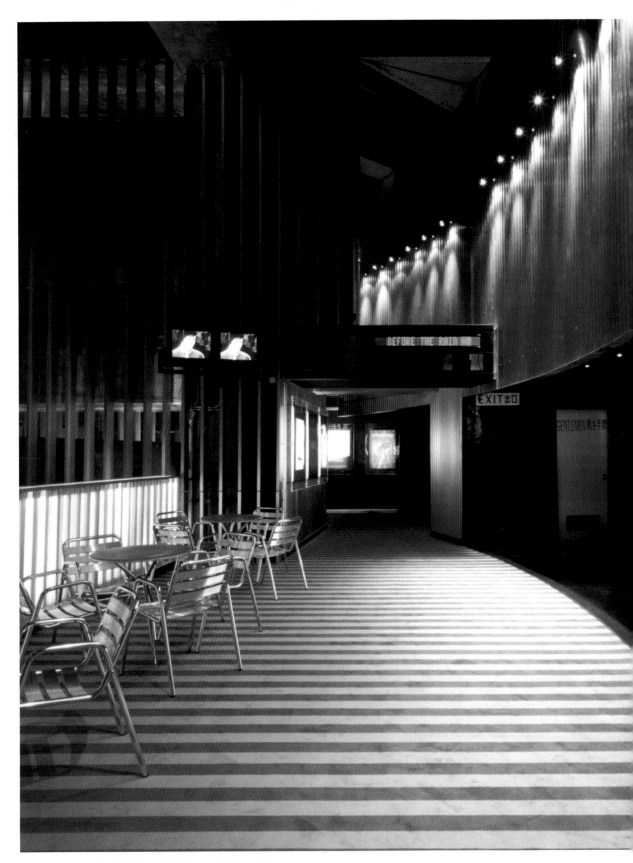

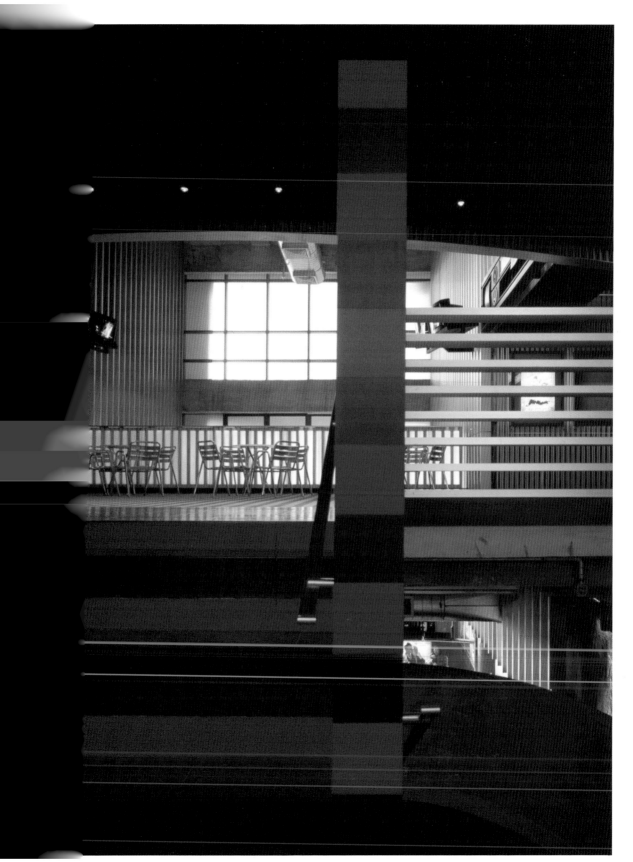

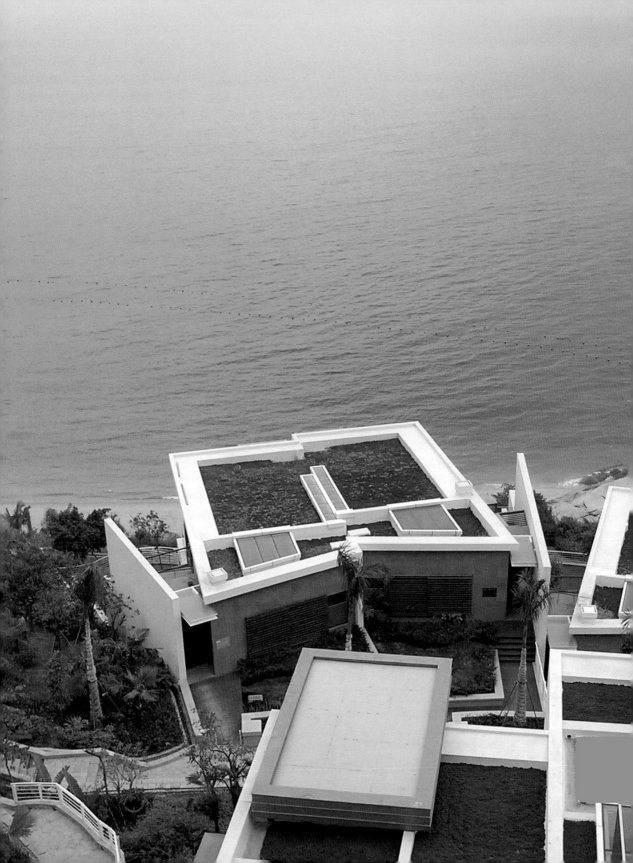

EDGE DESIGN INSTITUTE | HONG KONG
17 MILES HOUSE D
Hong Kong | 2006

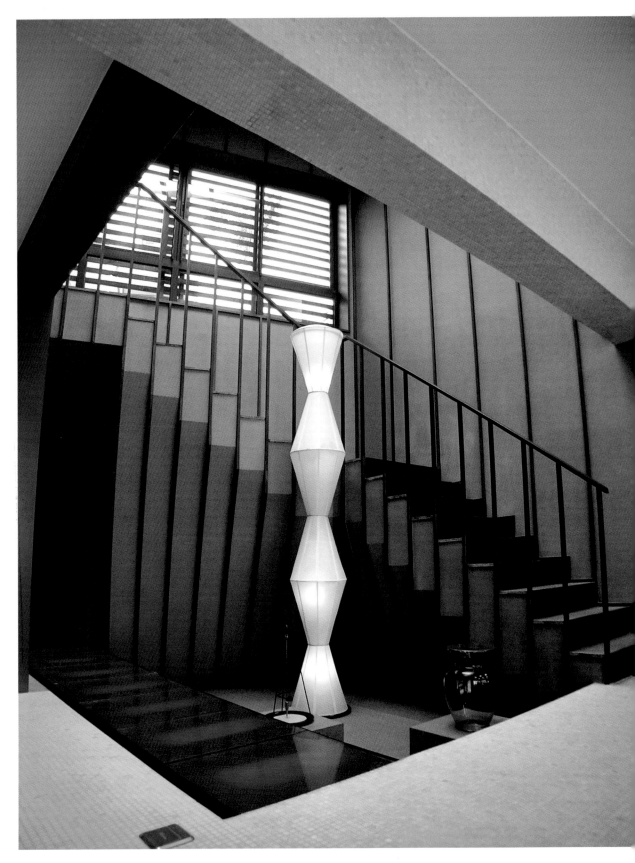

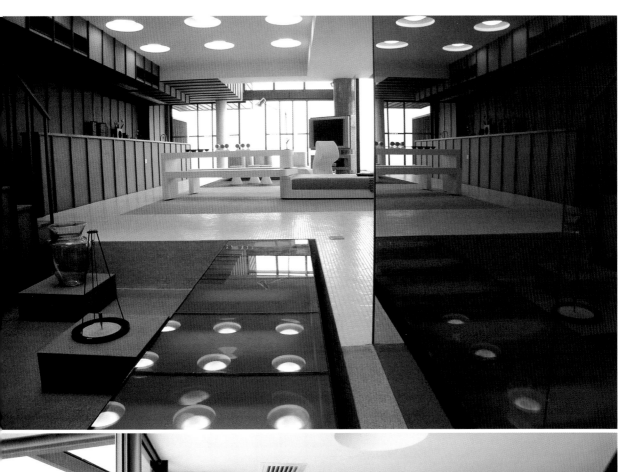
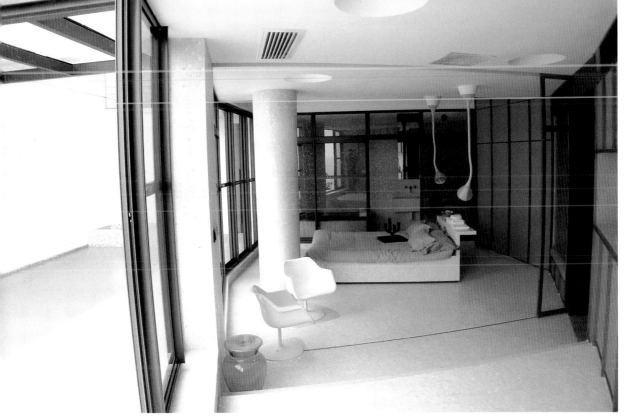

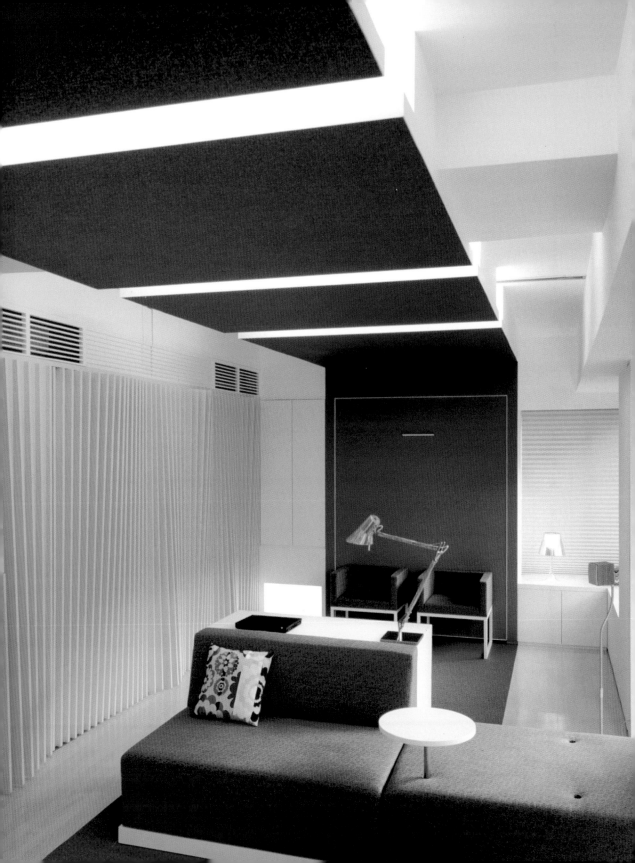

EDGE DESIGN INSTITUTE | HONG KONG
SANDRA'S APARTMENT
Hong Kong | 2004

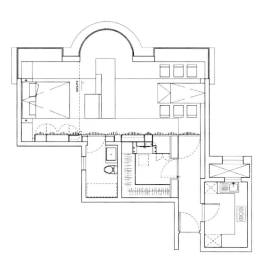

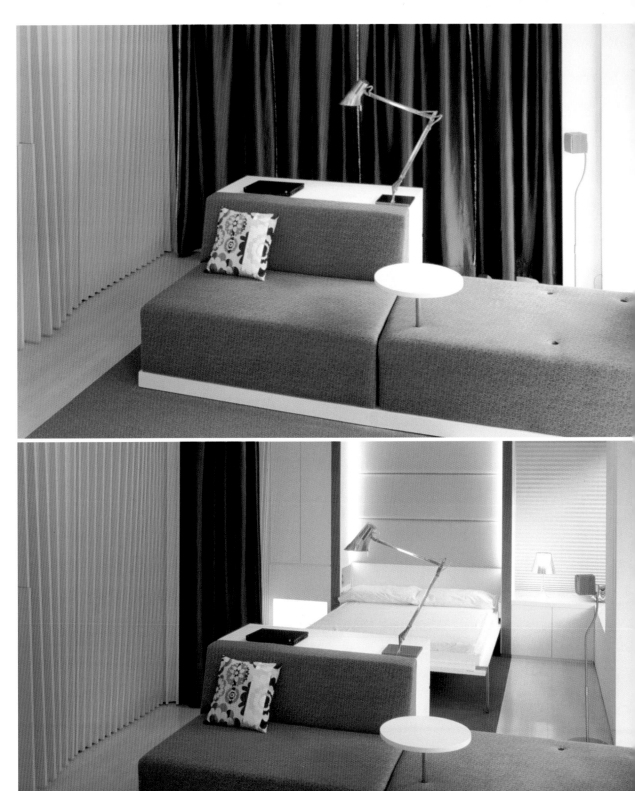

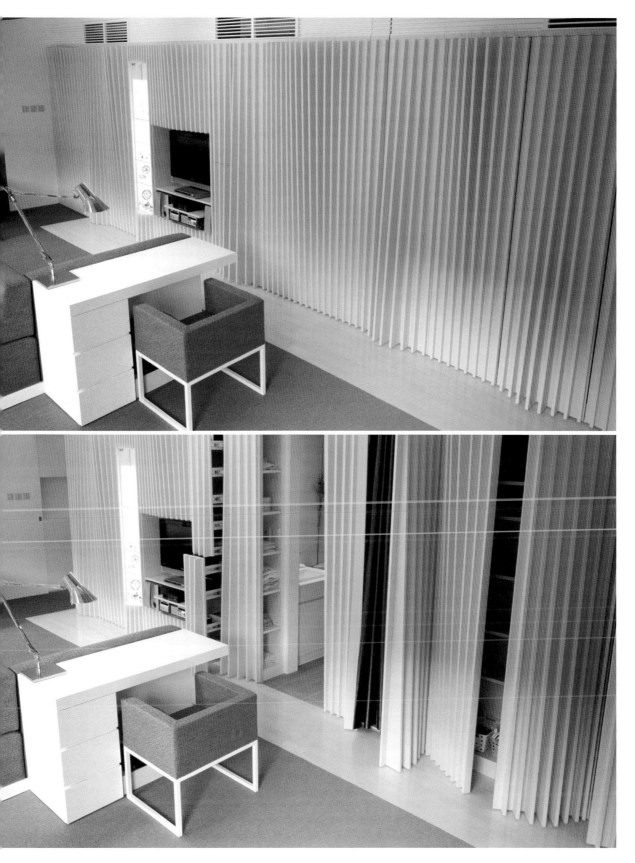

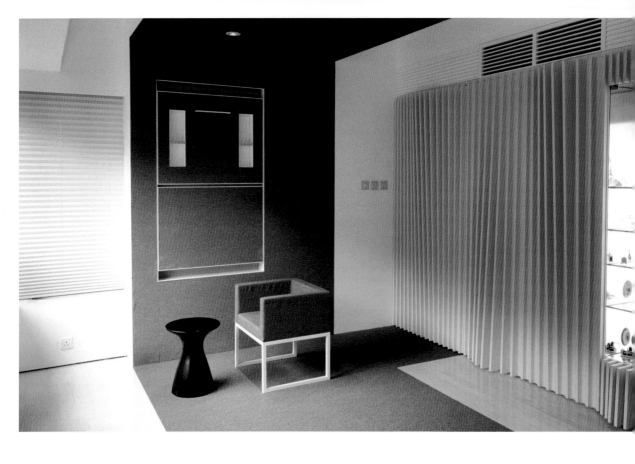

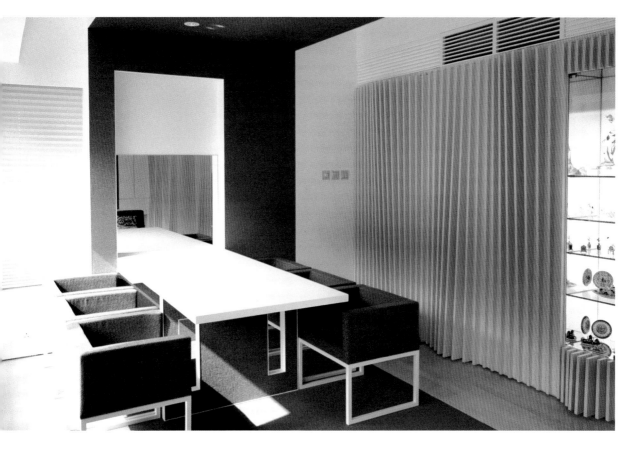

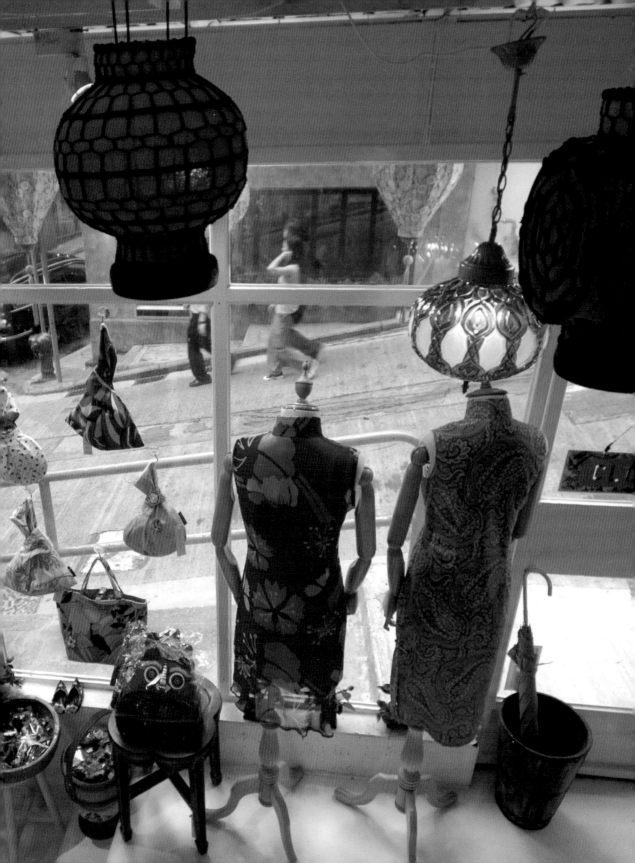

MAY YANG / MAYMAYKING | **HONG KONG**
MAYMAYKING SHOP
Hong Kong | 2003

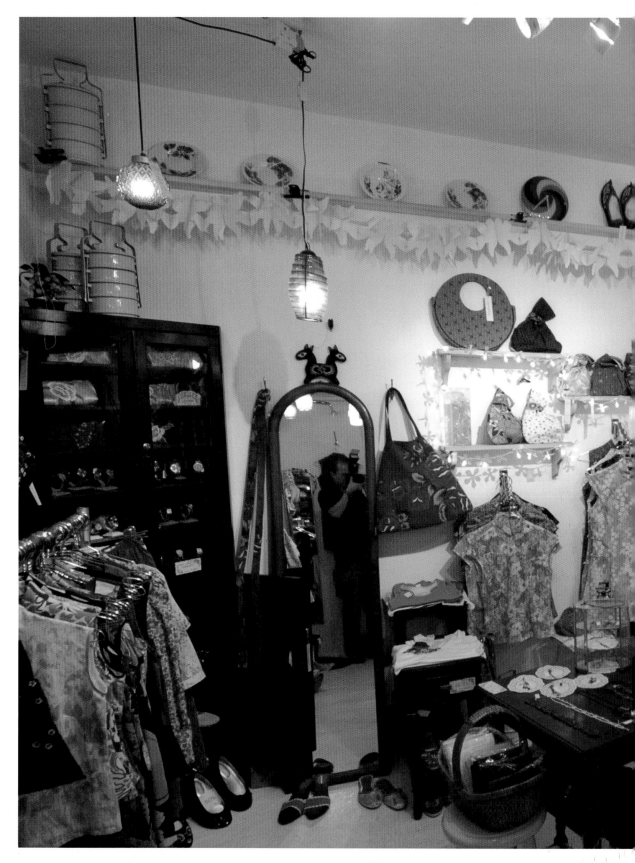

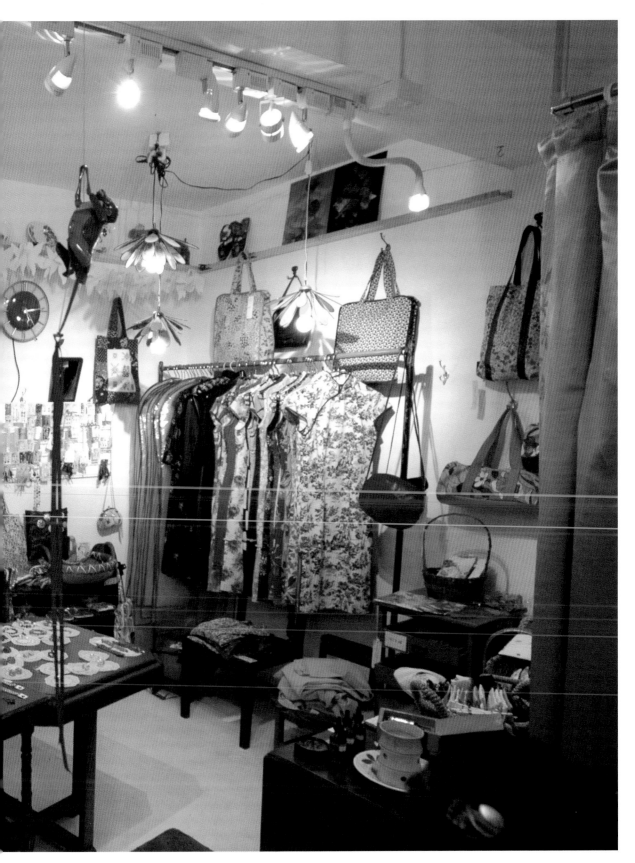

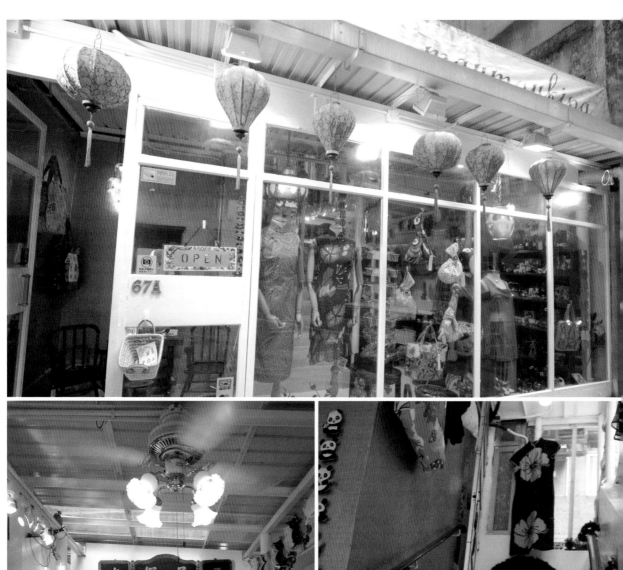

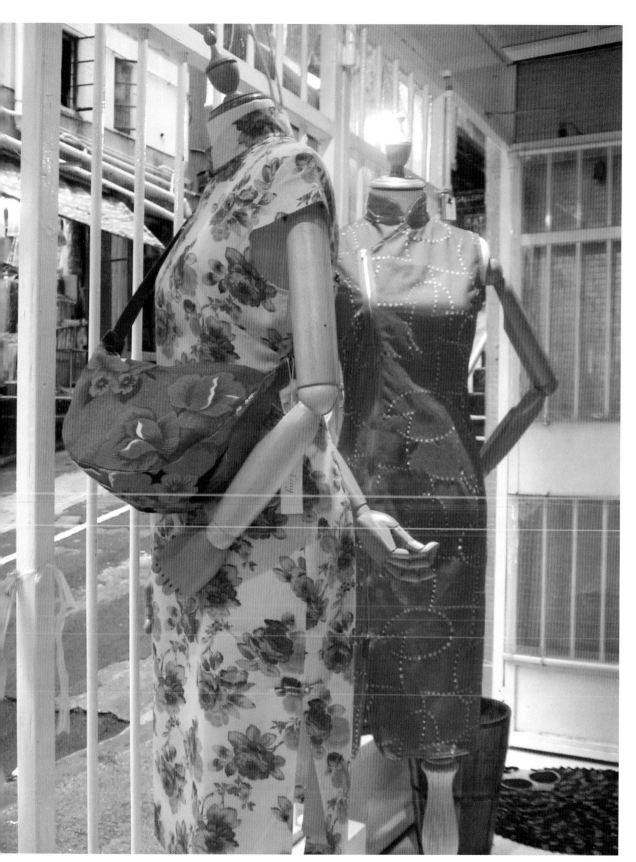

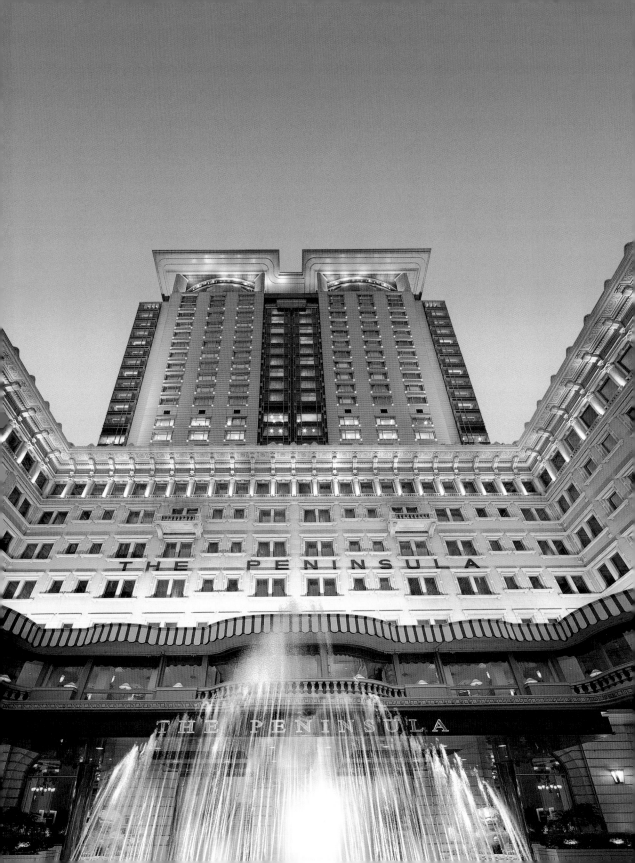

PHILIPPE STARCK | PARIS
FELIX RESTAURANT IN THE PENINSULA HONG KONG
Hong Kong | 1994

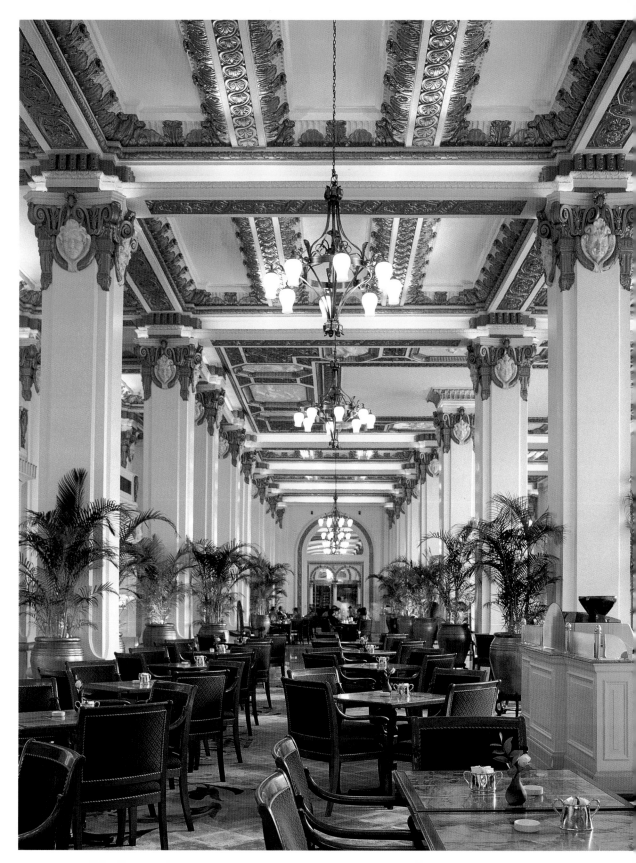

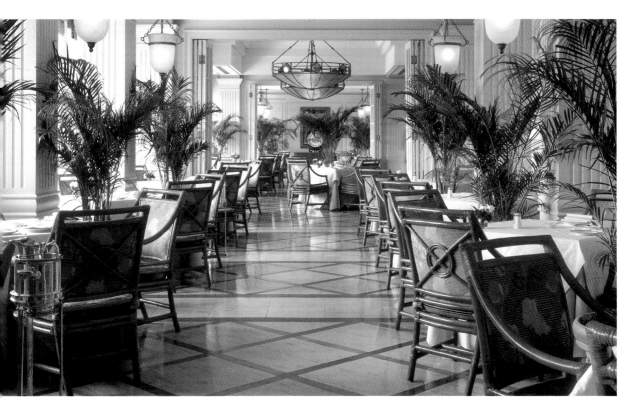

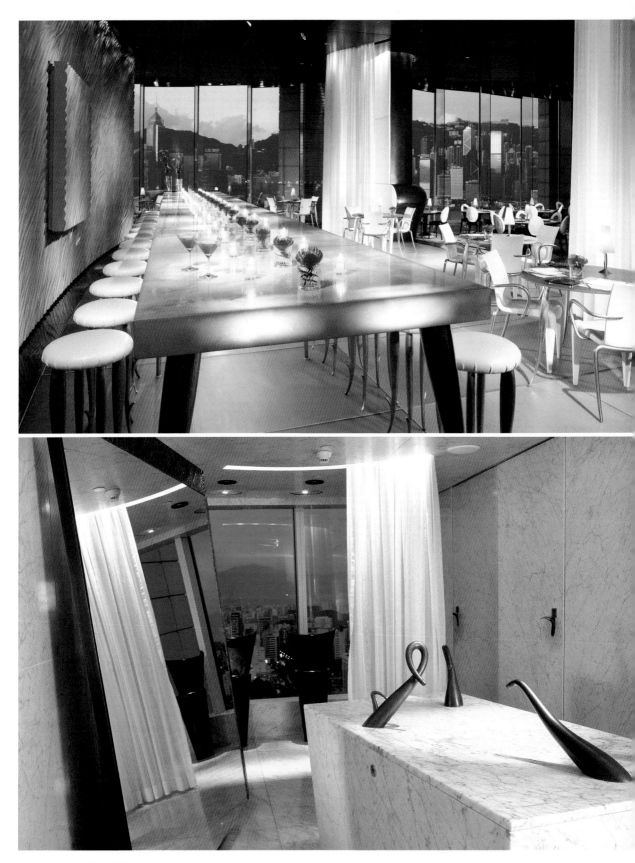

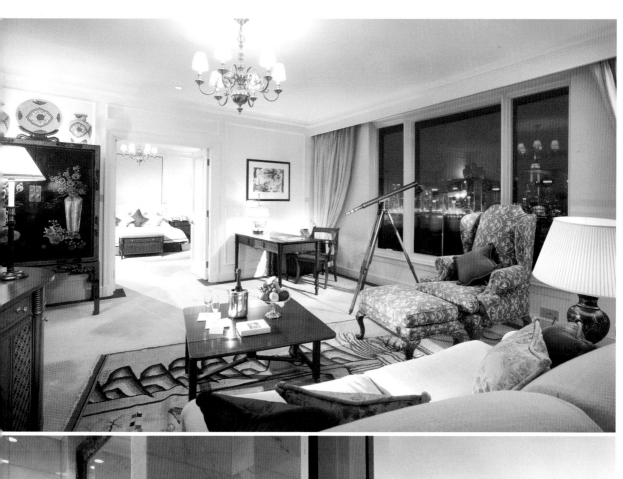

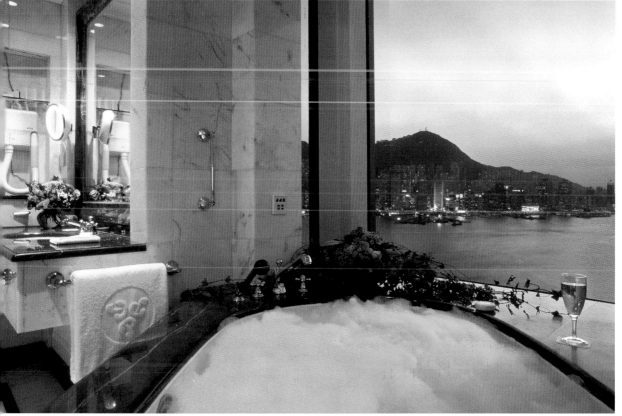

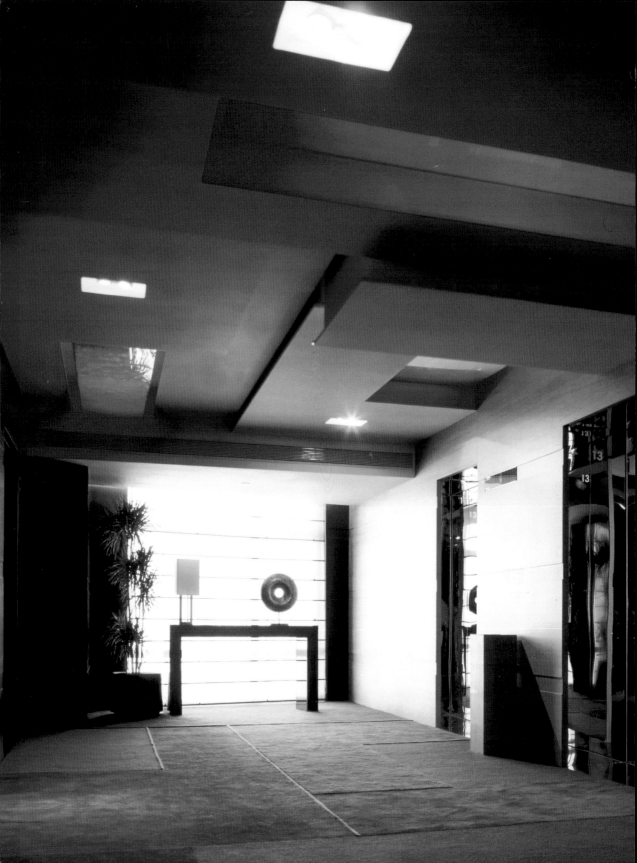

AB CONCEPT | HONG KONG
TIANLUN INTERNATIONAL HOTEL
Guangzhou | 2003

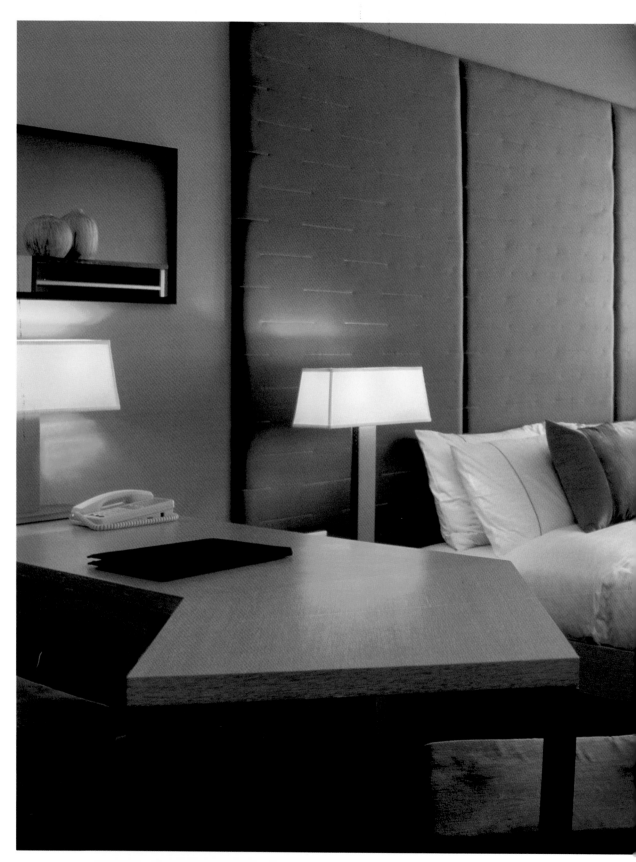

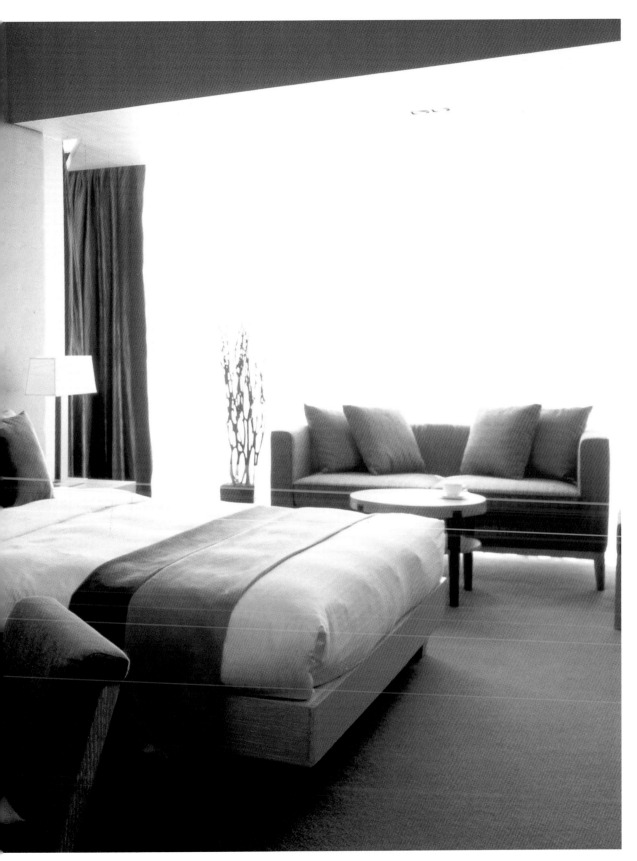

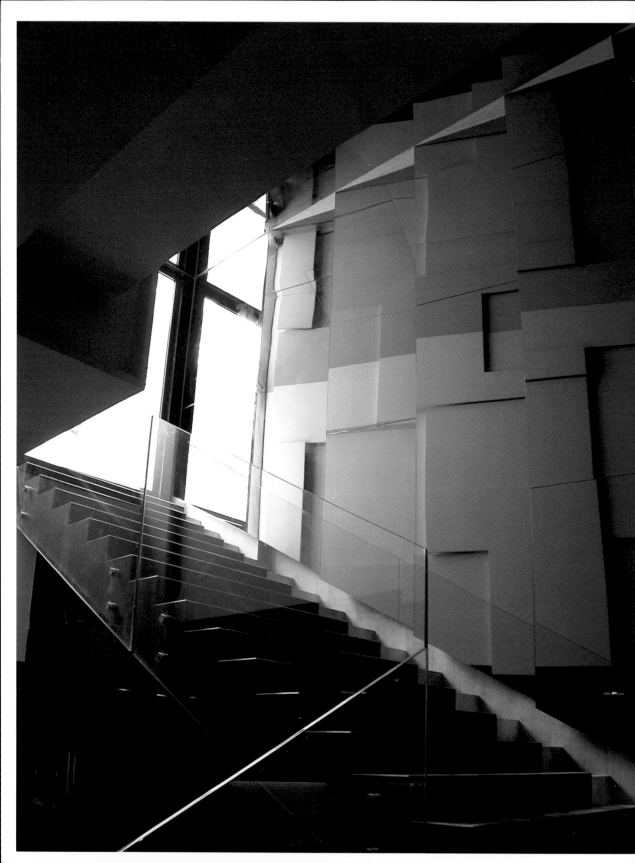

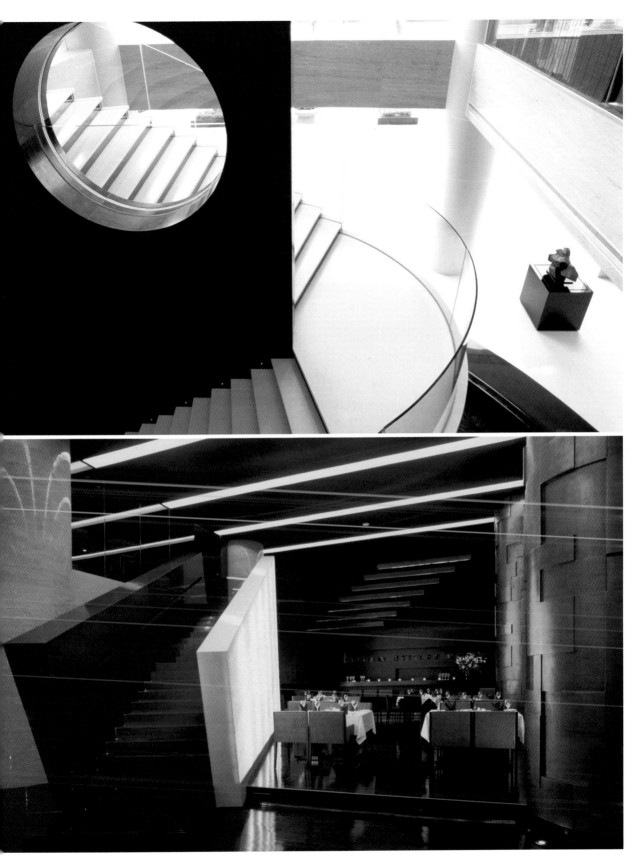

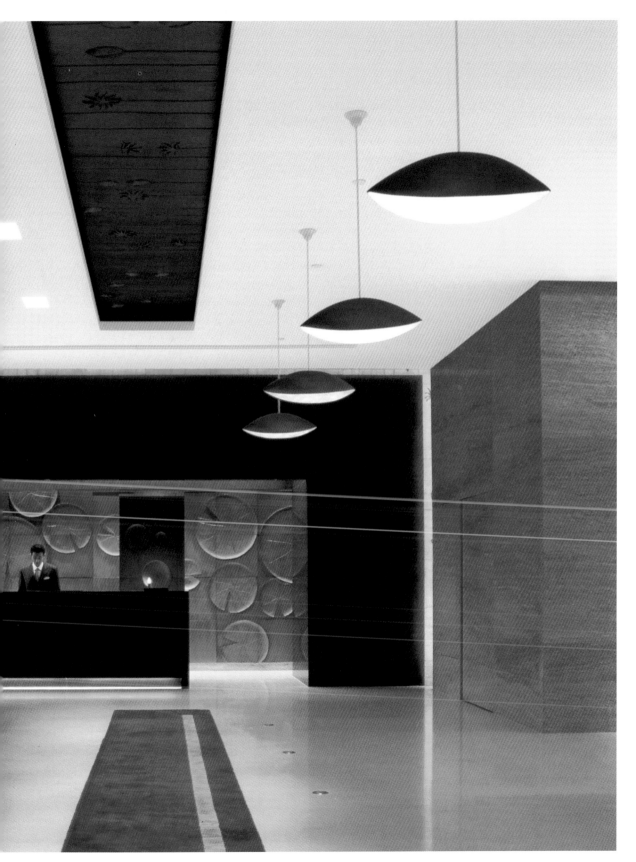

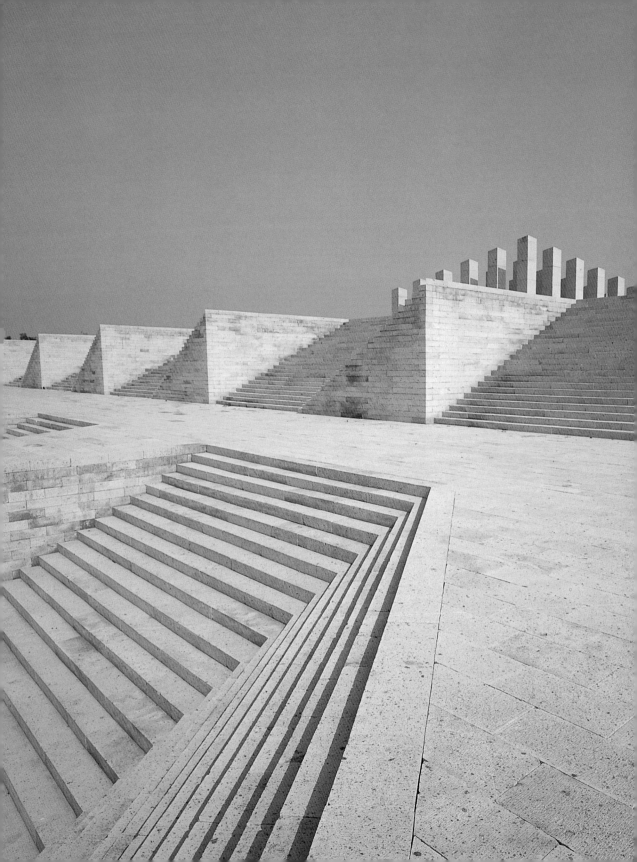

AI WEIWEI/FAKE DESIGN | BEIJING
THE SOUTH RIVERBANK OF YIWU RIVER
Jinhua, Zhejiang | 2002

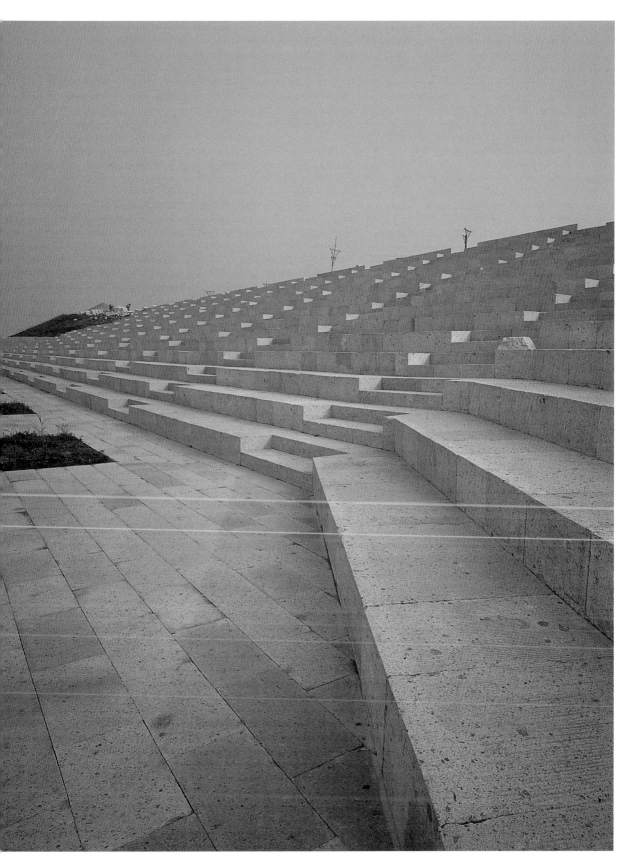

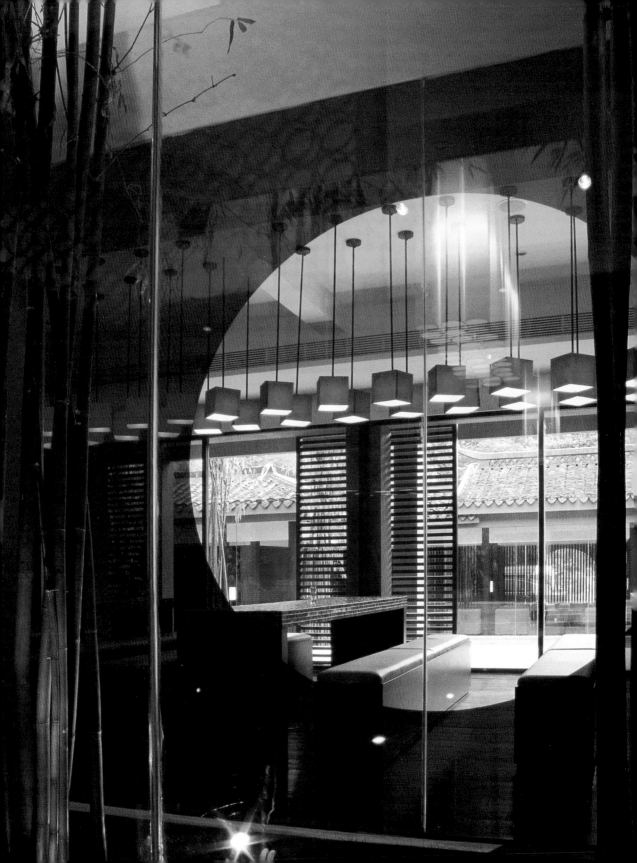

ALAN CHAN DESIGN COMPANY | HONG KONG
BAISHAYUAN TEA HOUSE
Changsha, Hunan | 2003

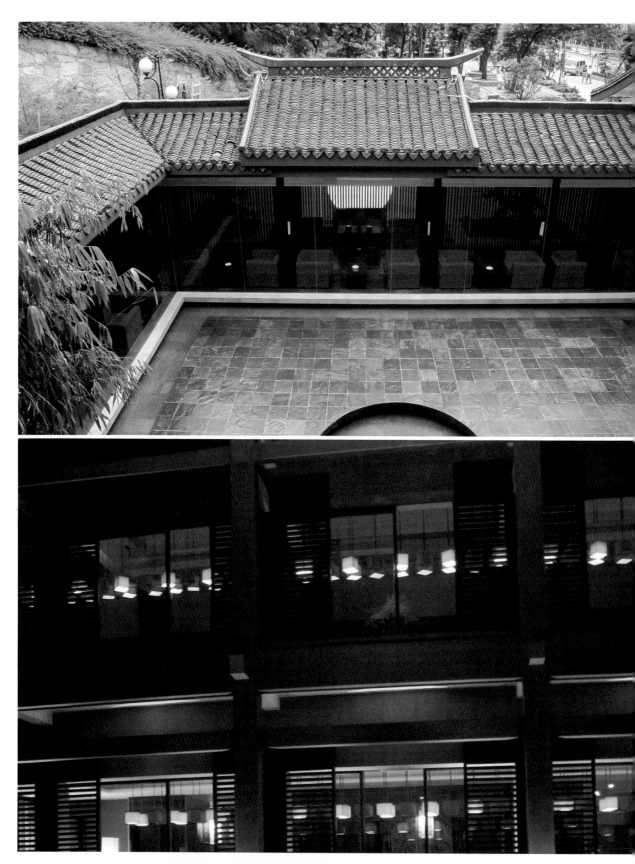

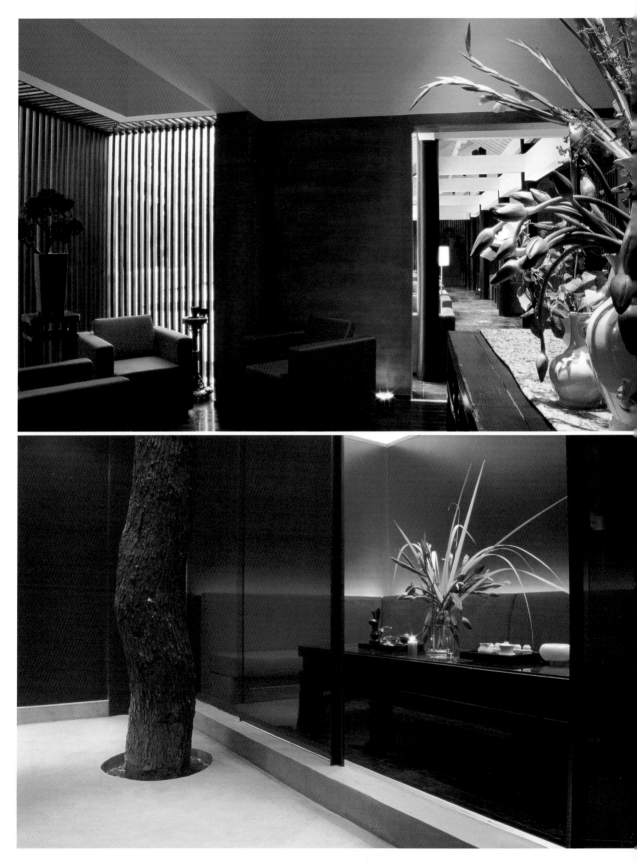

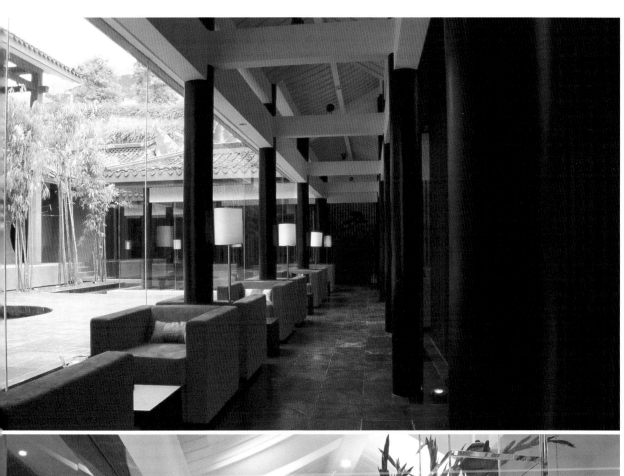

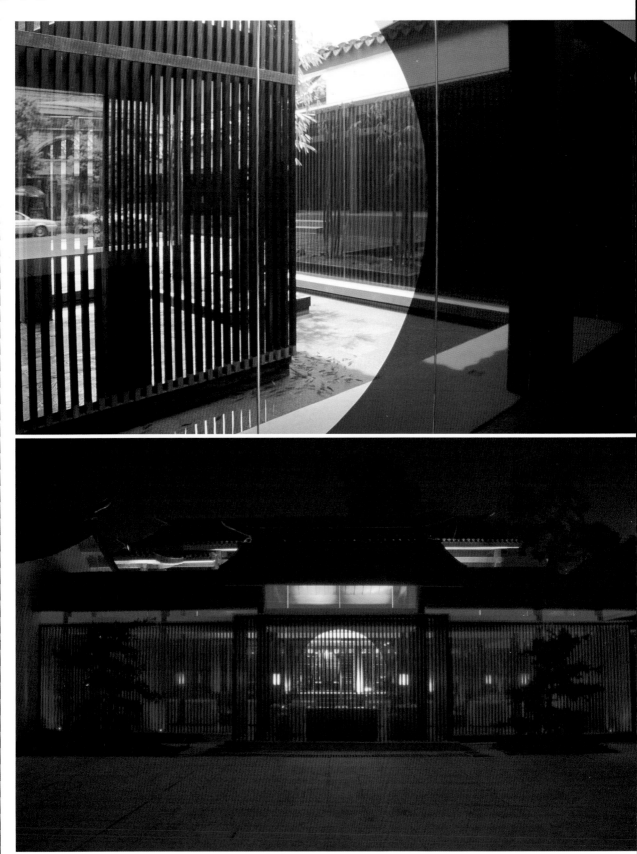

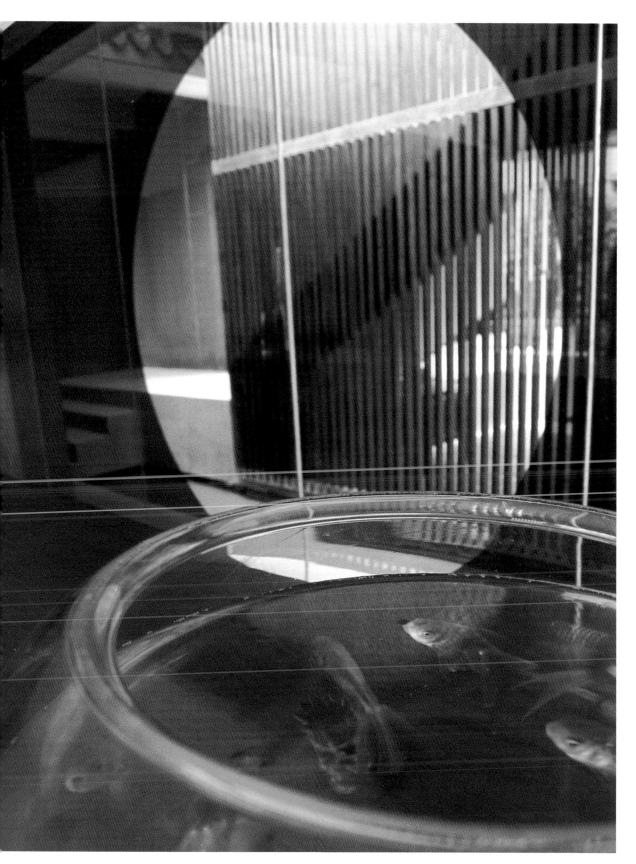

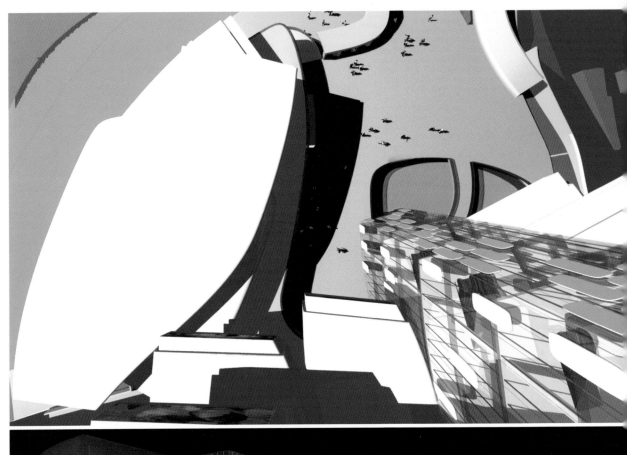

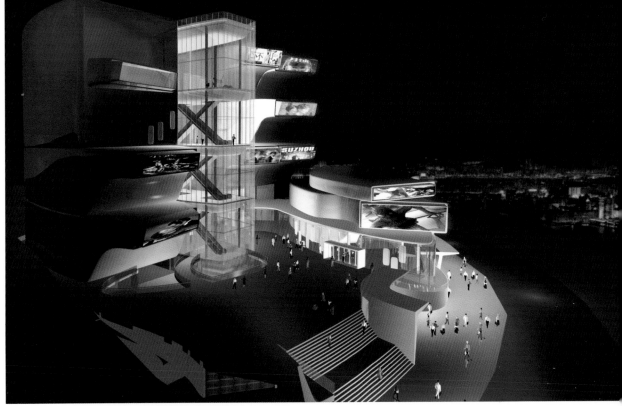

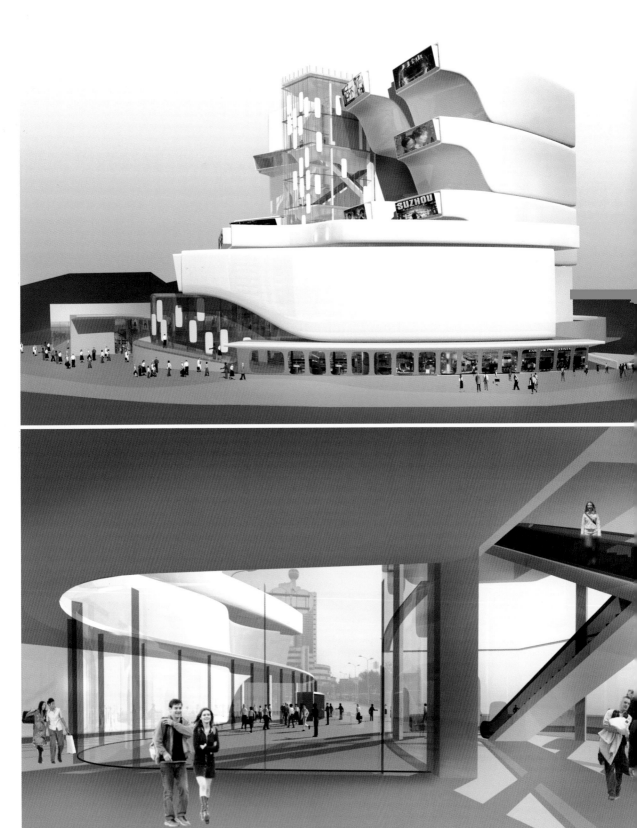

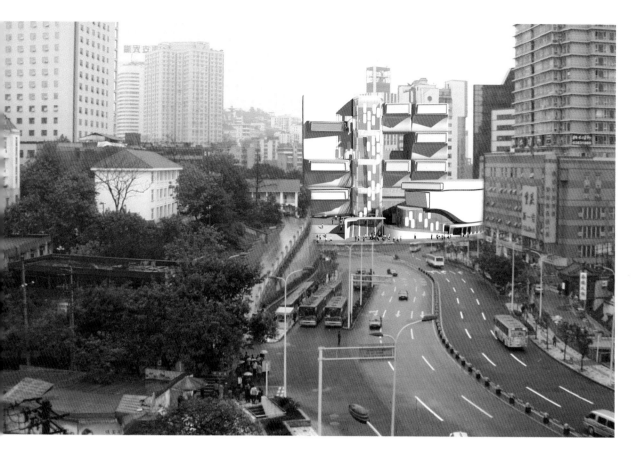

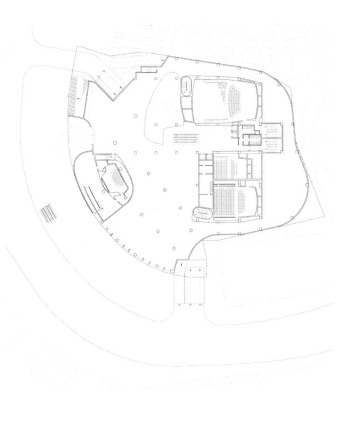

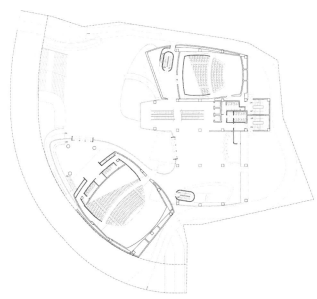

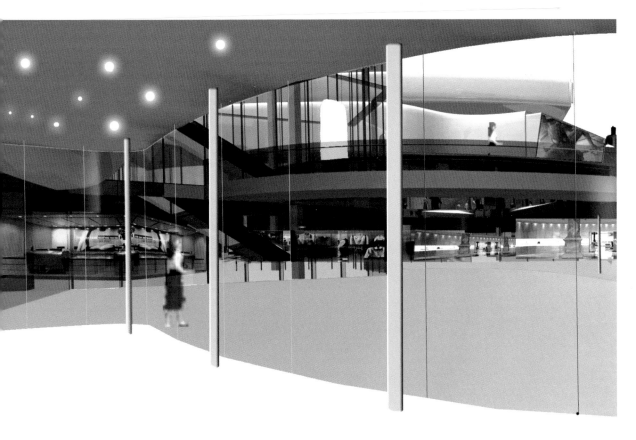

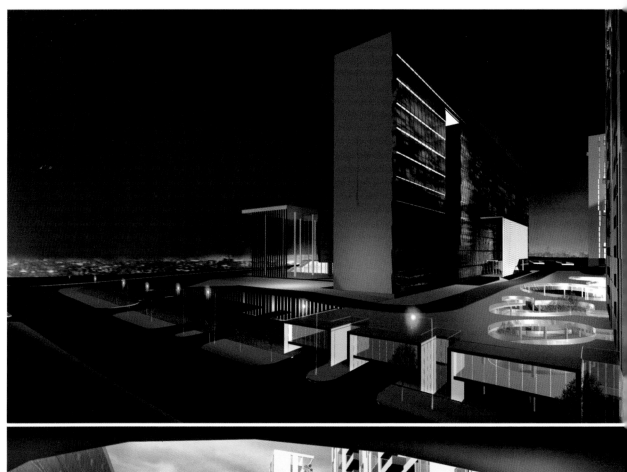
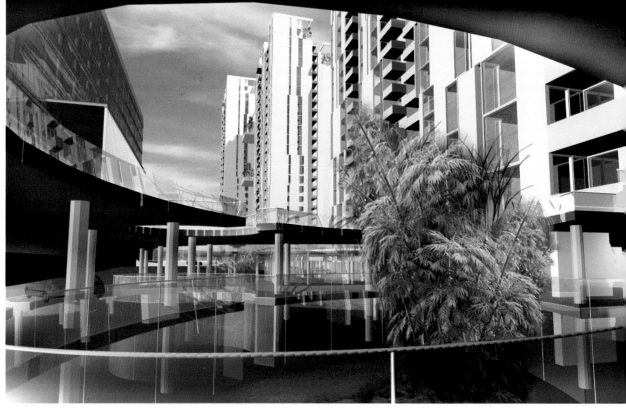

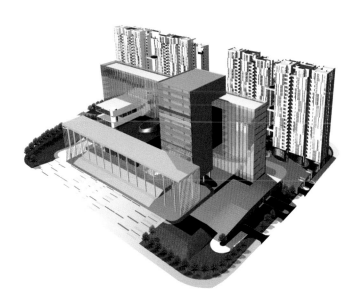

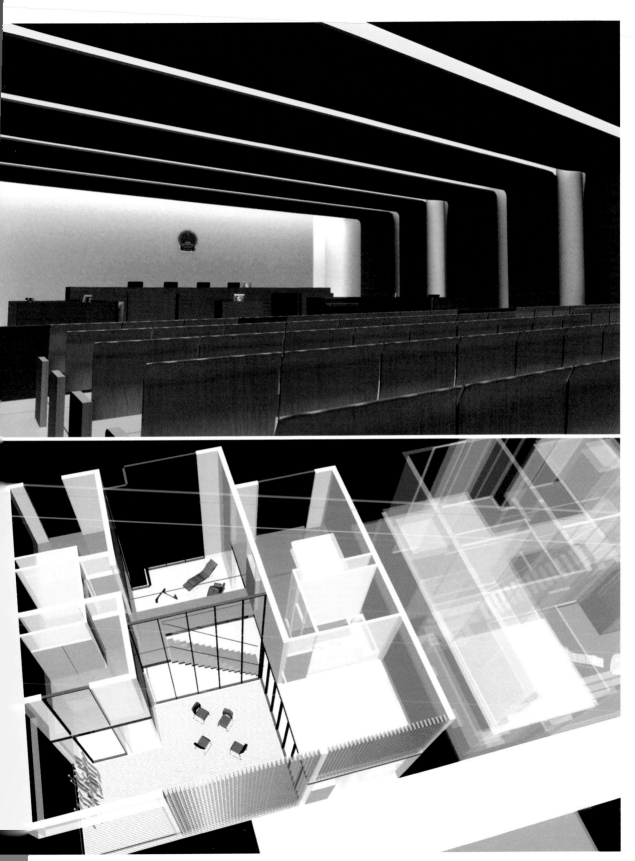

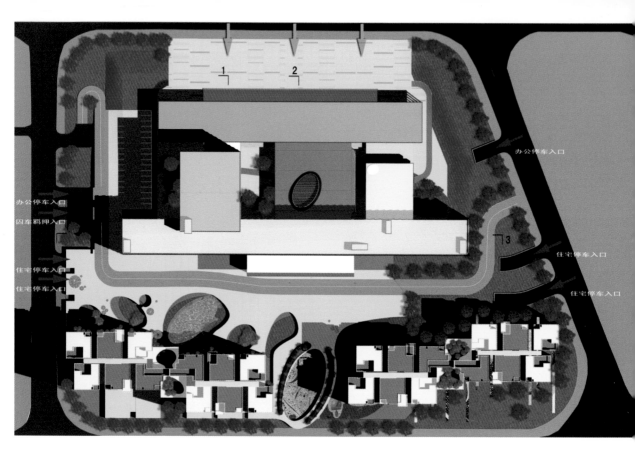

办公停车入口

办公停车入口

因车羁押入口

住宅停车入口

住宅停车入口

办公停车入口

住宅停车入口

住宅停车入口

1

2

3

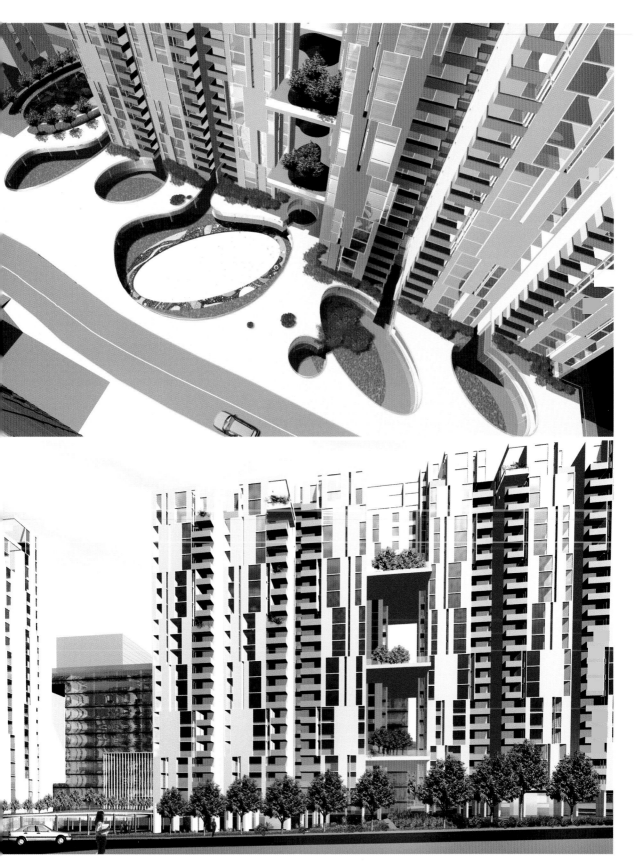

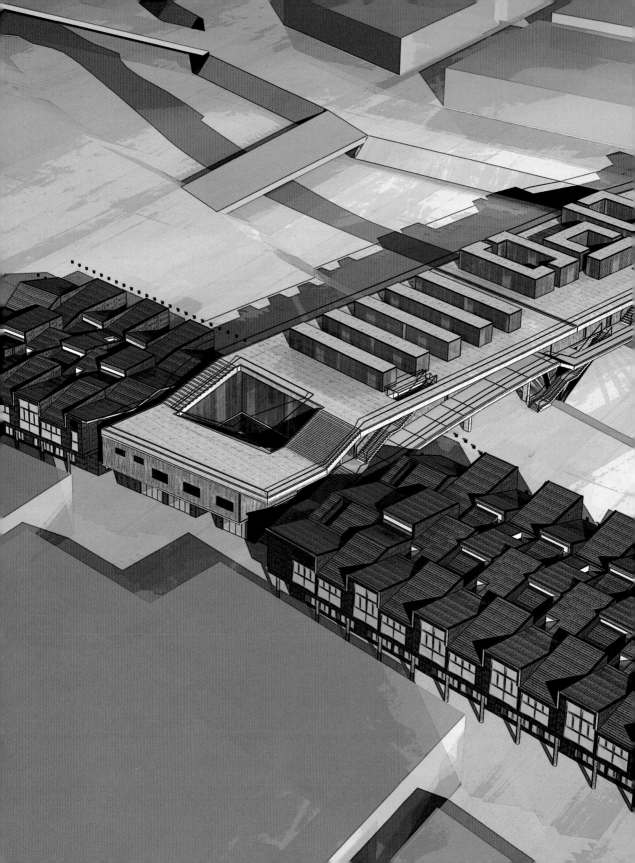

CHANG YUNG HO / FCJZ – ATELIER FEICHANG JIANZHU | BEIJING
AN REN BRIDGE MUSEUM
An Ren, Sichuan | Under Construction

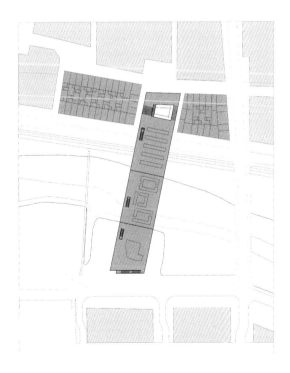

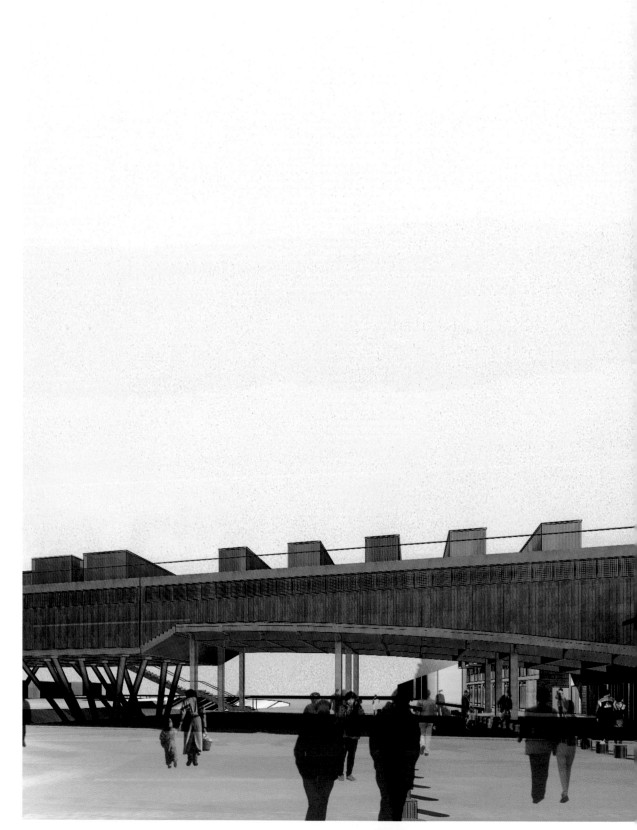

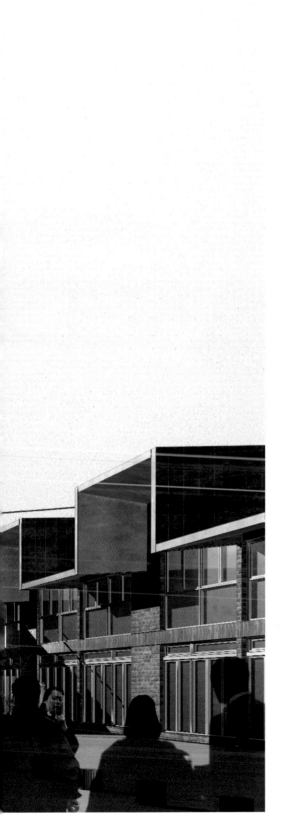

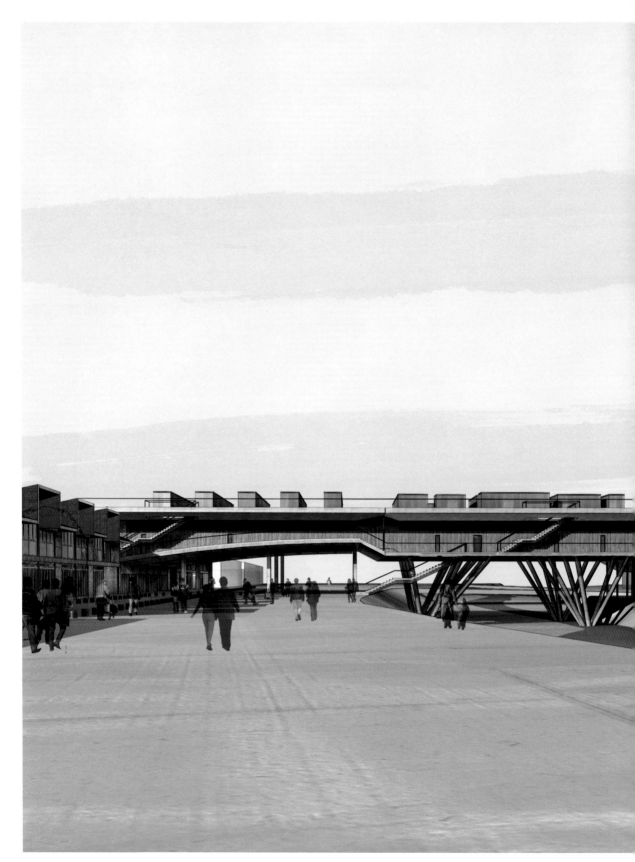

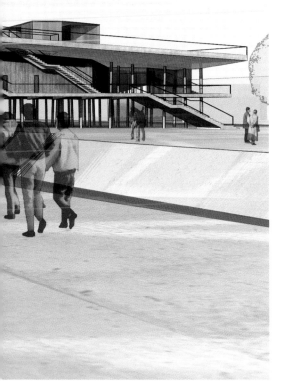

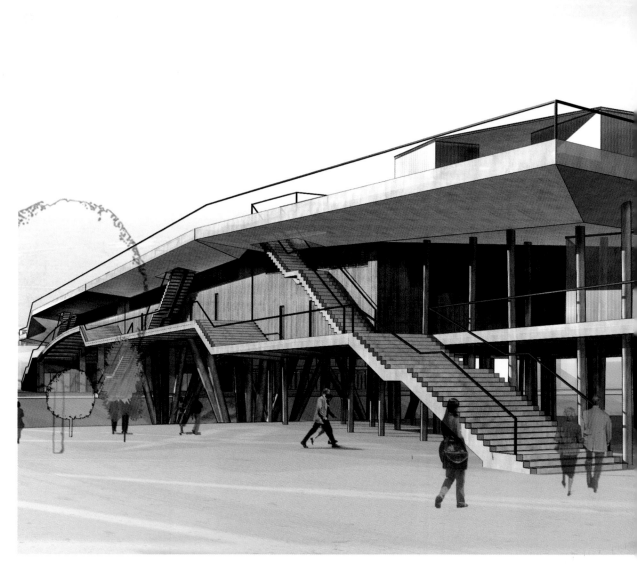

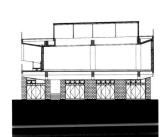

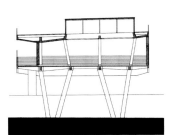

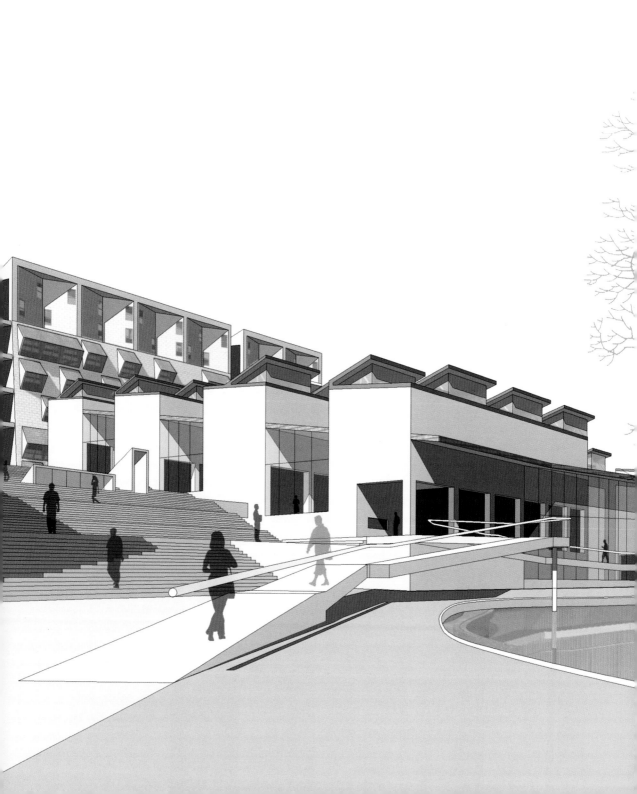

CHANG YUNG HO/FCJZ – ATELIER FEICHANG JIANZHU | BEIJING
RESEARCH AND EDUCATION BUILDING & HUANG YONG YU MUSEUM OF JISHOU UNIVERSITY
Jishou, Hunan | Under Construction

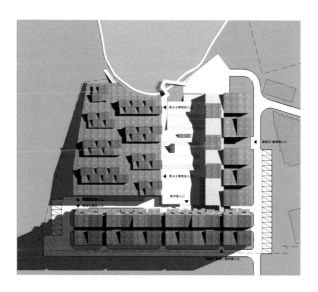

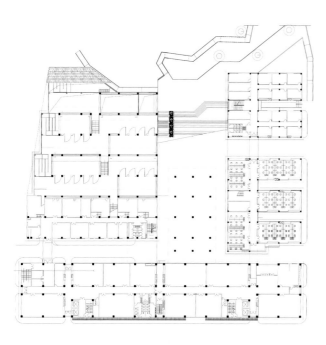

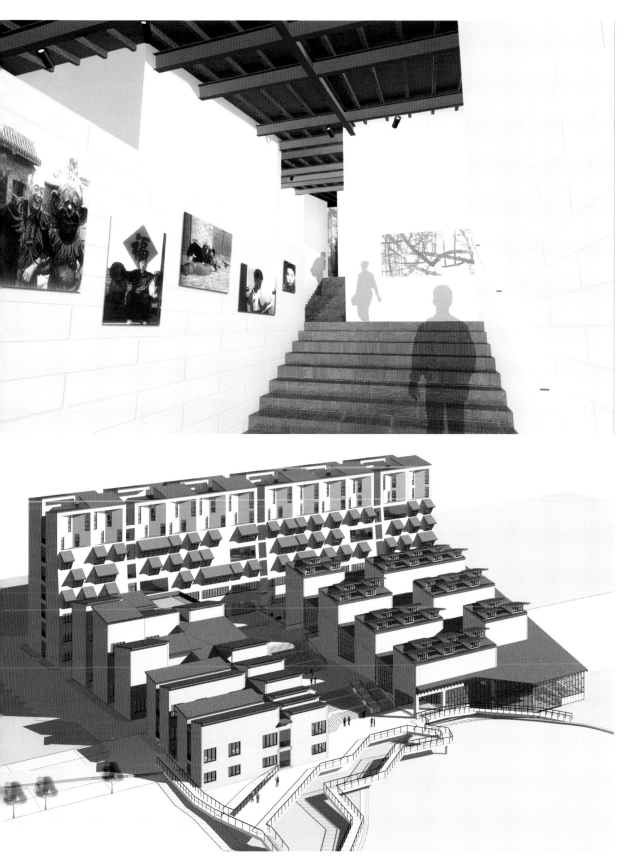

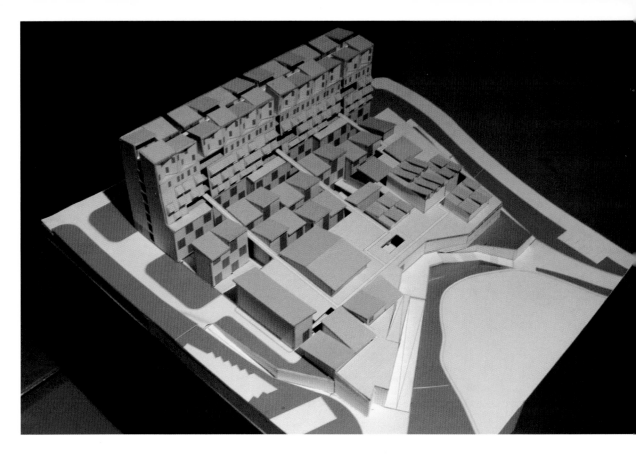

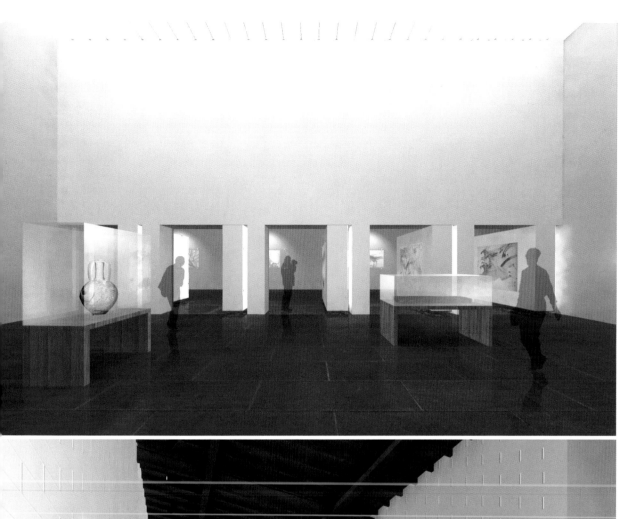
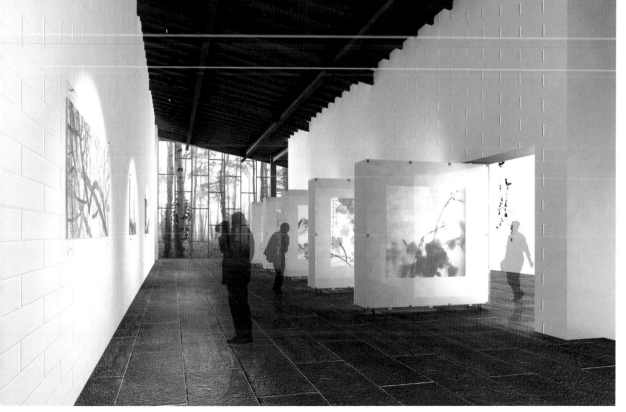

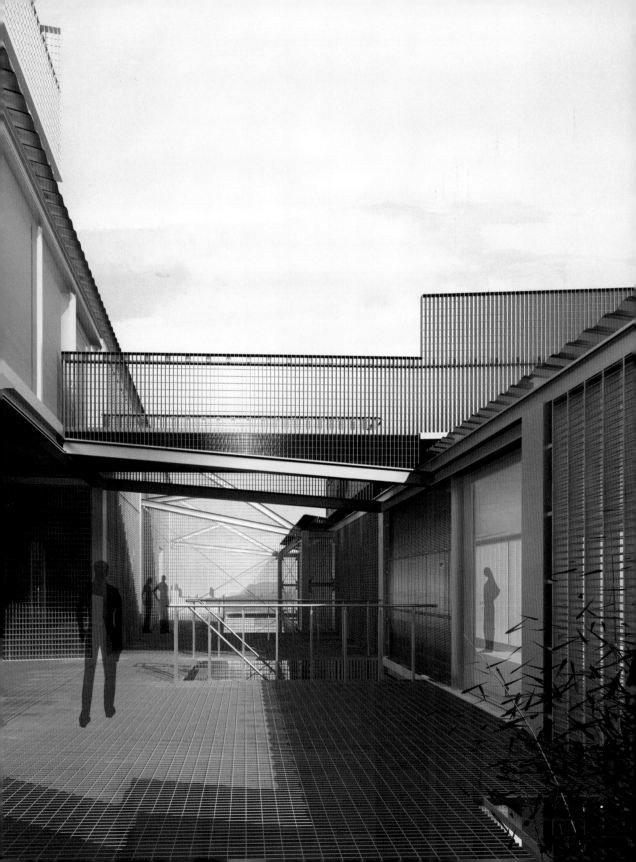

CHANG YUNG HO / FCJZ – ATELIER FEICHANG JIANZHU | BEIJING
STEEL GRATING HOUSE
Nanjing | Under Construction

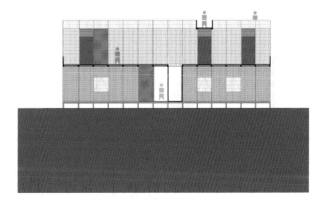

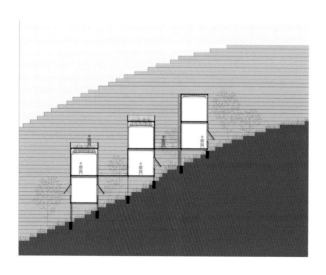

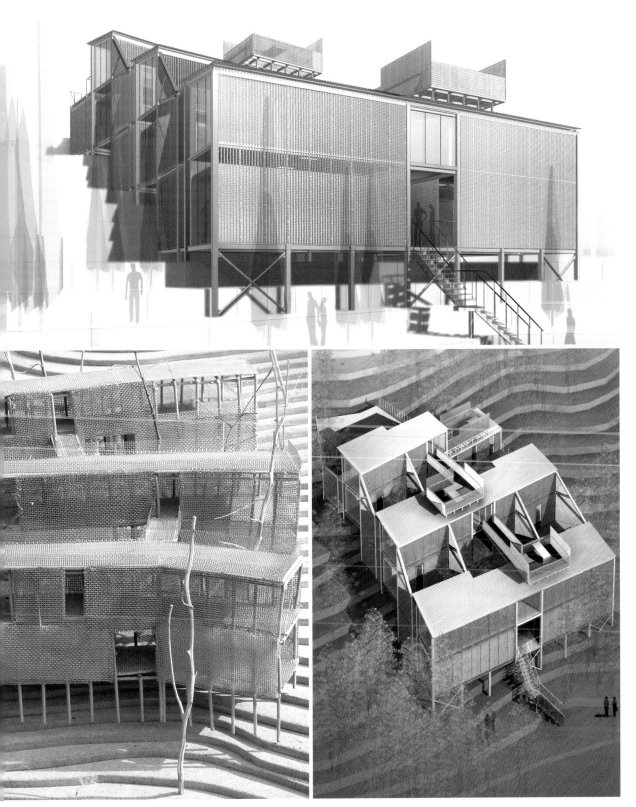

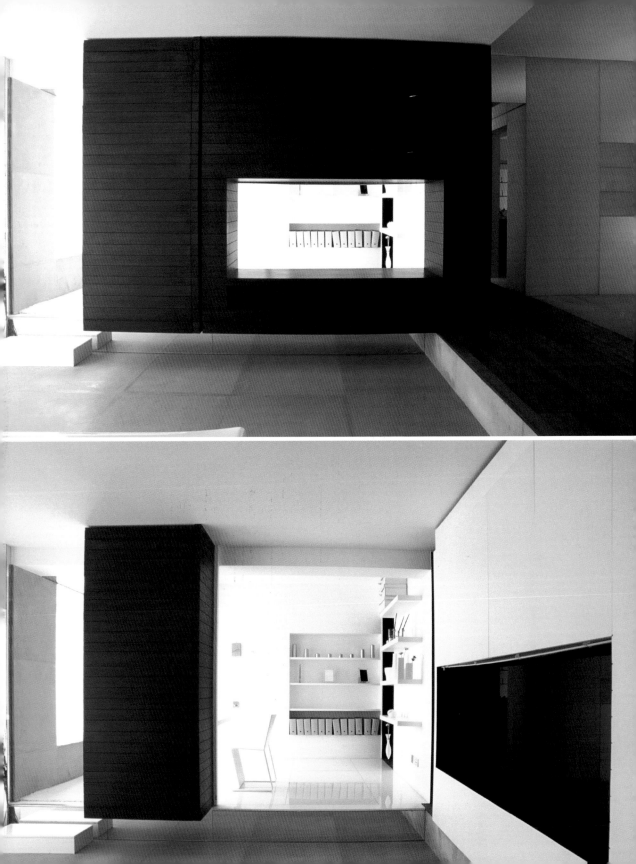

EDGE DESIGN INSTITUTE | **HONG KONG**
CANNES GARDEN SHOWSUITE
Guangzhou | 2001

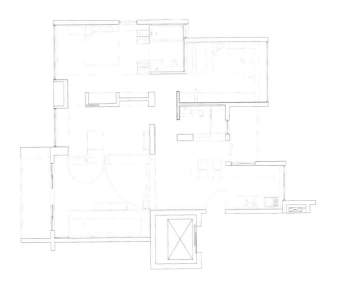

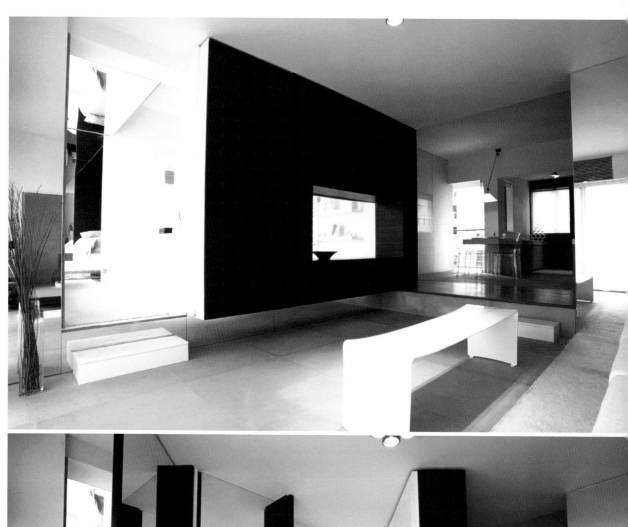

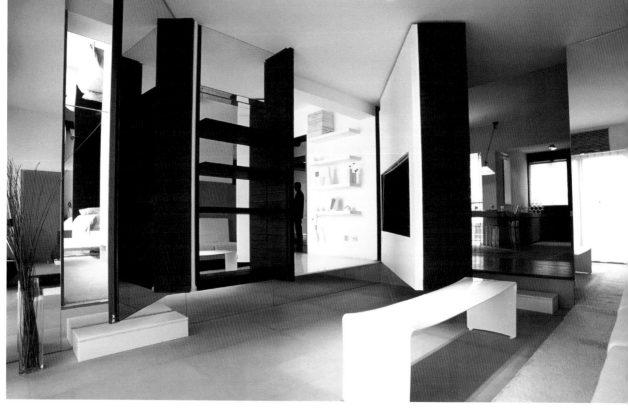

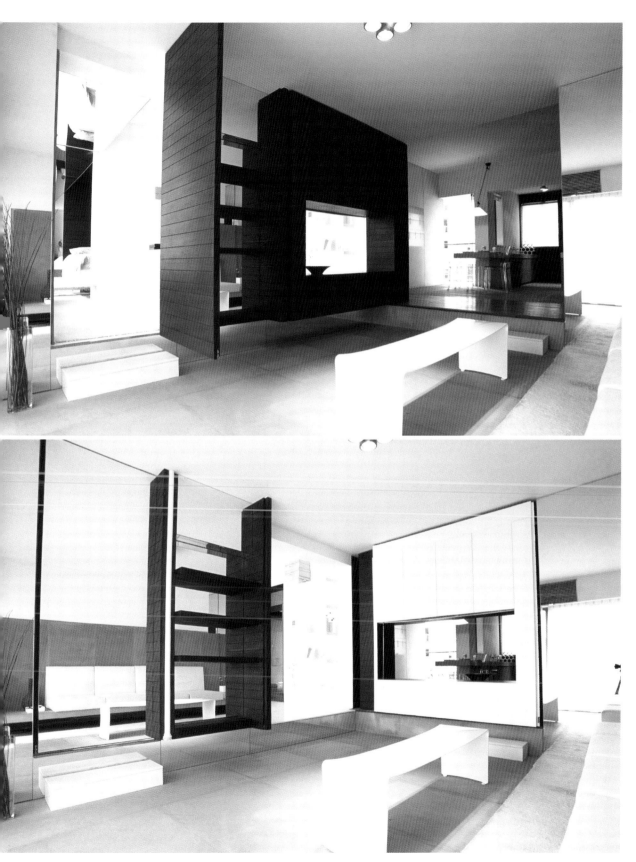

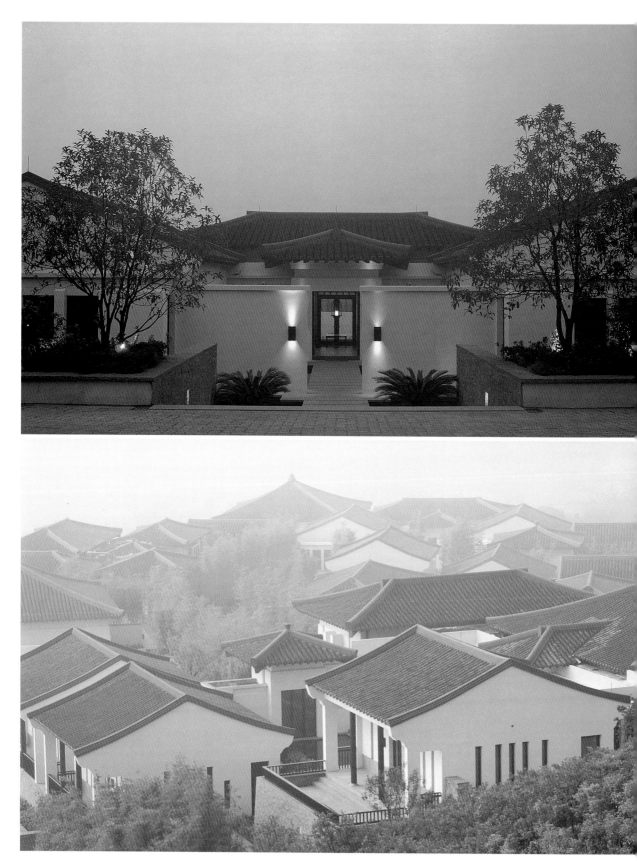

JEAN-MICHEL GATHY/DENNISTON INTERNATIONAL GROUP FOR FUCHUN RESORT | HONG KONG
FUCHUN RESORT
Hangzhou | 2003

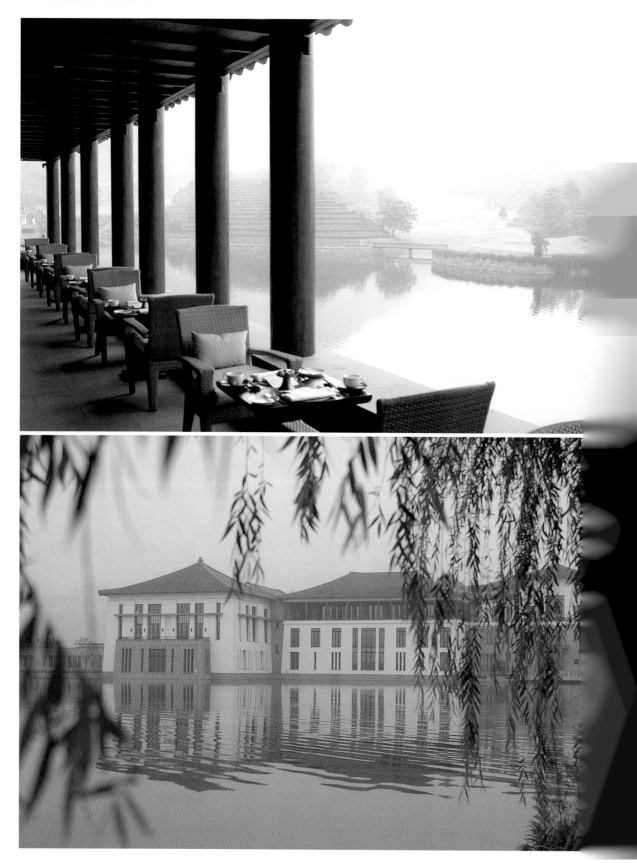

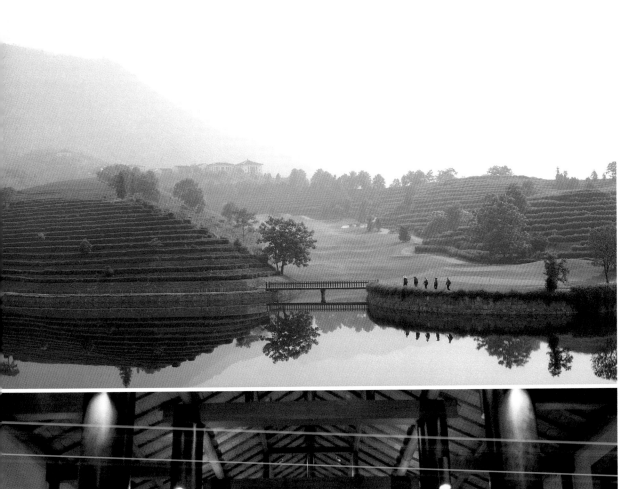
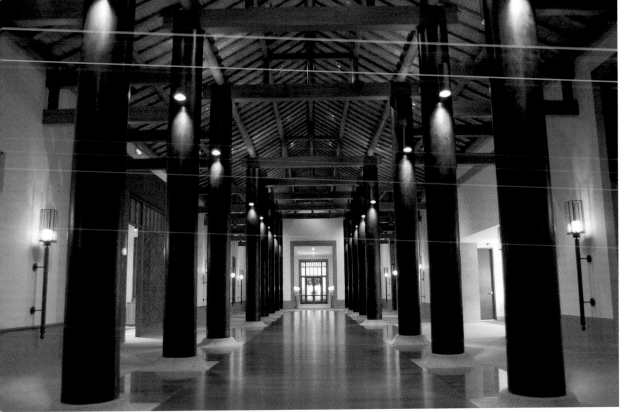

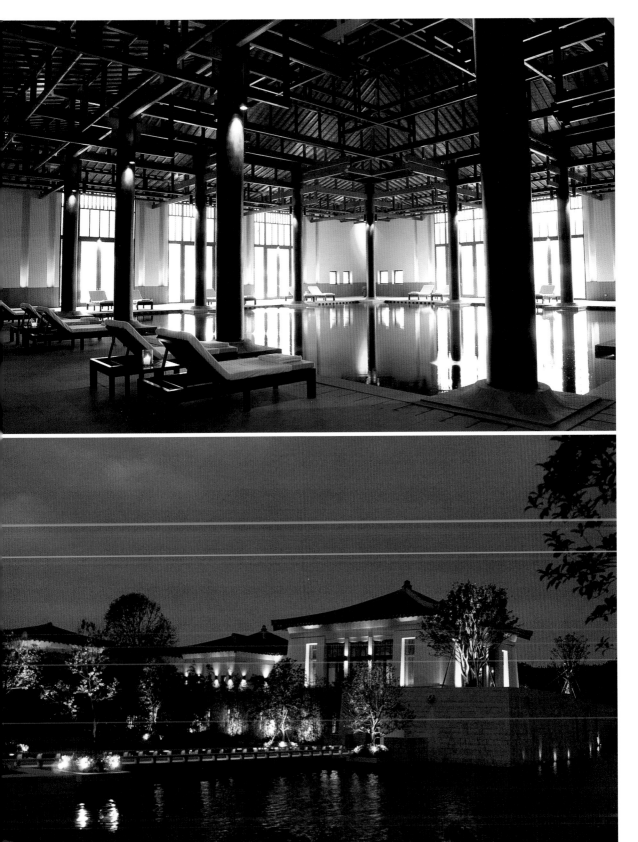

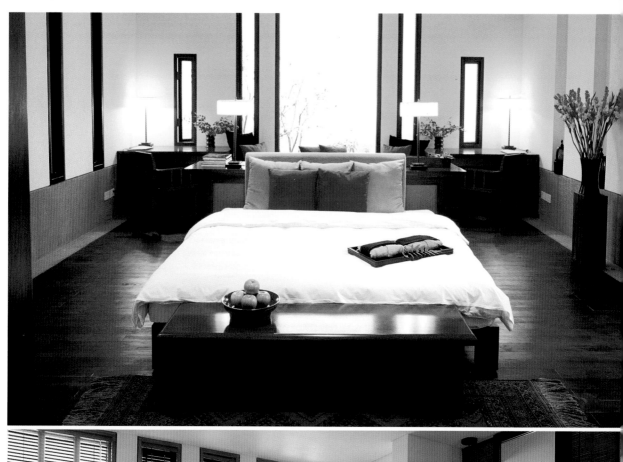
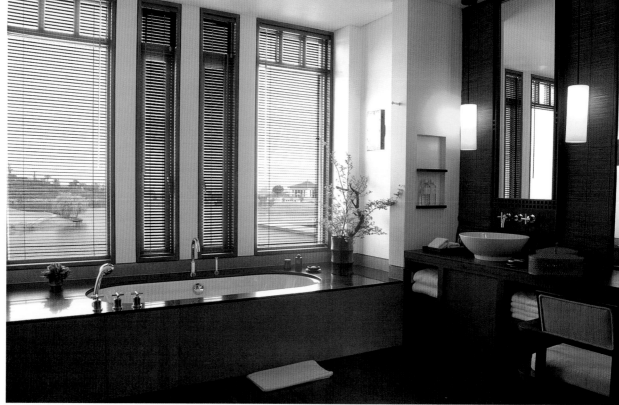

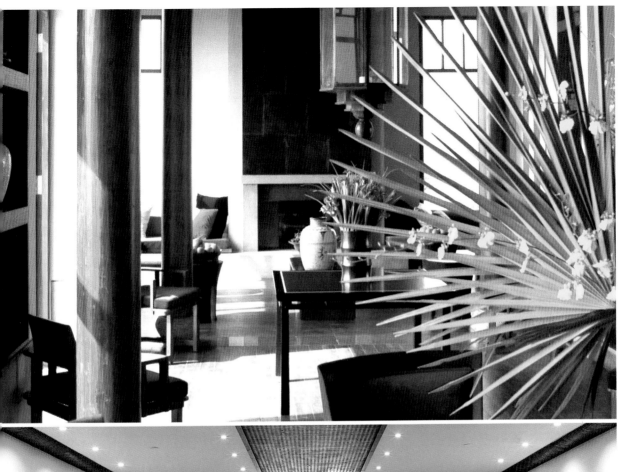

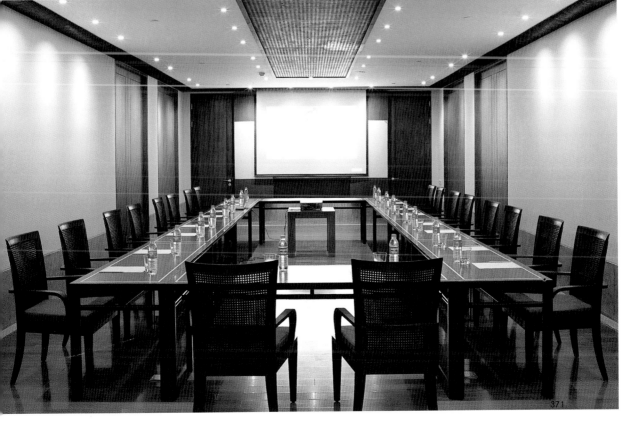

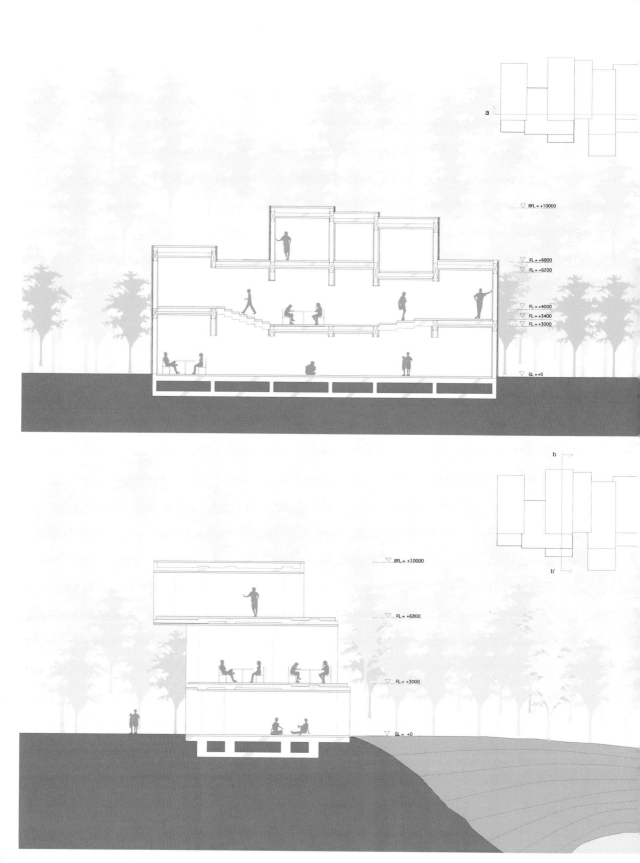

▽ RFL = +10000

▽ FL = +6800
▽ FL = +6200

▽ FL = +4000
▽ FL = +3400
▽ FL = +3000

▽ GL = +0

a

b
b'

▽ RFL = +10000

▽ FL = +6800

▽ FL = +3000

▽ GL = +0

KEIICHIRO SAKO / SKSK ARCHITECTS | BEIJING
TUBE HOUSE
Qiandao Lake, Zhejiang | Under Construction

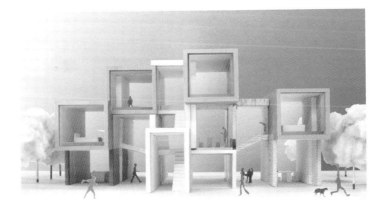

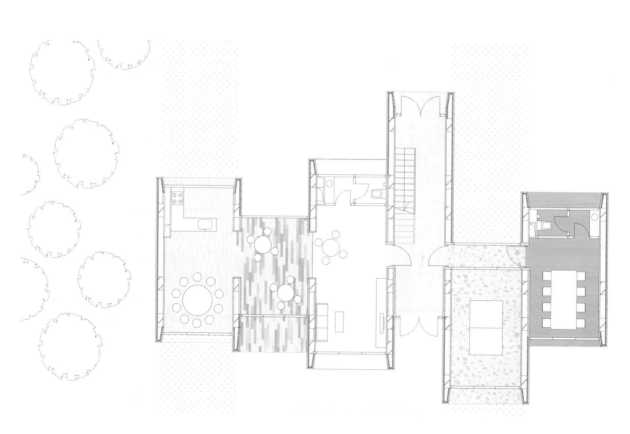

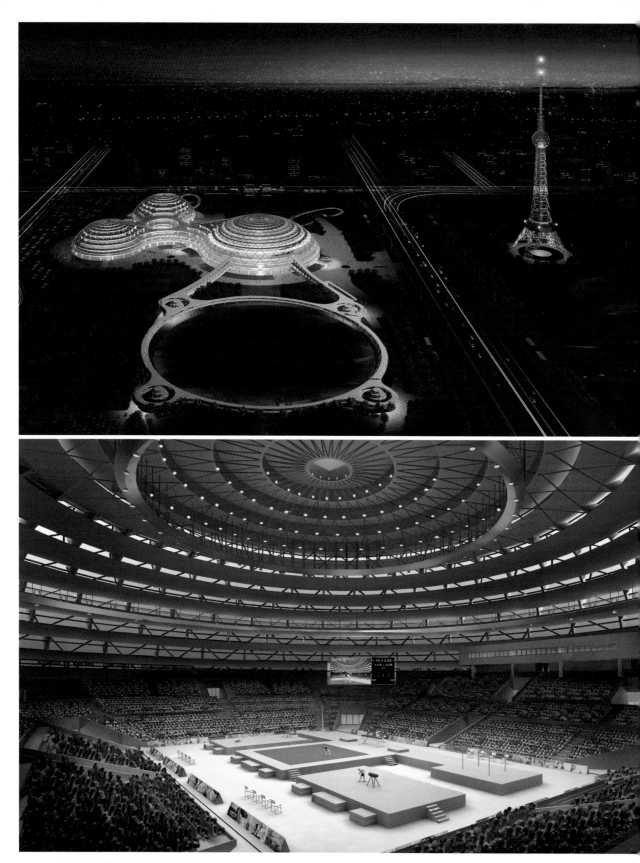

MITSURU SENDA / ENVIRONMENT DESIGN INSTITUTE | JAPAN
FOSHAN GYMNASIUM
Foshan, Guangdong | Under Construction

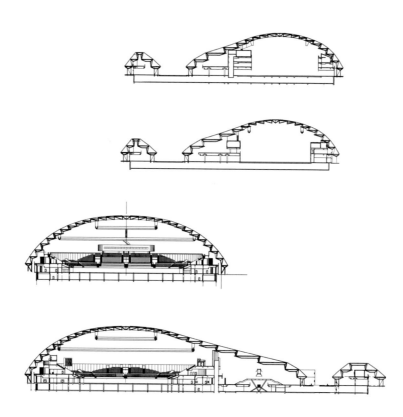

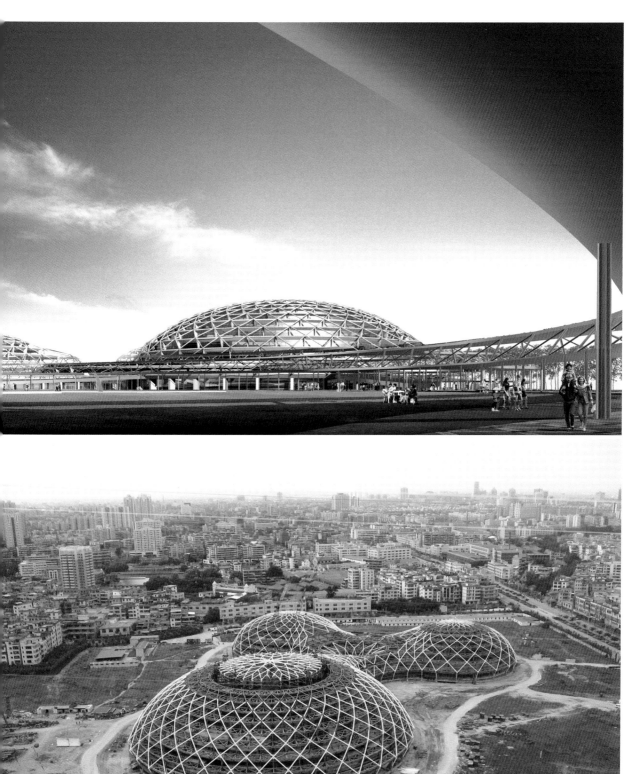

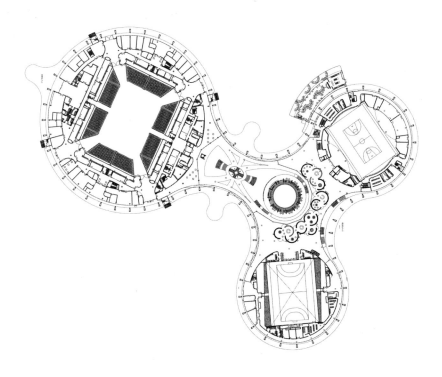

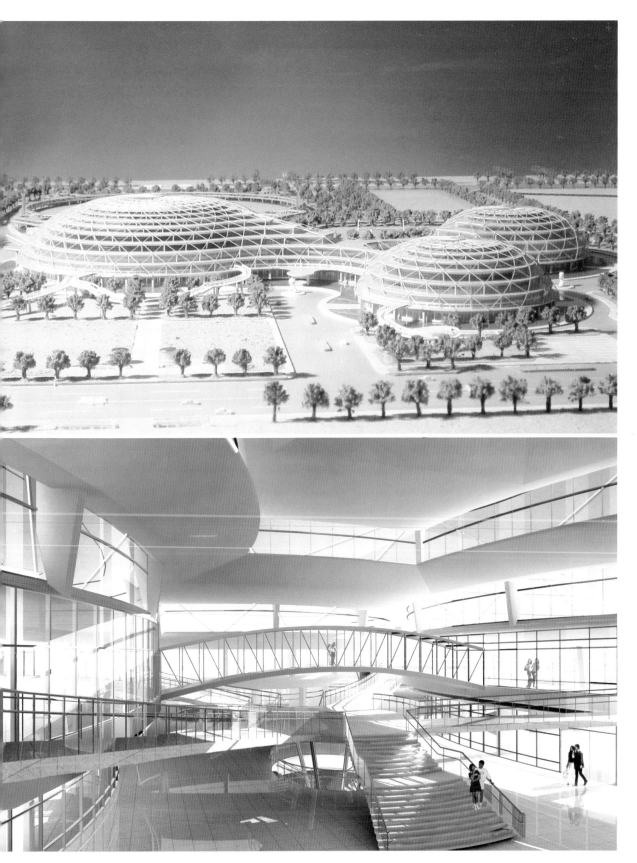

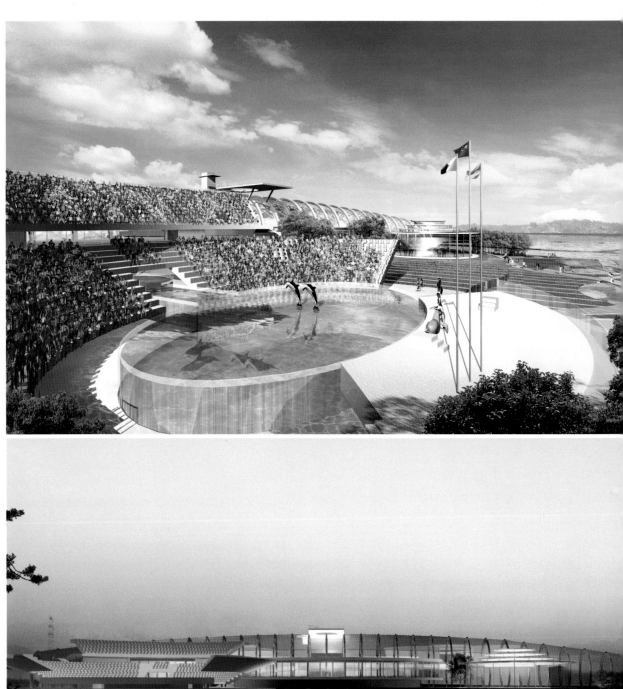
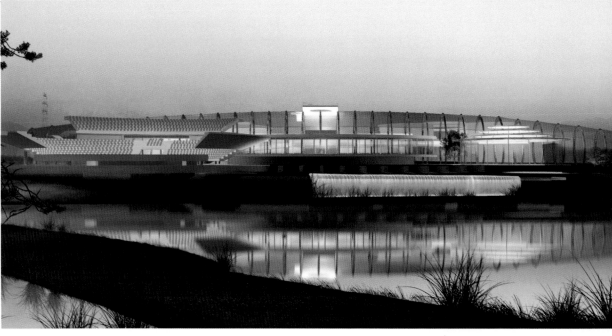

MITSURU SENDA/**ENVIRONMENT DESIGN INSTITUTE** | **JAPAN**
SUZHOU AQUARIUM
Suzhou | Under Construction

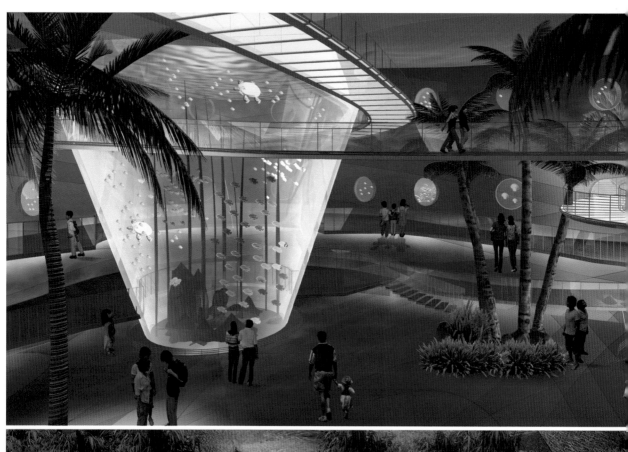

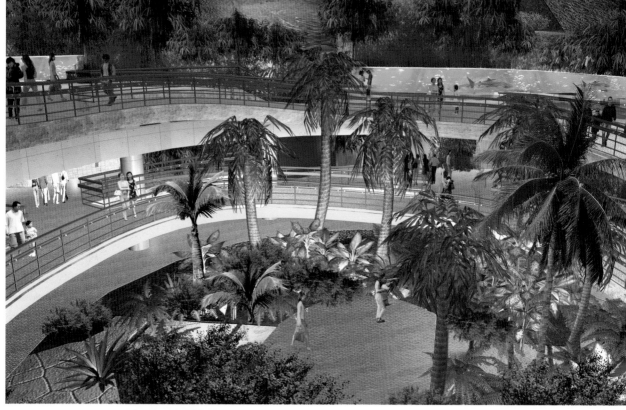

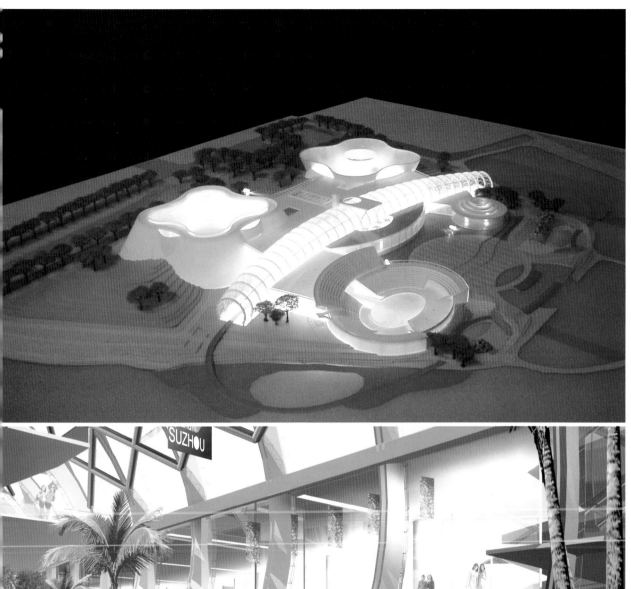

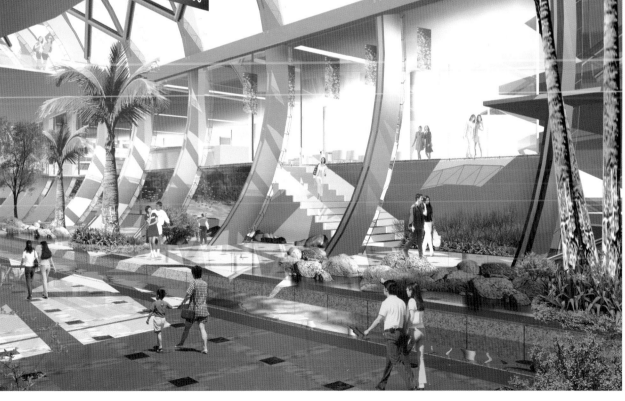

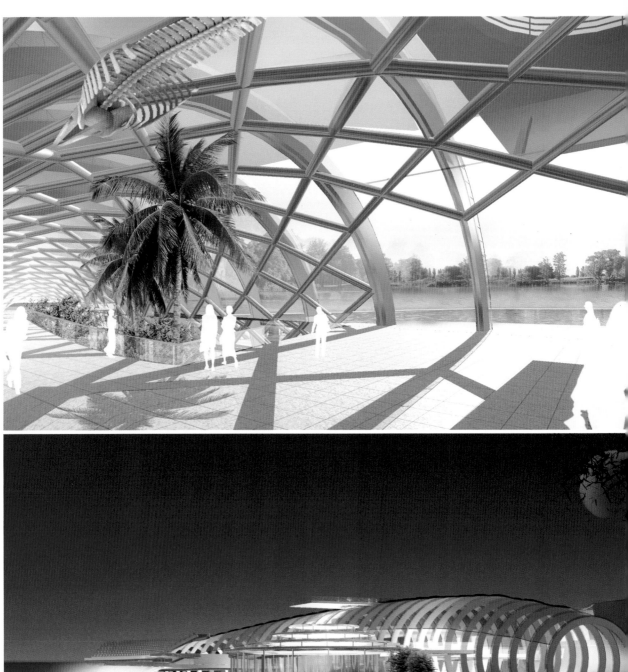
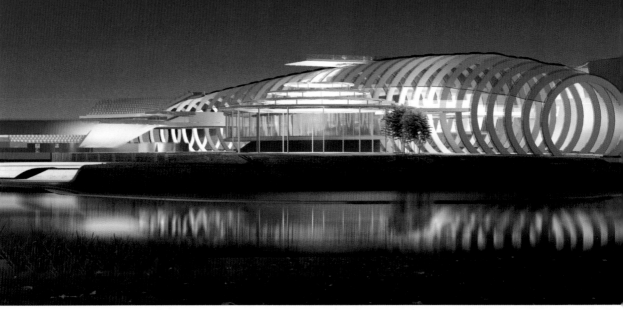

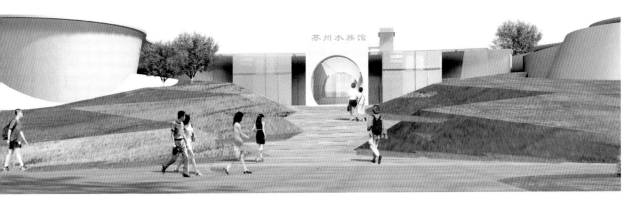

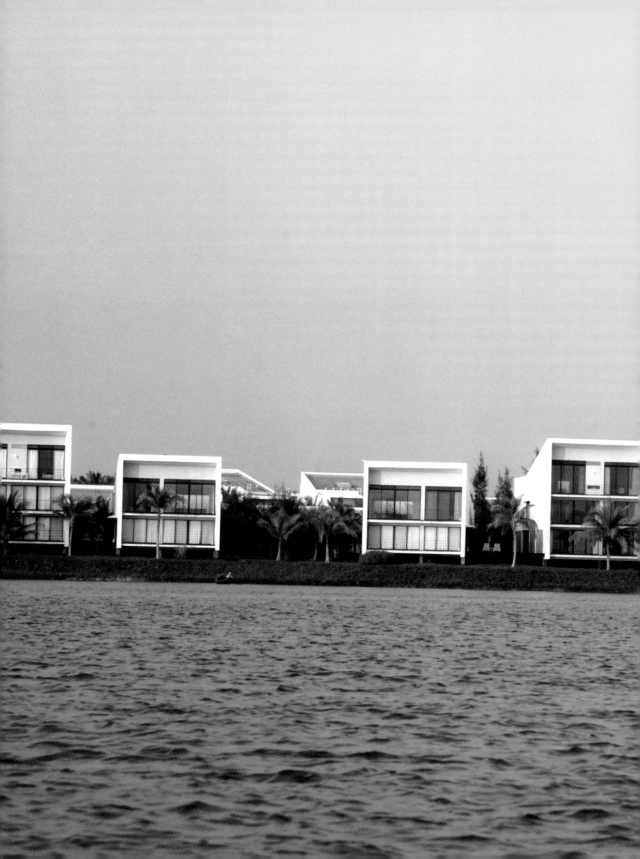

ROCCO YIM AND SEUNG H-SANG FOR SOHO CHINA | BEIJING
BOAO CANAL VILLAGE
Hainan Island | 2002

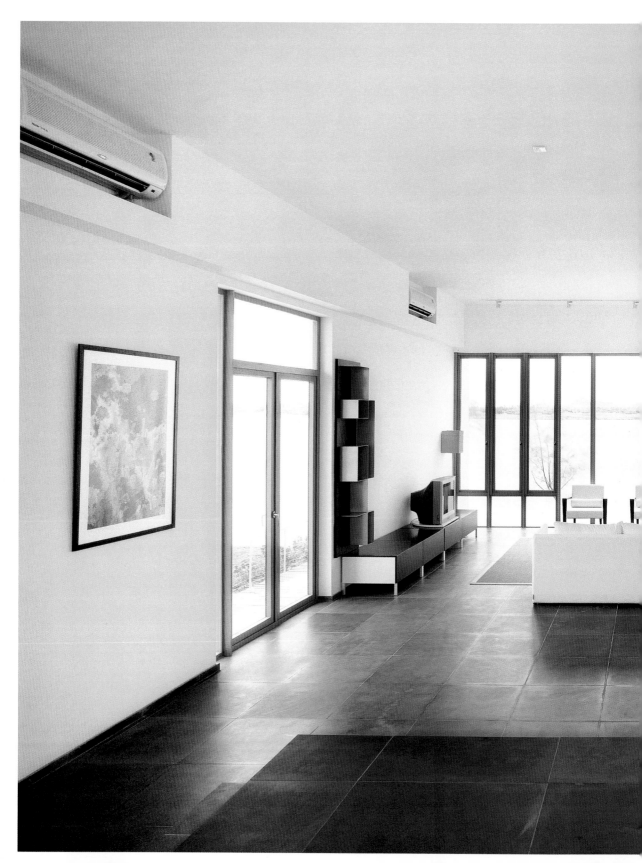

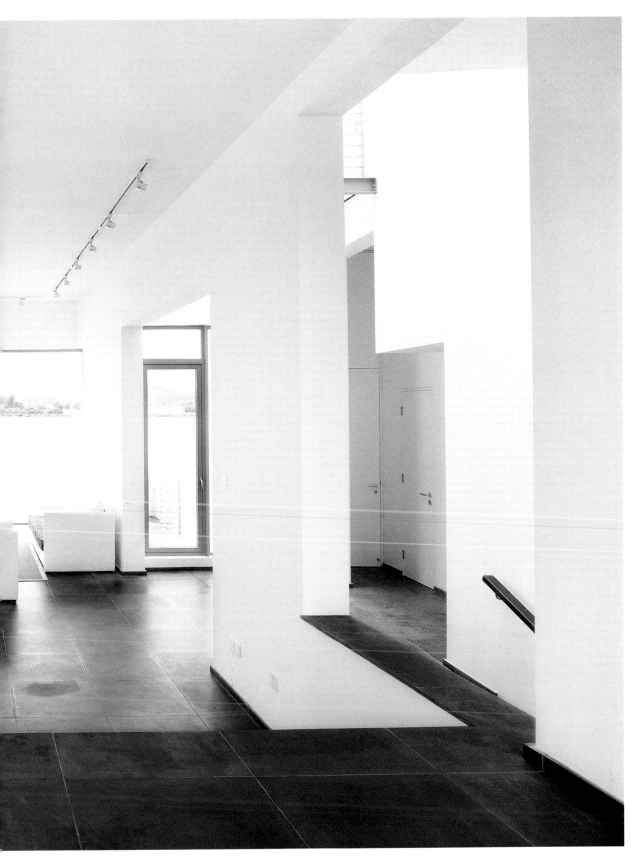

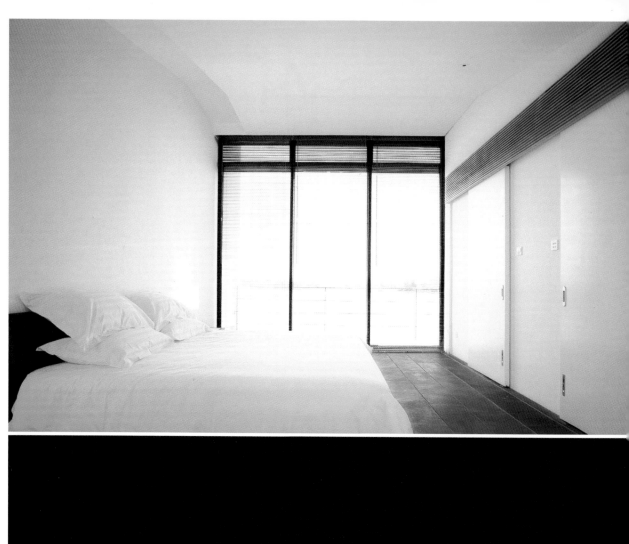

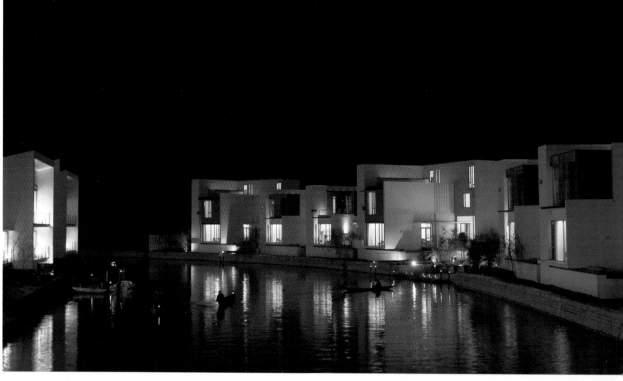

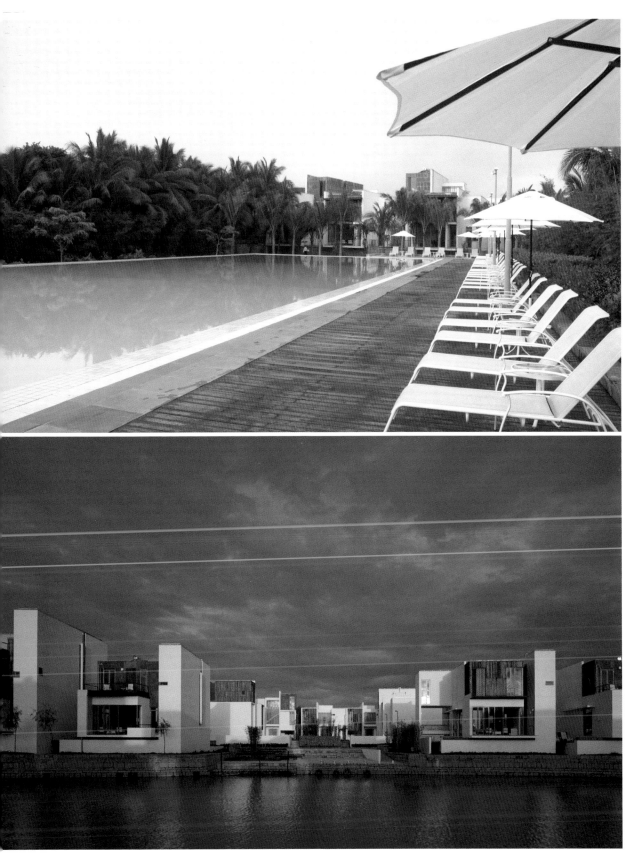

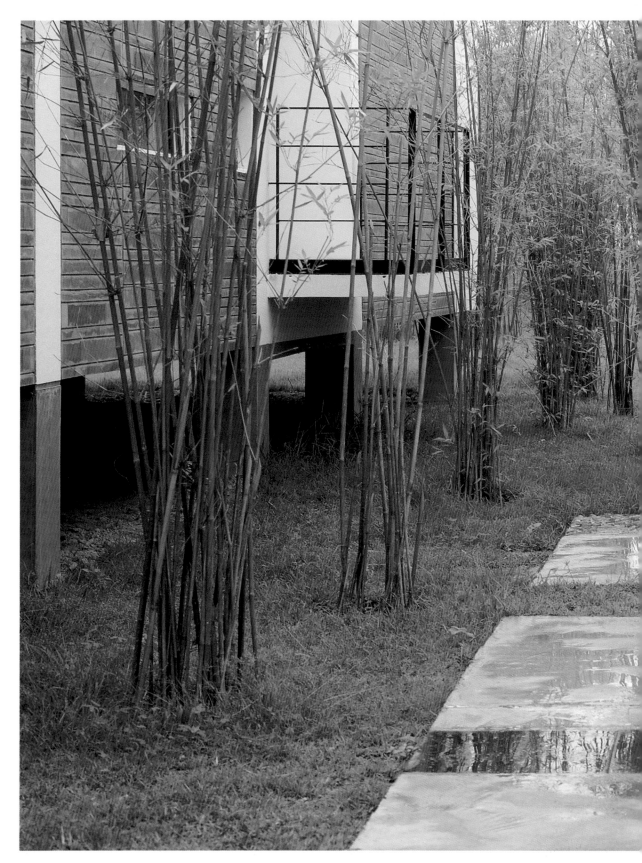

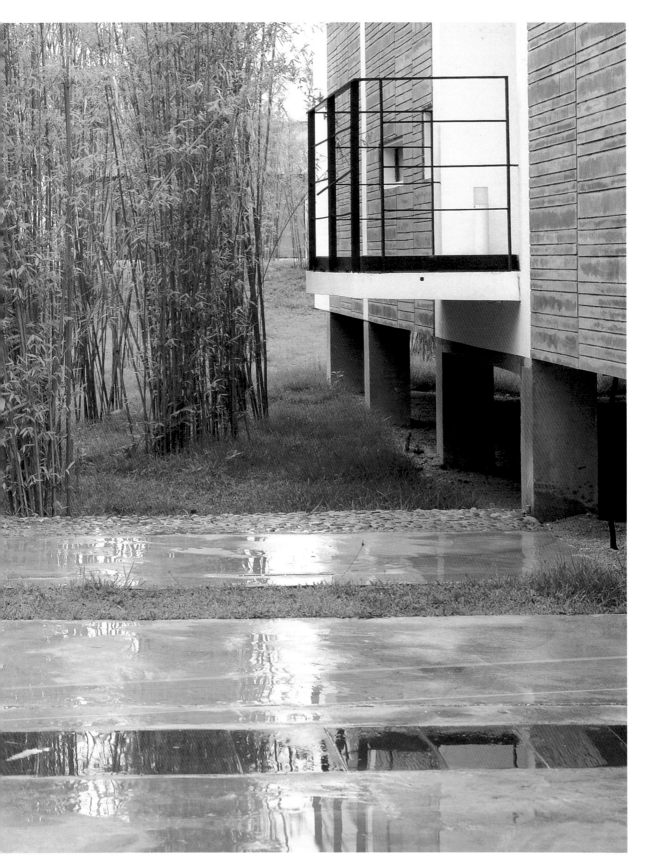

AB Concept
11/F Tai Sang Commercial Building,
24-34 Hennessy Road, Wanchai, Hong Kong, China
P +852 2525 2428
F +852 2854 1038
info@abconcept.com.hk
www.abconcept.com.hk
Apartment in Chung Hom Kok
Photos: © Chester Ong
Apartment in Old Peak Road
Photos: © Chester Ong
House in King's Park Hill
Photos: © Chester Ong
Zenses Restaurant
Photos: © Chester Ong
Tianlun International Hotel
Photos: © Chester Ong

Alan Chan Design Company
1901 Harcourt House, 39 Gloucester Road,
Wanchai, Hong Kong, China
P +852 2527 8228
F +852 2865 6170
acdesign@alanchandesign.com
www.alanchandesign.com
Fairwood Fast Food Restaurant
Photos: © Alan Chan Design Company, Steve Leung Architects Ltd.
Alan Chan Design Company Office
Photos: © Alan Chan Design Company
Baishayuan Tea House
Photos: © Alvin Chan

Amphibian Arc
5410 Wilshire Boulevard, Suite 208,
Los Angeles, CA 90036, USA
P + 1 213 933 3698
F + 1 213 933 3826
information@amphibianarc.com
www.amphibianarc.com
Beijing Planetarium
Photos: © Fuxing + Zhang
Chongqing Cinema
Chongqing Court House

BMA – Beijing Matsubara and Architects
Moma Tower, Room 1714, 199 Chaoyang North Road,
Chaoyang District, Beijing 100026, China
P +86 10 8598 3342
F +86 10 8598 3343
office@bma.net.cn
www.bma.net.cn
Courtyards by the Canal
Photos: © BMA
Liuliuqiao Office Renovation
Photos: © BMA, Satoshi Asakawa
Manzo Bar & Japanese Restaurant
Photos: © Fang Zhenning
Zhongguancun Multi-storey Bookshop Interior Renovation
Photos: © BMA

Bamboo Garden Hotel
24 Xiao Shiqiao Jiugu Lou Street, West City,
Beijing 100009, China
P +86 10 6403 2229
F +86 10 6401 2633
bbgh@bbgh.com.cn
www.bbgh.com.cn
Bamboo Garden Hotel
Photos: © Minoru Iwasaki

Barrie Ho Architecture Interiors Ltd.
1+3+4/F, 31 Wyndham Street, Central, Hong Kong, China
P +852 2117 7662
F +852 2114 7661
barrieho@barrieho.com
www.barrieho.com
Image Center
Photos: © Barrie Ho
Lan Kwai Fong
Photos: © Barrie Ho

CA Group
2F, 1305 South Suzhou Road, Shanghai 200003, China
P +86 21 6327 2561
F +86 21 6327 2560
www.cagroup.cn
CA Group Warehouse on Suzhou Riverbank
Photos: © Nacása & Partners

Café Sambal
Doufu Chi Hutong 43, Jiu Gulou Dajie, Beijing 100009, China
P +86 10 6400 4875
cho@cafesambal.com
Café Sambal
Photos: © Minoru Iwasaki

Chen Mi Ji Cultural Production Co. Ltd.
G/F, 69 Peel Street, Soho, Central, Hong Kong, China
P +852 2975 9266
F +852 2179 5388
chenmiji@netvigator.com
www.chenmiji.com
Chen Mi Ji Furniture Shop
Photos: © Chen Mi Ji

Chhada Siembieda and Associates Ltd.
Western Harbour Centre, Room 1501,
181 Connaught Road West, Hong Kong, China
P +852 2521 2191
F +852 2810 6061
Huang Ting Restaurant in the Peninsula Palace Hotel
Photos: © Peninsula Palace Beijing

Datrans
Building 13-1F, 50 Moganshan Road, Shanghai 200060, China
P +86 21 6299 6236
F +86 21 6299 6237
info@datrans.cn
www.datrans.cn
Datrans Studio
Photos: © Datrans

Edge Design Institute Ltd.
Eastern Harbour Centre, Suite 1604, 28 Hoi Chak Street,
Quarry Bay, Hong Kong, China
P +852 2802 6212
F +852 2802 6213
edgeltd@netvigator.com
www.edge.hk.com
Broadway Cinematheque
Photos: © Aimond Chu
17 Miles House D
Photos: © Gary Chang
Sandra's Apartment
Photos: © Richard Yip
Cannes Garden Showsuite
Photos: © Popeye Tsang

Environment Design Institute
5-12-22 Roppongi, Minato-ku, Tokyo 106-0032, Japan
P +81 3 5575 7174
F +81 3 5575 7178
msedi@ms-edi.co.jp
www.ms-edi.co.jp/index.html
Shanghai Qi Zhong Forest Sports City Tennis Center
Foshan Gymnasium
Suzhou Aquarium

FCJZ – Atelier Feichang Jianzhu
Yuan Ming Yuan East Gate Nei, Yard 1 on Northside,
Yuan Ming Yuan Dong Lu, Beijing 100084, China
P +86 10 8262 2712
F +86 10 8262 2712
fcjz@fcjz.com
www.fcjz.com
Canal Residential Project
Photos: © FCJZ Atelier
798 Space
Photos: © Minoru Iwasaki
An Ren Bridge Museum
Research and Education Building &
Huang Yong Yu Museum of Jishou University
Steel Grating House

Fake Design
CaoChangdi 258, Chaoyang District,
Beijing 100102, China
P +86 10 8456 4194
F +86 10 8456 4194
aixx@vip.sohu.com
nobody@vip.sina.com
Ai Weiwei's House
Photos: © Ma Xiaochun
Where to Go Restaurant
Photos: © Fake Design
The South Riverbank of Yiwu River
Photos: © Fake Design

Fuchun Resort
Fuyang Section, Hangfu Yanjiang Road, Hangzhou,
Zhejiang 311401, China
P +86 571 6346 1111
F +86 571 6346 1222
www.fuchunresort.com
Fuchun Resort
Photos: © Fuchun Resort

Jian Fu
23-3 Yang Fang Hu Tong, Xi Cheng District,
Beijing 100009, China
P +86 10 6616 0725/6616 6343
F +86 10 6616 0725
reservation@fulinjiuge.com
www.fulinjiuge.com
Cha Jiafu
Photos: © Minoru Iwasaki

Jin R. + Jiang Tao/Jia Xin Yi He
6 Gongti Xi Lu, Chaoyang District, Beijing 100027, China
P +86 10 6552 8310/8311
F +86 10 6553 8750
info@green-t-house.com
www.green-t-house.com
Green T. House
Photos: © Xiao Mei, Laurent Segretier

LIN Design Studio
11F-3, 1 Lane 91, Sec. 2, Taipei, Taiwan
P +886 2 397 5020
Il Milione & Q's Café
Photos: © Minoru Iwasaki

Linstallation Workshop
2 Road Jiu Xian Qiao, Da Shan Zi, Chaoyang District,
Beijing 100015, China
P +86 10 8456 0105
F +86 10 8456 0105
mumujing@vip.sina.com
Lin Jing's Loft
Photos: © Xiao Mei

Maymayking
G/F, 67A Peel Street, Soho, Central, Hong Kong, China
P +852 2445 5655
F +852 2445 5655
hello@maymayking.com
www.maymayking.com
Maymayking Shop
Photos: © Birdy Chu, May Yang

MIMA Design Workshop
Yuan Ming Yuan East Gate, North of ZhongGuanChun Street,
Haidian District, Beijing 100084, China
P +86 10 8262 6580
F +86 10 6263 3106
mima@mima.com.cn
www.mima.cn
Apple Sale Center
Photos: © MIMA Design
MIMA Café
Photos: © MIMA Design

Philippe Starck
18/20 Rue du Faubourg du Temple, 75011 Paris, France
P +33 1 48 07 54 54
F +33 1 48 07 54 64
info@starcknetwork.com
press@starcknetwork.com
www.starck.com
Felix Restaurant in the Peninsula Palace Hotel
Photos: © Peninsula Palace Hong Kong

Red Capital Club
66 Dongsi Jiutiao, Dongsheng District, Beijing 100007, China
P +86 10 8401 6152
F +86 10 6402 7153
info@redcapitalclub.com.cn
www.redcapitalclub.com.cn
Red Capital Club, Red Capital Residence
Photos: © Red Capital Club
Red Capital Ranch
Photos: © Minoru Iwasaki

RTKL Associates Inc.
333 South Hope, Los Angeles, CA 90071, USA
P +1 213 627 7373
F +1 213 627 9815
webmaster@rtkl.com
www.rtkl.com
Chinese Museum of Film
Shanghai Science and Technology Museum
Photos: © RTKL Associates, Tim Griffith

SKSK Architects
Jianwai Soho, Tower 2, Middle Street, East Third Ring Road,
Chaoyang District, Beijing 100022, China
P +86 10 5869 0901
F +86 10 5869 1317
sksk@sksk.cn
www.sksk.cn
Felissimo
Photos: © Minoru Iwasaki
Tube House

Soho China Ltd.
Soho New Town, Tower B, 18/F, 88 Jianguo Road,
Chaoyang District, Beijing 100022, China
P +86 10 5878 8866
F +86 10 6567 8383
pr@sohochina.com
www.sohochina.com
Soho New Town
Photos: © Soho China
Soho Shang Du
Jianwai Soho
Photos: © Soho China
Boao Canal Village
Photos: © Soho China

Super Potato Co. Ltd.
3-34-17 Kamikitazawa, Setagaya-ku, Tokyo 156-0057, Japan
P +81 3 3290 0195
F +81 3 3290 1650
info@superpotato.jp
intl@superpotato.jp
www.superpotato.jp
Made in China Restaurant in the Grand Hyatt Beijing
Photos: © Grand Hyatt Beijing

© 2006 daab
cologne london new york

published and distributed worldwide by
daab gmbh
friesenstr. 50
d-50670 köln

p +49-221-9410740
f +49-221-9410741

mail@daab-online.com
www.daab-online.com

publisher ralf daab
rdaab@daab-online.com

creative director feyyaz
mail@feyyaz.com

editorial project by loft publications
© 2006 loft publications

editors jaume nasple & kyoko asakura
mail@nasple-asakura.com
www.nasple-asakura.com

born in barcelona, jaume j. nasple-baulenas studied political science and japanese
studies at the university of london. having been extensively engaged in international
relations and trade, he has also been working as an editor, translator and interpreter
mostly in europe and japan.

kyoko asakura trained in psychology and interior design at university
in tokyo, japan. after having worked for the "workshop for architecture and
urbanism" in tokyo, she has been excercising in europe as a freelance writer
and editor for design magazines and tv companies.

layout cris tarradas, zahira rodríguez mediavilla
original english text nasple & asakura
french translation michel ficerai
italian translation maurizio siliato
german translation susanne engler
spanish translation nasple & asakura
copy editing susana gonzález
special acknowledgements junko haraguchi

printed in spain
anman gràfiques del vallès, spain
www.anman.com

isbn 3-937718-34-6
d.l. B-2755-06

29